SATHER CLASSICAL LECTURES

VOLUME FORTY-SIX

ASPECTS OF DEATH IN EARLY
GREEK ART AND POETRY

ASPECTS OF DEATH IN EARLY GREEK ART AND POETRY

Emily Vermeule

UNIVERSITY OF CALIFORNIA PRESS
BERKELEY, LOS ANGELES, LONDON

UNIVERSITY OF CALIFORNIA PRESS

BERKELEY AND LOS ANGELES

CALIFORNIA

UNIVERSITY OF CALIFORNIA PRESS, LTD.

LONDON, ENGLAND

COPYRIGHT © 1979 BY

THE REGENTS OF THE UNIVERSITY OF CALIFORNIA

FIRST PAPERBACK PRINTING 1981

ISBN 0-520-04404-5

LIBRARY OF CONGRESS CATALOG CARD NUMBER: 76-55573

PRINTED IN THE UNITED STATES OF AMERICA

2 3 4 5 6 7 8 9

The paper used in this publication meets the minimum
requirements of American National Standard for Information
Sciences—Permanence of Paper for Printed Library Materials,
ANSI Z39.48–1984. ⊗

For

RHYS CARPENTER

and

LILY ROSS TAYLOR

"O exceedingly painstaking, but nevertheless highly inopportune Kai Lung," he replied at length, while in his countenance this person read an expression of no-encouragement towards his venture, "all your entrancing efforts do undoubtedly appear to attract the undesirable attention of some spiteful and tyrannical demon. This closely written and elaborately devised work is in reality not worth the labour of a single stroke, nor is there in all Peking a sender forth of printed leaves who would encourage any project connected with its issue."

ERNEST BRAMAH, *The Wallet of Kai Lung*

CONTENTS

PREFACE

WHEN the Department of Classics at Berkeley honored me with an invitation to give the Sather Classical Lectures in 1975, the chairman expressed a hope that the lectures could be illustrated, which was not usually done, and that, while remaining within the prescribed confines of classical literature or history, the theme might combine literature and art. Initially death seemed a promising subject, for one who had cleaned a few skeletons and wondered about them, since archaeology provided so many views of graves and funeral gifts, and Greek poets were fond of talking about death in certain moods.

There had been no general book about the Greek view of death in English, for only German scholars have published consistently and well in this field since the days of Lessing and Furtwängler; Erwin Rohde's magnificent *Psyche* remained the model of insight and documentation, and the works published in German by scholars of several European nations, such as Bickel, Bruch, Drexler, Eitrem, Heinemann, Lesky, Malten, Nilsson, Otto, Radermacher, Robert, Schwenn, Stengel, Waser, Weicker and Wiesner were the standard authorities. Three fine new books covered aspects of the subject of death with style and a wealth of factual material—Donna Kurtz and John Boardman's *Greek Burial Customs* (1971), Walter Burkert's *Homo Necans* (1972), and Margaret Alexiou's *The Ritual Lament in Greek Tradition* (1974). At first it seemed possible to put together six lectures with pictures out of the enormous source material, and yet the whole broad theme of death proved surprisingly recalcitrant. Pictures taken in cemeteries refused to come out, references were found but more often lost, and attempts to put even arbitrary order upon the chaotic material dissolved into imprecise whirls of confusion.

The lectures were illustrated in greater detail than the printed version could possibly be, but an attempt to rewrite them to be more independent of art and archaeology was unsuccessful. Yet Greek poets and Greek artists refused to cooperate with each other and both were disdainful of Greek graves. Greek poets did not care for bones, apart from tasteful collections of white bones which had lost their *thumos* or might be seen rolling lost in the salt sea. They seldom mentioned graves or cemeteries or funeral processions; a few tragic passages mentioned mourning at the tomb or libations or cut locks of hair, but not enough to sustain six lectures. In any case, the fifth century was developing a different view of, and sentiments about, death than the preceding three centuries, and to examine the philosophical and literary alterations in Athens after 450 B.C. seemed inappropriate for a prehistoric archaeologist. The artists, with the exception of a group of late black-figure vase-painters, were usually, and naturally, more struck by the mythological than the practical aspects of death, and this seemed the best meeting ground. It would have been hard to illustrate the usual poetic gnomai—weep, do not weep, life is short, death and old age are

coming—at least at the quick pace which has come to be expected of the contemporary slide lecture.

As the two sides of Greek talent came together in the mythological world of death they agreed upon the wounding and slaughter of legendary heroes, glimpses of *psyche* and *eidolon*, some figures of the underworld (but not its landscape), Hermes, Persephone, Kerberos, Sisyphos, Charon after the Persian Wars, an occasional Hades. There was the usual army of winged daimons, Sphinx, Siren, Harpy, Eos and Eros, Sun and Night, Sleep and Death, who may have helped to illustrate some points but lent an unnervingly airy and insubstantial quality to their documentation. The need to illustrate also caused the summary treatment of many proper topics—the bones of heroes and their oracles, sacrifices to the dead, mysteries and initiation, chthonic aspects of Demeter and Dionysos, ghosts and dreams and the careers of fearless tomb-robbers. What remains is a derivative and arbitrary selection of aspects of Greek death in terms of artistic documents and familiar passages which could be combined (and which could likely be recombined in a more orderly way by others).

The attempt to limit the discussion to the early period of Greek poetry and art was also prompted by a feeling of uneasiness about proper method in this field, where it has always been customary to serve up a Homeric tag, a passage of Euripides, a red-figured vase, a quotation from one of the sacred laws of the Greek cities and a passage of Plutarch, a skeleton, a loutrophoros, a lekythos, and some lines of Cicero and Demosthenes, and to call the mixture "what the Greeks thought about death." After four years of reading I still do not know what the Greeks thought about death, or what Americans think either, or what I think myself. Berkeley faculty members showed me the little cemetery at Saint Helena, with a grand simple tombstone of wood—oak, to last so long?—carved "To Dan from his friends in the circus 1860." They never knew his full name, but missed and remembered him, the theme of these lectures. Don Marquis' "Lines for a Gravestone" are appealing in a different direction:

> Speed, I bid you, speed the earth
> Onward with a show of mirth,
> Fill your eager eyes with light,
> Put my face and memory
> Out of mind and out of sight.
> Nothing I have caused or done,
> But this gravestone, meets the sun.
> Friends, a great simplicity
> Comes at last to you and me.

Prefaces to Sather Lectures are always remarkable for their expressions of gratitude toward the Department of Classics. Lecturers recall their brief visit as

being among the happier episodes of their lives. Particular thanks go to
Professor and Mrs. Thomas G. Rosenmeyer for hospitality, library training,
and a willingness to discuss the souls of California seals; to Professor and Mrs.
J. K. Anderson for broad teaching, ranging from the Feejee mermaid to the
perils of hunting wild boar from horseback; to Professor and Mrs. Ronald
Stroud for glimpses of family life; to Professors D. A. Amyx, J. Dillon, C.
Greenewalt, C. Murgia, and W. K. Pritchett (who supplied the Dionysiac
element missing in the lectures); and to Professor D. Brinckerhoff of Riverside,
who, in an emergency, showed the slides for the final lecture at a temperature
only an archaeologist could endure. In the department, Mrs. Marjorie Kaiser
and Miss Mary Thomsen were quietly invaluable. At the University of
California Press I would like to express warmest thanks to August Frugé, then
Director, for constant courtesy and good humor, to Susan Peters for setting
standards, and to Stephen Hart for correcting hundreds of blunders with re-
markable tact.

At the Museum of Fine Arts, Boston, Cornelius Vermeule and Jock Gill
prepared new brilliant slides of many Boston objects; Kristin Anderson, Mary
Comstock and Florence Wolsky were invaluable; Edward Brovarski and
Timothy Kendall spent hours on my education. At Harvard University I owe
a great deal to Glen Bowersock, Louise De Giacomo, Albert Henrichs, Gregory
Nagy, Juliet Shelmerdine, and Calvert Watkins.

A number of institutions have provided photographs and information: my
thanks to The American School of Classical Studies, Athens, and C. Williams;
the Athens National Museum and B. Philippaki; the Basel Museum and E.
Berger; the Bibliothèque National, Paris; the British Museum and A. Birchall;
the Danish National Museum in Copenhagen and M. L. Buhl; the German
Archaeological Institute in Athens and B. Schmaltz; the Greek Archaeological
Service and T. Spyropoulos, I. Tzedakis; the Metropolitan Museum of Art in
New York and J. Mertens; the Musée de Lausanne; the Musée du Louvre; the
Pierpont Morgan Library in New York; the Trustees of the Mount Auburn
Cemetery in Cambridge, Massachusetts; the Martin von Wagner Museum in
Würzburg and E. Simon. Among individuals I would like to thank particularly
J. Boardman, M. Caskey, A. Greifenhagen, T. Jacobsen, V. Karageorghis, S.
Karouzou, M. Lefkowitz, J. Mellaart, D. and M. Ohly, N. Schimmel, Lord
William Taylour, Mrs. Samuel Thorne, and Blake and Adrian Vermeule for
letting me go and being glad to see me back.

LIST OF ABBREVIATIONS

Homer's *Iliad* and *Odyssey* are cited without title, in upper case roman numerals for the *Iliad*, e.g., XXII.416 is *Iliad* Book 22 line 416; and in lower case numerals for the *Odyssey*, e.g., v.11 is *Odyssey* Book 5 line 11. Fragments of the Greek lyric poets are cited with D. for E. Diehl, *Anthologia Lyrica Graeca* (1936) and P. for D. L. Page, *Poetae Melici Graeci* (1962).

AA	*Archäologischer Anzeiger*
AAA	*Athens Annals of Archaeology*
ABV	J. D. Beazley, *Attic Black-Figure Vase-Painters* (1956)
AbhBerl	*Abhandlungen der Akademie der Wissenschaften, Berlin*
AbhGött	*Abhandlungen der Akademie der Wissenschaften. Göttingen*
AbhMainz	*Abhandlungen der Akademie der Wissenschaften, Mainz*
AJA	*American Journal of Archaeology*
AM	*Mitteilungen des deutschen archäologischen Instituts, Athenische Abteilung*
Alexiou, *Lament*	M. Alexiou, *The Ritual Lament in Greek Tradition* (1974)
Andronikos, *Totenkult*	M. Andronikos, *Totenkult. Archaeologia Homerica* W (1968)
ANET²	J. B. Pritchard (ed.), *Ancient Near Eastern Texts²* (1955)
Annuario	*Annuario della R. Scuola Archeologica di Atene*
AnthPal	*The Palatine Anthology* (*The Greek Anthology*)
AntK	*Antike Kunst*
AnzWien	*Anzeiger der Akademie der Wissenschaften, Wien, Phil.-hist. Klasse*
APAW	*Abhandlungen der preussischen Akademie der Wissenschaften*
ArchClass	*Archeologia Classica*
ArchfRel	*Archiv für Religionswissenschaft*
ArchHom	*Archaeologia Homerica*
ArchZeit	*Archäologische Zeitung*
ARV²	J. D. Beazley, *Attic Red-Figure Vase-Painters²* (1963)
Athens NM	National Archaeological Museum, Athens
BABesch	*Bulletin van der Vereeniging tot Bevordering der Kennis van de Antieke Beschaving*
BCH	*Bulletin de correspondance hellénique*
BICS	*Bulletin of the Institute of Classical Studies of the University of London*
BIFAO	*Bulletin de l'Institut français d'archéologie orientale*
BLund	*Bulletin de la Société royale de lettres de Lund*
BM	British Museum
BMMA	*Bulletin of the Metropolitan Museum of Art*
BMFA	*Bulletin of the Museum of Fine Arts, Boston*
BSA	*Annual of the British School at Athens*
Burkert, *HN*	W. Burkert, *Homo Necans* (1972)
BVSAW	*Berichte über die Verhandlungen der Sächsischen Akademie der Wissenschaften zu Leipzig*
BWPr	*Berlin Winckelmannsprogramm*
C-B	L. D. Caskey and J. D. Beazley, *Attic Vase Paintings in the Museum of Fine Arts, Boston*, I (1931), II (1954), III (1963)
Chantraine, *Dictionnaire*	P. Chantraine, *Dictionnaire étymologique de la langue grecque* (1968–1976)
CJ	*Classical Journal*
CP	*Classical Philology*
CQ	*Classical Quarterly*
CR	*Classical Review*
CVA	*Corpus Vasorum Antiquorum*

Deltion	Ἀρχαιολογικὸν Δελτίον
Development	J. D. Beazley, *The Development of Attic Black-Figure*, Sather Classical Lectures 24 (1951)
Dieterich, *Nekyia²*	A. Dieterich, *Nekyia²* (1913)
D-K	H. Diels, W. Krantz, *Die Fragmente der Vorsokratiker⁷* (1954)
DMR	*Studies in Honor of David M. Robinson* (1951, 1953)
Dodds, *Irrational*	E. R. Dodds, *The Greeks and the Irrational*, Sather Classical Lectures 25 (1951)
Eitrem, *Opferritus*	S. Eitrem, *Opferritus und Voropfer der Griechen und Römer* (1915)
EphArch	Ἀρχαιολογικὴ Ἐφημερίς
Ergon	Τὸ Ἔργον τῆς Ἀρχαιολογικῆς Ἑταιρείας
Fairbanks, *AWL*	A. Fairbanks, *Athenian White Lekythoi* I (1907), II (1914)
Farnell, *Cults*	L. R. Farnell, *The Cults of the Greek States* (1896–1909)
Fittschen, *Sagendarstellungen*	K. Fittschen, *Untersuchungen zum Beginn der Sagendarstellungen bei den Griechen* (1969)
F-R	A. Furtwängler, K. Reichhold, *Griechische Vasenmalerei* (1904–32)
Frazer, *Pausanias*	J. G. Frazer, *Pausanias' Description of Greece* (1898)
Frisk, *Wörterbuch*	H. Frisk, *Griechisches etymologisches Wörterbuch* (1954–72)
GöttGelAnz	*Göttingische gelehrte Anzeigen*
G-L	B. Graef, E. Langlotz, *Die antiken Vasen von der Akropolis zu Athen* (1925–33)
GRBS	*Greek, Roman and Byzantine Studies*
Hampe, *Grabfund*	R. Hampe, *Ein frühattischer Grabfund* (1960)
Harrison, *Prolegomena*	J. Harrison, *Prolegomena to the Study of Greek Religion* (1908)
Haspels, *ABL*	C. E. H. Haspels, *Attic Black-figured Lekythoi* (1936)
Heinemann, *Thanatos*	K. Heinemann, *Thanatos in Poesie und Kult der Griechen* (1913)
HSCP	*Harvard Studies in Classical Philology*
HThR	*Harvard Theological Review*
IG	*Inscriptiones Graecae*
JARCE	*Journal of the American Research Center in Egypt*
JdI	*Jahrbuch des deutschen archäologischen Instituts*
JEA	*Journal of Egyptian Archaeology*
JHS	*Journal of Hellenic Studies*
K-B	D. Kurtz, J. Boardman, *Greek Burial Customs* (1971)
Karo, *Schachtgräber*	G. Karo, *Die Schachtgräber von Mykenai* (1930–33)
Kerameikos	K. Kübler, *Kerameikos* V,1, *Die Nekropole des 10. bis 8. Jahrhunderts* (1954); *Kerameikos* VI,1, *Die Nekropole des späten 8. bis frühen 6. Jahrhunderts* (1959); VI,2 (1970)
Kunze, *Schildbänder*	E. Kunze, *Olympische Forschungen* II: *Archaischer Schildbänder* (1950)
Lattimore, *Themes*	R. Lattimore, *Themes in Greek and Latin Epitaphs*, Illinois Studies in Language and Literature 28 (1942)
LGS	D. L. Page, *Lyrica Graeca Selecta* (1968)
MDOG	*Mitteilungen der deutschen Orient-Gesellschaft*
Mellink-Filip, *FSK*	M. Mellink, J. Filip, *Frühe Stufen der Kunst*, Propyläen Kunstgeschichte 13 (1974)
MFA	Museum of Fine Arts, Boston
MonAnt	*Monumenti Antichi*
MusHelv	*Museum Helveticum*
MWPr	*Marburger Winckelmannsprogramm*

N²	A. Nauck, *Tragicorum Graecorum Fragmenta*² (1889)
Nilsson, *GGR*²	M. P. Nilsson, *Geschichte der Griechische Religion*² (1955)
Nilsson, *MMR*²	M. P. Nilsson, *The Minoan-Mycenaean Religion*² (1950)
NSc	*Notizie degli Scavi di Antichità*
ÖJh	*Jahreshefte des österreichischen archäologischen Instituts*
OpAth	*Opuscula Atheniensia*
OpRom	*Opuscula Romana*
OpSel	M. P. Nilsson, *Opuscula Selecta* (1951–60)
OxPap	*Oxyrhynchus Papyri*
Paralipomena	J. D. Beazley, *Paralipomena, Additions to Attic Black-Figure Vase-Painters and to Attic Red-Figure Vase-Painters* (1971)
Peek, *GV*	W. Peek, *Griechische Vers-Inschriften* I (1955)
PMG	D. L. Page, *Poetae Melici Graeci* (1962)
Praktika	Πρακτικὰ τῆς ἐν Ἀθήναις Ἀρχαιολογικῆς Ἑταιρείας
Prosymna	C. W. Blegen, *Prosymna, The Helladic Settlement Preceding the Argive Heraeum* (1937)
RDAC	*Report of the Department of Antiquities of Cyprus*
RE	W. von Pauly, G. Wissowa, *Real-Encyclopädie der klassischen Altertumswissenschaft* (1890–; *Der Kleine Pauly*, 1964–75)
REG	*Revue des Études Grecques*
Reiner, *Totenklage*	E. Reiner, *Die Rituelle Totenklage der Griechen* (1938)
RevArch	*Revue Archéologique*
RevEtAnc	*Revue des Études Anciennes*
RevPhil	*Revue de philologie, de littérature et d'histoire anciennes*
RhM	*Rheinisches Museum für Philologie*
Riezler, *WGL*	W. Riezler, *Weissgrundige attische Lekythen* (1914)
Robert, *Thanatos*	C. Robert, *Thanatos* (1879)
RömMitt	*Mitteilungen des deutschen archäologischen Instituts, Römische Abteilung*
Rohde, *Psyche*	E. Rohde, *Psyche*⁸, trans. W. B. Hillis (1925)
Roscher	W. H. Roscher, *Ausführliches Lexikon der griechischen und römischen Mythologie* (1884–1937)
SBBerlin	*Sitzungsberichte der Akademie der Wissenschaften, Berlin*
SBLeipzig	*Sitzungsberichte der Akademie der Wissenschaften, Leipzig*
SBMünchen	*Sitzungsberichte der Akademie der Wissenschaften, München*
SBWien	*Sitzungsberichte der Akademie der Wissenschaften, Wien*
Stengel, *Kultusaltertümer*	P. Stengel, *Die griechische Kultusaltertümer* (1920)
Stengel, *Opferbräuche*	P. Stengel, *Opferbräuche der Griechen* (1910)
SymbOsl	*Symbolae Osloenses*
TAPA	*Transactions of the American Philological Association*
TAPS	*Transactions of the American Philosophical Society*
*Vasenliste*³	F. Brommer, *Vasenliste zur griechischen Heldensagen*³ (1973)
Vermeule, *GBA*	E. Vermeule, *Greece in the Bronze Age* (1964)
Weicker, *Seelenvogel*	C. Weicker, *Der Seelenvogel* (1902)
Wiesner, *Grab und Jenseits*	J. Wiesner, *Grab und Jenseits* (1938)
Wilamowitz, *Glaube*	U. von Wilamowitz-Moellendorff, *Die Glaube der Hellenen*³ (1959)
WVDOG	*Wissenschaftliche Veröffentlichungen der deutschen Orient-Gesellschaft*
ZAeS	*Zeitschrift für ägyptische Sprache und Altertumskunde*
ZPE	*Zeitschrift für Papyrologie und Epigraphik*

I

CREATURES OF THE DAY:
THE STUPID DEAD

O me, why have they not buried me deep enough?
Is it kind to have made me a grave so rough,
Me, that was never a quiet sleeper?
Maybe still I am but half-dead;
Then I cannot be wholly dumb.
ALFRED, LORD TENNYSON, *Maud xi*

A PANORAMIC survey of death in early Greek culture is not a sensible under-
taking. The adventure into the grave and the underworld clearly needs some
limits, for death is as protean as life or love. One natural limit for a classicist
exploring death is lack of experience. The witnesses who might supply direct
evidence have simple faults: the skeletons are mute, the painters and poets
adopt peculiar tones, and the old explorers who managed to die twice and tell
us about it, the clever Greek *disthanees*, produced tales which may be treated
with some reserve.[1]

The dead themselves, or parts of them, are not at all fugitive. The earth's
crust is filled with them, in the forms of bones, dust, oil, monuments, memories,
myth—with different techniques of access. On the physical side it is easy to
disturb them and to learn how the human race has cared to bury its dead in the
past. Artists recorded the ceremonial gestures of grief, and the forms of funeral.
Poets created the images of love and longing, and views of another land where
the dead might still move and talk in a persistent weak imitation of life. When the
different kinds of evidence and testimonies about death in the Greek world—
about body and soul, about the grave and the underworld, about mortality and
immortality, loss and creativity—are drawn together, it is entirely natural that
they should conflict and refuse to be drawn into any easy harmonious picture.

More than any other experience, death engenders uncertain feelings and
confused thoughts. Life and death are the most obvious opposites, even to
children, and the most obvious unity, in untutored instinct as well as in old
poetic and religious tradition: irreconcilable principles insistently held together
like twins in a nurse's arms. In this naturally illogical sphere, where body and
soul lead separate but linked lives and deaths, Greek logic was only gradually
and precariously applied, with minimal success.[2] From Herakleitos to Lucian,

I

whenever reason was brought to bear upon the unknowable, a sense of self-mockery was produced which, almost inevitably, cured itself only by slipping sideways into mythical fantasy, where opposites are so often congenial.

It is nearly impossible to recreate any general "Greek view of death," although Greek practical behavior when confronted with death is well known, and was not very different from practice in other cultures. Early Greeks took death extremely seriously, as we all do. If they were less elaborate in their ceremonies and less optimistic in their beliefs than the Egyptians, perhaps less creative in ritual than the Hittites, they still had powerful emotional and religious feelings about burying the dead, for which there is the most persuasive and moving evidence in Greek epic and tragedy. A significant part of their artistic energy was focused on themes of death, and on burial as a partial solution to the problems of death.

"Burial" is used here, perhaps wrongly, as a general term for the permanent disposal of a corpse.[3] It does not seem to affect either ceremony or views of the afterlife, whether the corpse was put dressed directly in the ground, or was burned on a pyre with the ashes and bones collected later. Students of Greek culture have long tried to detect differences in how the different generations understood the *psyche* or the *soma* according to whether the prevailing fashion was to bury or burn. It does not seem to matter; any form of burial marks the family or community action which transfers the body to a new state of belonging, and the absent element of individuality called the *psyche* always is absent, and so "elsewhere." The ideas about what happens when someone dies are too deep to be affected by physical techniques of disposal, just as they extend beyond the limits of languages and cultures which may modify them.

A death is not completed in an instant. The Greek dead were translated to a new sphere by a long transitional passage which was marked out by several clear stages. Whether the person's new "house" was an ash urn of 900 B.C. with a "killed" sword wrapped around it, or a child's sarcophagus of 400 B.C. filled with little vases, there can be little doubt that the processes of establishing him safely there were practically the same. The Greek tradition of burial has been, to our eyes, the longest-surviving and most powerful of all Greek traditions; it scarcely changed between the later Bronze Age and the Hellenistic world, and apart from the intervention of the church into private conduct is nearly unchanged today. Funerals in most cultures have points of similarity, since the basic work to be done is the same.

The body from which an essential element has departed, and which is itself no longer stable or quite clean, must be cleaned and prepared and dressed; the family and larger clan must come together, the grief felt for one whose absence deprives them of familiar comforts must be lifted from the heart by gesture and mourning, with public and private farewells. There must be a processional escort to the burial place, a permanent separation of the group from the

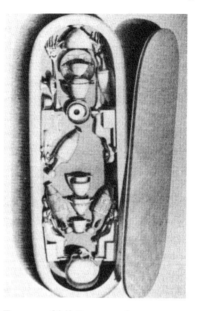

FIG. 1 Ash urn with "killed" sword:
Geometric Grave, Athens c. 900 B.C.

FIG. 2 Child's sarcophagus:
Athens, c. 400 B.C.

visible body, which is concealed or dispersed, and replaced, in a sense, by a tombstone or a mound.[4] There is a practical control of ceremonies meant for purification and family unity, and whatever further support, from time to time, the dead family member is thought to need. The ceremony of burial confirmed the value of the efforts a man had made during his lifetime, and in some way released him from any further effort.

What cultured Greek individuals really thought about death is hidden from us except through literary interpretation. The Solonian legislation against excessive mourning is guarantee that the ceremonial aspects of burial in archaic Athens were protracted, expensive, and enjoyable to aristocrats. A good funeral has always been a lot of fun, a reunion stirring open emotions and bringing news to exchange, the periodic intersection of the family, the clan, and the city. Beyond behavior, private thoughts are harder to discover, except as they were like our own. Statements on tombstones of the archaic period are not sentimental; the family is proud of the deceased and will miss him. There is no other real source for individual thoughts except poetry, which is surely atypical. By tradition a Greek poet expressed outrage and restlessness when a body of a friend or a hero stayed unburied, rolling in the waves at sea or played with by dogs and birds on land. When he sang of the "soul," or individuality, or memory of the dead his feelings were less certain; and, like a swan, he used tones different from his ordinary voice. Greek death poetry often deceives us with its ornamental wit, a kind of formal black humor which is in itself a

familiar defense against death. The singer about death plays with an ironic sense of deficiency. He may tempt us to think that, if we understand him, we understand Greek ideas about death, although it is in fact unlikely that he knows any more than the rest of us.

The Greek poet's concern with death was at once practical and mythical. Some form of poetry was necessary to launch the dead on their way, the mourning song which relieved the living and confirmed the excellence of the dead, the *threnos*, *goos*, *ialemos*, a choral of family. The simple evocative phrases we know— "you were my dearest child . . . ," "you were kind to me . . . " are designed to assure the dead person that he has been loved and will still be loved, and that memory of him is vivid while his family lives. This memory is freshened both by attendance at his burial place and by repeated narrative of his past words and actions. In this direction, the practical and mythical coincide, for an obvious part of the poet's work is to keep the past, that is the dead, alive by quotation and interview. Even the most mocking and "disillusioned" poet will maintain this illusion. "O Charidas," Kallimachos calls down in a famous epigram, "how's the Underworld?" "Very dark." "And the ways up?" "A lie." "Pluto?" "A myth." "You kill me."[5] Even in his deceptive detachment, Kallimachos is posing as a new Odysseus, interviewing the dead to gain experience. This is in some sense a poet's basic work. Poets, critics, historians, archaeologists, artists spend their working lives as necromancers, raising the dead in order to enter into their imaginations and experience, an ordinary and probably necessary human pastime.

The Underworld which Kallimachos visits in literary play to consult the dead is a world we think of as having been established by Homer, and probably ancient in tradition long before him. We are familiar with the dark and dangerous way down, the crossing of ocean or passage through a lake or cave to reach it, where roaring or fiery rivers hammer on a rock underground;[6] where Charon in his ferry will take the dead across the final stretch of water to join the other countless crowds of weakened and impalpable shades, guarded by Kerberos in their asphodel meadow; where a gate or stomion refuses exit; and where Hades and Persephone sit on their thrones or watch from their porch a scene of restless confrontations or pitiable mourning, with glimpses of judges and sinners in the distance, in a darkened landscape of dreamlike figures. In fact, many of the features which we regard as familiar and essentially Greek in this landscape are late in making their appearance—Charon and his ferry do not seem to come into vogue before the second quarter of the fifth century,[7] and the peculiar sights of the second *Odyssey* Nekyia like the gates of the sun or the White Rock are scarcely repeated at all in the tradition. The underworld which the western appreciator of the Greeks regards as ancient and characteristically Hellenic was unsung by any responsible poet before Euripides, nor synthesized in art before Polygnotos' great mid-fifth-century wall-paintings at Delphi.[8] In a sense

it took the Romans, Vergil or the artist of the Odyssey landscapes with their trick lighting, shadow menaces, thrill of public horror, and heroes in a landscape too large for their courage, to give us the Greek death scene as we secretly like it, though not as the Greeks always saw it.

It is possible to discover the stages, or some of them, in which this underworld was composed, and the function which it played in satisfying Greek anxieties about death and the dead. It is possible, and necessary, to distinguish this fictitious view of the living dead from the facts which shape the real world of the grave. The difference between the two worlds is profound, although it may merely reflect the simple difference between what you do when death disrupts the family, and what you tell children when they ask about it. Just as the world of Kerberos and Charon scarcely influences the composition of Greek grave epigrams before the later fifth century, so the poetic fictions of the afterlife scarcely appear in Greek art before 450 B.C. The exploration of the themes of death in early Greek art and poetry follows the clearest line in the first three centuries of classical development, from Homer to the Persian Wars or shortly after, from about 750 to 450 B.C. After that period, an influx of strange ideas and philosophic or metaphysical inconsistencies (modulated by poetic exhibitionism and religious cynicism) began to play with the old tradition, to alter it almost by individual will, to adapt it creatively to new contexts. The persistence of elements of the ancient tradition and their unending capacity to create new values is noticeable on a grand scale in Plato.

The exploration of Greek behavior in the presence of death, and Greek ideas about the dead, involves many themes: the ceremony of burial, and its psychic and social function; attitudes toward the dead in their graves; the distinctions among the body, the *psyche*, and the *eidolon*; the sinner, the hero, and the mythical dead as a source of continuing knowledge and power for the living; the dead as presented in literature and in art (necessarily different in their handling of the invisible); the kinds of fictions which the Greeks found most satisfying; the death of enemies and of friends and family members; the relations among the kingdom of Hades, the Islands of the Blessed, and the death figures of fantasy like gorgons, sirens, Hesperides and divinities of the sea and sky; mourning, poetry and monuments; and the enormous importance of death as a path of access to the past.

Burial, Myth and Poetry

Most people preserve the dead and learn from them. We like to distinguish ourselves from the simpler beasts by declaring that we are the only animals to bury our dead and so to rescue the past. Elephants may put branches on a dead friend, or sprinkle him with dust; bears will bury another animal to ripen it for eating; dolphins hold formal mourning rites, as even cows do.[9] Still, human

speculation about death has been historically self-centered and self-flattering, rejoicing in unique anguish and burden. What other animals may do has seemed unimportant, because to us they have neither history nor myth, which our dead have given us.

We also like to believe that we are the only animals who know we are going to die, and who carry this secret in our imaginations from childhood on.[10] The foreknowledge of death, the legacy of Eden or any of the other forbidden fruits of understanding, of those moments when we remember with surprise that we are not immortal, has brought with it in every culture such a brilliant variety of alleviating measures that man's capacity for invention is nowhere more beautifully displayed. It is the ego, they say, which resists death or the prospect of oblivion. Like Snoopy doomed by an icicle, we feel we are too young, too nice, too *me* to die (fig. 3). The consequent flight from death is through fictions of its pleasures, and efforts to create things which may have a better chance than we of being immortal. Death is the practical source of a good deal of poetry, music, art and myth.

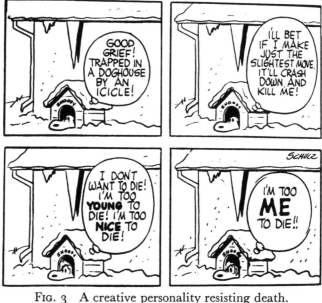

FIG. 3 A creative personality resisting death.
© 1960 United Feature Syndicate, Inc.

The Greek fictions about death are not peculiar to Greece; they contain universal elements, by necessity. The Greek view of death is no more imaginative or potent than other peoples' views; it is typically bizarre and inconsistent, and conventional even where it seems most individual. What is perhaps peculiar to the Greeks is the quality of their writing about death; it is the

poetry, not the thinking, which has so powerfully affected readers of Greek literature, in versions of many languages. The Greeks, who retained an affinity for myth-making well into the fourth century B.C., agreed that everyone would die; yet they made escape clauses for a surprising number of figures, who served as mythical models for the living. In this manner the dead controlled Greek life, not only as important objects of ancestor or hero cult, but also through their role in myth and poetry and art.

The Greeks are a very active dead: no living person has the power of even a minor nameless hero, whose power flows simply from the fact that he is dead and angry about it, and cannot sleep still. Not even the Great King had the power of some of the named heroes, Achilles, or Herakles or Orpheus, who lived in poetry and managed later minds, with poets and prophets and politicians as their mouthpieces. These dead figures stalking through myth, history, and figured art were the major sources of meaning for most Greeks—most human experience could be understood in their terms. As models they embodied the fear of death and the courage of facing it frankly, of flight and acceptance. They were shown in scenes of mourning, of murder, of attack by enemies and lovers (although seldom succumbing to disease and accident, since their lives were to be significant and so not trivially lost). They were strongly suggestive of life after death, both in the way they were held in memory as active figures, and in the way they were often treated in cult as having the power to respond to the living. Many cultured Greeks represented themselves as anxious to get down to the underworld and talk to the fabled dead, who could illuminate the lost past and the truths of life. A surprising number of the dead, as they lived again in mythical tales, demonstrated how a man might get past his appointed day of death and destiny, the πεπρωμένον ἦμαρ, by intelligence and the faculty of love, or at least how he might retain a spark of *nous* or *thumos*, perception and feeling, which could help the intercourse with the other dead.

Body and Soul

From the great range of ancient testimonies about the dead a few elements of thought may be selected. The Greeks made a clear distinction between body and soul, between the flesh that decayed and must be buried, and the wind-breath *psyche* that left the carcass and went elsewhere into a pool of personalities which could be activated by memory. The distinction was clearest at the moment of death itself, when from the mouth or from a wound a little element or fragment of a breath or wind passed, small and nearly unnoticed, from the body. Yet when the dead were considered as figures of the past, this bit of wind grew curiously substantial. In both literature and ceremony we detect a feeling among the early Greeks that there is a deeper concern for the body than for the soul, and that the body is perceived as double: one stays in the grave where it

retains particular powers, and one goes to the kingdom of the dead, where it can still be hurt.

When the Greeks considered sin at all they punished it, in the dead, in an oddly physical manner.[11] For a thousand years after Homer the scene of the underworld tortures of the dead in the *Odyssey* remained corporeal, in the absence of *corpora*, physical for those who had not much physique left to speak of. As Tantalos is punished with hunger and thirst, appetites alien to the *psyche*; as Tityos has his liver ripped out and Sisyphos sweats rolling his stone, we encounter an enduring folktale element in the vision of the afterlife which runs counter to the theoretical distinctions between body and soul. This enduring concept is seen in Polygnotos' picture, where the dead are drugged or poisoned, and survives into late Greek evangelical or apocalyptic visions of the future, where the dead are tortured for their sins with whips, hangings, infliction of worms, immersion in mud, or slicing of tongues. These themes stress an old feeling that the body was, in fact, existence; that if existence continued it would to some degree be bodily; and that wrong treatment of a dead body was, as Greek tragedy constantly demonstrates, a major wickedness. That is why so much Greek poetry and art which touches on death naturally focuses on burial and mourning.

By contrast, in early Greece at least, the soul was rather poorly and shiftingly visualized.[12] It is not impossible that there had been common images of the soul in the Bronze Age—the butterfly or the soul-bird or the winged apparition in human shape (chapter 2). The soul-bird reappears in the seventh century, and the concept may never have been lost as the artistic image was. By the fifth century there had come to be a variety of interlocking figures, *psyche*, *eidolon*, and *skia* (shade), and dream-figure, the *onar* or *opsis*.[13] The usual Greek soul, the *psyche*, is not really capable of spiritual feeling; it is not punished by mental anguish or deprivation of the love of god, but mourns its own lost body and the sunlight in a repetitive and uncreative way. It may last forever as an image in the underworld if its living owner had entered into mythology or history, or it may be forgotten when that identity on earth has faded from common memory. This endurance in the underworld is not precisely the same thing as immortality. The particular *psyche* in the underworld is of course available to any necromantic poet who cares to address it, but many have lost their individuality, and are seen in massed crowds or fly around anonymously to welcome newer dead (fig. 4).

The *psyche* is real, not fiction. When someone dies, a man or woman who had just hours before been a recognizing friend now fails to respond to normal stimuli; the eyes do not focus but do not close as in sleep either; the body temperature drops, the flesh is cold and pale, the limbs have no power and the blood stops flowing; it is clear that something activating—breath or strength of concentration, intelligence and feeling—has vanished. The Greeks did not

FIG. 4 Charon, Hermes psychopompos, and the souls of the dead:
Attic white-ground lekythos, fifth century.

know that this little element would ever be weighed by modern science, although its images were often weighed in Greek and Egyptian art. Now a doctor in Düsseldorf has succeeded in quantifying the soul by placing the beds of his terminal patients on extremely sensitive scales. "As they died and the souls left their bodies, the needle dropped twenty-one grams."[14] Homer's successors would have enjoyed this scientific accuracy, although the doctor does not tell us if something like a puff of smoke went past him, ἠΰτε καπνός, or if he heard any slight batlike noise. The Greek *psyche* picked up qualities of strength from the living individual; its poetic representation had necessarily to be ambiguous.

When the *psyche* was corporeally conceived, it was a miniature replica of the individual, endowed with wings to account for its swift daimonic flight, retaining some powers of memory and emotion. The *psyche* often flutters near the head from which it extracts its future qualities, or perches upon it as on the lovely lekythos by the Achilles Painter (fig. 5),[15] weeping and protesting with formal mourning gesture—ὃν πότμον γοόωσα, λιποῦσ' ἀνδροτῆτα καὶ ἥβην, "mourning its destiny, leaving manhood and youth," (XVI.857, XXII.363) in the Homeric phrase that links the model deaths of Patroklos and Hektor. This *psyche* naturally cannot be disembodied in art, and is not really impalpable or witless in poetry either. The feeling that it is "like shadow and dream" (xi.207) is persistent, but "the thoughtless dead," νεκροὶ ἀφραδέες (xi.476) is a phrase more of rhetorical despair than of general community belief.

It is the ambiguous connections between the mourned and concealed body, and the mourning soul of weakened intelligence and capacity, which concern us

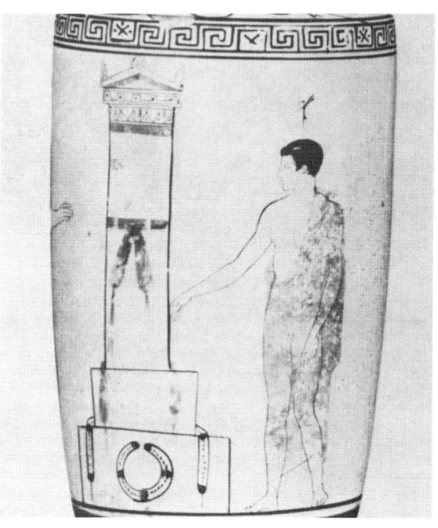

FIG. 5 The soul mourns the body at the grave:
Attic white-ground lekythos, fifth century.

first; and then the fantasies which surround both. The Greek tradition of
behavior, and of creative song and painting, in the face of death is at the core
more religious and ceremonial than personal or psychological. The usual
emphasis is on proper behavior toward the body, and not on the tendance of
unprepared or chaotic souls. There are few death-bed or sick-bed scenes before
Sophokles and Euripides, few anguished soliloquies on the fears of departing
from the light. States of anxiety, resistance, resignation, anger and grief before
death were handled all through epic, lyric and tragic poetry with varying

skills, but often in general and almost trite terms; and the anxieties are clustered about visions of what would happen to the body after death, rather than on the state of individual emotions before it.

Burial and Mourning

The two great art forms of early historical Greece, Ionic epic poetry in the east and Geometric painting in the mainland provinces of Attica, Boiotia and the Argolid, focus on burial and mourning in styles so similar, that scholars understood they both shared an older tradition long before it could be proved. The themes of the Homeric *Iliad* are precisely those of Attic painting, battle by land and sea and the ceremonies for the dead. These were the old themes of the Mycenaean Greeks, and of most other Bronze Age cultures around the Mediterranean. The power of the persistent conventions is clearest at Athens where the

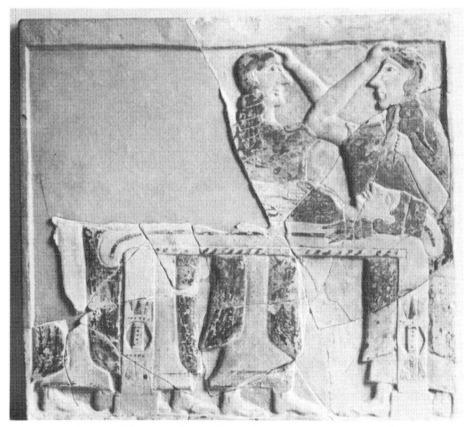

Fig. 6 Mourners lamenting a dead woman on her couch: painted terracotta funerary relief, late seventh century.

dead are the great interest of the best painters in the late eighth century, on vases designed as tomb monuments and funeral gifts.[16] Along with some scenes on gold funeral strips, the paintings celebrate the mourning of the dead, his size and beauty, the warmth of family feeling for him, and his place in the extended circle of those who grieve his loss and assist at his passage. As he lies on his specially prepared bed at home with the shroud lifted for a last glimpse of his body, or is drawn toward the cemetery on a cart like one who sleeps, the members of his family, the little children, even animals, the assembled clansmen and friends dressed for both peace and war, gather to bring him small gifts, to offer him escort, and to form a mourning chorus. The painter may suggest special marks of identity, a sword hung over a man's body, or oars for a sea-faring man. There is emphasis on the sung lament, the gestures of beating the head and breast, lustration, small gifts, dancing and the waving of branches or rattles.[17]

This kind of family and clan mourning marked the most proper and accept-able passage toward death, relieving the survivors and assuring the necessary decent disposal of the body. It was best to die at home, although the heroic and military code proclaimed that it was also best to die on the battlefield with honor. At least one should be mourned at home if possible. The recovery of the dead in wartime was a constant value in Greek history, as it is now. In the *Odyssey*, the bodies of those murdered suitors who came from beyond Ithaka were shipped home by fishing boat (xxiv.418). If a man died away from home he might be brought back to his parents and wife, or at least be buried with honors by his friends on an alien battlefield.[18] The Greeks who died at Troy may have accepted this burial in foreign earth the more easily because the old grave-mounds in the Trojan plain belonged to heroes who were still remembered in local legend. The new Achaian tombs among them, visible to sailors on the Hellespont, guaranteed that their occupants would be drawn into this world of antique fame, of *kleos aphthiton*. The worst was not to be buried, not to be mourned by mother or wife, or to have your body dallied with by the careless dogs and birds on land and the fish at sea. When the body was really lost, as when a man died at sea, it was often felt best to prepare a cenotaph and a stone *sema* to replace the body.[19]

The religious ceremonies of mourning and farewell to the dead were simple, probably the oldest and least changing art-form in Greece. They marked the practical steps any family must take, and the stages in the slow process of transitions between the body's faltering and the soul's stabilized condition in another world. The *psyche*'s departure from the body was only the beginning of death, in both poetry and fact. Hades accepted only the man whose death had been completed, τὸν τεθνειῶτα, not the starting dead man, τὸν θανόντα.[20] To join with full rank the "renowned tribes of the dead," κλυτὰ ἔθνεα νεκρῶν,[21] required the three obvious phases it still does: the washing and preparation of

the body and the house; the *prothesis* or vigil wake over the prepared body, at which the major mourning was expressed; and the *ekphora* or procession to the cemetery, by chariot or cart or on foot, our automobile cavalcade. Around these practical steps the ordinary duties of greeting guests, collecting gifts, cleansing possible contaminations and singing the laments fell into place.

The body was washed and dressed first. The warm baths, θερμὰ λοετρά (XXII.444), were necessary for removing stains of blood and sickness, preventing corruption and contagion; they were also ceremonial as for all the greater passages like birth and marriage. The washing gave rise to the persistent connection between bathtubs and coffins, cauldrons and urns.[22] The body was anointed with oil, wrapped from head to foot in a cloth, spread with another cloth, and laid on a bed or bier, usually with the feet toward the door, facing the journey. The house was hung with wreaths and sprays of leaves, and these were also offered to the dead man. There was special use of marjoram and celery, myrtle and laurel leaves. A bowl of water from a source outside the house might be offered to anyone who touched the corpse, although the Greeks did not in general believe that death was contagious.[23] The bier was usually dressed like a bed with mattress, blanket and pillows, part of the old association between sleep and death which is still natural for us.

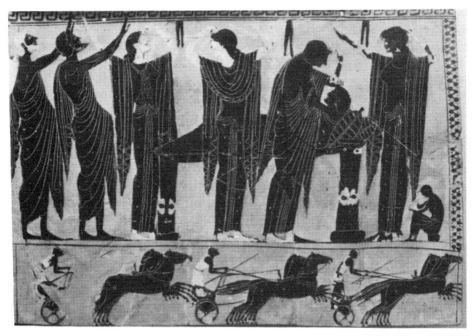

FIG. 7 Men and women mourn a dead man on his couch:
Attic black-figured plaque, sixth century.

These are family responsibilities of the women in the household who loved the dead dearest and miss him most. The dead are helpless, and need comfort or mothering like infants, from mother or wife, to close the eyes, straighten the limbs, fix the jaw shut. "My bitch of a wife would not even close my eyes or fix my jaws," complained murdered Agamemnon in the underworld (xi.425), a refusal of family duty which was a clear measure of her distaste for him. The pleasant presentation of the body was partly prompted by feelings that it might appear in the underworld as it had left the upper world, a matter quite separate from the theory of the *psyche*. This is clear with the chin band, of gold, leather or linen (fig. 8),[24] often seen in funeral paintings and occasionally surviving in gold; sometimes, as on the Nekyia krater, the dead person runs down to Hades still wearing it, a natural confusion of body and soul.[25]

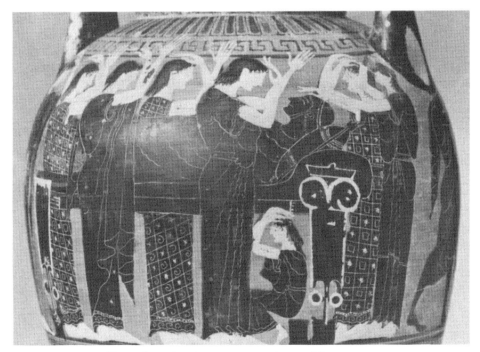

FIG. 8A The dead man wearing a chin-strap:
Attic black-figured loutrophoros, early fifth century.

As in modern wakes, the dead are instinctively felt capable of hearing the funeral lament, and perhaps even of noting the ceremonial funeral gestures of striking the head, tearing out the hair, beating the breast, and scratching the cheeks till the blood runs.[26] Lucian complains of the contrast between the peaceful dead and the convulsed mourners: "The living are more to be pitied than the dead. They roll on the ground time after time and crash their heads

on the floor, while he, decent and handsome, lies high and crowned with ornamental wreaths, exalted and made up as though for a procession" (*On Funerals* 12).

The key role in this mourning was played by women through song, because the center of the ceremony was the expression of love, made memorable by form. The tradition of the lament scarcely changed between the Bronze Age and the Hellenistic period. The singer-woman usually cradled the head of the dead between her two palms (fig. 9), as Thetis clasped Achilles' head when she foresaw his death, crying sharply, ὀξὺ δὲ κωκύσασα κάρη λάβε παιδὸς ἑοῖο (XVIII.71).[27]

There are several forms of funeral songs, distinguished as *threnos, epikedeion, ialemos,* and *goos.* Of these the *goos* is most intense and personal, its theme the

FIG. 8B A girl still wearing her chin-strap
runs down to the underworld to greet her family:
Attic red-figured krater, fifth century.

memory of the lives the two shared and the bitterness of the loss. It survived brilliantly from Homer until the early twentieth century in the Greek rural *moirologia.*[28] "Hektor most dearest to my heart of all my children . . . now you lie dewy and fresh for me in the hall" (XXIV.78); "Hektor, you leave your time young and leave me a widow; . . . you did not reach out your arms to me

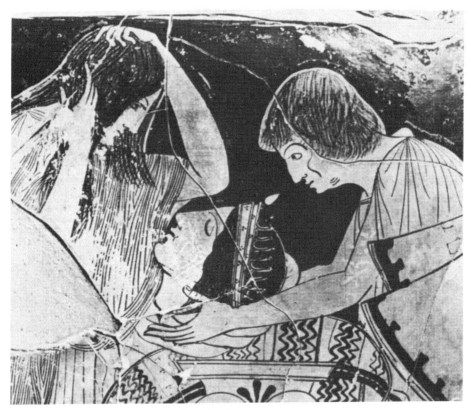

Fig. 9 The classic mourning gestures:
Attic red-figured loutrophoros, fifth century.

from your bed when you died, or tell me a word I could always remember at night" (725, 743). So now:

> Ἄ δὲ φουσκώσῃ ἡ θάλασσα, ὁ βράχος δὲν ἀφρίζει,
> κι ἂν δὲ σὲ κλάψῃ ἡ μάνα σου, ὁ κόσμος δὲ δακρύζει

> For if the sea won't swell and rise the rock's not wrapped in foam,
> and if your mother mourns you not the world won't weep you home.[29]

The formal power of Geometric painting in Homer's day does not often allow the music and emotion of the scene to rise to the surface, any more than the people's γόος ἀλίαστος sounds aloud in words at Troy (XXIV.760), though occasionally the swaying mourners or their intense concentration on the dead let a sense of words fill the air (fig. 10). The early *gooi* seem neither artificial nor metaphorical, although a professional singer also appears in a funeral role in Homer (XXIV.720); later the songs developed predictable formal themes, more often handled and influenced by professionals, the light darkened, the sapling cut, the flower plucked, the water spilled, the house weeping.[30] In early

FIG. 10 Emotions at the prothesis:
Attic Geometric fragment, eighth century.

times the chief mourner was the direct communicant with the dead, the
ἔξαρχος γόοιο, sometimes thought to be the model of the later magician, the
γοής, who attracts the attention of the dead through songs and spells, exchanges
messages with them, temporarily resurrects them; the necromantic counterpart
of the poet.[31]

There are survivals of extremely archaic practices in Geometric funeral art,
but almost nothing of the supernatural. Sometimes the dead are fed, apparently;

FIG. 11 Mourners wearing dresses ornamented with horse, sphinx, and mourner:
Attic funeral vase, seventh century.

a row of dead ducks is tied to the bier, or a child holds a fish to his father's lips.[32] The only element of metaphysical belief which presents itself seems to be the occasional representation of the *psyche* as a bird, the renowned soul-bird whose native habitat is Egypt, who is at home until the late classical period in Greece also, Sophokles' εὔπτερος ὄρνις "one after the other like a lovely-winged bird you may see them rushing faster than ravening fire to the shore of the western god" (*OT* 174). The famous terracotta funeral cart from rural Attica (fig. 12)

FIG. 12 The procession to the grave with mourners, a child,
and a soul-bird: terracotta funeral cart from Vari, Attica, seventh century.

which gives the essence of the calmer procession to the grave when mourning has been partly expressed and completed, has a shroud one could lift off to see the image of the dead inside, hooded mourners, a little child crying on the shroud, and a bird perching.[33] A seventh-century plaque (fig. 13) distils the essence of Attic feeling in both phases of the ceremony, the mourning women, the *goos* being sung, a flight of storks to the right, a good omen, and under the bier not a household pet but another soul-bird, with human feet. The soul-bird (fig. 14) continues to hover around mythical figures in death scenes for two centuries. From the beginning the behavior of the mourners, the grand state of the dead, and the pictorial rendering of the invisible *psyche*, were the big themes of early Greek art.

Burial was normally at night, a procession with mourners shouldering the coffin (fig. 15), or with the bier on a cart (fig. 16). In the Sappho and Theseus

FIG. 13 Mourners, a flight of herons and a soul-bird:
Attic funerary plaque, late seventh century.

FIG. 14 The soul-bird hovers at the death of Prokris:
Attic red-figured krater, fifth century.

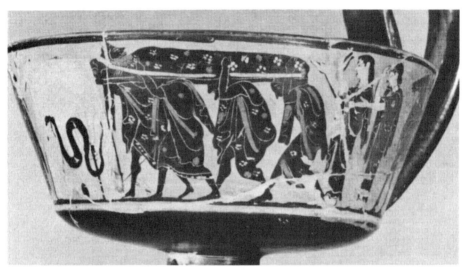

FIG. 15 The funeral procession with pall-bearers:
Attic black-figured kantharos, sixth century.

FIG. 16 The funeral procession with the bier on a cart:
Attic black-figured kantharos, sixth century.

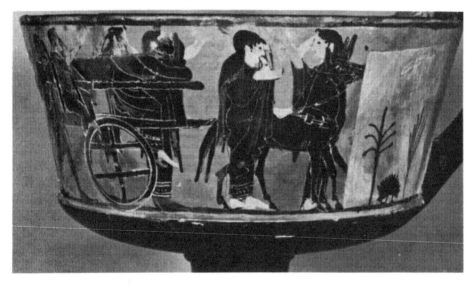

FIG. 17 Lowering the coffin into the grave at night:
Attic black-figured loutrophoros, fifth century.

Painters' several scenes (fig. 17) the stages are marked; the carpenters and diggers have their lamps, and the coffin is lowered down to the grave-diggers by torchlight. The funeral was finished and the slow process of death completed when the soul finally departed at the coming of dawn, as at the funerals of Patroklos and Hektor (XXIII.226f., XXIV.788).[34]

This sequence of ceremonies was rooted in the Bronze Age and barely changed through Greek history; the quiet scenes have a power of their own still in the time of the Peloponnesian Wars on white ground lekythoi. Nothing needed to change: the grief of the women, the youth and gentleness of the dead, the contrast in fate and experience. The artist, like the poet, concentrates on the moment of last love, the heart of the celebration of a mortal.

Within the long tradition of funeral painting, there is little of the mythical and fantastic. Early grave epigrams are almost equally innocent of references to supernatural imagery. Hades is the familiar core of ideas of the afterlife, but the elaborations around it, or him, are not so much wanted as the facts about the dead man, his parentage and place, his good qualities, like a permanent *goos* excerpted on stone. The epigram might be adorned sporadically with a few poetic tags, like *moira kichei*, fate came; *thanatoio potmos*, destiny of death; *thanatos dakruoeis*, tearful death; but such allusions to epic language are rarer than one might suppose.[35]

There were points at which the spheres of real experience and of mythical imagery did intersect, and these linkages were intensified with the progress of classical feeling, perhaps roughly from the time of Simonides to the time of Euripides. Ordinary behavior was increasingly retrojected onto the mythic past, and mythical figures brought comfort to the present. So Achilles is shown grieving at Patroklos' bier, on a vase of the 440's (fig. 18), while the assembled

FIG. 18 Achilles mourning Patroklos on his bier;
the Nereids sing (see also chapter 6 fig. 28):
Attic lekythos, red-figured and white-ground, fifth century.

Nereids on their dolphins bring new armor and join Thetis in her mourning song, just as friends join the bereaved Athenian family. This easy sliding from present to past to present is a characteristic of the way myth functioned in Greek society, where conjunction with the figures of old poetry could confer heroic stature on present mortals, as in an ode of Pindar. The Nereids singing for the dead in the *Iliad* and *Odyssey* are reincarnated to add a poignant dignity

to less gifted ordinary fifth-century songs. A mood of reminiscence is induced, for the long chain of ancestors who had the experience of death since time began, as Simonides recalled it, "Not even those long ago, the sons of our lords the gods, the half-gods, came to old age without pain and danger and dying" (18 P.); their finished lives had a normative power to illuminate the incomplete experience of their descendants.

The Survivor

Because the figures of the past were still on call for mortals of the present, most Greeks felt instinctively that the body's death did not mean total extinction of the individual. The twenty-one grams of deathless individuality which they usually called the *psyche*, the wind or breath which passed from the flesh to another place, was distinct in name as in function from the mind, or the aspect of intelligence called *nous*.[36] By classical times *nous* also came to have some immortal aspects, independent of the body which had temporarily sheltered it. *Nous* was on the whole more important for philosophical speculation than for the basic imagery of death, and played only a minor role in death-fiction; while the *psyche* was regarded as in some way intelligent, because it retained a memory of the past, and, once gone, could still speak to the living if it were properly aroused. Its powers of memory and speech were seriously weakened in death, but not extinguished so much as dormant. In visions of the afterlife, therefore, the *psyche* was the element which approached most closely the enduring powers which were sensed to reside in divinity and in the natural world. The gods of heaven and the forces of nature were for Greek poets the usual immortal, constant foils to the quick accidents of mortal lives, and what Simonides called man's dragonfly metastases (355 P.).

Unfortunately the *psyche* usually lost creative powers after death, and so was helpless in comparison with divinity and nature. This was the source of the familiar old quarrel between Simonides and Kleoboulos of Lindos. Kleoboulos thought men could make things—a bronze statue, a carved stele, a poem— which would not waste away or be extinguished "so long as water flows or the tall trees bloom, so long as the sun goes up to shine, and the brilliant moon, so long as rivers flow and the sea-waves surge on the shore." That was immortal memory, fame, *kleos aphthiton*, the oldest ambition in Greek poetry.[37] Creativity was a magic drug, a *pharmakon* against death and against being forgotten. Simonides thought he saw a tougher truth, that rivers, flowers, sun, moon and waves were immeasurably stronger than human creation because they were divine. It was idiocy to "set the strength of a stele against the flame of the sun and the gold moon and the whirling sea" because our work is inescapably mortal.[38] Still, in the short time between the Greeks and ourselves, rivers have dried up and oceans shifted while many Greek *pharmaka* against death are still potent.

Short life and limited creativity were the more painful to the Greeks because they seemed marked by failure of intelligence. Our minds are too weak to control our destinies, to understand the gods and what they want from us or to see what our lives really "mean." Semonides of Amorgos stressed this flaw:

νόος δ'οὐκ ἐπ' ἀνθρώποισιν· ἀλλ' ἐφήμεροι
ἃ δὴ βοτά ζώομεν οὐδὲν εἰδότες
ὅκως ἕκαστον ἐκτελευτήσει θεός

"There is no intelligence in men, but, creatures of the day, we live like cattle, knowing nothing of how god will bring each thing to finish" (1 D. 3–5). The poet sees us at grass, chewing, like sacrificial animals unaware when our meat will be wanted by our masters. We get through one day and then another in ignorance of any larger design. *Ephemeroi*, animals and men, are probably called so, not in the sense of living one day's span in contrast to the infinite forward time of the gods, but rather as short-witted creatures whose intelligence responds to or is shaped by each day's events and accidents, ἐφημέρια φρονέοντες (xviii. 136, xxi.85). As the sun may be born fresh each day, so is the mind, infant and *nepios*, unable to use the past as a guide to the future or find meaning in passing events.[39] From the eighth to the fifth century this was a standard Greek complaint. Herodotos felt as Homer did: *ephemeroi* live too long to see any consistency in their lives (I.32). Intelligence, if we had it, might link us to the immortal sphere, but it is normally so defective in us that we replace it with hope and delusion, as winged and weightless as the *psyche*. Down to the time of the Persian Wars, Greeks felt the double burden, of being mortal and being stupid. After that, perhaps, a sense of being Greek partly compensated.

The Greeks disliked being stupid. "It has been decided since very ancient times that the Hellenic nation is cleverer than the barbaric nations . . ." (Herodotos I.60.3). The Greeks are of course partly responsible for the western overestimation of the value of intelligence. The most familiar Greek virtue, *sophrosyne*, began as that quality of mind which would keep you safe and draw you back from the stupidity of the sleeping and the dead.[40] Even more stupid than the barbarians are the dead. It is sad that they are not more aware of us, and are unable to admire us more or to judge sympathetically our fall from their higher standards. We regret it for them often: "Your father would turn in his grave if he knew . . ."; "Agamemnon would groan aloud if he found out . . ."; but it is safe, he does not know or fails to pay attention.[41] To be stupid is to have your faculties dulled, to be stunned or struck senseless, to be slow of perception, tiresome, apathetic, uninteresting. Stupidity may have external causes like an eclipse or a hard blow on the head, or a vision, or causes to which your own body contributes, natural defect or disease or death. After death, at least, most settle in their graves asleep, hard to rouse and generally inattentive, or seem penned more distantly in the underworld, sometimes irritable as sleepers are, and possibly dim witted.[42]

This dimness is both external and internal, because darkness is the oldest metaphor for both stupidity and for death, and always the most common. As one of America's popular philosophers, Woody Allen, put it, "The thing to remember is that each time of life has its appropriate rewards, whereas, when you're dead, it's hard to find the light-switch."[43] This was a cliché already in the epics of Gilgamesh or in the sun-hymns of Egypt.[44] The Greeks also felt that the sun was the external monitor and shape of intelligence even when it had the disadvantage of being born new each day, not storing wisdom. The intelligence which reveals itself through the eye as brightness, like the interchange between *auge* "ray" and *augazomai* "see," *leusso* "look" and *leukos* "white (light)," is the miniature mortal counterpart to Helios, the eye of heaven who knows everything because he sees everything (III.277).[45] It is within this convention that we are all still called bright or dim. As the sun sees because there is fire in him, the agent or fluid of sight, so the Greek eye is its own source of light, looking brilliantly or darkly at friends and enemies. The eye feeds information to the mind; and although it operates less well in the darkness of a dead world, there is hope that, like Empedokles' man with the lantern, a little forethought may help illumine the way:

> As when a man who has in mind to journey forward [πρόοδον νοέων] through a stormy night prepares a lantern, a flame of gleaming fire, and fits lantern plates to keep out winds of every kind . . . [and] the light leaps out since it is finer and shines across the opening with untiring rays . . . so did ancient aboriginal fire, confined in membranes and delicate tissues, hide itself in ambush in the round pupil. . . . [B.84]

The man with the lantern in the dark had intelligence and made his preparation for the journey. And even in death, though the eyes close and the fire is shut off, so that the intelligence shrivels for lack of fuel and power, it can, under certain circumstances, be sparked to a degree of brightness again.

For Herakleitos there was light in the mind's night when the sleeper shut his eyes and attained some deeper communication (B.26). Although slang expressions like "I'll darken your daylights," or "θὰ σᾶς σκοτώσω," "I'll darken (murder) you" may suggest that once the light is extinguished life is inevitably diminished, there was among the Greeks, in their confidence that Hellenic intelligence could be genuinely superior to the buffets of fortune, a real strain of optimism allied to guile in the mythology of death. The internal sunshine of wit might conceivably rescue a man from darkness under proper circumstances. Hermes, as the god who guided men between life and death, who could use his magic wand both to enchant the eyes of men into darkened quiescence, ὄμματα θέλγει (XXIV.343, xxiv.2) or to waken the sleeping mind, was not accidentally made the wittiest of the Hellenic gods. His regular psychopompic roles are in

taking the uncertain dead to their new home along a new path or in releasing the dead souls out to the light again (fig. 19).[46]

Wit is internal mortal light controlled and supported by external immortal light; while in many ordinary people this light survives only feebly in the dark underground and must be sparked with injections of blood or other vital juices before it brightens enough to speak again, there are exceptional heroes whose wit is not so extinguished in death. Everyone dies, but the wittier at least die twice. These are the *polytropoi* like Odysseus, or Sisyphos, πλεῖστα νοησάμενος, πολύιδρις ἔων (Alkaios 73 D.), whose skillful ideas were rapid as a god's (Pindar, *Olympian* XIII.52). Before him no one had figured out the way, ἐπεφράσατο, but he went into the shadowy land of the wasted dead, passed the dark gates which keep in the souls of the dead against their will, and out of there back up again came Sisyphos the hero, "into the light of the sun by his own multiple wits," ἐς φάος ἠελίου σφῇσιν πολυφροσύναις (Theognis 702–12). At least in the archaic period, for some poets, wit was the only reliable *pharmakon* for death, and was their favorite quality in themselves.

The spark of reflective intelligence was thought to distinguish men from children and animals. It was the faculty that contemplated death and in some

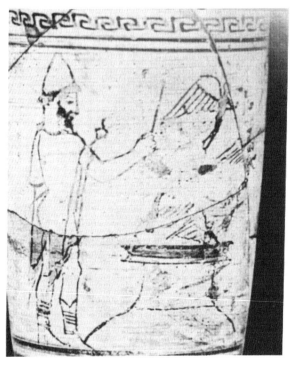

FIG. 19 Hermes releases the souls of the dead from a jar
into the light (?): Attic white-ground lekythos, fifth century.

sense controlled it. Greek suggestions that intelligence was the only effective defense against death were literally true. Occasionally, in folk-tale, a display of muscular power could check death for a moment, but even Herakles fetching Kerberos up from hell usually had divine help to support the intelligence for which he was not renowned, from Hermes, or Athena in many Athenian pictures. Strong emotions like anger might also resist the enfeebling effects of death; many heroes die angry, like Sarpedon, κτεινόμενος μενέαινε (XVI.491). Heroes are known to be irritable in their graves or when sleeping as prophets in caverns of the earth,[47] or waiting to be avenged for their murders; these are potential actors in ghost stories, dangerous and partly wakeful. Yet normal Greek hopes for survival, apart from folk-tale, focused on memory as a function of intelligence.

If a dead man can remember his own name, who he was and what he did, he is still partly himself. This is perhaps one reason why we write the names of the dead so clearly on tombstones (figs. 20 and 21). With memory working, other functions may also be restored, although no Greek ever stressed physical vigor in death to the degree that the Egyptians did: "My eyes and ears are opened . . . ; the bonds that are on my mouth are opened." "I do not grow blind, I do not become deaf"; or even, with near total control, "I eat with my mouth, I have motion in my behind."[48] Admiration for such physical prowess in resurrection is as rare in Greek eschatology as it is in Greek literature, where bowels are scarce. Greek dead do not eat in Hades, and are seldom interested in the motions which are the logical consequences of the banquet of the dead; the intelligence was more interesting than the flesh, and it might, with god's grace and human help, function like a little miner's headlamp in the dark.

The fear, then, is that the dead have lost what we most admire in ourselves, our intelligence and wit. The fiction is that they may not lose it altogether,

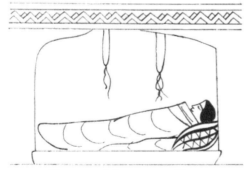

FIG. 20 A boy on a pillow
asleep in his tomb:
Attic white-ground lekythos, fifth century.

FIG. 21 The sleeping dead
as babes in the woods:
nineteenth-century tomb sculpture.

although the eyes are closed. This is one of the deep beauties about the two underworld scenes in the *Odyssey*, in xi and xxiv, different as they are in their dark geography and highlit scenes with heroes; in both the central theme of the sentient, remembering and feeling dead man is raised and examined in a brilliant series of refracted lights, changing personalities and conditions—young and old, warrior and woman, honored and dishonored, resigned and angry and melancholy and curious; as though to assure us that personality, or careers won through with hardship, or emotions toward the living, or mood or intelligence, are not in fact extinguished in the darkness.

It is within this sphere of convention that the curious incident of the prophet in the *Odyssey* underworld, Teiresias, has sometimes been misunderstood. The Theban prophet is singled out by the poet as being the only dead man whose wits are unshaken by death, to whom Persephone has granted *nous* and the capacity to be wise (x.493). Odysseus is to consult him on how to get home safely; and the distinguished and logical scholars who have observed that, in fact, Teiresias tells him no such thing, have sometimes concluded that *Odyssey* xi was stitched together within itself and to its surroundings by an incompetent.[49] The voyage to the underworld is held to be extraneous to a plot which brings Odysseus home by Circe's advice and his own wits; perhaps undertaken for the pleasure of the panorama of the past, the excellent ghosts, the stress on uncertainty in the relations of parents and children, and the high adventure of penetrating such a difficult place, but not for the stated reason of consulting the blind prophet in the dark. Yet apart from the poetic inevitability that, as in other epics, the serious voyager will experience death and will learn as at an oracle of his own death, Odysseus receives from Teiresias the most ancient possible instruction, and the one most worth having: "do not anger the sun." Only the sun, in its intelligence, comes intact through the darkness and the water beneath the world, and may draw a mortal caught in that darkness out with him again into the light. A mortal may force his wishes on the sun, as Herakles demands the sun's gold bowl for travel back out of the western seas, but an intelligent man like Odysseus should honor the sun's intelligence, as the only mechanism of survival. The sleep which poured on Odysseus' eyelids on the island of the sun (xii.338), and his subsequent near-drowning and descent into the black hole of Charybdis, are equally archaic motifs which would have been as easily understood in Egypt or Mesopotamia. The distinction in the way in which these motifs are handled is the greater role of faith, practice, and rote worship in the older cultures, and the greater insistence on individual qualities of mind among the Greeks.

The power of Greek poetic treatment of the underworld was bound to introduce a considerable separation between the ideas of death which a singer might explore, and the ideas which controlled actual burial practice. One obvious point needs renewed emphasis. There have been many areas of

confusion about the Greek imaginings of death and its consequences. Some of the confusion is inherent in the subject. Some is caused by reluctance to distinguish between instinctive ideas, or community religious beliefs, and poetic fiction. In myth, in poetry and in art the dead are naturally alive. The *psyche* cannot be shrivelled, feeble and witless, for a poet who has sent his hero, his alter ego, to the Underworld to talk with such a crowd would soon lose his audience. The *psyche* cannot be truly separated from its body, because the Greeks are not really good with ghosts, nor are they able to describe the dead consistently in language other than that which they use for the living. The "theory of death" on which any poet is operating may be maintained with a fair degree of consistency so long as convenient, and may then be quickly dropped. So Homer in the *Odyssey* Nekyia injects and livens some souls with blood, to bridge the gap between the stupid and the bright with life-fluid; but sometimes the step is forgotten, or suppressed to prevent boredom by repetition. Clearly, for poetic purposes, the theoretical deprivation of the *psyche* or *eidolon* in Hades, that is, the loss of parts of the self in the world of invisibility and darkness which covered eyes, nostrils and mind, is quickly remedied whenever the poet needs to talk to such deprived people.

Achilles' happy strides across the asphodel meadow or Aias' angered silence in the gloom are not true reflections of popular beliefs about the dead, so much as stage directions for a theatrical mysterious scene. Homer is as much the choreographer of a beloved familiar drama as his Persephone is an operatic director arranging the entrances and exits for the souls with great skill, collecting them back inside the depth of the stage "with a supernatural noise" in the closing scene (xi.632). Within a thousand-year-old tradition, Homer made his own shapes, which directed popular belief for a very long time after. Although it is not what everyone really believed, it represented a set of images which it was convenient for people to have in common, and to call "religious belief" when they were in the mood.

Homer's first concern was stagecraft and a kind of magic show, which demanded that the actors wear their own bodies and exhibit a certain liveliness of mind. A magic show needs at least dim light. But Hades ought to be dark, opening off those regions of the world "where the brilliant sun never shines down with his rays" (xi.15). Scholars and parodists both complained about the mixed results. One of the questions about the second *Odyssey* Nekyia (xxiv.1f.) which wanted "solution" by the scholiasts was, "how can they see the White Rock when there is no light in Hades?" The answer: "the parts of it turned toward the day gleamed pale."[50] Lucian also complained: "They suppose there is a place deep under the earth called Hades, wide and spacious and murky and sunless [ζοφερὸς καὶ ἀνήλιος]; I do not know how they imagine it is lighted up to see everything in it" (*On Funerals* 2). It is not imagination so much as necessity; one would know it was dark but render the needed light.

Elpenor, who killed himself falling drunk off Circe's roof because he failed to pay attention (xi.62), emerges from the sunless reedy lake, an unburied *psyche* "beneath the windy darkness," brightly lit on the Lykaon Painter's vase (fig. 22), and of normal size and solidity. Patroklos' *psyche* resembled him exactly, "like him in every way in size and fine eyes and voice, and he wore similar clothes on his flesh" (XXIII.65). In Bacchylides' witty Fifth Ode, the ghost of Meleager "shone distinctly" among the dead, "brilliant in armor," a ghost that can also cry and make jokes. To worry that, for religious consistency, the *psyche* ought to be small and disembodied, should reflect no nonexistent light, should have no juice to make tears and no feelings to prompt them; that dead Tantalos ought not to be hungry and thirsty, dead Tityos ought to have no liver for the vulture to eat, dead Sisyphos' body ought not to have enough flesh to make the sweat pour down his legs as he pushes the shameless stone, is to confuse folklore with religion, and above all to be discourteous to the poet.

The confusion between scene and idea has given historians of religion some difficulty in distinguishing the fixed features of the *psyche*, the *eidolon*, the *phantasma*, and other apparitions of the dead.[51] The small breath-*psyche* appears as a winged miniature replica of the mortal (fig. 5);[52] on a ruined but interesting lekythos, two *psychai* flutter near Charon the boatman and the lady, encouraging the shrinking girl (fig. 23); or a cloud of *psychai* may hover by the stream of death to welcome new companions (fig. 4). These *psychai* are painted as though they were sensitive to feeling and could act upon their sensations, for the artist like the singer must infuse his composition with sense.

FIG. 22 Odysseus sees Elpenor in the
marshes of the underworld:
Attic red-figured pelike, c. 440 B.C.

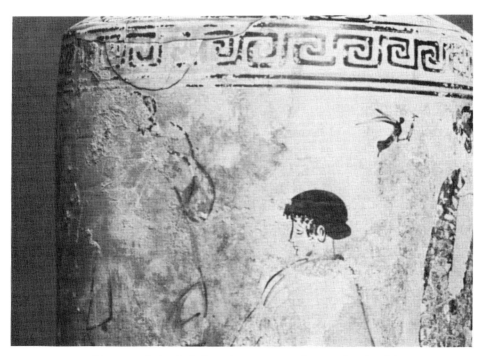

FIG. 23 A *psyche* brings incense to welcome the dead:
Attic white-ground lekythos, fifth century.

In other scenes, set in places where the presence of individual dead people is still sensed on earth, especially near tombs,* there is a more palpable image, the *eidolon*, less reduced to graph.[53] A dead Athenian lady (fig. 24) may sit in her household chair above her tomb, receiving offerings and thoughts from her family, as on so many later grave reliefs.[54] A dead soldier-hero rises in armor above his grave mound, perhaps attracted to the surface by the fresh fillets and gifts of those who still remember him; he has an alert expression and makes an active gesture (fig. 25). In the mythological sphere it is often the *eidolon* of Patroklos brought up from his tumulus at Troy to show his delight at Hektor's body being dragged around his own, a spark to his slumbering but still angry "self" in the tomb.[55] These artists' conventions for both *psyche* and *eidolon* are necessary, for it is difficult to draw the invisible with charm and conviction. They are also grounded in a real belief that emanations of the dead hover near their tombs, however impalpable, as now the actions of jumping on a grave or

* As Plato speaks of the disorderly and imprudent soul that still longs for its body, and flutters around it and the world of sight for a long time, persistently holding back and suffering greatly (*Phaido* 108 b).

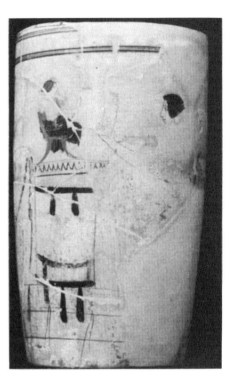

FIG. 24 The *eidolon* of a lady appears
seated on her tomb:
Attic white-ground lekythos,
fifth century.

covering it with flowers are felt to be sensed by the one within, however far he
may have gone toward heaven or invisibility. Such pictures and ideas should
not be taken entirely seriously as comments on the metaphysics of the soul; or
rather, metaphysical and metapsychical theories should not take themselves
too seriously, for ambiguity and confusion are built into this ancient series of
half-thoughts and no one would tolerate their eradication in any matter which
touches him personally.

Scholars used to wonder whether the *psyche* was reintegrated somehow by
fire or burial in the afterlife, or became the kind of *eidolon* which the poets
describe, once the ligaments were dissolved which kept some mortal power on
earth. Probably fire and burial have little to do with it; within the enormous
variety of burial habits around the world, there are still only a few central ideas.
But it is the artist who reintegrates the elements of the dead when he has need
to. It would be poetically awkward for Odysseus, when speaking with the
psychai of his dead friends, to go down on all fours outside the mouth of Hades
with a magnifying glass. It was not religious ceremony which inflated the *psyche*
to a reasonable size for conversation; it was the poet, who adjusted the scale of
the living and the dead to the requirements of his imagined scene and to the
dignity of his characters.

FIG. 25 The *eidolon* of an armed hero rises from his tomb:
Attic red-figured askos-lid, fifth century.

Hades and Thanatos

The strange world in which the *psyche* finds itself after death is not really clearly imagined by early Greek poets. As usual, figure and character dominate the landscape, and there is more color and tone than sharp definition of the forms of the underworld. Hades[56] is both far away, and straight down under the earth's crust, but a region separate from earth. From our earliest texts, the dead had an equal share of the world with the living and with the immortals. The cosmos was divided into three realms, of sky and sea and the dead. The earth was common to men and gods, and Olympos to all gods including the lord of the dead (XV.188). In Hesiod's view, the first mortals to go to Hades upon their death were the men of the bronze race, who introduced violence, war and murder into human history: "these were mastered by their own hands and went into the misty house of cold Hades, nameless; huge as they were, black death [*thanatos*] caught them and they left the shining light of the sun" (*Works and Days* 153). In the context of his poem, the gold and silver races of older times

were covered over by earth on their death, but were not in Hades; and Hades itself, house and god, is made more suitable for a warrior generation.

This is a necessary ambiguity, for the dead are set inside the earth, but when a man ploughs or disturbs tombs and bones, he does not go deep enough to reach the *psyche*; and the *psyche* is nearly always thought of as inhabiting an infertile region without crops and sunlight, consequently not really earth itself. The realm of chthonic figures, of furies and dreams and night and snakes and giants, is not the realm of Hades, except as Earth and Night are mastering figures which cover the passage of souls up and down.[57] Hades is, in contrast, a sterile and infertile realm without generation; and being a community with a queen and king and gates and a palace, is also thought of as a separate kingdom, of vast enough dimensions to suit the lordly role of Hades brother of Zeus and Poseidon, distinct from the elder goddess Earth. On Xenokles' lip-cup, Hades draws lots for his kingdom with his brothers, and looks surprised but not displeased with the result; he glances backward, like death-gods in other cultures (fig. 26).

It would be difficult to make even a schematic drawing of Hades, following the extensive but vague descriptions of Homer, Hesiod, Polygnotos and Plato. The kingdom of Hades is down under, so much is known. It is to some degree movable by poets, straight down under earth's surface, or off at the edge of the world, usually in the west toward the setting sun. How one got there was a matter of imagery. It lay outside the mapped spheres of the cosmos, like other regions beyond Ocean where even the sun scarcely travelled, islands and shores filled with wizards and monsters and figures with wonderful singing voices; it was closer to earth than the lower death-prison of the gods, the windy gated realm of Tartaros where dangerous or rebellious immortals could be locked away.[58] One could not normally reach Hades by sailing in a black ship (x.502),

FIG. 26 The three lords of the cosmos, Zeus, Poseidon and Hades:
Attic black-figured lip-cup, sixth century.

though the streams of Ocean were one barrier against or passage toward it. There were also land routes, ways down which were secret, hollow ways like snakes' holes, ὑπὸ κεύθεσι γαίης, κατ' εὐρώεντα κέλευθα (XXII.482, xxiv.10), In later times there were fixed entrances, through caves, woods and lakes. These were mysterious roads down which heroes, gods, or initiates in certain mysteries might pass, and might occasionally bring back a trophy, as Herakles brings Kerberos (never by sea) or Dionysos restores his mother Semele.[59]

In Homer, no strange voyage is needed, with the obvious exception of Odysseus' highlit trip. The *psyche* is able to wing its way to Hades' house easily and simply; the dying is often curiously effortless, and the *psyche* need not struggle or lose its way as it penetrates the earth's crust; it goes like a homing pigeon without any guide or fear.[60] If the dead traveller is pictured as still wearing a body, like the suitors in *Odyssey* xxiv, then it must walk, and may need a guide like Hermes, and may take its physical defects with it. The epic poet enjoys parading on his dim stage the figures of dead nameless warriors still wearing their bloody armor, the sorrowful virgins and strained old people (xi.38), at least as picturesque as the swarming bat-squeaking small sticklike *psychai*. The images flow into one another, and there is no express need for consistency. Hades, in one mood, may join the landscapes of dreams or childish fears, where one must descend in the dark, cross water, pass fire, meet danger, get lost and wander, or be bitten before arriving at a place as distant and as difficult of attainment as paradise; or it may be close, and reaching it as easy as entering a box or other space in the dark earth, with the help, good wishes and mourning of one's friends. This is the near place, with a thin crust over it, as in the *Iliad* passage of characteristic black humor from the battle of the gods, where Hades leaps from his throne and screams for fear lest Poseidon should crack the earth and show to mortals the houses, *oikia*, of the dead (XX.61). That is a palpable mixed image, of the walled graves which are the houses of the dead, which are also the individual noble houses built around a palace in a fortified Bronze Age town.

For this dark place of reunion[61] the epic tradition sketches what seems an essentially Bronze Age kingdom, a land fitted with walls and gates, a central palace and a great hall. The gates of Hades are hard to enter and harder to leave (XXIII.71, 76), with a shark-toothed dog to watch them, and a master adept at fastening the leaves, Hades πυλαρτής (VIII.367). "Hateful as the gates of Hades" (IX.312) is a stock expression for the central idea of a dark prison with an overseer; and in the rites representing annual release from Hades there may be a lamb offered "for the Gate-Keeper," the warrior who fought "at the gate among the dead" (V.397). The gates are not so many and formidable as the seven gates of death in the Near East, nor so picturesquely named and guarded as the crenelated gates of the Egyptian underworld, but they are the tough separators of a world which clearly had to be separated from

life, matching the gates which mark off heaven, or the Tartaros where unruly gods are kept.[62]

In the hall of the palace Hades and terrible Persephone rule from their thrones over their resigned subjects. They are childless, in archaic myth, since death is sterile, and they do not entertain much. The interior, or the porch, of their palace is better visualized by painters than by poets, and indeed there is not much Greek focus at all upon their private lives in an architectural setting, except when Herakles comes to take Kerberos from near the porch, or in late classical views of renowned captives and dead, like Theseus and Peirithoos sitting in their chairs under the queen's gaze, or Palamedes mourning near a pillar.[63] In the *Odyssey*, the *megaron* or *doma* is not filled with dead courtiers, and there is certainly no perpetual banquet of the dead in the throne room since in the older Greek view the dead do not eat and have no bodily functions. Rather they wander loose in an ill-defined countryside, like serfs on a farm, and they discuss with one another the brilliance of their funerals, as Agamemnon and Achilles do at the beginning of *Odyssey* xxiv, like patients in a hospital solarium telling each other about details of operations which, under the influence of temporary anesthesia, the protagonist has missed but is naturally interested in.

The Hades presented as place in epic poetry is a peculiarly exclusive kingdom, aristocratic and Hellenic. The Greek poet does not ask: Where do all the dead barbarians go? Where are Priam and Antenor, Sarpedon and Memnon and Penthesileia? What happens to dead centaurs, or to monsters like Geryon or the hydra? Persephone keeps a Gorgonish head of some huge monster in the lower world to frighten off intruders from the separate world of life (xi.634), and the later folk-tradition may supply other deformed and spectral female visions like Empusa, but the more famed monsters and animals of myth do not reappear below. In theory, one may suppose that dead barbarians and monsters, like slaves and children and animals, had no souls and therefore no future life; or, that the *psyche* is the persistent image of a remembered hero of the Greek community above, as his grave or tombstone marks his body, and just as Amazons or Trojans would be intrusive above, so are they below. The dead are pictured as clannish, as tribal; the *kluta ethnea* have won fame in their local tradition. Their privacy and relevance for Greek thought should not be intruded upon by aliens; that is an instinctive and not a theological idea, just like the rarity of Buddhists in Christian heaven. Since the underworld is controlled not by Hades, but by Greek poets, it is filled with those whom the poets would like to interview to illuminate the themes of their poems and complete their view of the absent dead, for whom the Greek community mourns. Later, in the fifth century, both for reasons of picturesque interest and because the great barbarian protagonists of the Trojan cycle had been drawn into Greek memory of the past, these figures begin to appear in the Hellenic Hades at need. Aeschylus calls up the Persian king from the Greek underworld, because,

starring in *The Persians*, he is still in a Greek play with information and advice for a Greek audience; on other occasions he is off somewhere more distant than Susa and forgotten. Polygnotos, in his panorama of the mythical dead for the Lesche of the Knidians at Delphi, can include Phrygian Marsyas among other legendary musicians, as well as Hektor, Paris, Sarpedon, Penthesileia and Memnon as Trojans and eastern barbarians, because the epic cycle has so firmly established them in the center of Greek heroic combat and Greek myth.[64] The older tribal kingdom of the dead can expand as the Greek view of the neighboring world expanded.

The distant Mycenaean royal couple in their walled kingdom of the dead, like their subjects, change with the social changes in Greece. In the archaic period Hades and Persephone may take on the role of archons, magistrates or judges, watching to see that Sisyphos really does roll his rock as decreed; or seated with a sheaf of wheat, marking the stable and benevolent overseers of law. In the fifth century the old warrior Hades, thundering out in his chariot to rape Persephone, has increasingly given way to the new Plouton figure of agricultural wealth, son-in-law of Demeter merging into son with the increasing influence of the cult at Eleusis, holding his cornucopia of riches to match Persephone's grain. The old Homeric picture had been less genial, but admirable and consistent: Hades as king, horseman, horse-breeder, warrior and charioteer, unbeatable and not to be softened, ἀδάμαστος and ἀμείλιχος (IX.158), lord of under-men, *anax eneron*, ruling in the windy darkness, ζόφον ἠερόεντα (XV.191), wounded defending his gates, going to clinic on Olympos with an arrow in his shoulder from mortal Herakles, and rescued by the poet with a mocking formula, "for he was not made to die," οὐ μὲν γάρ τι καταθνητός γ᾽ἐτέτυκτο (V.402). But throughout, Hades neither came out of his kingdom to collect the dead, nor did he kill them; he was not an agent of death but a king of remembered images.

In some sense there is no agent of death for the Greeks, because death is not a power—so Hades and Thanatos are notoriously unworshipped; death is a negative, a cessation, an inversion of life, but not a physical enemy. Thanatos is no more a killer than Hades; he represents an aspect of what happens when life stops, and is consequently the source of anxiety in the company of other lightly personified figures of epic poetry like *moira*, fate, *potmos*, destiny, and the *keres*. Thanatos is not a fully developed figure in Homeric epic. He appears incarnate and upper case only once in Homer, in the big set piece of *Iliad* XVI on the death of the Lycian prince Sarpedon (fig. 27). With his brother Sleep he carries the body home for ceremonial burial in Lycia, a benign escort with swift feet, not a killer (XVI.671). Sarpedon has long been dead, stripped, looted, rolled in blood and dust with arrows sticking out of his flesh, surrounded by enemies like flies on a milkpail in spring; in the context, Thanatos rescues him, cradling the body like a kinsman, as Harpies and stormwinds also do.

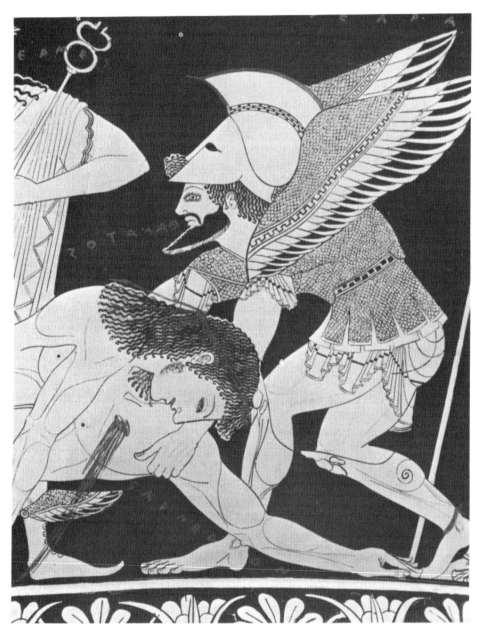

FIG. 27 Thanatos lifts the body of the Lycian prince Sarpedon at Troy:
Attic red-figured krater, late sixth century.

Poetic formula may sometimes grant Thanatos hands and legs, but not often.⁶⁵ He may run a man down, but a man can escape, θάνατον φύγε (XVII.714), or duck under, ὑπαλύξαι (XI.451, vs. XII.327), an image transferred from thrown spears or raised swords. He has heavy hands once (XXI. 548), is wicked three times, depressing to the energy of the *thumos*, καταθύμιος (X.383, XVII.201), and can smash it as though with a sledge-hammer, θυμοραϊστής (XVI.414), but the impact of that formula is softened, as death is shed gently around the head, ἀμφὶ δέ μιν θάνατος χύτο θυμοραϊστής, a mist or darkness, as a wave overwhelms a ship. Thanatos can make an ugly noise, δυσηχής, but never does so when a man dies; the noise is in the minds of gods who fear for particular men, like anxious parents listening for a crash. Thanatos can lay a man on the ground, τανηλεγής (VIII.70, XXII.210), as though on a bier; but, again, he never does so, for the word is only used in that passage of beautiful distressing sound,

καὶ τότε δὴ χρύσεια πατὴρ ἐτίταινε τάλαντα·
ἐν δ' ἐτίθει δύο κῆρε τανηλεγέος θανάτοιο

as Zeus sets the *keres* of death in the gold scale-pans to affirm externally the identity of the one who will die. The ambiguous *keres* have shapes and weights; *thanatos* itself cannot be weighed.

Thanatos is commonly a genitive, qualifying other agents.⁶⁶ These are neutral defining powers like *moira*, fate, or *telos*, end, not malicious but unarguable; or color, the black cloud of *thanatos*; or the wicked *ker* of black *thanatos*. In most descriptive passages *thanatos* is not a personification but a cloud, a veil, a mist drifting around the head, θάνατος χύτο, μέλαν νέφος θανάτοιο. The cloud appears in two colors, black and porphyry, with familiar interlocked poetic associations.⁶⁷ Black is shared with earth, both as it simply exists and when it is darkened with soldiers' blood; and with blood also, with cloud, night and sea, with blackwater springs in similes of grief, or springs that wolves lap with their thin bloody tongues; black is for pain and sorrow, for the ashes Achilles pours on his shining head in mourning, for the veil Thetis draws over her head, "dark blue, than which there is no blacker cloth" (XXIV.94). Porphyry is rarer, used for only six things in the *Iliad*: a cloud of warning on a god's shoulders; the water of Skamander river swollen with corpses; the sea rising in a great silent wave in a simile for disturbed anxiety; the heart which "purpled enormously" at the sight of Achilles advancing; and cloth, the cloth of battles and death that Helen wove, or the cloth of flowers Andromache wove for Hektor's gold coffin. The elemental form of *thanatos* in the *Iliad* is not as dangerous agent but as dark color.

The *ker*⁶⁸ seems more personal and dangerous. The *ker* of black *thanatos* can knock a man down and master him; no one can duck or avoid her, she is ten thousand. She is more active and vivid than the usual personifications of battle-field panic and noise, for she is sometimes dressed and her clothes are sprinkled

with blood; she has hands and drags corpses by the heels; she has jaws and will later have claws. She is the poetic and private equivalent of the corpse-ravagers of war, the birds and dogs, or the sphinxes, Sirens and Harpies; she has been understood as a ghost, a bacillus, lust, disease, lack of morals; a sister of sleep, death, and the furies, she may be an inherited Mycenaean figure elaborated into variously shaped patterns later. In art she is winged, and may be designed both as attractive and repulsive, as death is both. Patroklos says the most sinister thing about her, after he is dead:

<div align="center">

ἀλλ᾽ ἐμὲ μὲν κὴρ
ἀμφέχανε στυγερή, ἥ περ λάχε γιγνόμενόν περ

</div>

"The frightening *ker* who got me by lot when I was born has opened her jaws around me" (XXIII.78f.). The *ker* swallowed Patroklos with the rare verb *amphichasko*, like the dragon-child who sucked at Klytaimnestra's breast in Aischylos (*Choephoroi* 545), mixing mother's milk with clots of blood, for the *ker*'s nature is mixed of life and death. She is analogous to kind black earth

<div align="center">

FIG. 28 The Mouth of Hell: fourteenth-century manuscript.

</div>

opening to swallow men, like an animal swallowing her young, like Kerberos the biter, or the terrible *stomion* in Plato's hell which roared when any unpurified soul tried to escape; the mouth to the underworld like the *laitma thalasses*, the gullet of the sea, Patroklos' personal swallowing daimon.

Ker thanatoio: she is the agent and he is the aspect; not death-goddess of death, but of darkness. *Thanatos* is both less personal and less fatal. The etymological connections are with δνόφος, ζόφος, νέφος, κνέφας; darkness and cloud; Zephyros the west wind.[69] *Thanatos* is scarcely a real figure in epic poetry; it is a physical veil, a cloud between the man and the light, a private fragment of night for creatures of the day, a miniature Hades. The Greeks, significantly, had no word for irreversible death; one does not die, one darkens. There is then always the hope of the little interior light of intelligence, which may never go completely out inside the *psyche*, but waits to be roused by a human gesture like the oldest form of Sleeping Beauty. The *psyche* is memory and intelligence dormant, and can under proper circumstances be recalled by grief, love, magic or poetry, as we shall see in its further adventures.

FIG. 29 Kerberos leaves Hades against his will:
Lakonian black-figured cup, sixth century.

II

DEATH IN THE BRONZE AGE:
A HOUSE IS NOT A HOME

May I have a warm house with a stone at the gate
And a cleanly young girl to rub my bald pate.
WALTER POPE, *The Old Man's Wish*

THE STRONG conventions of behavior which surround the departure of the *psyche* are necessary comforts to the living. They are supported by a shared pretense of knowing what would happen to it afterwards. Greek ideas about the future of the body and its attached psychic image, as conventional and illogical as others, were imaginatively improved by those defects of logic which denied absolute separation of the two. Greek body and soul were not so parted in death as Plato hoped, or as Christian doctrine proclaimed. Even when the body was fully "dead," and the *psyche* had gone "elsewhere," men who wanted to speak with and comfort the *psyche* would quite simply and naturally go first to the body in its burial shelter. In principle, if the *psyche* had any attention to spare for the life on earth which continued without it, it should focus upon its old earthly housing, which was its point of contact with the upper world. The attachment was fragile, but not easily broken by the passage of time. The grave has always been the easiest place to try speaking with the dead.

The inexperienced living cannot be certain which of its places, or homes, the dead prefer, whether it is the shallow pocket in the earth above or the central assembly-place deep below. When the Greeks thought seriously about the matter at all, like most ancient peoples they seem to have imagined some kind of impalpable, spiritual tunnel running between the body's new resting place and the soul's new home, a tube through which physical tendance and living words of love and respect might reach.

It is not easy, professionally or temperamentally, for an archaeologist to make confident connections between tombs and thoughts. Archaeologists are ordinarily conservative, factual, and constrained by their training from flights of fancy. They are happier when they can leave spiritual interpretation to historians of religion, or even to anthropologists nurtured in another field than classics. Ideas about the journey underground, the voyage overseas, the sleeper in his grave and his care and feeding, cult and magical practice make excavators nervous because they cannot be proved, and may be rooted in fantasy. The philologist, in contrast, may find it repugnant to peer in graves or contemplate

42

disordered skeletons; it is restricting to him to keep the practical or historical aspects of death ceremonies in mind as he contemplates famous death scenes from Sarpedon to Sokrates or speculates upon matter and mind. He deals with character and idea; the archaeologist is confronted with the refuse from which character and idea are largely drained. Some merging of interests is advantageous in that sphere where body and soul refuse to be severed entirely.

Since the beginning of recorded history, from an archaeological point of view, there seems to have been some hesitation about considering death to be a permanent fact. In Paleolithic times a dead companion might be placed in a shallow pit near the fire, to warm him, or cheer him if he woke in the dark; he might be given a piece of meat, or a stone tool, to help him along if he came back when the others had left. A forged patina of life, an application of ochre or cinnabar to the face, or to the skull when the flesh had gone, was valued as a replacement of lost color. This quasi-magical practice continued in certain Neolithic cultures (fig. 1), and was a simpler prelude to the artistic creation of a new more durable face for the dead man. The plastered skulls of Jericho are improved by shells for eyes, false light in the sockets (fig. 2); or the face may be replaced by a whole frontal mask in stone.[1] Egyptian stone reserve heads or

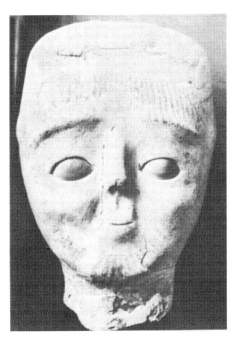

FIG. 1 Painting of dead man
with reddened skull and lips:
Çatal Hüyük, c. 5825 B.C.

FIG. 2 Plastered head
with shell eyes:
Jericho, c. 7000 B.C.

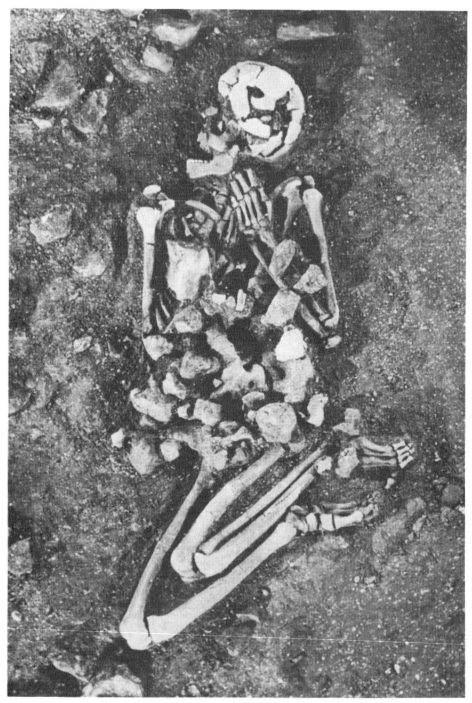

FIG. 3 Mesolithic skeleton covered with a screen of stones:
Franchthi Cave, Greece, eighth millennium B.C.

Mycenaean gold masks are only elaborations of this old effort to preserve individual features in memory; classical eye bands stamped with open eyes, West Greek clay heads on ash urns, Italic face and helmet urns, effigy tombs and cemetery portraits, or even the standard G.I. helmet hung on the soldier's cross—for home is where you hang your hat—all celebrate the idea that the head is the seat of life and personal identity, and that if it can be made more lasting the individual may be helped to withstand the darkening of time.[2]

Wherever earth-burial was even a sporadic custom, it was common practice to spread stones over the body in a light screen, to keep animals off (fig. 3). A stone was often placed near the head, sometimes as a pillow, sometimes in the mouth;[3] stone became closely associated with the dead for its durable and protective qualities. From that association it was a short step, in Mycenaean and classical times, to making an occasional substitution of a stone or a stone figure for a dead person who had been lost at sea or whose body for some other reason could not itself, *autos*, be buried. The classical *sema* can be both the external sign of the invisible dead in the grave, and the substitute person, especially kept alive in memory when written upon (fig. 4).[4]

FIG. 4 *Sema* and *mnema*: gravestone of a classical youth: stele from Nisyros, c. 450 B.C.

In some early communities, primary earth-burial was not the rule. The living rather developed a partnership with nature, with animals and birds and river torrents, to strip the flesh off the bones first, in the practical step of excarnation.[5] Afterwards, parts of the cleaned skeleton, especially the skull and the long bones, would be collected for secondary burial, in a house of the village, or in a separate village of the dead. Under such circumstances it was natural for the conceit to develop that feeling was more attached to the enduring white bones of the dead man than to his corrupted and vanishing flesh. Somehow the bones were a poetic ivory cage for the *thumos*, individual feeling, and although Homer parts the two in a tradition thousands of years old, λίπε δ' ὀστέα θυμός, the spirit left the bones; λίπ' ὀστέα θυμὸς ἀγήνωρ, the proud spirit left the bones (XII.386, XX.406), some traces of feeling were still caught in the hollow spaces of the cleaned skeleton.[6]

Where excarnation by predators was practiced in normal death, and on battlefield occasions of sudden violent death, the vulture and the fox (or in some countries the jackal and hyena) became the instruments of cleansing. Their intimate and ambiguous association with dead bodies was proclaimed in art from at least the sixth millennium B.C., and formed part of an archaic tradition which was much later brilliantly manipulated in Homeric epic, in the birds and dogs who "feasted" on humiliated corpses at Troy.[7] The reconstructed rites of the vulture shrines of Neolithic Çatal Hüyük in central Anatolia (fig. 5) are the oldest preserved documents of a relatively odorless and simple solution to problems which must have been widespread.[8] The headless bodies, the skulls collected and preserved in baskets, the great birds with their flailing wings, and the acknowledgement that physical destruction may ultimately be to spiritual and community advantage, all mark our first visual knowledge of the tradition which lies behind the winged, swallowing *keres* of Greece.

The female breasts molded in clay high on the walls of these shrines are clear symbols of the unity of life and death, of the obvious effects of the dead on fields and animals. The breasts promise the start of the life cycle with infant nourishment; and, when they on occasion conceal a vulture's beak or fox's jaw behind the red-painted nipple, they also offer the instrument of ultimate recycling. The symbol began as an acknowledgement of the ordinary unity of life and death in the social life of a community, but increasingly the predator side of the balance, and the ravaging of unconsenting bodies, becomes more marked in the iconography of death, particularly in the special sphere of the battlefield where scavengers worked on both sides. The predynastic Lion Palette from Egypt, or the Vulture Stele of Lagash (fig. 6) is eloquent testimony for soldiers' and artists' impressions of what happens to men on the losing side. Birds and dogs who eat corpses in the aftermath of victory were drawn into the conventional language of war art, and into the limited male repertory of boasting, millennia before the Greek epic singer flourishes them as malevolent

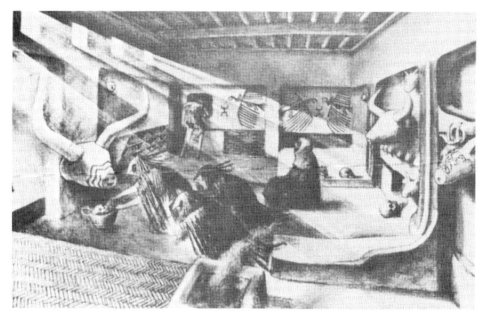

Fig. 5 Vultures cleaning bodies, heads kept in a basket:
reconstructed rites in the Neolithic Vulture Shrine, Çatal Hüyük, c. 6150 B.C.

Fig. 6 Vultures picking at the dead enemy:
the Vulture Stele from Lagash for King Eannatum, c. 2500 B.C.

threats on the plain of Troy. When gouging of the body is so connected with the humiliation of losing, the older idea of constructive recycling of human flesh by the animal world is overlaid by a convention of fear and outrage.[9]

In the ordinary management of the dead, whether in primary or secondary burial, there was occasionally an impulse among the survivors to make a little new home for those who were leaving their old home. From the fourth millennium onward, a full-scale tomb may imitate a house, or a little model house may serve as an ossuary for collected bones. These models are usually crude versions of village houses, sketches of what the dead will find familiar. They are rare enough in early cultures to suggest that they are impulsive personal commissions and not evidence for general practice. Modern cemeteries still feature simple house-tombs alongside the more grandiose temple-tomb made fashionable by the Egyptians and the Greeks.[10]

In Greece the idea that the tomb was a permanent model house was never so widespread as in Egypt, Asia Minor, the northern borderlands of Macedonia and the Crimea, or Etruria.[11] In the Bronze Age the most ambitious tombs, the *tholoi*, were not replicas of normal houses, and in classical Greece there was a basic pessimism about the chances of creating a stable future existence by surrounding the corpse with familiar architecture or furniture. This pessimism was connected with the belief in the distant kingdom of the dead, and with the feeling that the functions of the body, like dining, sleeping, and making love, had no need of further support once the flesh was gone. The house-tomb implies a sentient dead man pleased with his furnished apartment and its promise of perpetual resting, banqueting and pleasure; and while aspects of such belief surfaced occasionally in Greece, especially in connection with hero-cult, such imaginings were not the rule. Although the *psyche* often still wears its body in Hades, it is generally free from the problems and desires of the flesh except as folklore insisted on the bodily punishment of sinners.

However, the white bones at peace in the underground chamber of the grave necessarily inspired reflections about the sleep of the dead; the houses, *oikia* of the dead, and the *thalamos* or bedroom of the grave were early clichés in Greek. The sunken rectangle of the grave had to be provided with a door and a roof for practical purposes. The Mycenaean chamber-tomb might even have an architecturally dressed or painted facade like a house, and inside the rock-cut chamber the family might provide simple benches, stone pillows, even blankets and tables (although these are all rare) to make a more pleasant setting for the big sleep.[12] Coffins of the Late Bronze Age and of classical times often imitate a house; in the thirteenth century B.C. it was common to provide architectural treatment of the corners, even a pillar at the center, like a palace on a small scale. When these sporadic decorative impulses appear they may suggest that the dead prefer shelter in a familiar form; whether they were really thought to live in them with the vigor of the ghosts of *Ruddigore* is a matter on which Greek opinion was no doubt tangled like our own.

An important difference between the standard burial practice of the Mycenaean world, and that of earlier and later periods in Greece, is that from the sixteenth to the twelfth centuries B.C. it was felt proper to collect members of a family in a single tomb-chamber. This Mycenaean view of the importance of the family is part of the environment for the creation of epic poetry, although in epic, and in fact from the twelfth century B.C. onward, burial was once more commonly individual and lonely as it had been before the Mycenaeans.[13] In all periods it was natural for members of the same family or clan to be grouped near one another in a plot of land, in their individual cells; mothers and children, or married couples, might be buried together when they died together; nearness in death might lead to reunion in an afterlife. Mycenaean practice was more than this, more than the communal burials of early Crete or the mass burials of Cyprus. In shared shafts, *tholoi* or chambers, the Mycenaean family lay together in death through several generations, a principle conducive to dynastic pride and a passion for genealogy. Genealogy often bores the immortal young, and appeals more to those who will soon face a shift from the earth's surface to the family tree. Still, if one were to meet one's ancestors in the tomb or in the underworld, it would be courteous as well as useful to know their names and deeds. An expertise in oral and family tradition would support the refinement of one's manners and help bridge the generation gap.

The belief in a reunion of the dead comforts both sides. More recent dead can bring news to those who long for it, like the suitors in the *Odyssey*; the older dead can greet those just painfully arrived, like Iphigeneia kissing her murdered father at the quick-whirling ferry-crossing of Acheron.[14] The experienced dead who had already weathered the shock of disembodiment and dislocation could give practical advice on how to adjust. Since the dead family could be encountered both in the tomb and in Hades, they were fitfully imagined as still alive in both places. One poet will watch Agamemnon weeping a warm tear in Hades (xi.391); another will have him live on, remote and dim in his tomb, ἔνθα σ' ἔχουσιν εὐναί (Aischylos, *Choephoroi* 318), a figure of hero-cult.[15]

This double location of the dead brings complications; it is not a simple separation, body in the grave and soul in Hades. The body's condition will affect the condition of the soul. The magical function of the mutilation of the body, as in the *maschalismos* when the lopped-off members are tied to the body to be with it but not workable, apparently ensures that a revenant ghost will be equally helpless.[16] Oidipous blinds his body before death at least partly to not face his parents in the underworld, toward which he proceeds from a separate grave (Sophokles *OT* 1371). Cutting down the body early leaves the soul still infant; wounding the flesh means wounds in the shade below (xi.38); proper treatment of the dead produces a healthier and more cooperative shade, so that for family members, apart from the powerful influence of love and custom, it is particularly important not to offend those whom you will join.

The idea that there is a collective gathering place of the dead, who form a new community, is not of course dependent on how many people are buried in a single tomb; the community of the dead transcends the family and village group, although it is quite possible that, for some Greeks, the people of the next village would not be included in their own gathering. Do Spartans join Athenians, or Naxians join Arkadians? Perhaps only if they fell in battle together.[17] A community of corpses may establish rapport, as in the Homeric joke of the corpse assembly, ἐν νεκύων ἀγύρει (XVI.661). From this point of view, the Mycenaean family tomb may well have influenced the imaginative form of the reunion in Hades. It is the theme of many Christian tombstones too: We Will Meet Again In Heaven, or, on the Cambridge, Massachusetts, tomb of Thatcher Magoun, who died in 1890 (fig. 7):

> A Household's Tomb! To Faith How Dear!
> Part have Gone! Part Linger Here!
> United All in Love and Hope
> One Household Still!
>
> Together We shall Sleep
> Together We may Rise
> And Sing our Morning Hymn
> One Household Still!

The motif is lovely, where there is love, although the Greeks speculated as we do on what might happen when those who cordially disliked one another in life found themselves trapped eternally in the same bedroom-grave, *thalamos*, or were forced to meet in Hades. When there is more than one wife or husband, serious problems of precedence, harmony and *droit de mort* may arise (fig. 8),

FIG. 7 The tomb of Thatcher Magoun,
 d. 1890: Cambridge, Mass.

FIG. 8 Problems in family tombs: Cambridge, Mass.

and it is perhaps a mercy that no Greek poet exercises his talent on the reconjugation of Eriphyle or Klytaimestra. Aias' incivility to Odysseus is enough (xi.541).

The bedroom-grave and the underworld are merged imaginatively as often as body and soul are. They are shaped the same, to some extent. It is not that the Mycenaean chamber-tomb is a miniature replica of the configuration of the underworld; archaeologically the reverse might be true. The Mycenaean tomb is a practical construction with three functional parts: the *dromos*, or slanting downward path which leads in under a shelf of stable bedrock; the *stomion* or narrow mouth which is blocked up with stones or dirt, as much to keep animals and robbers out as the dead in; the *thalamos* or inner chamber which may hold from one to twenty skeletons (fig. 9). It is a sensible, functional tomb, no more symbolic than a garage with a driveway and closed door. The words for its parts are used transferably, however, for the parts of the underworld in classical Greek.[18] It is not impossible that the old Bronze Age tomb form which epic ignored but tragedy admired, in some way contributed to the poetic shape of Hades. The family has a private replica of the underworld, with the damp path down, the narrow guarded door, and the chamber from which there is no exit, yet from which the occupant invariably disappears: the original model for the mystery of the locked room.

In mythological and poetic imagery the Mycenaean tomb, viewed as a man-made cave, fills some intermediate stage between a very archaic tradition of the forms and entrances of the underworld, and the classical picture. Sir Denys Page pointed out long ago how close the Greek view of the underworld was to certain real configurations in caverns under the limestone hills of southern Greece.[19]

FIG. 9 A *tholos* tomb at Mycenae:
the entrance to the Lion Tomb, fourteenth century B.C.

The Dirou-Pyrgou-Alepotrypa caves of the Mani peninsula expand from the
low dark entrance into a series of wider and often fantastic chambers and halls
through which icy rivers run, or lakes spread out on sandy beaches, with water
so black the fish are white. One can travel by boat through passages, past
waterfalls and rocks like the rock hammered by the rivers in *Odyssey* x.515, or the
White Rock of xxiv.11. In some caves there must be hot springs, though

whether fiery Pyriphlegethon is matched in nature I do not know—might it have been the reflection of torches off the water?[20] In these subterranean passages early men could easily become disoriented or trapped under the earth, and the presence of an experienced guide would be welcome. Such dramatic caves were inhabited from Late Neolithic times at least, and others more open to daylight from Paleolithic. Some seemed like home, others were obvious entrances to a world the living could not normally reach. General ideas that death involves a plunge into earth or ocean, or into caves and lakes, with a crossing of water in the darkness, had natural support from the countryside.

In early times the caves had an animal population which included the hyena and the pygmy hippopotamus. Was it too long ago to make one a model for Kerberos snapping in the dark, the other the misshapen and greedy Lamia making love in mud and water? It may be that both these underworld figures, with other bogies like Gello, Mormo and Empusa, take their iconographical form from Egypt, where both are well drawn.[21] Lamia, an authoritative and persistent underworld lady, appears late in Greek literature, not before the fifth century, in company with Charon; she is fat, thick legged, stupid and inconveniently amorous; according to Aristophanes she smelled like a seal, and might be personally unclean about the lower parts, which were strangely adorned with testicles.[22] The Egyptian tradition that a hippopotamus in the lake of the dead devoured the souls of those who did not pass judgment, might conceivably be reinforced by old Greek encounters with a toothy and affectionate hippo in a dark river-cave—but it is, unfortunately, too likely that these animals were extinct before man moved into the caves and then out of them; the monstrous tradition must be more recent.

Caves have jagged, impressive rows of stalagmites and stalactites which are not reproduced in the Greek vision of the underworld. Are they blended into landmarks like the White Rock, the Gates of Hades, or of the Sun, or Dreams? Such gates merge with the caves of the sun and the wind, places like Tainaron the cave-entrance to the dead where the sun keeps his flocks, or places where bulls are driven into Pluto's caverns.[23] Most likely, the pointed rocks on roof and floor helped shape the long uneasy tradition of the *stomion*, the mouth entrance to the underworld which roars and bites, with serrated teeth fixed, animal fashion, up and down, the ceremonial mouth of hell which swallows everything at last, the universal counterpart of the individual *ker* who swallowed Patroklos. But it is long ago and far away, beyond the grasp of scholars.

Greeks who visited the underworld in a literary mood did not describe the landscape very precisely, being more interested in themselves and their friends or enemies; so the relation between the underworld and the grave is misty. In one the dead walk and talk, and in the other they sleep until called; the shallow chamber above having a mysterious but real connection to the larger hollow below. The chamber and *tholos* tombs of the Bronze Age have a more vivid role

in classical drama than in epic poetry, probably because of revived antiquarian interest in the fifth century, and a feeling that tombs of the heroic age were properly associated with narratives of heroes' deaths. The picturesque death-cavern of Attic tragedy was the more imposing for its connection with the impressive architecture of *tholos* tombs, and the ghastly thrill of speculation that the old dead were still vibrant inside. The death-cavern-prison of *Antigone* fuses the cave, the grave and the underworld masterfully, with witnesses standing, like Odysseus in the *Nekyia*, just outside the mouth of the chamber of horrors to watch the dead. For a natural cave the place is surprisingly architectural, a "rocky excavation" (774), a "roofed tomb" (886), a "walled-off earth-heaped strange tomb" (849), a "rock-spread hollow bridal chamber of death" (1204); "run up close," says Kreon, "stand by the tomb and look, push through the narrow place we piled the rocks, enter the *stomion*" (1214f.). Sophokles and Euripides surely had picnicked in the country, at Menidi or Marathon or Thorikos, and their stage tombs have little to do with contemporary graves in Athens.[24] The bedroom of the dead shifts from earth's surface to deep below, and keeps the sleeper private. Kapaneus' holy pyre turns swiftly into a *thalamos* (*Suppliant Women* 890); Rhesos lives on, aware, in his cavern in the silver mines (*Rhesos* 970); the *thalamos* which takes all men (*Antigone* 804) merges with the *thalamos* of Persephone (*Suppliant Women* 1022). The grave blends with the guest room of the queen below.

In grave or ghostly guest room, the belief that "he is not dead but sleeping" was an old comfort. How active and aware the sleeper stayed was unknown. A Mycenaean terracotta exhibits a couple under a blanket, in bed or dead or both (fig. 10). Could sexual activity still occur among corpses? Euripides makes

FIG. 10 A couple in bed, or dead:
Mycenaean terracotta, thirteenth century B.C.

FIG. 11 The cradle and grave of Mary Wigglesworth,
aged one: Cambridge, Mass.

Theseus laugh at the idea that the dead could make new children together in
the womb of earth (*Suppliant Women* 545); the dead in groups are usually
thought of as passive and infertile, although death-and-rebirth fertility themes
may apply to individuals in religious mysteries. Even when the folk-motif of the
Bride of Death was used, the bridal with Hades had no real implications of
lasting or overtly sexual union. Parents who placed a wedding loutrophoros on
the tomb of a child who died before marriage were not necessarily hoping to
arrange a substitute marriage with death, so much as they were trying to make
the child's cut-off life more complete and happy, affirming that the regular
stages of maturity and marriage had been at least potential in his interrupted
career.[25] In more northerly parts of the world in later times it was a matter of
sporadic local custom to marry the dead, to draw up a marriage contract
between a dead boy and girl so that they could be happy together below; and
the Romans sometimes provided a dead woman for every ten dead soldiers as a
camp-follower in the underworld—the Greeks were less routinely physical.
There were, certainly, rhetorical flourishes like Antigone's "O tomb, O bridal
chamber" (891), and mythological marriages like the sacrifice of Polyxena to
the dead Achilles, but the Greek sleeper was not usually restless for a woman

(the Hero of Temesa was an exception); and if, in Mycenaean tombs, children were buried in niches outside the door in the *dromos*, it was surely because it was too much trouble to unblock the door for such slight burdens, rather than out of any fear that they would witness midnight revelry at too early an age.

The Mycenaeans seem to have shared with most Mediterranean peoples the natural belief that the dead went on a journey from the burial house to a lower world. We cannot tell how they thought this happened—whether quickly, at death, or eventually, when the flesh and ligaments had dissolved. To judge from the remaining evidence, early Greeks were no more clear or consistent on this point than their descendants were, and entertained a confusion rather like the corpse in Aristophanes who is briefly tempted to carry baggage to Hades (*Frogs* 170f.). Certainly Mycenaeans had a tradition of putting gifts in the grave, as most peoples do, whether to share the last good things of life with the dead, to show respect and affection, to help the transition in the chamber, or to supply the journey toward the distant walled town of the charioteer king.

The usual gifts are weapons, jewelry, and vases, most often laid near the head and hands, or at the feet. The vases are designed for liquids, aromatic substances, and oil; occasionally there is a little solid food, meat on the bone or shellfish. The most recent dead in any tomb are neatly arranged; they would have been washed and dressed in good clothes as for marriage or any other crisis. The gifts are in a sense part of the costume; the sword and dagger, the gemstone, the smith's tools or the priest's implements complete a man's identity underground, more surely than they help him in future spiritual life. Most archaeologists agree that after a decent interval the Mycenaeans felt free to take these gifts back from the dead who no longer needed them, when they piled the older bones against the walls to make way for newcomers. Sometimes they were startled or embarrassed when the skeleton they were shifting was still intact, the transition not quite finished yet; once at Perati they apologized, as one might after bumping an old gentleman, and gave the incompletely dissolved corpse some new seashells and a fresh pillow.[26]

One cannot understand the "meaning" of such gifts, because in a sense they are meaningless, or mean more than one thing, and are not quite in the realm of rational gesture. If, in a burial, the weapons are in working condition while the vases are dented or misshapen in firing, this tells us nothing about the supposed perceptive power of the dead: it is not that the dead man will be angry, if the living withhold his sword or spear; it is not that he is too stupid to understand that the vases are damaged. It is a practical matter; the weapon was his and he may want it; the vases were bought cheap for the occasion. There is no reason to believe that the Mycenaeans feared the dead particularly, or took precautions against ghosts of ill will, as we may pretend in dithyrambic moments. Their behavior toward the dead is practical, sensible, an expression of tradition which is not thought out afresh on each burial. There are some

oddities worth observing, although they are rare enough that they cannot imply general belief and practice.[27]

Mycenaean dead are given more drink than food, in kraters, cups, jars and feeding-bottles for infants. The dead in many cultures are rumored to be thirsty, and our communication with them is more commonly by toast and libation than by food. The "thirsty ones," the *di-pi-si-jo-i* of a few Pylos Linear B texts are sometimes interpreted as the dead, in a local euphemism, although the word may as easily represent a place name.[28] In Egyptian belief it was important for the newly dead to drink cold fresh water in the underground (fig. 12).[29]

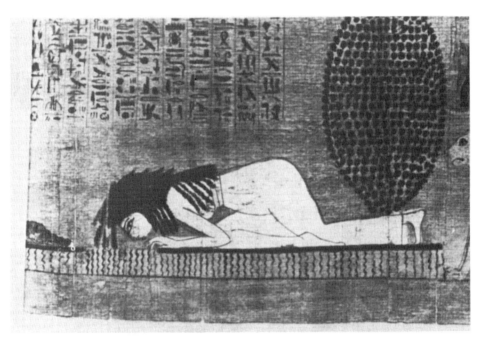

FIG. 12 Drinking the fresh waters of the land of the dead:
Egyptian papyrus, the Book of the Dead of Lady Cheritwebeshet.

Liquid is prominent on the Haghia Triadha sarcophagus, in the rite for the dead, and blood from the sacrificed bull may serve the same purpose, just as blood flowed κοτυλήρυτον around the corpse of Patroklos (XXIII.34).[30] Geometric evidence is ambiguous, especially if the holes in the bases of the big Dipylon vases were designed for post-supports and not for libations, but a preference for liquids is still suggested by the shapes of the vases in the graves.[31] The first Greek "Totenmahl" reliefs, which begin to be made in the Aegean world around 450 B.C. under eastern influence, consistently stress drink more than food (fig. 13).[32] "Drink" (and where not to drink) is a primary instruction

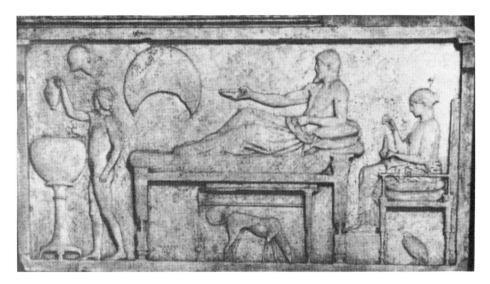

FIG. 13 Relief of the dead man drinking at a banquet:
from Thasos, c. 450 B.C.

on the so-called Orphic gold-leaf guides for the dead, as in the fourth-century text from Pharsalos in Thessaly:

> In the halls of Hades you will find on the right a spring, with a white cypress beside it. Go nowhere near this spring, but farther on you will find cold water running from the Lake of Memory. Above it are guards . . . You tell them the whole truth . . . "I am dry with thirst, allow me to drink from the spring."[33]

The thirsty dead are also involved in the painting of the so-called Leaky Pithos of the later sixth century (fig. 14). The little winged figures are clearly not Plato's punished daughters of Danaos filling an ever-leaking jar, but small male *psychai*, or even the daimon "guards," who may serve drink to the meritorious and parched newcomer to the underworld.[34] The deep thirst of the dead was in some way alleviated by gifts in the tomb and for the journey, while the underworld made its own arrangements for hospitality. The popularity of the "pilgrim flask" in Mycenaean burials of the eastern Mediterranean from about 1400 B.C. onward may well reflect this ultimately eastern nervousness about the consequences of losing the liquids of life.[35]

It is hard, sometimes, to understand the mood in which people tried to satisfy the physical needs of the dead, and as hard to interpret the gestures made to support the lonely spirit. Was it for companionship or transportation that several horses and some dogs were buried in Mycenaean tombs? (Some dogs

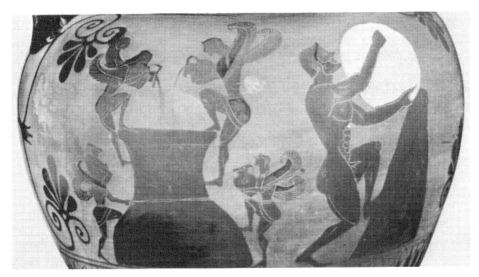

FIG. 14 Winged daimons pouring liquid in the underworld; Sisyphos:
Attic black-figured amphora, late sixth century B.C.

were trapped inside while chasing rabbits; but other intrusive animals like
tortoises, hedgehogs and bats offer no insight into ancient funeral practice.)[36]
The horses and dogs are often discussed in connection with the funeral of
Patroklos in the *Iliad*, for Homer usually colors the archaeologist's view of the
Bronze Age. Patroklos' horses are not poetically special, not singled out as
being his favorites, or as valuable captives in battle; the whole passage is
remarkable for its speed and condensation, as Achilles drives the four horses up
the timber pyre and groans aloud (XXIII.170). More attention is given to the
two dogs who get their throats cut, since they are Patroklos' own and will stay
with their master in death, up to a point not clear to us. None of the bones of
sacrifice, human or animal, are collected with Patroklos'; Achilles stresses that
his friend lies apart from the Trojan captives and horses whose remains are
mingled, *epimix* (242). The peculiar and partly unreal form of an Homeric
funeral screens from us the feelings which were expressed at a real ceremonial
horse-burial. If Patroklos were not pure poetry, if an archaeologist should hope
to have stumbled upon his first temporary grave or his second less-renowned
joint tomb with Achilles,[37] what would he see? No marker, and a small patch
of ground, τύμβον δ' οὐ μάλα πολλόν (245), the gold jar holding the valiant
bones not in it (254), mixed scrapings from the pyre consisting of boy, war-
horse, dog, sheep and ox, and the grandeur of *Iliad* XXIII as vanished as the
winds Boreas and Zephyros when they stopped blowing the flames.[38]

The tradition behind the scene was different, a reflection of an old Indo-
European custom which seems to have nearly faded out in Mycenaean Greece,

where horses were probably expensive, and which intended the warrior's life-long companion to be with him in death, a mark of dignity, leadership and affection. It was a sign of individual grandeur, a continuation of kingly rank and of the favorite endeavors of life, to be buried with a chariot and team as one had lived on the battlefield. Even though we have suffered a loss or trans-mutation of such desires proper to a warrior society, the same instincts some-times surface in America today, as witnessed in an interesting letter to Ann Landers:

> I'm not on my deathbed, but I'm getting on in years. . . . I have a modest collection of antique automobiles. . . . The car I love best is a 1937 Dodge . . . whenever I look at that great automobile, it makes me feel good all over. . . . Instead of a casket, I'd like to be sitting at the wheel and lowered into the ground.[39]

Here is the ancient pleasure in the horse and in the prestige which it conferred, transferred nearly intact to its mechanized successor, drawing upon the same set of feelings as must have stirred the princes of Marathon in Attica or Salamis in Cyprus, or the simpler archaic Athenians who wished to be buried with a horsehead amphora (fig. 15).

The rare confirmed examples of horse-burial in Mycenaean Greece (fig. 16) may be supplemented by less expensive funeral versions of painted chariot-

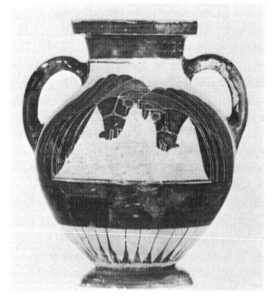

FIG. 15 Horses mourning the dead:
Attic black-figured amphora, early sixth century B.C.

FIG. 16 Mycenaean horse-burial in the tholos tomb at Marathon.

kraters or terracotta horse-and-chariot miniatures.[40] The focus seems to remain on the burial, and not on providing transportation for the journey to the hereafter. If epic tradition intended that human captives, dogs, and horses should accompany the dead man on his road, it does not care to exhibit this funeral throng in Hades; the sacrificed alien and the soul-less animal have slipped away.[41] Even the horse with his own grave at Marathon is less likely to be a daimonic three-legged Death Horse than a proper memorial for the soldier who bred and trained him, an older parallel for the mourning of Achilles' horses over their dead charioteer, κλυτόπωλος like the lord of the dead.[42] The motif persists with the chariot and horses of the Mausoleum, the grave of Alexander's Boukephalos, and, in some sense, ancient and modern equestrian memorial statues.

Horse and dog burials express part of a continuum of feeling and ceremony which flows from the moment of death through the escort of the dead man to his tomb (still partly sentient?), to the funeral games celebrating him, and then—but we do not know how far?—on the journey to the other world. Vignettes survive on the painted kraters of Mycenaean Greece and Cyprus.

Fig. 17 "Their Favorite" faithful in death:
Cambridge, Mass.

The dead man is escorted upright in his chariot, shrouded, accompanied by a
groom and sometimes by footsoldiers with swords and spears, just as in ekphora
scenes on later Geometric vases. Occasionally there are painted excerpts from
the funeral games, belt-wrestlers or spear-throwers, or pairs of boxers flourishing
at each other with gay science (fig. 18). So Nestor in his youth boxed at the
funeral games of King Amarynkeus (XXIII.634), or Epeios threatened at the
funeral games of Patroklos, "I will break right through his meat and smash his
bones" (673). Funeral games were celebrated in a similar style on both sides
of the Dark Ages, a traceable element in epic tradition,[43] and the honor they
paid to the dead man was probably apparent to him in his tomb, since he had
not yet wholly released his grasp on the upper world.[44]

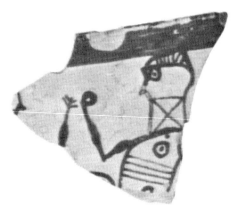

Fig. 18 Mycenaean boxers at the
funeral games: thirteenth century.

The unbroken continuity of funeral imagery and behavior between the Bronze Age and the classical world is very clear in the artistic documents that survive from the earlier period. There are only slight differences in style, and none in concept, between the mourning women mounted on rims of Mycenaean bowls, and the mourning women of sixth-century Attica on bowls for liquid or the corners of gaming tables (figs. 19, 32). They are extracts from a familiar tradition of washing the dead and making the standard gestures to accompany the *goos* of lamentation.[45] The files of mourning women on the Mycenaean coffins of Tanagra make the same gestures, like women on the funeral loutrophoros-hydria of archaic Athens. The *prothesis* scenes are equally formally linked, although the Mycenaean painter may show the dead man sleeping inside his transparent coffin like a baby in his cradle whereas the Geometric painter (to whom coffins were unfamiliar because he normally cremated) raises the subject on his funeral couch preparatory to burning. The Mycenaean may also be raised on a bier while the mourners tear their hair beside him.[46] These are unpracticed pictures drawn from the observation of real events, perhaps influenced by prototypes in Egypt, but quickly established as one of the Greek scenes which had the most profound meaning in the life of the community, surviving all the cultural and economic vicissitudes of the Dark Ages as the most stable tradition in art, save scenes of war.

The otherworldly aspects of death, as conceived of in the Bronze Age, are naturally harder to appreciate because they are so rare in art. Occasionally the dead man seems to continue his journey beyond the tomb by chariot, drawn by supernatural animals,[47] or he may, rarely, be equipped with special boots for the road, like Viking hell-shoes. The two pairs of Mycenaean clay boots from Attica are painted with patterns at the ankles which may suggest wings (fig. 21). The form of tall boot with curled toes may be Hittite, and Hittite gods

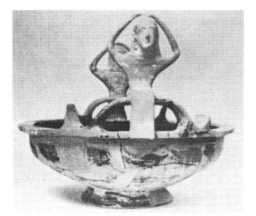

FIG. 19 Modelled mourners on the rim, and painted sirens: Attic black-figured bowl, early sixth century.

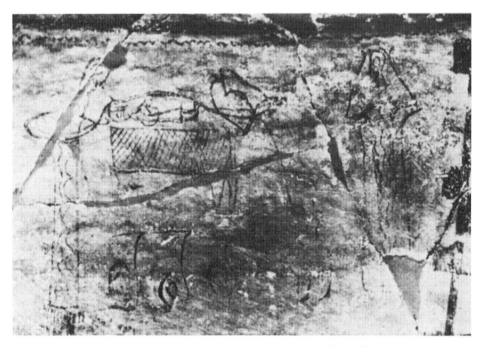

FIG. 20 Women mourning the dead in his coffin:
Mycenaean larnax from Tanagra, Boiotia, thirteenth century.

FIG. 21 Mycenaean clay boot with
winglike patterns at the heel: from a
tomb at Voula, Attica, thirteenth century.

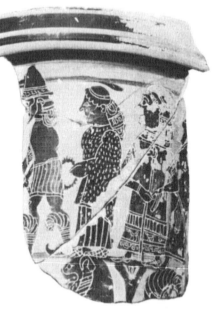

FIG. 22 The Judgement of Paris,
Hermes wearing winged boots:
late seventh-century Attic fragment.

had winged ankles; the same boot appears in archaic Greek art as the "lovely sandals" of Hermes, καλὰ πέδιλα, which carried him over the liquid sea or endless earth as messenger or psychopomp (fig. 22). The facsimile boots in the grave would keep a man from what Alkman called ἀπ]έδιλος ἀλκά, bootless strength (I.13), stumbling on the road; the concept re-emerges in Geometric Athens; and later in South Italy an entire sarcophagus is made in the form of a shoe.[48]

To ride or walk to Hades presupposes a body, but the Mycenaeans also sent the disembodied soul. One of the big Tanagra coffins shows this image flying tentatively on batlike wings from its coffin house to its new home while the mourners sway and scratch their bloody cheeks around the body (fig. 23). The leathery flanges of wing along the arms, unfeathered, look like earlier imaginative models for the famed *Odyssey* simile in which the suitors pass to the underworld squeaking like bats, disturbed and fluttering in a huge cavern (xxiv.6). This is the first *psyche* in Greek art, an impressive rendition of the invisible. On two other coffins the passing seems to be rendered in the different image of the soul-bird, which the Egyptians had long used and which classical Greeks would still find appropriate. The bird stalks through a flowery meadow behind two soldiers, or, in a magnificent construction at the four corners of a coffin lid—four corners to my bed, four angels round my head—the soul-birds alight from their flight upon sun-discs set between horns of consecration.[49]

Such glimpses into Mycenaean fantasy about death are rare; more commonly they expressed their ideas through images of animals invested with a significance

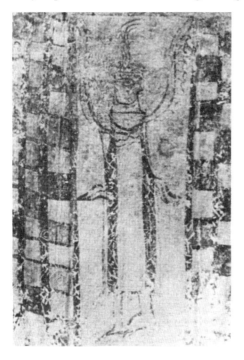

FIG. 23 The winged image of the dead woman flies off: Mycenaean larnax from Tanagra, Boiotia, thirteenth century.

now mainly obscure to us. In the fourteenth and thirteenth centuries both
Minoan Crete (partly occupied by mainland Greeks) and parts of Greece
turned increasingly to hunting themes in funerary contexts. Hunting art had
not been traditional in Crete, but it was intimately connected with ideas of
death in early mainland Greece, from the time of the Shaft Graves onward.
When these ideas spread to Crete following the Mycenaean occupation of the
island, they began to appear on the painted coffins which Crete made before
Greece adopted them. These late Cretan coffins often show wild animals wan-
dering peacefully in the fields, sometimes among cult symbols which belonged
to older religious generations, like double axes and horns of consecration. Such
bulls and deer and goats seem to be protected in rustic sanctuaries, expressive
of the ancient Cretan spiritual intimacy with nature. In the thirteenth century,
however, the consecrated and protected animal may become the victim of a
human hunter who spears it or pulls it down with hunting dogs. The connection
with the grave may be through the role of the sacrificial animal who becomes
holy as it dies. There is some vision on these coffins comparable to Semonides
of Amorgos' vision of ephemeroi, human cattle or game grazing at grass with
god's protection, then suddenly called to a death which has earned a meaning
in violence. A deliberate deepening of the motif comes from the number of

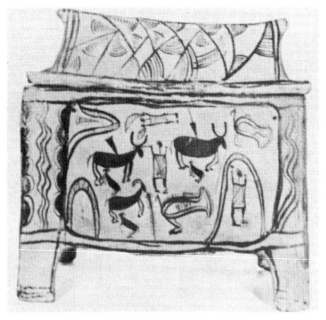

FIG. 24 The funerary hunt:
Minoan larnax from Armenoi, Crete, thirteenth century.

animals who are shown suckling their young and playing with them, as the hunter and hounds come up to kill them. The parental shock and separation is the keynote on several coffins, a doe with her fawn in a place full of flowers with elements of sea-life, perhaps magical, watching her mate killed in front of a drawn game net. Or, a peaceful herd is suddenly so disrupted by death that the birds fly off upside down in shock at the violence (fig. 24); the animal plays some double role as sacral and as killed, as at the Attic Bouphonia.[50]

Death by hunting can be joined to an image of the journey overseas. In a series of awkward but impressive studies on the spectacular larnax from Episkopi, panels of animals nursing their young and being suddenly attacked by hunters and hounds form a background or environment. While they are being speared and trapped, a boat-shaped chariot drawn by a hornless bull travels over the sea waves (represented by an octopus with rippling tentacles). The passengers face outward in a weightless, dissociated stance, already departed.

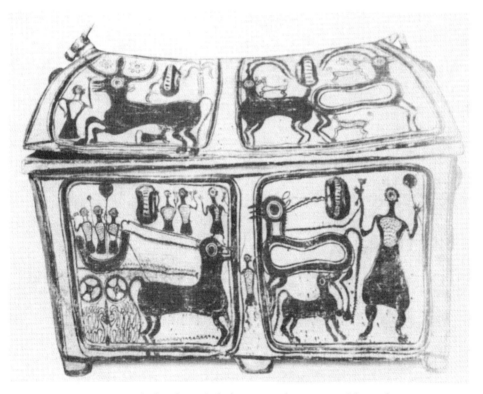

FIG. 25 Animals and their young, hunters and hounds,
the dead travelling in a bull-chariot over the octopus-waves:
Minoan larnax from Episkopi, Crete, thirteenth century.

Among their gifts is a rattle, a precursor of the rattle music (a ghost-staying mechanism?) shown in Geometric graveside scenes. The whole complex suggests unexpected disruption of fertile life on this side, combined with a grand ceremonial procession to an overseas haven like Elysion or the Isles of the Blest, in mixed images of happy hunting grounds and the ultimate voyage. Simpler coffins may use only the octopus, or a ship.[51]

Mainland coffins are generally less pastoral or sea-minded, more focused on the act of mourning, as classical funeral art would be. Files of men and women pass along the coffin body making formal gestures of grief, or look out of windows as in Near Eastern iconography. The Tanagra coffins also include strange scenes of bull-jumping, of hunters with their dogs pulling down wild goats, and of chariots with escorts. The hunting scenes seem to be connected with real practice in certain parts of Greece, to judge from the presence of heads of wild goats buried in some chamber tombs at Tanagra among the human skeletons. Stags and bulls are also found in thirteenth-century tombs on the west coast near Pylos, although these may be later offerings to the dead.[52] These are only sporadic and very rare signs of the direction in which Mycenaean

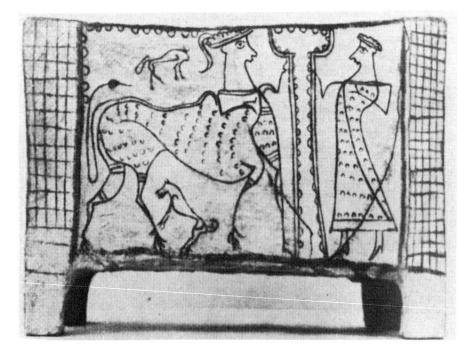

FIG. 26 The sphinx at the column:
Mycenaean larnax from Tanagra, Boiotia, thirteenth century.

Greek thinking about death was being crystallized in the last phases of the Bronze Age, but they suggest a real connection between practice and the traditions of oral epic, emerging in the standard Homeric image of the death hunt.

The mourners, chariots, hunters, winged *psyche* and soul-bird were joined, at Tanagra, by the monster who would be the favored associate of tombs in classical times, the sphinx. The sphinx was an old formal familiar of the Mycenaeans, as of the Minoans, but it was only in the thirteenth century that she really came alive, reproducing and suckling young, and moving into the funerary sphere. Here is the prototype of the *ker* of death, the attendant on the corpse if not its swallower; perhaps because of the limitations of Mycenaean artistic technique she had not yet, apparently, assumed the role of demon lover, the "esprit avide de sang et de plaisir érotique," who in late archaic Greece combines the snatching of the dead with the passionate pursuit of handsome youths.[53] She is still a slightly remote agent of the supernatural who, as she touches the central pillar of the coffin-house (fig. 26), suggests a theme still current in modern Greek laments for the dead:

> Four columns of my house, I bid you good-night,
> Tell my wife I'll come at night no more;
> Four columns of the house, I bid you good evening,
> Tell my father I'll come at evening no more.[54]

The broken column was popular as a monument in Victorian cemeteries (fig. 27); the Mycenaean column, in the same manner, united the dead man with the image of his house which would now lose its support: Archilochos' dead Megatimos and Aristophoon, the lofty pillars of Naxos ([16]D.); Aischylos' "footed column of the high roof"; Pindar's shorn oak that kept the palace up (*Agamemnon* 897, *Pythian* IV.267). The sphinx who will escort the dead also protects the house, and on another coffin she sits to guard it in the classic position of the archaic tomb-sphinx.

These Bronze Age patterns of thought and representation, the tomb as a house for the body, the soul in a new home, the mourning in files and beside the coffin or bier, the *psyche*, the soul-bird and the sphinx-*ker*—were not all developed spontaneously on the Greek mainland without influence from abroad. The natural source for such influence was Egypt, which had the grandest, most monumental, and most detailed funerary tradition of the ancient world. The mechanics of transmitting some of the Egyptian ideas and some physical forms to Greece is not at all clear yet. There were Greek visitors to Egypt, of course, traders and mercenary soldiers, especially in the later Eighteenth Dynasty and the Nineteenth Dynasty reigns of Ramses II and Merenptah.[55] The contact was never very strong; there is almost nothing beyond small amulets and trinkets of Egyptian manufacture as souvenirs on the mainland; we have no

FIG. 27 The Broken Column:
nineteenth-century funeral monument.

way of detecting the ideas and image-making capacities which might have
come back through visitors. The Levant might have been a partial source,
through Ugarit or Byblos, where the sarcophagus of Ahiram is approximately
contemporary with the Tanagra coffins, shows undeniable Egyptian influence
and has similar figures of mourners on the ends.[56]

The mainlanders do not adopt Egyptian styles, or all beliefs, of course; yet
certain established practices in Egypt seem to exist behind some of the oddities
of both Bronze Age and archaic iconography and myth in Greece. The Bronze
Age contacts from the fifteenth to the twelfth centuries B.C. were reinforced in
the seventh century with the foundation of Naukratis as a Nile trading post;
and some elements of the Greek canon which seem late, like Charon the
ferryman, may be added onto an earlier influence which had already been
absorbed and transformed in the Mycenaean period so as to appear outwardly
Greek.

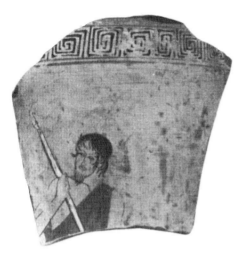

FIG. 28 Charon looking backwards: Attic white-ground lekythos fragment, fifth century.

The boatman carrying souls across a shallow river-lake to their new community is a good emblem of the kinds of complications met when trying to trace traditions which appear in two cultures in rather different forms; there is no way to make a direct connection between Greek Charon, the traveler in his hairy sailor's cap whose head may be averted like other death-figures', and the Egyptian Seth, the ferryman, the lord of storm.[57] Charon does not look much like Egyptian models but he functions like his counterparts in Egypt and

FIG. 29 Charon in a sailor-cap poling his ferry: Attic white-ground lekythos, fifth century.

Mesopotamia while keeping a local vitality. Because his name does not seem Greek and he appears relatively late in Greek literature and art, he is probably not wholly indigenous, but smoothly adopted and camouflaged. In the same way, the concepts of *makar*, of the Elysian Fields and the Ialu Fields, of the soul-bird, the fruits and waters of the underworld or the weighing of the dead, which appear in both Egyptian and Greek traditions of death, present real difficulties for those who assume direct transference—but at the same time they exhibit close and instinctively-sensed connections. The two sets of ideas and themes cannot be wholly separated; it would be a matter for wonder if the rich Egyptian iconography of the dead had not affected the growing Greek interest in the topic in the Bronze Age and the archaic period, and wonderful if that influence had not been quickly Hellenized.

Egyptian ceremony focused on the intact survival of both body and mind, and was supported by an opulent offering of life's goods to the dead. These natural hopes are less confident in Greece, when eschatology is first marginally discussed in Homer, and probably the Greeks always accepted death as a drastic and generally bodiless translation to an unknowable new condition; Greek hopes are more concentrated on intelligence and fame than on nourishment for flesh which they knew was not immortal.

Hesiod's description of the Isles of the Blessed is consequently surprising, in going beyond the gifts of drink and food offered at Greek graves, and raising for modern scholars a range of spectres, heroes, who demand more extended service in some "Elysian paradise."[58] "And they live with no sorrow on their spirit in the islands of the blessed beside the deeply swirling Ocean, prosperous heroes for whom the grain-giving field bears honey-hearted harvest ripening three times a year, far away from the immortal gods" (*Works and Days* 170f.). "Hero" can sometimes mean little more than soldier, sometimes simply a dead man, sometimes one who is especially honored in life and death;[59] but Hesiod seems to be the first to make a hero both happy and hungry. Pindar, too, in his odd eschatological fragments, remarks how special dead men are removed from weather and can eat without labor, not disturbing the earth with their hands' scratching (*Olympian* II.62). This paradise where the dead hunger and eat lies on the *Islands of the Makares*, like Hesiod's, where ocean breezes cool the climate and gold shines in the trees; or where flowering prosperity blossoms for them as the dead play games, *pessoi*, or amuse themselves with music, horses and exercise, in a meadow red with roses, in a land heavy with gold fruit (fr. 114, a,b B).

These ideas are very much those the Egyptians had long expressed about the paradise of the dead, the *Sekhet Ialu* (*Iaru*), the Ialu Fields or Fields of Reeds. Those dead who had qualified as *maakheru* lived there in pleasure: "Of the going in and coming out of the underworld, for a stay in the Ialu Field, to be mighty there, to be blissful there . . . to eat there, to drink there, to be a

husband there and to discharge all functions there as on earth."[60] This is like the earlier Coffin Spells for the Field of Offerings, the *Sekhet Hetepu*, "I row in its lakes and arrive at its cities . . . I equip this your field which you love . . . that I may be content and be mighty in it, that I may eat and drink in it, that I may plow and reap in it, that I may make love and awaken in it . . . I have not perished and I have not been apprehensive in it . . . ";[61] like Greek divinities with careless, happy spirits, ἀκηδέα θυμὸν ἔχοντες (*Works and Days* 170).

Maakheru seems one of the few certain Egyptian loan-words into Greek although there are etymological problems. *Maakheru* described the dead man who had passed judgment in the underworld, the dead man who had the voice to pronounce the proper formulas before the judge, who was thenceforth "justified by a voice before god, happy, blessed." This is Greek *makar*, or *makarios*.[62] In early Greek, the *makares* are usually the blessed gods, μάκαρες θεοί, who lack nothing, who feast and make love and sleep ἀκηδέα θυμὸν ἔχοντες. Hesiod's Islands of the Blessed are not inhabited by gods but by the dead "far from the gods"; so the Egyptians thought of the *Sekhet Ialu* as opposite the gods, but corresponding. The dead nature of the *makar* persists in Greek alongside the eternally blessed nature, as though the significance of the word had split two ways when it hit the basic Greek belief in the dark sad life of the dead: one aspect clung to the happy gods, one to those dead who were somehow excepted from the general rules of Hades. So Hesiod, burying the silver generation, makes them underground or chthonian *makares*, τοὶ μὲν ὑποχθόνιοι μάκαρες θνητοῖς καλέονται (*Works and Days* 141); Aischylos, too, in calling on the spirits of the dead, ἀλλὰ κλύοντες, μάκαρες χθόνιοι (*Choephoroi* 472). Μακαρίτης became a familiar way to speak of one who has died, μακαρίτας ἰσοδαίμων Βασιλεύς (Aischylos, *Persians* 633),[63] as it is still used in modern Greek. Plague-stricken Athenians who "rose from the dead" were called blessed and practically immortal, ἐμακαρίζοντο (Thucydides II.51.6); and there is a useful definition in Hesychios—dead man: *makarios*: corpse, ὁ τεθνεὼς· μακάριος· ὁ νεκρός.[64] It is a word without good etymology in Greek, a word whose aspects are all traditional and richly deployed in Egypt.

In Egypt the blessed dead live on islands in the waters of a great lake filled with reeds, where there are winding waterways like the Lake of the Hippopotamus, and a ferryman to help the crossing. The lake may hold devourers, just as a hippopotamus is often one of the devourers for those dead condemned in the underworld. The islands are usually four, called, to the best of my knowledge, Peaceful, Verdant, X, and Y.[65]

On these islands, according to Egyptian pictures of the Eighteenth and Nineteenth Dynasties, the dead plowed and reaped and finally banqueted, working for a living and for the grace of the gods.[66] In the Greek adaptation of the idea of the Islands of the Blessed, the dead did not need to work, but food came spontaneously to them; they shared the life of the gods, at a distance from

them, while the Egyptians continued as dependants and servants of the gods and worked to eat. After the Persian Wars and the basic revolution in ideas which marked the fifth century, the Greek dead were also provided with wives, sexual satisfaction, and honor, on the White Island in the Black Sea and other remarkable spots close enough to the edges of the world to seem mysterious, yet accessible enough to receive the marks of worship which had more a literary than a practical tone.[67] For earlier times, it was odd enough that the dead should require food and should rejoice in the surroundings of paradise, matters alien to the central tradition.

As the Greek dead play games, and eat, and enjoy the blessings of fresh cold water, and of the gold fruits of the tree, the pictures and texts of the life of the Egyptian dead offer some striking analogies. There, the dead drink from streams of fresh cold water, and are offered fruits of the tree, painted yellow, by the kind tree-fairy. There is an obvious analogy to the torture of Tantalos in the *Odyssey* underworld, during which the water sank away from the sinner's lips and the trees tossed their fruit too high for him to touch, toward the shadowy clouds (xi.582f.). The touches of landscape and atmosphere, of growing plants and water, are odd indeed in the darkness of Hades, and so is the emphasis on

FIG. 30 Egyptian "tree-fairy," fruit and water for the dead and the *ba*-soul:
Tomb of Tjanefer, Thebes, Eighteenth Dynasty.

the sinner's hunger and thirst from which the normal *psyche* is free, as Lucian did not fail to remark. It is possible that a fragment of eschatology borrowed from Egypt was used by the poet for its picturesqueness, to replace the version of Tantalos' punishment preferred by Archilochos and others, the stone hung over his head.[68]

The happy Egyptian dead supplied with water and fruit are often accompanied by their *ba*-birds, or *ba*-souls. The *ba*-soul has a portrait face on a feathered body, and functioned as an agent to reintegrate a dead person; it could hover over a stiff corpse with the *ankh*-sign of life, or fly into the dead man so that he awoke to energy and could walk away with the *ankh*-sign in his hand (fig. 31). The *ba* could mediate between the living and the dead, bringing the

FIG. 31 The *ba*-soul entering the dead to make him quick: Book of the Dead of Neferrenpet, Nineteenth Dynasty.

sustenance of funeral gifts from the earth's surface to the deep tomb, flying down the tomb shaft from the upper chamber to the sleeping dead. There is little doubt that the Egyptian *ba*-soul was the model for the Greek soul-bird and for its mythological offshoots the Siren and the Harpy, both of whom had intense and often sustaining relations with the dead.[69] So far as one can tell from pictures, as Herodotos said about the phoinix, the *ba*-bird looks very like

the soul-birds of both Bronze Age and Orientalizing Greece except for the portrait head; it shares with the Harpy the task of hovering over the dead or transporting them, and with the Siren the task of the spiritual nourishment of of the dead; the Greek Siren more naturally stimulates the intelligence than the flesh.

Another traditional Egyptian theme with repercussions in Greece is the weighing scene of death,[70] with the dead man's heart in its preservative jar set in the balance against the feather of Ma'at, Truth or Justice, while the Devourer stands by the Judge. The first funeral scales of Greece appeared at the very beginning of the Mycenaean age, in the Shaft Graves and a few of the richer burials of Late Helladic I-II, when there was only fitful contact with Egypt, and it is impossible to know whether the butterfly stamped on some Shaft Grave scale-pans might signify the soul as it did occasionally later. Perhaps the old Greek idea, which began to lapse in later Mycenaean times, was partly connected with a tradition at the funeral of Hittite kings, when a Wise Woman heaped jewels in one scale-pan, and brick dust, mortal dust, in the other.[71]

The classical Greek *psychostasia*, with poetic models in the death of the eastern prince Memnon in the *Aithiopis* as well as Hektor and the Achaians in the *Iliad* (VIII.69, XXII.209), uses the artistic convention of the whole *eidolon* of a man in the scales, one man against another, and the poetic convention of the *ker*, a man's own death which gets the downward signal and takes him away.[72] It is not a judgment but an external affirmation of destiny. Greek judges of the dead, Minos alone or with his colleagues Rhadamanthys and Aiakos, are neglected in the vision of the underworld between Homer and Plato, and when they do appear they do not make judgments with scales, but with the sceptre and rod of an earthly king who must make decisions. The scales belong to Zeus—Ζεὺς γάρ τοι τὸ τάλαντον ἐπιρρέπει ἄλλοτε ἄλλῳ (*Theognis* 157)—or his deputy Hermes, and in their normal function they are, like prophecy and oracle, indicators of inescapable fact, death, rather than adjuncts to the administration of justice. (The scales of justice seem to appear first in the Hymn to Hermes, where there is a set for each contestant: κεῖθι γὰρ ἀμφοτέροισι δίκης κατέκειτο τάλαντα [324]).

The image of the weighing of the dead has been altered, clearly, from the Egyptian motif of weighing an individual against an abstract principle of virtue, toward a more competitive principle of weighing one fighter against another, while the element of the Devourer has been absorbed into the individual *ker*; the theme is fairly rare in Greece and is mythologically restricted, but it does seem to have been linked originally to several other rich and picturesque elements of Egyptian eschatology absorbed and transformed in the Hellenic imagination. The Isles of the Blessed and the four islands of Egyptian paradise where the blessed dwell, the former "near Ocean" and the latter across the

Lake, the hippopotamus devourer, the reeds, the ferryman, the fiery river, the fields of grain, gold fruit and clear water, and easy life of bodily enjoyment, *maakheru* and *makares*, the weighing of souls and the *ba*-soul, all seem to point to aspects of the complex Egyptian iconography of the other world becoming known to the Greeks and adapted in part by them, probably at intervals between the fifteenth and the fifth centuries B.C. Much is not yet clear, like the etymology of Charon or of the mysterious Elysion which looks so much like the Ialu Fields and may be connected with cemetery names like Ialysos, the Champs-Elysées of Mycenaean Rhodes. The need for the dead to carry written spells with them is perhaps the latest element to become popular, with emphasis on guards, water and trees in a landscape, in so-called Orphic doctrine. The uncertain relation between these images and the old Greek Hades underscores the likelihood that they were grafted sporadically onto an essentially recalcitrant tradition, and the ultimate Greek picture which increasingly stresses the happiness of the dead could not be totally coherent.

One last Egyptian theme converted to Greek funerary imagery is the playing of board games by the dead. In literature this is best known from Pindar's

FIG. 32 Board-game with the Invisible Opponent, and *ba*-soul:
Tomb of Nofretari, Thebes, Nineteenth Dynasty.

famous fragment, where the game is *pessoi*, probably a generic word with a specific application to a game of battle and blockade. Most early Mediterranean board games have themes of war, hunting, and racing. The problematic early Aegean boards, from the palace at Knossos and from the Shaft Graves, seem based on a problem of hunting and pursuit, where you wait, pass, and advance on lucky throws. The ivory gaming box from Enkomi in Cyprus, of about 1200 B.C., is for a different game, based on an Egyptian model. Its being found in a tomb may have no special significance, for ancient games rarely survive except through burial, but the top of the box is for a game played frequently by the Egyptian dead, and the sides of the box use the hunting motifs familiar on Bronze Age coffins.[73]

A favorite Egyptian game, from predynastic times onward, was *snt*, the game of passing, played with thirty squares, using throwing sticks colored white on one side, red or dark on the other.[74] It was a secular pastime, but was also desired in the underworld. The squares are often intricately marked with signs for "water," "danger," "trap." Across these, five to seven playing pieces for each of the two players move by a combination of chance and skill. By the

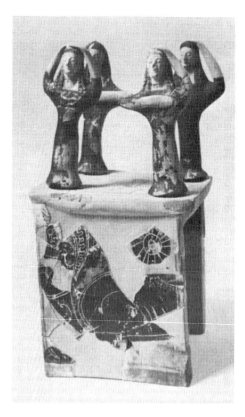

FIG. 33 Gaming table from a tomb, with modelled mourning women and painted lions: Attic black-figure, early sixth century.

mid-Eighteenth Dynasty the game had acquired lightly symbolic overtones, and in tomb-painting the usual pair of players may be replaced by a single player facing an invisible opponent, evidently death, or an evil spirit of the underworld (fig. 32). The squares may be inscribed with texts appropriate to the passage to death; "you tread the staircase of the souls of Heliopolis," or, for the water-square, "you shall ferry across the lake without wading." Good moves indicate safe passage through the underworld with the sun, and union with Osiris, and in funerary game texts the match between the fortunes of the game and of the soul are evident: "May you be justified [*maakheru*], O you who are in the Thirty [spaces on the board]. May you go down upon your lake of truth. May you embark in the divine ship, which goes straight toward the necropolis of the Two Truths." Or, with some malice, "I pass with the breeze

FIG. 34 Funerary relief, men at the gaming-board:
Palmyra, third century A.D.

together with the sun to the House of Repeating Life. My opponent lingers in the House of the Net [?] and he is humiliated in a papyrus thicket."

In Greece, during the seventh and sixth centuries when the Nile was once more opened to trade, gaming boards and dice appear again in private tombs, especially in Attica.[75] The boards are clay models on a small scale, roughly marked off in squares, made specifically for burial, and they are occasionally ornamented with small sad figures of mourning women at the corners (fig. 33). These are the same mourners who stand on basin rims, or at the neck of mourning hydriai, very like those of Mycenaean bowls; their presence invests the game board with some particular meaning for the chances and skills of life and death. Sometimes a die is found too, or a die by itself, painted with figures out of the Geometric funeral repertory, a woman with raised arms, or a horse, a horseman, a bird, even a Siren with a lyre. The custom is rare in Greece, compared to Egypt, but suggests that for certain Greeks gaming was, as for the Egyptians, a metaphor of chance, of winning and losing in an unreal world, the ultimate game with the last opponent. The gaming board continued in

FIG. 35 Ajax and Achilles at a gaming-board in the Trojan War:
Attic black-figured amphora, late sixth century.

this sphere of imagery until the end of the Roman Empire (fig. 34), as in Fitzgerald's conceit in the *Rubaiyat*,

> Tis all a Chequer Board of Nights and Days
> Where Destiny with Men for Pieces Plays:
> Hither and thither moves, and checks, and slays,
> And one by one back in the Closet lays.
>
> [I.xlix]

One may wonder whether the famous game between Aias and Achilles at Troy is not more than a simple pastime (fig. 35). One was going to rescue the other, in death, on the battlefield, and lose the *aristeia*, the prize of valor. The pictures begin in the third quarter of the sixth century, with Exekias' amphora, on pieces of size and value, and the scene is linked by Exekias at least to the life-and-death exchanges of the Dioskouroi. It may be a deeper game being played, an equivalent of *psychostasia*, an older illustration of the theme in Sophokles' *Aias*,

> τί γὰρ παρ' ἦμαρ ἡμέρα τέρπειν ἔχει
> προσθεῖσα κ'ἀναθεῖσα τοῦ γε κατθανεῖν;

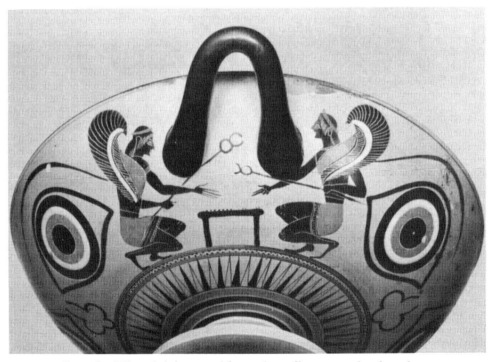

FIG. 36 Winged daimons with magic staffs at a gaming-board:
Attic black-figured cup, sixth century.

"What pleasure does each day bring after each day, moving the pieces forward and pulling them back from death?" (475).[76] The Bronze Age hero, as he survived into classical times, may have brought his metaphors with him, metaphors taken from Egypt and bearing on the central issue of mortal and immortal. So on one strange memorable cup, a pair of divine winged messengers with magic wands replace Aias and Achilles at the board (fig. 36), and perhaps reassure the hero, or the bereaved shopper, facing death, that there may in the end exist a higher happiness, as the daimons blend in their forms the aspects of Thanatos, death, and Eros, love.

III

THE HAPPY HERO

He knew that the essence of war is violence, and
that moderation in war is imbecility.
T. MACAULEY, *Lord Nugent's Memorials of Hampden.*

μή πως, ὡς ἀψῖσι λίνου ἀλόντε πανάγρου,
ἀνδράσι δυσμενέεσσιν ἕλωρ καὶ κύρμα γένησθε.

V.487

ODYSSEUS likes war as well as any man. "You ruinous man," he says angrily to
Agamemnon, "I wish you gave signals to some other indecent army, and were
not lord over us—us, to whom Zeus has given as a gift from our boyhood until
our old age, to wind the thread in savage war so that each of us may be
destroyed" (XIV.83f.).[1] Happy Odysseus. His first pleasure, after the sack of
Troy and the killing of the small prince Astyanax,[2] is to start fighting again.

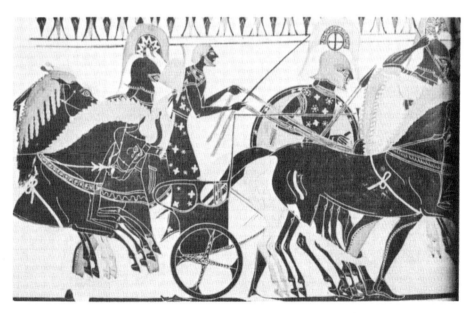

FIG. 1 Homeric warriors setting out for battle:
Attic black-figured dinos, early sixth century.

83

"From Ilion the wind carried me close to the Kikones, at Ismaros," he begins the Sea Tales, "then I destroyed the city and killed them," ἔνθα δ'ἐγὼ πόλιν ἔπραθον, ὤλεσα δ'αὐτούς (ix.39). He shows skilled leadership in dividing up the women on the beach so that no sailor will miss his share, the happy blend of loot and rape which is the sign of victory. Some of the men enjoy the battle so much, μέγα νήπιοι, they stay on too long at the beach barbecue and get killed, and off Odysseus sails calling aloud three times to the souls of his dead friends.[3] When he finally reaches the land of the dead he is surprised to see Agamemnon there ahead of him: "How did you get here? fighting on dry land for a town and its women?" (xi.403). War is a habit, the natural way of life for an adult, a pastime and the only path to honor. In Greek poetry and art the climaxes of war are expressed as a formal and elaborate ballet lightened with constant humor and decorative effects.

In most ancient arts war is the second theme, after hunting and before the celebration of death. In archaic and classical Greece the themes of war surpassed the others in popularity, as they had done earlier in Egypt and the East. It was best for a man to die in war, and the expression of this valued death was coded in a few scenes much older than classical Greece. The *Iliad* and *Odyssey* use an antique language of art for death, in the formal patterns long used for animal combats and hunting scenes. Animal art, which was established in Greece at the time of the Shaft Graves in the sixteenth century B.C., avoided crowd scenes and expressed valor and pathos in duels between a predator and a grass-eater, usually a lion attacking a bull or a deer, the antagonists balanced, one springing to back or throat, the other galvanized, startled, or slumping in prelude to death (figs. 2, 3).[4] Two lions or leopards may act as partners, like the two Aiantes at Troy, Ajax and Teukros. These themes were favorites in Greece from early Mycenaean art through the fourth century, a taste shared with other ancient cultures, but developed by Greeks with special poetic skill.

FIG. 2 Predator and grass-eater: FIG. 3 Warriors duelling:
Caeretan hydria, sixth century. Corinthian skyphos (kotyle), early sixth century.

As Greek poetry gains power in its chosen restrictions of formula and pattern, variations on a resonant type, the motif of the meat-eating killer leaping at a victim off guard and unable to defend himself, which might have become dull through repetition, maintains a surprising emblematic power in Greek hands. Although the outcome is predictable, the grass-eater seldom escapes, the narrative is immune to surprises, and it is a conflict of species rather than individuals, the theme is capable of wonderful variation. In the animal similes of Homer, the lion may be old, or tired, or wet, or starving, the wolf may be thirsty, the bird angered at the loss of its young, or the deer shocked as it returns to an empty foaling ground; in art the wrinkled bull's neck, the gasping lips and starting eyes of the deer, the surly rage of the wounded boar, the pathos of the lion trying to pluck an arrow from his flank offer subtleties of coloring which distinguish but do not change the structure of the natural fight.[5]

On the battlefield of Troy the duel between enemy heroes is handled in precisely the same formal patterns as the animal fight. There is a restricted series of formulas and scenes, which can be used for almost any Greek and Trojan, marked by the same variable but predestined shape as in the forest. The epic style allows for brilliant individual vignettes without permitting the structure to be broken accidentally, except when the poet wants to save the victim for another day. The battle books of the *Iliad* are almost entirely composed in the inherited animal style. It is often a playful tradition. The choreographer of the battle ballet must create a mood of audience belief without crossing the border between high style and parody. Many battlefield deaths in the *Iliad* have a decorative humor, light or dark. To call them decorative or formal does not imply that they are meaningless; those scenes are often packed with meaning handled at different levels for changing purposes, because every long series of killings needs leavening and every death is ultimately important. Most of them are handled as contests between grazing helpless *ephemeroi* and the hunting predator or sacrificer, as on the coffins of the Bronze Age.

How the hunt and the battle are linked in male psychology, or were in the early Greek period, is not for a female to guess. They seem so inextricable, one supposes a man could become confused about which he was engaged in, or fuse his human and animal opponents in his mind. The line might be drawn between the malicious intelligence of the human creature and the simple self-protectiveness of the animal. That line is blurred on purpose in many wartime messages. The hunting party and the war party merge, and kill the enemy more easily if he is called an animal—monkey, pig, dog, snake, rat, vermin— or a bewildered deer when a lion is on the prowl.

The lion was for the Greeks as for almost all their Mediterranean neighbors the image of success in both war and hunting, the most skilled hunter himself, the most frightening object of the hunt, the representative of male ambitions

FIG. 4 The lion hunt:
gold ring, Shaft Graves, Mycenae, sixteenth century.

to be courageous, dangerous, intelligent and successful. One is not surprised
to see, in the middle of a good Geometric battle scene, an "intensive" lion
eating a man, or a lion's head topping a seventh-century battle vase where men
fight among themselves (figs. 5 and 6), because the labile shift between the lion
and the winning warrior is so old and familiar in the traditional language of

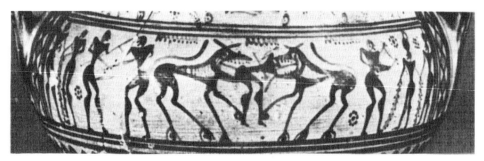

FIG. 5 Lions on the battle-field: Geometric kantharos, eighth century.

FIG. 6 Modelled lion, painted battle-scenes:
Proto-Corinthian aryballos, seventh century.

war art and war boast. If a warrior can kill a lion, he has reached the top of his
skill as a hunter and absorbs the qualities of his enemy for good and bad. The
lion may be the adversary, as Gilgamesh woke from a dream filled with death
and killed the circling lions who were "glorying in life"—or the lion may be the
self and king, a favorite idea in Egypt ever since the great epoch of Egyptian
predynastic palettes, and soon a cliché, like Amenhotep II's boast, "His
majesty reached Shamash-Edom. He hacked it up in a short moment, like a
lion fierce of face." Herakles in the lion-skin, or Alexander the Great in
Herakles' lion-skin, the lion-hunter and the man-hunter, have been so blended
in image, it would be surprising if they could be clearly separated in thought.[6]

In Greek myth the preeminent lion-soldier was always Herakles, whose
heroic initiation began with the killing of the Nemean lion and who masquer-
aded ever after in its skin, which was the badge of his skill, a warning, a
confirmation of inner quality (fig. 7). Since Herakles became a god, and was
said to be the only mortal thus elevated asexually, the image may have been
meant to persuade the viewer that the carnivore is right and magnificent, the
victim weak and wrong in his weakness, with an inborn failure of intelligence
and courage. The power to shed blood and eat meat was not all, since the lion,
and his counterpart soldier, has qualities suitable for companionship and the

FIG. 7 Herakles as a lion-man: Rhodian modelled vase, sixth century.

protection of the weaker. That motif is commonplace in grave-epigrams from
the sixth century to Hellenistic verse,

> εἰπέ, λέον, φθιμένοιο τίνος τάφον ἀμφιβέβηκας;
> Βουφάγε, τίς τᾶς σᾶς ἄξιος ἦν ἀρετᾶς;

"Tell me, lion, what dead man's tomb are you guarding between your legs?
Bull-eater, who was worthy of your power?"[7] Ἀμφιβέβηκας: the lion is the
dead man's battle-friend who has straddled the corpse to keep it from being
mutilated, stripped, fed to dogs and birds; he has saved it for the critical
ceremony of burial and from accidents after death, and continues to live on the
tomb as a guardian, checking the offerings (fig. 8). As with all death figures, it
is ambivalent, and the dead person is also like the carcass of the lion's freshest
kill, guarded from jackals or hyenas for future meals.[8]

In Homer, lions are often interchangeable with boars—"as when a boar or
lion turns exulting in its power against the dogs and hunters . . . " (XII.41)—
as the two most dangerous animals of the hunt. A boar can disembowel a horse

FIG. 8 Lion as tomb-marker:
limestone monument, Perachora, sixth century.

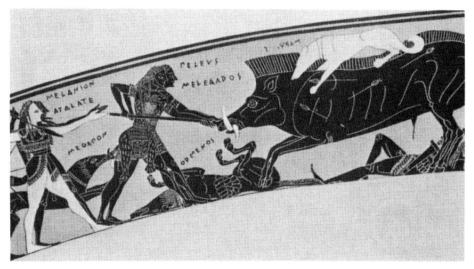

FIG. 9 Dead dog Ormenos (Rusher) at the Kalydonian boar hunt:
black-figured volute krater, early sixth century.

on the run, and in Greek art its path is littered with dead men and dogs (fig. 9).[9]
The artistic, calligraphically-looped entrails of the poor hound Ormenos on the
François Vase remind us that the favorite deadly confrontations of the Greeks
are usually transmuted into a language more stylish than real. It is in this style
that the boar takes his place on funeral monuments, eloquent of power and
danger, and yet, as in hunting scenes, often the gallant loser. There is some
persistent weakness in a creature that does not eat meat; the boar was most
useful to Homer as an image of bravery in retreat; the lion was the hero in
attack because of the old analogy, or fact, of the predator-warrior style which
demands that he claw and eat his enemy with a literal blood thirst. When the
lion and boar are shown together in the sphere of death, as on a Klazomenian
sarcophagus (fig. 10) the lion should win, to become the grave watcher and
guardian of the body; the boar, representing danger over which the dead man

FIG. 10 Confronted warrior heads with lion and boar:
East Greek, Klazomenian sarcophagus, sixth century.

triumphed in some way as a warrior, must incarnate the victim. The lion and his counterpart soldier below taunt the other side, with roars and mocking words; the boar and his counterpart soldier seem curiously immobilized and silenced. The style is coded. Patroklos was the lion while he was winning, and became the boar as he died (XVI.487, 751, 823); the lion role was inevitably assumed by Hektor. It was the normal, favored expression for the magnificence of a fight: "as a lion does violence to a tireless boar in the joy of battle, when they both have grand ideas and fight on the hill-tops around a little spring of water where they both wish to drink . . . "(XVI.823).

Neandros painted a bestiary band-cup with the same vignette (fig. 11) and writes out the results: "a lion got this boar, yes he did, well fought." The

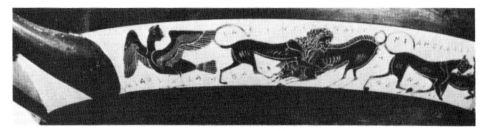

FIG. 11 A bestiary, with a duel between lion and boar:
Attic black-figured band-cup, sixth century.

traditional poetic and visual languages coincide, even at very different periods, both because the formula needs no change, and because a distinct advantage of formulaic language and design is the distance it sets between the audience and messy reality. Just as Homer's lions do not roar and his battlefield does not stink, as his earth is stained with blood when he wants it so but is clean and freshly fertile at other times, and in ten years all those men and animals only leave one small pile of ordure (XXIII.775), so his hunts and duels are generally protected from accident and dirt, and his bloodshed is constrained in a ballet as much sparked with humor and grace as Neandros' cup.

The language, whether it focuses on animals or other shapes, is not symbolic in any real sense. In Exekias' battle over the body of Patroklos (fig. 12), the corpse and the contestants are mirrored by the lions and the bull directly below, but they are not analogues—the soldiers are not partners, like the lions, and, with luck, the corpse will not be eaten. It is the simple conversion of the dead to the helpless animal. (The same animal scene appears on the other, happier side, Herakles' apotheosis.) How light-hearted and patterned such conversions may be is clear on two vases where horses duel over a fallen mare, in parody of the usual combat scene, or a dead soldier takes the mare's place

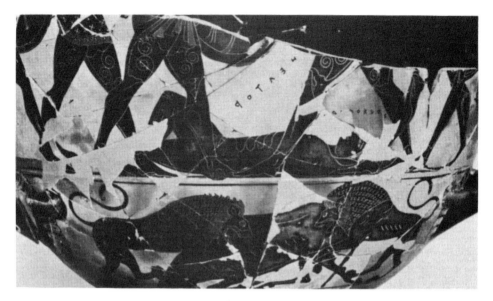

FIG. 12 Battle over dead Patroklos, lions tearing a bull:
Attic black-figured calyx-krater, sixth century.

FIG. 13 Stallions duel over a mare:
Attic black-figured amphora, sixth century.

FIG. 14 Stallions duel over a fallen soldier:
Attic black-figured amphora, sixth century.

(figs. 13 and 14). A symbolist might go mad trying to find a translation; but a Greek who had grown up in the ornamental vernacular would not bother.

The intense Greek use of animal language and beast mechanisms to express feelings about the victories and defeats of mortals is common in military or hunting societies. The warrior's model in the behavior of animals is apparently grounded so deeply in male emotion as to be nearly universal and free from change through time; the soldier on the rampage will claw and eat. The Greeks entering Troy behaved no differently than the Assyrians in Egypt,

> And [the officers] put to the sword the inhabitants, young and old, of the towns of Sais, Pindidi, Tanis, and of all the other towns which had associated with them to plot, they did not spare anybody among [them]. They hung their corpses from stakes, flayed their skins and covered the wall of the town.
>
> [Annals of Ashurbanipal, *ANET*² 295]

or the Cambodians in mutiny:

> Soldiers defiantly displayed the mutilated fly-covered corpse of one
> of their officers whom they had killed in . . . dispute. They had eaten
> his lungs, liver, heart, biceps and calves . . . Villagers who had
> gathered around giggled as one soldier playfully stuck a cigarette in
> the corpse's mouth. . . . Cannibalism has been frequent practice in the
> Cambodian war, though the victims were almost invariably captured
> prisoners or enemy corpses.
>
> [*Los Angeles Times*, 6 April 1975]

The scene recalls the Achaians standing around dead Hektor, poking him and
laughing (XXII.369f.). The Homeric soldier is usually protected by formula
and convention from lapsing into the animal form of his daydreams; perhaps
he contemplated messy action, κακὰ δὲ φρεσὶ μήδετο ἔργα (XXI.19), ἀεικέα
μήδετο ἔργα (XXII.295); or would like to express his anger physically, as
Achilles would like to cut off pieces of Hektor and eat them raw; but he will
let the dogs do it for him, starting at the head (XXII.345). His cannibal
impulses and his animal language stay in the realm of rhetoric, like almost all
"ugly actions" in the *Iliad*. The *thumos* has been civilized away from the raw-
meat glut, and there are plentiful animal surrogates in the poetic landscape.

Of course it is the language more than the action which makes the battle
books so grand—a deceptive blend of conventions, wishes and humor. In the
cycles of scholarship Homer has often received his due as a war-artist, but at
times scholars have been nauseated by his effects, perhaps confusing them with
reality, or bothered by their deviation from "classical ideals." The goal of a
good epic poet, in a battle song, is to kill people with picturesque detail, power
and high spirits. Homer does it extraordinarily well. The *Iliad* begins with
corpses burning in an alien plain and ends with a gallant corpse burning in
prelude to the city's burning. The verses are studded with corpses in between,
pierced and collapsing in a panorama of pictorial conventions, and gestures of
ferocity held in check by formula and rhetoric which, as they killed, still
invoked a more general life cycle through images of animals, planted fields and
wild forests, storms and seas. The serious, implacable role of death as the pri-
mary focus in Greek literature begins in western minds with Homer, although
Homer himself surely found it already traditional. The *Iliad* put dying, though
not death itself, in stage center and shaped the tradition of subsequent litera-
tures, that death is not the enemy of achievement or creativity but its cause,
since the contemplation of death is the single factor which makes us long for
immortality. Mortals, βροτοί, are etymologically destined to be eaten, or are
at least filled with delicious nourishing blood, βρότος. Immortals, ἄμβροτοι,
are inedible, I suppose, as well as bloodless and soul-less; they are at least

exempt from the animal food-chain and from the cycles of nature.[10] It is part of Homer's contribution to have set mortality in the proper gallant light.

Yet classicists sometimes wipe history and human behavior clean as fast as they read about it, and find the battle books of the *Iliad*—which are Homer's context for the gallantry of mortality—only "traditional" background against which the "new spiritual Greek" (represented by Achilles) can be watched emerging, as a sign-post toward a more introspective and democratic future. "Hellenism" has sometimes been equated with reason and restraint, especially since the Renaissance, and the "Hellenic ethos" is occasionally contrasted to the old, dark, fierce Bronze Age tradition which, through Homer's poetic insight, is being transmuted to a higher plane of self-knowledge and reflection. Achilles' claim to higher self-knowledge is mostly based on his famous lines in *Iliad* IX, in which, through a spiral of magnificent and mannered rhetoric, he comes to the conclusion that he would prefer to live than to die in glory. Probably most soldiers from the Stone Age on have debated that point; in Homer, the language is more interesting than the idea. Achilles also came to understand the significance of companionship in a community war, and the proper courteous treatment of the dead, a critical Greek value long after the *Iliad*. But the normal expression of his heroic quality is found in such passages as,

> So under great-hearted Achilles' hands the solid-hooved horses stamped on the dead bodies and shields; the axle underneath was all sprinkled with blood, and the rails round the chariot box, which the bloody spray from the horses' hooves and from the wheels kept hitting; the son of Peleus hurled himself to win glory, his untouchable hands spotted with bloody muck.
>
> [XX.498f.]

This is also a favorite scene in Greek art, where the painters often catch the spirit of the adventure, a scene exploited long before in the war documentaries of Egypt and the East.

At times Homer's success in making the encounter of the hero and his adversary unforgettable turns modern readers uncomfortable. A German may find some scenes redolent of "niederer Realismus." An Englishman may convince himself nervously that Homer is really cleaning up even more barbarous and savage practices out of the past. An American may be shocked: "The degree of brutality is extraordinary. If one may judge by classical literature, it would be felt as especially shocking."[11] One assumes that classicists who are shocked by Homer are not shocked by Herodotos or Sophokles, because the fifth century has more "moral" themes than the eighth; but philologists whose souls have been uplifted by the moral beauty and civilized behavior in Greek tragedy are, possibly, too quick to blame the Mycenaean tradition for relics of "savagery" in Homer.

Perhaps there is a naive instinct in all of us to regard Greek history as a progress from archaic savagery toward the cultural enlightenment and democratic institutions of the fifth century. The Attic poets thought so. For them, the old half-mythical world of their ancestors was filled with barbaric behavior now curbed by the application of law and philosophy. One consequence has been to view what is historically elder, the Bronze Age world, as a source for unpleasant violence which persisted (against Homer's will, built into his oral epic language) in the poems of the Trojan cycle, and in myth. The Mycenaeans are unfairly blamed for being old, dark, bloody and chthonic, bound to peculiar vegetation cults and ancient Aegean mother goddesses, an irrational and illiterate people too primitive for the ordered splendors of Olympian religion and the civilized restraints of classical thought. Yet so far as an archaeologist can tell, the average Mycenaean was as rational as the next Greek, spoke the language well, observed the customs, paid the taxes, and obeyed the king, gave splendid presents to the Olympian gods and to others of more local affection, fought well in single combat and in group battle, and no more bloodily than his classical descendants; the Mycenaean mind was no more darkened by ancient goddesses and bloody rites than the classical Athenian's was by Athena or the Bouphonia.[12]

When, in classical times, Lycidas the Athenian was stoned to death by his enlightened democratic fellows while the women pounded his wife and children to a pulp (Herodotos IX.5); when the Athenian seer and the roaring crowd, after the battle of Salamis, offered three children of the Persian king's sister as living sacrifices to Dionysos Eater of Raw Flesh (Plutarch, *Aristeides* IX.1–2, *Themistocles* XIII.2); when civilized susceptibility to divine weather caused Athenians to kill each other at a clap of thunder (Herodotos V.85); when the restrained Xanthippos, father of Perikles, had the Persian governor Artyaktes pegged alive to a plank (Herodotos VII.33), these episodes are not counted as primitive or savage in our estimation of the cradle of democracy. But when some poor Trojan gets wounded in the bladder, not by the Greeks but by their favorite poet, it is held to be a relic of primitive Mycenaean savagery which noble Homer would eradicate if he could. The truth is, Homer does not want to, for he and his audience enjoy the scene enormously. The *Iliad* is, among other things, a poem which confronts the perpetual threat of death with the energy and humor of life, and draws bitter, witty conclusions, a very Greek taste.

There is an almost baroque magnificence in the physical ruin of Homer's heroes. Fears of what may be done to one's body, alive or dead, reverberate through the *Iliad* and *Odyssey*. Greek epic vocabulary for parts of the anatomy is probably richer than in any other language. Nearly every part is vulnerable. The distinctions regarding merely the head are impressive: back and front of the neck, upper and lower jaws, mouth, lips, tongue and tongue-root, nose-

root, eyes, eye-sockets, pupils, eyelashes, brows and lids.[13] For Homer the
human body is a marvellous network of connecting parts he can pierce or sever
or use for pictorial and emotional effects, from the practical connection
between the hip-socket and the buttock, to the differentiated actions of the
heart—the coward's knocking violently at the chest wall, the woman's rising
to shake in her mouth, or the dead man's panting and beating to shake the
butt end of the spear stuck in it.[14]

I do not know how many people are killed in the *Iliad*—Bassett counted 243
killed by name[15]—and Homer the murderer never bores us. The battle-
weapons are too simple to sustain, by themselves, the poetic interest of killing
and dying on such a massive scale (for there are limits to the variety which even
the most ingenious poet can impart to the flight of a spear, the thrust of a sword,
the smash of club or boulder, a crushed shield or pierced *mitra*). It is, conse-
quently, the little individuals who must provide the interest, and express them-
selves and win poetic immortality through the breakage of their bodies. These
are the minor soldiers brought on to be cut down like Demoleon, men briefly
colored with small histories, whose fathers slept with naiad nymphs, whose
mothers met Hermes at a dance, whose parents failed to interpret their dreams
for them; pretty ones, fast ones, scared ones, boys shocked at the wounding of
their brothers, in lines fleeing and pursuing, men peering, chasing, shrinking
back among their companions, running foolishly through the fighting, snatching
helmets, lusting for horses, boasting, mocking, taunting; men with a physical
appetite for fighting, πολέμου ἀκόρητοι, whose principal role is dying. The
death is made more marvellous by the poet's ingenious methods of puncturing
the shell of flesh or smashing the protective white bones to release the *psyche*.
But except in a few special cases, the *psyche* is far less interesting to the poet than
the mutilated body which he can control, or threaten with scavengers, or save
for burial.

In a way it is wrong to regard the *Iliad* as a poem of death, even in some
partial aspect, although death is so powerful a theme. It might be truer to
regard it as a poem of mortality and mortal accidents, and of the kinds of
behavior only mortals need have to confront these. The *psyche* is not a major
concern for Homer; the realm of death is more a series of standard expressions
and a few deliberately poignant contrasts than a serious focus of imagination.
We may be tempted toward a general belief that the *psyche*, however stunned
and bewildered it might be as it passes to a new and not altogether happy
experience, is the living element in a mortal, while the body is relatively
unimportant after its capacity to act is finished. Homer's object is the body,
however, to which he does such things, with wit and skill, as to leave on many
occasions the impression that it, not the *psyche*, is self, αὐτός.[16]

The battle books are in some ways the ancient equivalent of silent movies.
There is the unforgettable moment when Archelochos, Antenor's son, is hit so

hard in the neck that his head, mouth, and nose thump to the ground in front
of his standing legs and knees (XIV.465). There is Phereklos the carpenter who
built Paris' ships, pierced through buttock and bladder and dropped screaming
to his knees (V.66). Meriones the Cretan specializes in this blow, which
stretches a man like a worm on the ground (XIII.652).[17] Mydon falls off his
chariot and sticks head first in the sand until his horses knock him over, which
must have raised a laugh (V.585). The bronze feels cold in Pedaios' mouth
when the spear blade crashes through his teeth and cuts under his tongue
(V.73). Teeth and tongues carpet the poetic ground (V.291, XVII.617), or
rattle in the head while the eyes fill with blood (XVI. 345), eyes also pop out on
spearpoints like poppy flowers, or plop in the dust at one's feet (XIV.499,
XIII.616, XVI.741). It has always been a popular moment when Patroklos
taunts the eyeless Kebriones diving over the chariot rail with being an oyster
fisher (XVI.746): partly the pictorial aptness of the image, partly the detailed
précis of the cause, "the stone caught both brows, the bone did not hold there,
the eyes dropped on the ground before his feet"; partly the scene of the happy

FIG. 15 Merry scenes of war:
Attic Geometric jug, eighth century.

hero who descends to the ground to play tug of war against Hektor, with the blind corpse as the rope.

Agamemnon prefers to cut off arms and legs, and roll the limbless trunk through the crowd (XI.146), or sever a head (XI.261), just as Aias and his brother roll Imbrios' head like a ball to Hektor's feet (XIII.203), three famous scenes. This black and ornamental wit offers pictures of the brain running out through the eyehole along the spearshaft (XVII.296), the bone marrow spurting from the cut spinal column (XX.482), Oinomaos clawing the dust with his entrails hanging out (XIII.507), or Polydoros, Priam's son, catching his own bowels in his hands, προτὶ οἷ δ᾽ἔλαβ᾽ ἔντερα χερσὶ λιασθείς (XX.417). It is the epic equivalent of the barroom brawl or ambush in a western film, or mass attacks by the Zulu on the thin red line, with enough incidental ingenious detail in good vocabulary to render the length of the engagement supportable.

One damage Homer always avoids is to the genitals.[18] If Homeric battle scenes had been untransformed records of battlefield behavior, one would expect more vignettes of this particular form of humiliation of the enemy's body. Of course the scenes are not documentary, or they would have smelled worse; they are artificially wrought out of an old tradition, picturesque and unsentimental ballet scenes. They offer, in a richer variety of action and more subtle orchestration than any comparable poetry in the world, devices for placing in front of us in unforgettable style the fragility of the human casement and the animal nature of human ambition and weakness; while the facts of the killings are held in restraint by the poetry, like the odorless plain of battle.

The hero who moves with mixed confidence and weakness through such scenes had a long training—from boyhood, Odysseus says,[19] and part of the hero's training was in techniques to shake the enemy's self-confidence. In the *Iliad*, psychological warfare is as formulaic as physical warfare and damage. It must have been a great physical strain to puncture an armored man with a spear in a duel (fig. 16), even after years of practice with sandbags or straw dummies. An infusion of anger was needed at the critical moment, and formal taunting mockery of the opponent to lower his self-esteem at the instant he might hurt you.

It is interesting to note which themes could shake a man; the art of battle mockery had as fixed a repertory as the funeral lament. The man's physical weakness should be exposed to public laughter; he should be humiliated in front of his fighting comrades, his ancestry must be doubted (although not to the same degree of pungency as is common with us); and, most of all, the future of his body and the quality of his mind should be pictorialized in a manner certain to distress him. At least it might make his hand shake.

Tell a man he is witless, has no warcraft, has not learned πολεμήϊα ἔργα, and is up against one who has. So Tlepolemos to Sarpedon, "Why must you crouch and cower out of the fighting like a man who has learned nothing," ἀδαήμονι

FIG. 16 Prelude to the duel:
Attic black-figured amphora, sixth century.

φωτί (V.634), chiding between friends. So Hektor to Aias, "Don't tease me as though I were a weak little boy or a woman who does not know warcraft," ἦ οὐκ οἶδεν πολεμήϊα ἔργα (VII.235). Achilles throws the "love talk" of war at Hektor, "Come closer and die quicker" (XX.429) and Hektor, stung, yells back "Don't expect to frighten me with words as though I were a foolish child [νηπύτιον] because I know perfectly well myself how to shout insults and wicked remarks [κερτομίας ἠδ' αἴσυλα]." These *aisula* are meant to reduce a grown and famous soldier to the feebler level of those he is protecting, the women and children behind the walls of the town.[20]

When taunting, the aim is to turn the opposing soldier into a female, or into the weaker animal role. Female qualities may be detected in the prettiness of his face—"O, handsome, Hektor, but not much in fighting" (XVII.142) or, to Paris, "virgin-face, shiny with hair wax" (XI.385)—or in the horizontal position of his stripped and lilylike *(λειριόεις)* body. A duel at close quarters may be treated formally as a love-struggle, two bodies straining against each other in a match of death. Aischylos also saw it so, in the prelude wedding rites when the spear is broken, διακναιομένης τ' ἐν προτελείοις κάμακος (*Agamemnon* 66).[21] (Aischylos shares the general fifth-century delight in the inter-penetration of war and love, like the two sides of a drinking cup.) There is an ambiguity to killing, as to loving, and a verb like μείγνυμι with both connotations, mingling in battle or mingling in sex, helps the poet in his play. "So in eager desire strong Diomedes penetrated the Trojans," ὡς μεμαὼς Τρώεσσι μίγη κρατερὸς Διομήδης (V.143); "he is not asking us to a dance, but to fight; . . . better to mingle hands and strength with them at close quarters," αὐτοσχεδίη μῖξαι χεῖράς τε μένος τε (XV.510).

Damazo or *damnemi* have similar values, working in three related spheres of action: taming an animal, raping a woman, killing a man. In a duel, an isolated world inside the main battle, one soldier must be the female partner and go down, or be the animal knocked down. It is a role naturally marked by unwillingness to cooperate; the sea-goddess Thetis unwillingly submitted to a mortal to conceive Achilles,

> ἐκ μέν μ' ἀλλάων ἁλιάων ἀνδρὶ δάμασσεν,
> Αἰακίδῃ Πηλῆϊ, καὶ ἔτλην ἀνέρος εὐνὴν
> πολλὰ μάλ' οὐκ ἐθέλουσα.
>
> [XVIII.432]

and in battle the victim submits unwillingly, ὑπ' ἐμοὶ δμηθέντα, ἐμῷ δ'ὑπὸ δουρὶ δαμέντα (V.646, 653). Men do it to each other, to women, and to animals; gods do it to men; so do Fate, Eros, Sleep and Night.[22]

Homer's habit of playing on sex and war is not new with him, one imagines, but is common war talk and wartime humor. The idea is equally popular in Greek art, and in the sixth and fifth centuries the playful interest in an erotic

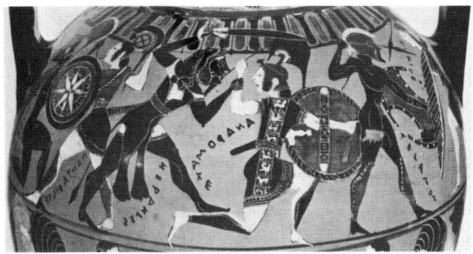

FIG. 17 Herakles fighting the Amazons:
Tyrrhenian black-figured amphora, sixth century.

shudder in wartime may partly explain the new interest in Amazon pictures.
In painting, the white boyish limbs of the girls and the black lunges of the
Greek soldiers could be deliberately exploited for the ambiguity of slaughter and
sex.[23] Greek and Amazon may be set in a composition more familiar for the
relations between silen and mainad (figs. 18 and 19), and the pictures are often

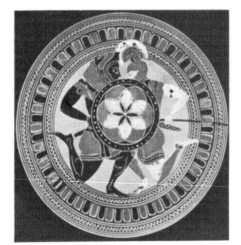

FIG. 18 Herakles locked
in battle with an Amazon:
Attic black-figured cup, sixth century.

FIG. 19 Silen locked
in play with a mainad:
Attic black-figured cup, sixth century.

witty. The same mordant wit is evident in the "enchanting love-talk of war,"
πολέμου ὀαριστύς:

> ἀλλά κεν ἢ στέρνων ἢ νήδυος ἀντιάσειε
> πρόσσω ἱεμένοιο μετὰ προμάχων ὀαριστύν,

"[the weapon] would meet your breast or belly as you went forward to the
love-talk of the front fighters" (XIII.291). Hektor fears he will be stripped
naked like a woman and killed by some piercing weapon, which is what happens
(XXII.126), and when he is dead the Achaians find him "softer to handle,"
μαλακώτερος ἀμφαφάασθαι, as a girl would be (XXII.373). "Come to the ships
for your marriage," they taunt Othryoneus who is to marry Kassandra, "we
are not bad marriage brokers" (XIII.381). In death the enemy's body will be
treated like a lover's body—not much use, perhaps, to a wife, as Homer
remarks of Iphidamas who lies locked in a bronze sleep (XI.241), but a delight
at least to the birds and dogs who will "love" the corpse in a special sense,
making it a *helor*, a *kurma*, a *melpethron*.[24]

Hektor makes a formal threat to Aias (XIII.830): "You will stuff the Trojan
dogs with your fat and meat, when my spear shall bite your lilylike body," χρόα
λειριόεντα δάψει. The dogs and birds who are constantly invoked as an unseen
chorus to the fighting, the scavenger allies who will complete the humiliation
of the body, almost never come on stage to show their mode of "loving." They
are spiritual extensions of the warrior making the taunt, a hunting image, in the
realm of traditional rhetoric and exaggerated mockery. Homer does not show
us dogs quarreling over the dead on the field, just as he saves his special
characters from worms. They are ceremonial and verbal evocations, descended
from the old call to vultures and foxes to help prepare the body for burial like
women, the living tombs as Gorgias later put it, γῦπες ... ἔμψυχοι τάφοι
(*Epitaphios* 5a D.).

FIGS. 20, 21 Birds on the battlefield:
fragments of relief pithoi, Tenos and Eretria, seventh century.

Birds have an older and stronger position in the arts (figs. 20 and 21) than dogs do; when the epic is being formed, eighth- and seventh-century Cycladic artists use them freely in battle scenes. They attack the organs of love, the eyes and genitals, in a way scholars have described as "exceptionally brutal" and marked with "Krudelität," rejoicing that the idea left no trace in classical art.[25] There is no real reason to regard the theme as barbarous; it cannot match, in its Greek execution, the brilliance of the reliefs of the same subject in the Assyrian palace of Sennacherib (fig. 22), but it is not at all un-Hellenic. Rather

FIG. 22 Birds picking at the enemy:
Assyrian relief, palace of Sennacherib, Nineveh, seventh century.

it is an integral part of the rhetoric of war-mockery, an element in the general jovial tone and picturesque effect of Greek epic. A hero had to learn to take such rough joking in good part to be accepted. Even Aias son of Oïleus, who slipped in the manure of the sacrificial cows at the funeral games, had the sense simply to spit the stuff out of his mouth and shrug while the other Greeks "laughed happily at him," πάντες ἐπ' αὐτῷ ἡδὺ γέλασσαν (XXIII.775–84). It enters the gamesmanship of being a hero. "It is not your mother and father who will clean your eyes when you are dead," boasts Odysseus over the Trojan Sokos, "but the birds who eat flesh raw will pluck them out as they strike you

all over with their wings" (XI.454). However true the prediction, Homer does not let it happen.

Death in wartime becomes a feast, a picture of communal festivity. So Patroklos will be *melpethron* for Trojan dogs, something they can sing and dance over as they eat (XVI.255). So Patroklos and Hektor are both invited by the gods, in a twist of phrase, not to dinner or assembly but to death, θάνατόνδε κάλεσσαν (XVI.693, XXII.297). There is no skeleton feast of death in Greece, though the theme of joining the ceremonial banquet of the dead becomes common several hundred years later in art, in the *Totenmahl* reliefs circulating after 450 B.C.[26] If in epic the dying warrior becomes the feast, and the gods invite the hero to it, the theme once more recalls Semonides' sacrificial animals, whom we have seen in various guises. It is part of heroic etiquette to mention the discomforting future of the enemy's body, to grieve a dying man's spirit the more; to focus its attention, as it leaves its earthly housing, on the chance that its only familiar identity will be torn up and played with, and that the man will lose his hopes of family mourning, decent burial, and a tomb.

There is the parallel thought, that, as a man's body lies on the earth, horizontal, feminine, white and helpless, being "loved" by attentive animals, so will his wife and children be "loved" when the city falls. The Greeks state flatly, if the Trojans break their oaths, "the vultures will eat their tender flesh while we take their dear wives and foolish children to the ships" (IV.237). Horses rattle their empty chariots along the bridges of war longing for their drivers, who lie on the ground more closely loved by vultures than by their wives,

> πολλοὶ δ'ἐριαύχενες ἵπποι
> κείν' ὄχεα κροτάλιζον ἀνὰ πτολέμοιο γεφύρας,
> ἡνιόχους ποθέοντες ἀμύμονας· οἱ δ'ἐπὶ γαίῃ
> κείατο, γύπεσσιν πολὺ φίλτεροι ἢ ἀλόχοισιν
> [XI.159]

Diomedes boasts, "if I hit a man ... he stains the earth with red blood and rots, and there are more birds about him than women," οἰωνοὶ δὲ περὶ πλέες ἠὲ γυναῖκες (XI.393), a ceremonial boast which mingles the sex life of the warrior with the role of the women of his household,[27] in tending, cleaning, and loving his body in the ceremonies of death.

The Homeric taunt has several pictorial counterparts in seventh-century painting, the epoch when old poetry and new style coalesce most successfully (fig. 23). The dog may be more swaybacked and long-toed than fleet of foot, but is evidently thirsty, and the eager bird rushes overhead. A waiting sphinx, a dog-bird or lion-bird of a kind, had been involved in such deaths since late Mycenaean times, and we will see again the mixed complexion of her love.[28]

The dogs and birds who ravage the corpse in place of women composing and

FIG. 23 Dog and bird on a funeral vase:
Proto-Attic krater fragment, seventh century.

cleaning it for the grave, Greek images distilled from a far older tradition, offer material for private nightmares. Priam's famous vision is the worst, for the dogs are his own:

> I wish the gods loved Achilles the way I do. Then the dogs and birds would eat him as he lay stretched out. . . . But god will ruin me when I have seen enough terrible things, my sons dead, my daughters dragged away, the bedrooms ripped up, the foolish children smashed on the ground, my wives pulled along by Greek hands. . . . At last the dogs who eat flesh raw will drag me to the outer doors of the hall . . . the dogs I bred in the hall at my own table to guard the doors will drink my blood in their madness and loll at the courtyard gates.
> [XXII.42, 66]

Priam particularly imagines his dogs humiliating his gray head and genitals, that is, the authority of the king and the hopes of the dynasty; places where the

birds attack in Egyptian, Sumerian and Assyrian reliefs. The normal, realistic fears of war are compounded by the thought of treachery in the hall, with domesticated companions turning suddenly as savage as the soldiers outside the walls, eating their master in a foodless city when the fragile bonds of community are broken by war.[29]

There are occasions in the *Iliad*—not many but enough to be interesting— when the soldiers feel like joining the dogs in dissecting the enemy; the act might bring as much pleasure as a hunting animal's bringing home meat to the lair. Hektor prays for his son to grow up "and bring home the blooded spoils and delight his mother's heart" (VI.481). The head is the most valued trophy, as the carrier of identity. Euphorbos thinks it might cheer his parents if he could give them Menelaos' head to play with, "if I could carry them back your head and armor and toss them into the hands of lovely Phrontis and of Pan- thoös" (XVII.38). Hektor would like to cut off Patroklos' head from his stripped body (XVII.126), and mount it on a stake (XVIII.175), an old practice in the East, still standard treatment in wartime in the fifth century, as the Persians did to Leonidas after Thermopylai, and the Aiginetan Lampon suggested doing to Mardonios after Plataia (Herodotos VII.238, IX.78). Achilles meant to take Hektor's head as a special comfort for Patroklos (XVIII. 335). The ornamental character of this threat, which does not get translated into action, is clear on the Beldam Painter's lekythos where three soldiers in dance file each hold a severed head (fig. 24).[30]

Obviously the behavior of the predatory hero is conditioned, through language, by a whole nexus of old hunting imagery. Probably there were warriors of all periods who bit off parts of their enemies and swallowed them,

FIG. 24 Warriors dancing with severed heads:
Attic black-figured lekythos, fifth century.

"Why, there's Carver now."

FIG. 25 The head-trophy as a valued souvenir.
Drawing by Chas. Addams; © 1941, 1969 *The New Yorker* Magazine, Inc.

or tacked head-trophies on chariot rails or in front of their campaign lodges. Homer keeps this behavior in the realm of rhetoric, but gives plentiful signals of his recognition that the hero, so often compared to a lion, often feels and sometimes acts like one. The pressure of the imagery, the feelings behind it, and the formulaic restriction of language, can under certain circumstances drive both the heroes and their gods in a specific and not altogether unwelcome direction.

Where carnivorous animals and birds had been made the agents for the cleansing of the dead, they prevented pollution, first physically, then spiritually. They assisted the natural cycle of birth and death in an economical style, and

were in a sense allies of those who kept order, the gods. The three common ways of avoiding the pollution of the dead are scavenging, burial, and fire, with the common element of eating. The first may be illustrated by the image of the goddess Hekate, shown as part dog, eating a dead man in the underworld (fig. 26),[31] a powerful gracious goddess performing a necessary task. In earth burial, the earth may be thought to swallow, although in Homer the expression is normally reserved for a warrior who is shamed and wants to hide: "may the black earth swallow us all if we cannot save the body of Patroklos" (XVII. 146).[32] When burial by fire became increasingly common, after the late thirteenth century, this image was transferred to the new agent, fire: fire eats the dead man as the animals and the earth had done before. Like the *ker* or the *stomion* of the underworld, fire has a raging jaw, $\pi\upsilon\rho\grave{o}s$ $\mu\alpha\lambda\epsilon\rho\grave{a}$ $\gamma\nu\acute{a}\theta os$ (Aischylos, *Choephoroi* 325, Phrynichos' $\mathring{\omega}\kappa\epsilon\hat{\iota}\alpha$ $\mu\acute{a}\rho\gamma o\iota s$ $\phi\lambda\grave{o}\xi$ $\mathring{\epsilon}\delta\alpha\acute{\iota}\nu\upsilon\tau o$ $\gamma\nu\acute{a}\theta o\iota s$ "the swift flame banqueted with greedy jaws" ($N^2$5)). It is ravening, like the mouth of the Chimaira, $\mathring{a}\mu\alpha\iota\mu\acute{a}\kappa\epsilon\tau os$, $\mathring{a}\nu\alpha\mu\alpha\iota\mu\acute{a}\epsilon\iota$ (XX.490); it eats the Trojan captives on Patroklos' pyre, $\pi\acute{a}\nu\tau\alpha s$ $\pi\hat{\upsilon}\rho$ $\mathring{\epsilon}\sigma\theta\acute{\iota}\epsilon\iota$. $\H{E}\kappa\tau o\rho\alpha$ δ'$o\mathring{\upsilon}$ $\tau\iota$ $\delta\acute{\omega}\sigma\omega$ $\Pi\rho\iota\alpha\mu\acute{\iota}\delta\eta\nu$ $\pi\upsilon\rho\grave{\iota}$ $\delta\alpha\pi\tau\acute{\epsilon}\mu\epsilon\nu$, $\mathring{a}\lambda\lambda\grave{a}$ $\kappa\upsilon\nu\acute{\epsilon}\sigma\sigma\iota\nu$ (XXIII.182); it makes a man invisible, like Hades or Thanatos, $\mathring{a}\H{\iota}\delta\eta\lambda o\nu$ (II.455). The connection with animal sacrifice at a flaming altar is obvious.[33] The gods oversee both sacrifice and burial, which are both acknowledgements of order and responsibility.

The way in which Homer deploys his gods is far too complex and important to be touched on in passing, but it is clear that they are an excellent group to reflect in heaven the styles of heroic behavior below. The war is their will, and

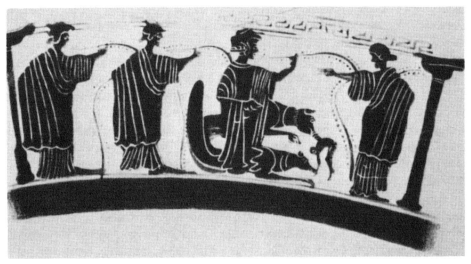

FIG. 26 Hekate with dog limbs eating a dead man in the underworld: Attic black-figured lekythos, fifth century.

they watch with interest and personal glee or sorrow those scenes of heaving sweating bodies, or pursuit and slaughter, or corpses being dragged by the feet. Zeus presides over the war as over a banquet; he is in charge of supplies, ταμίης πολέμοιο. It is an enjoyable occasion, except when a son or grandson is killed: "even when they die I care about them. I am going to sit here on a fold of Olympos where I can see, and delight my heart," φρένα τέρψομαι (XX.21). Gods are not complete in themselves, for Homer; the poet exhibits them earnestly wanting the regard and fame awarded to them by men, needing visible signs of success in their roles, and sharing the lives and feelings of men with peculiar intensity. So Ares strips armor off corpses; he is too big to wear it, but it will publicly signal his success in looting, like the other heroes.

The grand scene at the opening of *Iliad* IV transfers to divine breasts those feelings nurtured in the heroic predatory Hellenes and Trojans below. Homer lets Zeus play the same role toward the angry Hera as the poet plays toward the angry hero on earth: the god is disturbed at the cannibal impulses which the queen of heaven shares with the queen of Troy. Just as Hekabe would like to set her teeth in the middle of Achilles' liver and eat it raw (XXIV.212), Hera seems angry enough to eat whole enemies. Zeus is disturbed, μέγ' ὀχθήσας: "Daimonic lady, what have Priam and Priam's sons done to you? . . . If you could walk through the gates and long walls, and eat Priam raw, and his children, and the other Trojans, you might heal your anger" (IV.34f.). Greeks, in poetry, are concerned by those who do not cook their prey; it seems uncivilized of fish or lions or vultures to eat flesh raw. Even Hades, when he becomes a corpse-swallower for Euripides in the late fifth century, has the meal cooked for him (*Cyclops* 396–97), at least partly observant of the niceties of civilized society.[34] Yet Hera's feelings reflect those of her warriors, and are as proper in Hera the Mother as in Hekabe the mother of Troy. Like lions, deer, or soldiers, they must protect their young.

Gods, like lions, will also protect the dead, and insist on the responsibility of the men they favor to see that human obligations are observed with due respect. The battle over the body of a fallen friend is a central theme from the beginning of Greek figured art, although it did not apparently exist in the Bronze Age, which focused on the killing but not on the aftermath. Perhaps the loss of the grand Mycenaean past made it the more imperative to preserve recent heroes in cult and memory (chapter 6, p. 206). Saving the dead in battle became a crucial task for soldiers, in art and literature as in fact. When myths and legends of the past became the preferred vehicle for expressing complex thoughts among the Greeks, the preservation of the dead was usually exhibited through focus on the *Iliad* or the apparently savage scenes in the epic cycle, the series of battles over the body of Achilles, (or Antilochos), or Aias carrying dead Achilles off the field. These engagements, where so many were wounded or killed to save the dead, put a seal of proper action upon the soldier's life. A lost

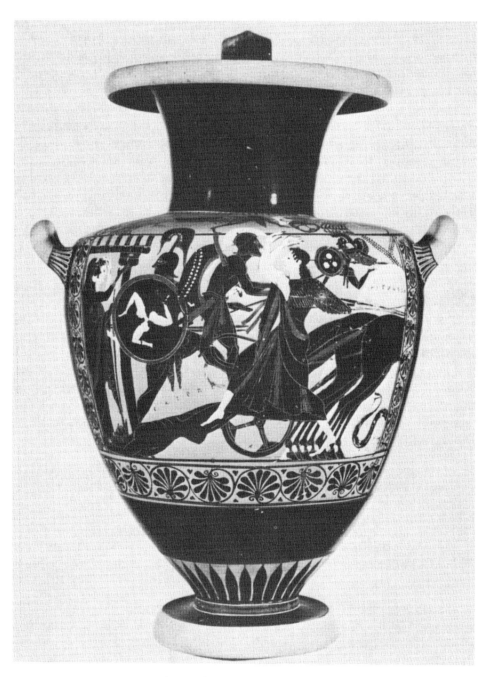

FIG. 27 The tomb and *eidolon* of Patroklos at Troy:
Attic black-figured hydria, sixth century.

body is not necessarily a forgotten hero, but the prospect of its being mangled by the enemy and his dogs stirs up soldiers even more than the prospect of death for themselves. A tomb and a substitute identity could be managed even were the body lost, but it left a career incomplete if the gallant actions of a man like Achilles, who had come slowly to understand the inevitability of death and the demands of divinity upon a hero to be something more than a lion, could not be celebrated through burial.

Learning respect for the body of the dead is one of the principal lessons of the *Iliad*, a training for heroes to drop the carnivore mask and express courtesy to mortality. That is one of the points of the Leagros Group hydria (fig. 27), where improper treatment of Hektor's dead body gives simple pleasure to the *psyche* of dead Patroklos in his tomb, while at the same time Achilles is learning about the interchangeable roles of war. As he drags Hektor past his parent's feet, Achilles in the stance of the warrior departing from home assumes Hektor's place as son, with ultimate responsibility to restore the body to the family, and to the women for the mourning which gives formal seal to a hero's life.

Nepia Tekna

The female mourners whose song completes the life at burial are not so fortunate as those they bury. The singers of the *Iliad* and *Odyssey* are not, on the whole, sentimental, but the spectacle of what happens to women and children in wartime moves them to occasional lyric terror. The fall of Troy will inevitably mean murder, rape, and fire, and not many will be able to tend to the bodies then. The proper burial of women and children means little to an epic poet, since the soldier is his concern, and even in the famous simile of *Odyssey* viii, the dead man is center stage:

> as a woman cries who has fallen on the body of her dear husband who has dropped in front of his people and town trying to keep the pitiless day from his town and children, and she sees him dying and panting for breath and pours herself around him and lifts the shrill mourning song; but the soldiers, behind her, hit her with spears on the shoulders and buttocks and pull her away to slavery, to her grief and lonely tears; so Odysseus dripped pitiable tears under his eyebrows
> [522f.]

The analogy of grief is in the poet's mind, not in the hero's, for Odysseus is a trained hero, accustomed to the disasters of the weak, and even in his lies about raids in Egypt he automatically slips in the accomplisher's phrase, "I ruined their lovely fields and took away the women and innocent children," *nepia tekna* (xiv.264, xvii.432). "Women and children" is a standard phrase in the history of Mediterranean warfare. Egyptians, Akkadians, Assyrians, Greeks

and others use it and traditionally place the women on the city walls in siege time.[35] The wives and sons behind the walls are incarnations of the pleasures of peace, or the pleasures of victory, since such a high proportion of ancient warfare was for portable loot in which women figured at least as importantly as cattle. Epic almost never refers to war as winning houses or land, any more than classical war actually did; the success of war is centered on wives and

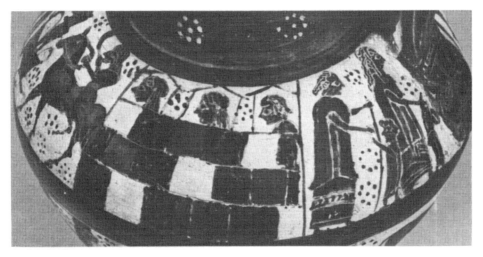

FIG. 28 A city under siege, watchers on the walls, women and children:
Corinthian oinochoe, sixth century.

nepia tekna. As a unit with the soldier they comfort him, offer a part of himself to fight for, and perpetuate his name; after conquest the unit is split and the soldier's line gone. The dead in the *Odyssey* underworld ask first about their sons. The *Iliad* lays so much emphasis upon young fighters who are losses to their parents that there is little room for mourning a younger generation of children, but there is a constant unsettling deployment of *nepioi*.

Nepios may mean one who has not yet attained full powers of reason, who is not πινυτός; or one who cannot yet speak well, or express his thoughts in language, νη and ἔπος; or one who is not yet, or no longer, integrated into the gentle (ἤπιος) circles of kinship.[36] The Greeks may have considered the very young to be not seriously alive, with limited intelligence or language skill. At least, in the *Iliad*, *nepios* normally points to one who is going to die. From the "innocent children" of the sparrow at Aulis who were swallowed by the snake (II.311) or the *nepia tekna* of the fast deer who are crunched by a lion in his bed as he rips their hearts out (XI.113), to Hektor who was *nepios* to think that if he killed Patroklos he would be safe (XXII.333), the word is fatal. It denotes limited perception or wit which will bring death.

The Karian Nastes was *nepios* to come to Troy in gold armor; it would not save him (II.872). Asios was proud of his horses and chariot: *nepios*, for they would not save him from the evil *keres* (XII.113). Chromios and Aretos were *nepioi* to chase Achilles' horses, and died (XVII.497). Polydoros Priam's son was *nepios* to show how fast he could run when Achilles was standing close; his bowels spilled into his own hands (XX.411). Patroklos was *nepios* to ask Achilles if he could go into battle; fool, he asked for his own death (XVI.46, 686); he was a fool when he killed a child playing dice (XXIII.88), a fool to think he could take their liberty from the Trojan women (XVI.833), all facets of unintelligent behavior. *Nepioi* are those who do not understand battle and its design, or the gods and their design, fatal defects.

Since women and children know nothing of battle and little of what the gods intend for them, they are especially vulnerable. The panels of the Mykonos Pithos show them most interestingly,[37] in that world of seventh-century Cycladic imagery which seems so close in tone to the *Iliad* (figs. 29 and 30).

FIGS. 29–30 Greeks taking care of Trojan women and children:
panels of a relief pithos, Mykonos, seventh century.

For all its superficially grisly arrangements, the pithos is in fact as elegant, intellectual, and mannered as most Homeric battle scenes. It combines titillation of ornamental horror with skilled figure variations, partly grounded in the same tradition as animal combat scenes, a kind of witty ballet. The Greeks have conquered Troy and are taking care of the lingering remains of Trojan opposition. Some women are run through while their suppliant hands are outstretched; mother and child may join together in an unheard prayer for mercy; the mother may offer herself as a victim in the foolish hope of saving her boy, or may try to hold a soldier's hands as he cuts down the child. The boy may be split on a sword through the groin, or in more usual epic style be smashed head down on the ground. This is the so-called Astyanax technique; there are two

such scenes here, an old and simple way to kill an infant. The general public learned with some surprise and secret pleasure a few years ago that chimpanzees were carnivorous, with special appetite for baboon and colobus monkey babies, and had long ago mastered the epic technique:

> Through some thick bushes I glimpsed Rodolf standing upright as he swung the body of a juvenile baboon above him by one of its legs and slammed its head down onto some rocks. . . . Rodolf settled down and began to feed, tearing into the tender flesh of the belly and groin of his prey. . . . The brain appears to be a special delicacy, and Mike very often ends up with the head of the prey. I have watched him gradually enlarging the foramen magnum, where the vertebral column joins the skull. . . . When the opening was large enough he scooped out the brain with a crooked index finger.[38]

While there is no suggestion that Greek soldiers really ate Trojan babies, Hera was perhaps not the first to wish to eat Priam and Priam's children raw.

It should be stressed that, in this aspect of death, the images are an art form and express with the control of distance some aspects of the hero's fantasy which the hero does not often allow into his behavior. The Homeric soldier is neither ape nor lion, however the images around him, drawn from ancient hunting tradition, crowd him toward the brute side of war. It should be stressed, too, that neither the epic singer nor the war artist of early Greece ever exploited raw sex, just as they did not exhibit wounded genitals. There is no rape in these scenes, and even the so-called Rape of Kassandra in the epic cycle is not open sexual molestation, in the pictures or what we know of the poetry. It took the fifth century to add the explicit erotic element needed to turn the image nasty. Perhaps the absence of rape in early Greek scenes of captured cities may be explained in the words of E. Howard Hunt, the Watergate conspirator, about his behavior in World War II: "I didn't want to rape the Jap women," he mused, "I just wanted to kill them so they couldn't reproduce."[39] That is how Agamemnon felt, too, when he reproached Menelaos for being tender-hearted (VI.55): "Squash-head [πέπον], why do you care for people so much? I suppose the Trojans treated your household wonderfully? Let none of them escape the cliff of ruin and our hands, not even the boy-child the mother may be carrying in her belly, let him not escape but all of them die together out of Ilion, unmourned and invisible." It is a fact of life, or war-behavior at odds with life.[40]

Since the hero's war is predatory, and the predator or vulture concentrates on head and genitals, Troy herself is seen as a body to be humiliated. Troy is holy, as well as being an enemy, destined to die like a child, smashed head down in the dust, the body looted and then burned according to custom. "Now all steep Ilion is ruined from the head down" (XIII.73); "The people were held in mourning and tears . . . as though all Ilion with her rocky brow were burning

in fire from the head down'' (XXII.411). "The child is still *nepios* whom you and I made . . . and I do not think he will reach young manhood; before that this town will be destroyed from the head down" (XXIV.729).[41] Agamemnon prays,

> O Zeus most great and glorious in black cloud, living in the upper air, do not let the sun set and the darkness come before I throw the glimmering hall face down and burn the doors with enemy fire, and rip Hektor's shirt ragged around his breast with bronze.
>
> [II.412]

Troy is the most holy city of Greek poetry, Ἴλιον ἱρήν, ἱερὸν πτολίεθρον; that is, Troy is dedicated to the gods, like a sacrificial animal, and becomes an instrument of communication between men and gods. Sacrifice is necessarily a bloody business, when animals are offered, and a serious one involving the death of a living thing that one has nourished;[42] and for the Greek hero, life was at many times a serious and bloody business in which the gods were deeply involved. After sacrifice the animal is shared between gods and men, so that the death has meaning.

In wartime, it is the gods who charge themselves with giving meaning to the lives cut short below them, when men fail. The gods bury the dead children of Niobe with their own hands: "They lay nine days in their blood, and there was no one to bury them, because the son of Kronos turned the people into stone; on the tenth day the heavenly gods buried them" (XXIV.610). The gods direct the burials of two neglected fallen heroes, Patroklos and Hektor, bringing the men concerned out of animal savagery into human responsibility. The gods order burial, to complete the lives and the honor of efforts and love which might seem wasted, but which would have been struck by innate mortality anyway, and to gain for the dead a measure of immortality in mourning and ceremony.

With Homer as their necromancer, the Greeks elaborated a tradition for heroes in which death was as natural and inevitable as in any quick conflict between animals, and in which heroism was best expressed, in a form of art and wit, as an oxymoron. The hero allies a kind of gallantry of mind to bloodiness of body and purpose; he is half-god, ἡμίθεος, as much an oxymoron as a centaur is. He does the impossible—combines immortality and mortality, in a fragile shell steered by some kind of awareness. The hero's life was a hard one, the only genuine intelligent profession of death, in which attendant glimpses of life were given increased intensity. But mortality always prevails because it is stronger than immortality, as well as more common and more natural.

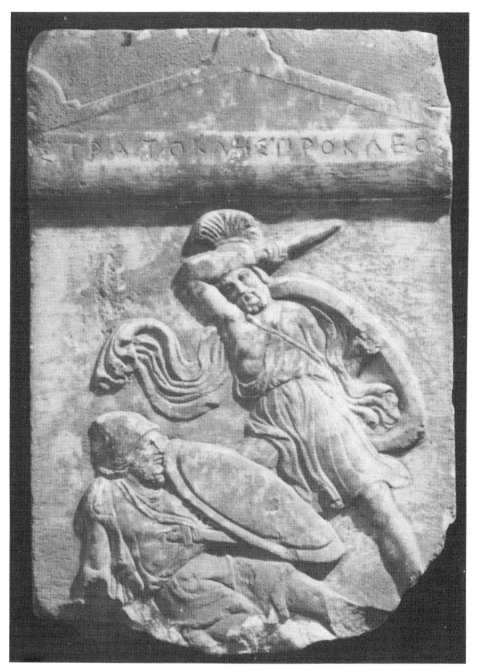

FIG. 31 Battle scene: marble grave-relief, fourth century.

IV

IMMORTALS ARE MORTAL,
MORTALS IMMORTAL

'Tis now dead midnight, and by eight to-morrow
Thou must be made immortal.
Measure for Measure, IV.ii

IT WOULD not be difficult to call a hero of the *Iliad* a dead immortal. The manifold self-contradictions in Greek ideas and phrasing about death are not errors. They are styles of imagining the unimaginable, and are responsive both to personal needs and to old conventions. The same conflicts surge up in many cultures. They are necessary ambiguities in a realm of thinking where thinking cannot really be done, and where there is no experience. Logic is not fruitful in the sphere of death and was scarcely applied to it by any Greek before Lucian,[1] although Plato's brilliant views mingle the rational and the poetic at their best.

The illogical themes of the Greeks flourish in our own cemeteries almost untouched by changes of religion, thriving under a screen of austere or hopeful religious doctrine. The dead are somehow alive; they are asleep in their tombs or in Christ. They may recall their own names and make the past live again with the aid of inscribed tombstones.[2] The grave is their passage, or dumbwaiter, or stair to another world. The dead have not disappeared, even if they are remote. They are the largest constituency in the world, though organized in small communities, perhaps not in touch with one another. They are often dim-witted, or do not concentrate with quick emotional energy on the daily crises of their children and descendants, but they are ready to be aroused like Sleeping Beauty if the right words are said and feelings transmitted. They are still occasionally visible as a *psyche* or an *eidolon*, sometimes small, weak, and miserable, sometimes large, stalwart, and informative; now, as in the Greek world, the form depends upon the evocator or poet's need and stagecraft. The dead body often keeps its soul in the grave, and the soul often wears its body to the underworld.[3] The tie is hard to sever.

The Greeks understood that the body and the soul parted in death, of course, and they focused on the sorrow of the parting in many epic and lyric verses. They never quite accepted it, however, and, as strongly as any other people, felt that the link endured, which was one of the western world's great contributions to the argumentative literature about mortal and immortal. The

terminally damaged body and the persistent soul were neither fully split apart at death, nor really well coordinated after it. These images, set deeply in the text of Homer, are implied by Bronze Age monuments long before. The Greeks suggest, without fully admitting it, the idea that although death may be inevitable, it is not entirely fatal. Just as the Greeks, so far as we know, were the first to raise the problem of how difficult it is to think of pure nothing, or non-being, so their portrayals both imaginative and pictorial of death and what happened after it are naturally filled with content. Because there are words for, and ways of drawing, mortal elements after death, there was also existence for those mortal elements, and their existence after death might easily be confused with immortality.

In quick review of the tradition around which such speculation played: we have seen the Greek hope that intelligence was a major defense against death as well as a way of contemplating it; contemplation led to control. We have seen the common link between the intelligence, the eye, and the sun; and the wit which never quite switched off in the darkness of Hades. We have seen the tomb coalescing in shape with the underworld, or lower cave; the relics of old ideas about the daimonic mouth, the *stomion*, or *ker*, that swallowed the mortal again into earth; the tomb as the mystery of the locked room, the tradition of traveling spirits, the central role of the *goos* and family mourning as the cele-bration of the passing of the dead and the invocation of his immortal renown; and the immense antiquity of such traditions, which were too powerful to be altered by even the greatest Greek poets. Successive poets and philosophers had a series of new insights into the meaning of parts of the tradition, or expressed it in new figures, but did not have and perhaps did not want the genuinely creative demiurgic power to substitute a new conception.

Of course additions were made to the basic imagery of the sad weak *psyche* in the walled kingdom of Hades, as in the Egyptian side-currents which evoked happier pictures of the *makares* passing to the Ialu Fields like Elysion, to work, plough, harvest, eat and play, with the attached images of the ferry-man, the sunlit underworld, the gaming boards, the gold fruit and water, and the *ba*-bird. But those attractive ideas of quasi-immortality for the dead who passed certain tests of goodness never fully replaced the older and more democratic vision of the kingdom of Hades where kings and commoners walked as equals.

In the Homeric picture of death, it seems likely enough that, behind the intricate combats of animals and men, and the rhetorical or witty humiliation of the body to which the soul responded courageously, there was a community acceptance of the cycle of life and death, for heroic *ephemeroi* as for beasts. The hero was a recognizable oxymoron, godlike, half-god, equal to the gods, ἰσόθεος, ἡμίθεος, ἀντίθεος, a vessel of god's blood and god's nurture, god-suckled, διοτρεφής; but an unstable compound of irreconcilables, immortality and mortality, a gallant mind in a bloody and vulnerable body.

The tradition of the godlike man in mortal casing who learns to accept death both as a proper part of the natural cycle, and as a proper expression of his relation to the gods, is fundamental to Greek poetry in the seventh and sixth centuries, following Homer.[4] Archilochos' double allegiance to war and the Muses, Kallinos' belief that death is woven by fate (I.8), and that longing and mourning certify a life (I.18); Tyrtaios' conviction that an immortal element survived, name or fame, though the man was underground (IX.32); Semonides' tough catalogue of deaths and contrast of the long term of death, the short years of hard life (1, 3); Mimnermos' leaves shed on the earth, and the black *keres* of death and age (2); Solon's salute to fate, τὰ μόρσιμα (1.55), all exhibit the elevation of old modes of coping with death into poetic tropes of fairly standard though elegant forms. Death was a major archaic theme in all Greek arts.

The corresponding tales of Greek myth were given new pictorial form or developed for popular appeal in the seventh and sixth centuries, telling of mortals who tried to alter the necessity of dying: Tantalos stealing the food of immortality, Bellerophon raiding the gates of heaven, Ixion and Tityos trying to rape the great goddesses, unaware that immortality cannot be achieved by friction. Whatever the ultimate genesis of such tales, which must have different starts and histories of growth, the Greeks regarded them more simply than we do, as expressions of the punishment which naturally follows man's ambition to become a god and avoid the penalty of the mortal cycle. Human power and wit were too weak to succeed in such adventures.

The famous text of Herakleitos,

> ἀθάνατοι θνητοί, θνητοὶ ἀθάνατοι, ζῶντες τὸν
> ἐκείνων θάνατον, τὸν δὲ ἐκείνων βίον τεθνεῶτες
> [B 62]

is hard to render with a single translation because it is characteristically structured by paradox and pun.[5] It seems to say: "Immortals mortal, mortals immortal, living their death, dying their life." There is little doubt that Herakleitos' thought is rooted in myth and shaped by the traditions of poetry. Double meanings and paradox are essential to the best myth. This particular paradox is a linked continuum like "the way up-down one and the same" (B 60), or the sleeper in the dark who catches light for himself (B 26). Since the relations between mortals and immortals are seldom simple, paradox and continuum are useful ways of exploring them, in myth and philosophy alike.

It was one of Herakleitos' many virtues, to have possessed the gift for crystallizing themes which had been for many generations incarnate in myth and poetry but scarcely expressible. In crystallizing, he analyzed and re-ordered old images or exposed them to another light in which the facets of the under-lying Homeric and older ideas refracted differently. Many sayings are simple

and gnomic: "gods and men honor those who are killed in battle" (B 24) is the Homeric theme of mortal courage in risking the only life we have, which the gods cannot do;[6] "the sun is new each day," *eph' hemerei* (B 6) was, long before, illustrated on Egyptian papyri of the Book of the Dead and told in the Mesopotamian legend of the Sun-god's daily rising from the portals of the mountain range of Mashu which the Scorpion-men guard, "awful in terror, their glance death."[7] This is standard childhood belief, too, as Piaget documented long ago,[8] and is partly suggested by Mimnermos' vision of the sun's bedroom in the east where extra rays are stored, either because the sun was damaged at night, or for his new growth at dawn (11.5). The thrust of Herakleitos' remark about mortals and immortals seems equally simple, and grounded in ideas latent in the *Iliad*.[9]

One might translate the text, " . . . immortals are quickened in mortals' darkening but darkened in their quickening," a close analogy to the sleep fragments. Sleep brings new life in the night through being in touch with the dead, like the Egyptian sun, passing through the river and world of the dead to come back to life; it is like Herakleitos' related pun on ὄψις as both eye and apparition by day and night.[10] The spiritual refreshment of being deprived of external light and illuminated internally is as old as the tradition of the blind harper, or possibly the short-sighted yet immortal snake. It is oracularly expressed in Klytaimestra's ghost's famous urging to the Furies, in Aischylos' *Eumenides*,

$$\text{εὕδουσα γὰρ φρὴν ὄμμασιν λαμπρύνεται,}$$
$$\text{ἐν ἡμέρᾳ δὲ μοῖρ' ἀπρόσκοπος βροτῶν.}$$

[103–4]

The sleeping mind grows brilliant in its eyes, but in daylight the destiny of mortals cannot be foreseen.

As life-light-sleep-darkness-death and knowledge are linked in Herakleitos B 26, so in B 62 immortals and mortals are inextricably linked by death as they had always been by sacrifice. They are dependent upon one another for support and nourishment, and mirror each other's qualities; for an immortal god is without qualities most men possess, being incapable of death and consequently deprived of the gallantry and understanding which men, short-witted though they are, acquire through the individual contemplation and social experience of death. As a sharpener of intelligence, a sundial to measure passing time, a heightener of present pleasure, and a fixed prospect of the future, death has values which the gods cannot touch but which are the common property of the "unluckier" race.

Immortality is a difficult state. The Greeks defined it negatively. Gods are *a-thanatoi*, not subject to the darkening of mortals. They are *a-mbrotoi*, non-mortal, possibly bloodless or inedible.[11] If the Egyptian derivation of *makares* is

correct, the *makares theoi* of Greece have emerged into blessedness after initial danger and judgment; their perpetual food and drink and joy is earned by vulnerability and passage from an uncertain to a stable state.[12] The frequent description of the gods as "existing ever," αἰὲν ἐόντες applies only to the future, because in the fantasies constructed for the gods they could not exist forever backwards. They had beginnings without predictable ends, struggling to birth and passing through childhoods which, no matter how swiftly they outgrew them, were often periods of danger, for they might be swallowed, mutilated, cast out of heaven, or banished from the blessed company. Since the lives of the gods were expressed in simple biological figures, they shared the familiar patterns of family life in myth and folktale, and to that extent experienced the weakness of the mortal child at birth and in early relation to his parents.[13] Other principal epithets of the gods, like Οὐρανίωνες, heaven-dwellers, or Ὀλύμπια δώματ' ἔχοντες, "possessing Olympian halls," mark some kind of stable condition, but also imply those places that are not heaven or Olympos to which gods may be drawn—earth and Tartaros—; they do not guarantee that immortality is static or secure.

The gods seem to have no *psyche*, since, in Dodds' words, "the only recorded function of the *psyche* in relation to the living man is to leave him";[14] and the gods by definition cannot die or lose their *psychai*, and therefore do not have or need them. This lack of *psyche* would theoretically put the gods in a class with children, slaves, animals and inanimate objects. Most Greeks did not push theory so far. Children, slaves and animals did not normally appear in Hades because they had no real hope of a future existence there (although we have seen that there are good storytellers' reasons, and religious reasons, for the exclusiveness of the kingdom of the dead). They are, in some sense, only marginally existent, deprived categories of beings. The gods, too, although blessed and brilliant, are deprived in their lack of *psyche*; and, in the later development of the meaning of the *psyche*, they are soul-less as they are care-less; from Homer onward, they are empty of a kind of promise implicit in Greek heroic manhood.

As Homer presents them, the gods lack the sense of mortality which gives a man's life energy and shape, μορφή. As Samuel Bassett remarked in these lectures, "not noblesse, but la mort, oblige."

> The gods are deathless; they live at ease, for unending existence—without the "inner check" which man has developed for himself—has little motive except the ever-present. . . . In the *Iliad* [the gods' life] would have been meaningless but for the War, in which the Olympian family had become bitterly involved. When the War was over there was nothing left but immortality without motive or meaning. . . . Theology in heroic tradition lagged behind Homer's own ethics. If we may infer his ethical philosophy from the words of

Sarpedon, it is something like this: Purpose and meaning give to human existence its supreme value; this value is possible only in the life that confronts obstacles, including insuperable death, and in meeting all obstacles this value is secured only by unfailing response to the heroic "inner check." Homer is thus the first great Humanist.[15]

This passage comes from a more optimistic and disciplined age than our own, when the hard way was the good way and suffering developed character, but it is still an excellent comment on some of the relationships between immortals and mortals in the older Greek world. It extracts from the fictional structure of the *Iliad* a problem which always troubled the Greeks (and was the more troublesome because they did not consistently distinguish between folk-tale and theology):[16] why immortal character and behavior were so much worse than mortal. When folk-tales of the gods, and poetic mechanisms in heroic poetry, were granted the standing of reality, it was almost inevitable that the archaic doctrine of *phthonos* should develop: the malicious, jealous attitudes of gods toward men as though men were a threat to their way of life instead of being their only support and clientele. If the gods could ruin a man's hopes they would:

σύμβολον δ' οὔ πώ τις ἐπιχθονίων
πιστὸν ἀμφὶ πράξιος ἐσσομένας εὗρεν θεόθεν·
τῶν δὲ μελλόντων τετύφλωνται φραδαί.
πολλὰ δ' ἀνθρώποις παρὰ γνώμαν ἔπεσεν,
ἔμπαλιν μὲν τέρψιος, οἱ δ'ἀνιαραῖς
ἀντικύρσαντες ζάλαις ἐσλὸν βαθὺ πήματος
ἐν μικρῷ πεδάμειψαν χρόνῳ
[Pindar, *Olympian* XII.7–12]

There has never been a man on earth who found from god a sign he could trust of action to come; ideas of what will happen are blind. Many things fall on men they did not expect, a sliding back from delight, though some, meeting storms of grief, exchange in a little time pain for deep good.[17]

Whether life is simply unpredictable, as the common poetic theme has it, and all action leads to danger; or whether there is active malice from "the blessed ones," or indifference, the Greek consensus was that life was short, deceptive and painful. It is part of the Greek legacy to the West, and almost a definition of humanism, that the Greeks found grief, defect and mortality, when faced with gallantry of mind, to be better than unearthly states of blessed existence.

Caged in their unending existence, the Homeric gods still managed to join men in suffering from fear, anger, spite, lack of discipline, overwhelming erotic impulses, greed and anxiety. In epic, gods have *mérmēra*; they *mermerizousi*; the word signifies, like its archaic counterparts *merimna* and *améchanie*, a kind of

floating anxiety and indecision, a sense of not knowing the right course of action because the future is unclear. Those who have most responsibility have most *mermera*; it is Zeus who cannot sleep and wonders what to do next, like any earthly king: Δία δ'οὐκ ἔχε νήδυμος ὕπνος, ἀλλ' ὅ γε μερμήριζε κατὰ φρένα (II.3).[18] Such uncertainty in manipulating action to bring a desired result is odd, perhaps, for the father of gods and men; but the poet has no choice except to represent divine thought and emotion in mortal terms. Uncertainty and worry are also a drain on the powers. When men are extremely depressed by *mermera*, they can wish for death to end a life of misery, but the gods are not so lucky. Zeus cannot always control events or protect his children; he is caught in perpetual feasting among the women of his family who dislike him and break his spirit with mocking words, and sons who boast and rebel against him, until the whole blessed pantheon is filled with grief and trembling. The assemblies of the gods have a handsome look, but often reveal in poetry those moments when life on Olympos was not well run, *ou kata kosmon*, but chaotic and bitter.[19]

The epic tradition displays a tough wit in its juxtapositions of gods and men, a folk-tale style which made Greeks uneasy later. The power of the Homeric gods is more muscular than spiritual. The only one who has real intelligence is Zeus. Epic is a panorama of blood, dust, and grief below, careless feasting and unquenchable laughter above. Such laughter, the ἄσβεστος γέλως, when it issues from mortal mouths, as from Penelope's suitors while the courtyard in Ithaka fills with ghosts, is regarded as the mark of insanity because the intelligence which ought to control the laughter has been knocked crooked. Among the dying men below there is effort, sensibility, loyalty, love, honor and fame; in the feast above there is hatred, deceit, quarrel, egoism, sensual pleasure and insecurity. The gods are insecure because they fear the future, which is long; they are afraid of being exiled from their social group, of being lonely or hurt, of being mocked and taunted; they are in bondage to unfulfilled wishes and to lack of self-discipline.

Gods can be whipped, as enemy monsters are (VIII.12, XV.17). They can be tortured with anvils, like slaves (XV.19), dashed out of heaven as Astyanax is dashed from Troy, and crippled if not killed (VIII.13). When they are wounded it hurts and they cry, while mortals try to laugh or be stoical. Aphrodite screams hugely and her flesh grows black as *ichor* leaks from her veins (V.343f.); Ares' belly drips "bloodless blood," ἄμβροτον αἷμα, and he roars (V.864f.); Hera's wounded breast is perceived as incurable, ἀνήκεστόν (V.394). Huge Hades, pierced with an arrow in the shoulder, is also pierced through with pains, ὀδύνῃσι πεπαρμένος (V.399), like the poet Archilochos when he fell in love; but he is saved by the useful poetic formula, οὐ μὲν γάρ τι καταθνητός γ' ἐτέτυκτο, "for he was not fashioned" by the poetic tradition "to be one of the mortals, of course" (V.901). Although these humiliating and painful events are clustered in the *Aristeia of Diomedes* and are not characteristic of the texture

of divine images everywhere in the *Iliad*, they and many related passages else-
where show that one facet of the epic's success with an audience was in pro-
viding an opportunity to laugh at and despise the gods their lords. A hostile
relationship, as well as one of dependency, was perhaps necessary to a Greek
who privately thought of himself as chief and sovereign in will until events
showed him otherwise.

The theme of the vulnerable immortal is conspicuous in myths of the Greeks.
Perhaps it reflected a chafing of spirit under despotic lordships of local princi-
palities, or an impatience with the powers of a father, and secret daydreams of
humiliating him and toppling him from place. Zeus' power is ugly, and possibly
temporary; he masters the gods because he is physically strongest. "I will lame
their horses," he threatens Hera and Athena, "I will throw them out of their
chariot-box and smash the undercarriage, and if I hit them with lightning their
wounds will not heal for ten years" (VIII.404). This is the threat of a crossed
child, or a despot whose infliction of pain is its own pleasure, like the tales of
torture and irrational revenge which Greeks were fond of attributing to tyrants
everywhere and in which they themselves often indulged. Zeus has been chained
up before, and may be again, with a probable future of being locked into
Tartaros below Hades.[20] In that prison under the roots of earth immortals
could be chained in the storm winds, roaring waters, and darkness, behind
triple bronze walls and gates, effectively more "dead" than the mortal *psychai*
in Hades. Gods in Tartaros were not free to move their limbs or to initiate
thoughts except at the command of a superior; that is, they had lost two
essences of godhead, power and intelligence. It amused the Greeks to "kill"
their gods in such fables. Sometimes the rumblings and fires sent forth in
spasms by other "killed" immortals like Typhoios, locked under a mountain
by Zeus, or by the imprisoned Titans, would suggest to the world on earth that
immortality could not be fully quenched any more than mortality could. They
were signs to men that others have the same problems on a larger scale, and
that neither the present cosmic order nor death among men were facts in the
sense of immutable condition. Both mortal dead and imprisoned gods might
get out again and upset the normal cycle, an optimistic doctrine which supple-
mented the comforting theme of the vulnerable immortal and gave hope in
myth before philosophy that with luck there was a future.

In folk-tale men could take their own share of pleasure in hurting the gods
or holding them as servants, through the model of old kings who held the gods
in bondage or threatened them with physical mutilation. Laomedon refused to
pay Poseidon and Apollo for their work on the walls of Troy:[21] "He threatened
us and sent us away. He said he would tie our feet and our hands underneath
us and sell us overseas in a distant island, and with a bronze blade he would
shave our ears off. So we both went away with hearts full of hate, angry for our
pay, which he promised but did not give" (XXI.450f.). There are several tales

of this kind, with reversed roles of the helpless immortal and masterful mortal. One tale creates an ogre-mortal, Echetos the ogre-king of western Greece in the *Odyssey*, who specializes in mutilating visitors, cutting off a man's nose and ears with pitiless bronze, and drawing out his genitals for the dogs to eat raw (xviii.85, 116). This is the folk-tale model for Melanthios' treatment at the hands of his master Odysseus, who introduced the improvement of lopping off his hands and feet in a fury of anger (xxii.474). When gods are drawn into such tales, they depart from their normal religious roles, and raise disturbing questions beyond the reach of any logic but a scholiast's. Are parts of gods immortal, and other parts like ears and noses not? What is god's ambition for wages? Will he lose social standing among the blessed immortals if he has fewer cauldrons, stallions, and gold ornaments? Upon what does Charon spend the obols of the late Greek dead—new steering oars and caulking? A drink in the tavern of the dead who have no appetites? The capacity to exalt and humiliate the gods in fiction was a talent appreciated by early Greeks, and a sign of mortal dominion.

The gap between mortals and immortals was bridged in other ways. One way was through the wonderful company of minor immortals who formed, as it were, a continuum between earth-walking men without special powers and the high gods of Olympos. These are the rivers and springs, the nymphs of glades and valleys, who come to Olympos at the opening of *Iliad* XX; the minor gods like Pan; or the Nereids, the Muses, Maia, Amphitrite, Triton, the Moirai, the Horai, the Charites; the gods who prefer the earth, like Demeter and Dionysos, or the sky, like Helios, Selene and Nyx; the whole happy motley company of divinities who extend in an unbroken chain from the life of the courtyard or the farm or hills to the peak of the divine hierarchy on Olympos. Some of these are like small landholders who need the great lords of heaven to protect them. They are immortal but relatively weak, like the river Skamander who, although he accepts sacrifices of horses like an eastern potentate, must call on superiors to save him from death by fire. Hera saves him: "Hold on, Hephaistos, it is not decent to batter an immortal this way for the sake of mortals" (XXI.186, 369). So the intelligent Sun cannot enforce his own rights when Odysseus' men eat his cattle, but can only threaten to "die" himself and descend to shining among the dead men (xii.377). Nymphs may be called immortal, or merely long-lived; but "immortal" Kirke can be frightened by mortal Odysseus with drawn sword. That is a pictorially sexual joke, of course, but it also matches other sets of images, like the *psychai* of the dead whom Odysseus warded off at sword's edge from the blood in his sacrificial trench, in *Odyssey* xi, or the arrow aimed by Herakles at Meleager's ghost in Bacchylides V. Neither the dead nor the immortals have reached a state of full security.

In theory, which myth was, the Greek world was clearly stratified. The gods were in heaven, men were on earth, and the dead walked below. Gods were

the most mobile, visiting earth and men at will, although only Hermes usually visited the dead. The stratification became a hierarchy, or was one from the start: considered as a low-caste class were those possessed of death; in the middle, those who had not yet attained or been possessed by it were still optimistic, although free to complain about the future; and at the top, the lucky, rich, and blessed divine, who would never descend the social order. The lower bridge to death could be crossed only by the middle class. Whether they could aspire upward, on rarer occasions, was a subject with which myth dealt in serious poetic form. One of the archaic fictions was that the gulf between men and gods could not be crossed, "the bronze heaven cannot be climbed" (Pindar, *Pythian* X.27), but archaic myth was busy providing bridges, or, rather, a double ladder up which some creatures ascend toward immortality and others sink down to the darker mortal condition.

Because gods need men to support (as well as invent) them, they are bound to a series of associations which are not always happy. The frequent unhappiness of mortals when gods intervene in their lives, or their wives, is notorious, and is summed up in the myth of the reluctant Marpessa who preferred a mortal sex life with security to a brief passion in Apollo's arms. On the other side, from the *Iliad* on, the atmosphere of feasting and unquenchable laughter among the blessed gods was spoiled in two ways: that only poets and artists regularly saw it to admire, or that other men they invited regularly proved treacherous. The feast was tinged with fear and weakness, and contaminated by the mocking anxieties of men. The ladder to the top was not like Jacob's Ladder, with angels descending and ascending, or those depressing religious pictures where the poor aspirant to heaven reaches nearly to the top only to be pulled down by devils in the sight of the heavenly gates. For the Greeks, the entrée was by invitation only, on grounds or with credentials we cannot now discover, but which evidently have their origins in local cult or folk-tale.

Mortals invited to heaven regularly contained their own internal spoiler, as in all the best folk-tales; they left their manners and wits at home, and brought greed (for immortality) and malice. The big sinners in the Greek world are those most successful in spoiling their contacts with the gods: Tantalos who abused their special diet trying to insert mortal flesh into their ambrosia as a test of divine perspicacity; or, conversely, tried to steal nectar and ambrosia to share among those who had not been asked, although he was, or should have been, aware that *nek*tar, so intimately connected with *nek*ros the corpse, may overcome death or itself be deadly to those not nurtured on it, and that am-*brosia* is not for mortal *brotoi*.[22] Ixion the murderer was one of those perpetually dissatisfied guests for whom no feast was complete without trying to rape the host's wife in another room.[23] Tityos tried immortality by rape too; and Sisyphos wheedling his way out of the prison of death with an expert vocabulary outwitted the gods and infringed upon their rights.[24]

FIG. 1 Pegasos shrugs Bellerophon off: Cretan relief pithos, seventh century.

The dividing line between men and gods was rarely crossed with complete success, but there was constant pressure to test it (in the fictions of men). The aspirant to heaven was generally sketched in such a manner as to leave no doubt of his singular lack of qualification to join the company of the blessed. The myths applaud the ambition, deplore the execution, and explain why most of us die.[25]

Ascent to Olympos is, statistically, the least successful method of escaping death. To provide an immortal future for the mortal in partnership with a long-term inhabitant, as for Ganymede and Tithonos, demands sexual co-operation from the gods. Those who went alone fueled only by ambition and a sense of competence, like Bellerophon, were shunted back to earth; as Pegasos, with that famous moral wriggle, threw his human master in exchange for a divine one in the stalls of Zeus. Monsters or sports like Pegasos were sensitive indicators in Greek myth of the status of ambitious man; when monsters stand for death, man may kill them. His other fantasies of conquering or postponing death normally included transformation, dreams of food and drink, and the exercise of cunning over a simple-minded opponent.

In transformation (quite apart from cult origins of such ancient figures as Kallisto or Iphigeneia) the animal who receives the mortal into its own shape becomes the receptacle for mortal destiny, yet it is rarely killed.[26] The transformed are often as long-lived as the nymphs, or even immortal, by virtue of losing mortal aspiration; it is a successful crossing of the downward bridge. One does not know if the wolves and lions whom Kirke had made out of men by

FIG. 2 Transformation from human to animal form—Kallisto turns into a bear:
South Italian, fourth century.

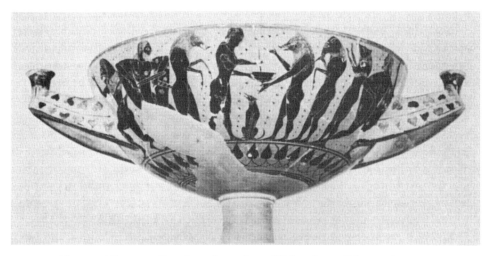

FIG. 3 The transforming *pharmakon*—Kirke alters Odysseus' crew:
Attic black-figured cup, sixth century.

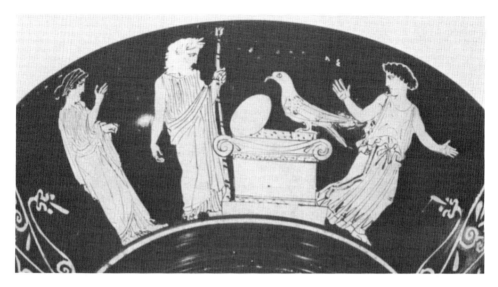

Fig. 4 The family waits for Helen's birth from the egg:
Attic red-figured skyphos, later fifth century.

charm (x.212) would have been as long-lived as their mistress, but it seems likely. (One does not know because the storytellers before Ovid stop with the transformation, or its successful reversal, and lose interest in the ultimate fate of the character.) When transformation is a simple *aition* for cult or natural history, for the bear cults of Arkadia and Brauron or for the weeping of the nightingale or the halcyon, it may have no essential relevance to the mythical escape from death, to the transformations up and down the ladder between earth and heaven, animal and man and god. Yet in so far as the mortal loses his *psyche* through transformation and still remains sentient, he has done well. In the language of myth it was perhaps inevitable that the Minotaur, product of Queen Pasiphae's union with a bull in Crete, should grow up to be killed by a hero, since he was a grass-eater, a generally fatal attribute in the Homeric system of imagery. Perhaps it was inevitable, too, that Helen, born from an egg, should have airy and predatory traits, swooping off and delighting in or even feeding upon corpses, although destiny in Greek myth and poetry is not always so simple. At least, it seems safe to say that Greek mythology offers many incarnations of the mutual shifts between mortality and immortality which Herakleitos later presented abstractly in his difficult text.

There is a minor strain in Greek mythology to suggest that immortality may sometimes be a result not of nature but of nurture. This is a simple extension of the idea that the gods live on special food. They may not eat meat or grain, and may not drink wine, because these substances endanger their status (just

as wine is the ruin of many giants, centaurs, and other innocent clean-living creative aberrations from the normal forms of life). On the principle that you are what you eat, you should be able to become something else by eating differently. There is a range of food and drugs able to achieve transformation both up and down—we cannot name it well, because the storytellers persist in mysterious allusions, since these materials are magical and therefore hidden secrets. The Greeks were familiar with the perils of chancy highs and lows in the ingestion of these magical substances, and used them to express a variety of feelings about the instability of the mortal condition.

Kirke's drug which transforms man to beast is the best known, whatever it may have been—"drugs of grief," Homer says, φάρμακα λυγρά, assisted by a touch of the magic wand. It affects only the mortal exterior and leaves the emotions intact, except that, as the men who taste it become animals, they experience *lethe*, forgetfulness of their desire to return to a human home, the key theme of the *Odyssey*, seen also in the effect of lotos food or Siren song. Their *nous* is basically unshaken, however, and when they emerge from animal form they are finer than before, like the sun after bathing in the ocean at night, or the sleeper of Herakleitos' thoughts, who gets more brightly in touch with himself in the dark.

The converse upward push by food or drug is an old human ambition, though fewer magicians offer it.[27] The principle is that one can escape death by ingesting particular substances which have the alchemical power to transform the blood from dull, mortal *haima* to divine *ichor*; with this new blood the quality of life should improve, perhaps even permanently. The gods support this state, of course, with nectar and ambrosia, fictions which may have developed simply from etymological playfulness. We are not in a position to know whether nectar, like *makar* with its uneasy chthonic history, may suggest an early recognition that god is dead, or at least that drinking nectar might be fatal to non-gods. Perhaps this is why Kalypso was so careful to separate her food from Odysseus': "The nymph set before him every food, to eat and drink, of kinds mortals take, and she sat opposite godlike Odysseus, where her servants put nectar and ambrosia before her" (v.196). Since Kalypso wanted very much to make her new friend "immortal and ageless for all days" as other goddesses had done, one would have thought a quick switch in the kitchen might have achieved her hope, but evidently, for Homer and his sources, a man cannot be made a god without consent of will; forced on him it may kill him.

For some mortals the transformation occurred by accident, therefore equally without an act of will. The chance ingestion of a strange substance could change a mild ordinary mortal into a truculent deity able to perform all sorts of feats too difficult for him before. The classic tale is told of Glaukos of Anthedon,[28] the fisherman who saw one of his dead fish land upon a bank of rare grass by the shore and come back to life. Glaukos tasted this "everliving undying grass,"

ὁ τὴν ἀείζων ἄφθιτον πόαν φαγών (Aischylos, *Glaukos Pontios* fr. 28N², fr. 60 M.) and like the fish entered the sea, a new immortal under the water with rather animal qualities. Like many sea-creatures he developed a gift of minor prophecy.

The sea which seems blank and trackless to us has special paths and ways in it, through its valleys and harbors, the κόλπους and πόρους ἁλός; sea-gods have traveled and learned them, in places out of the sight of the sun or of men. Like the *disthanees*, the mortal adventurers to Hades, they have acquired more than mortal knowledge and experience, both topographical and predictive. A lost sailor need only cry "Come out, Glaukos," ἔξω, Γλαῦκε!, for the new immortal to appear and tell him the way home.

Glaukos' immortal grass is a fixture in folktale: it is like the snake-herb which brought the other Glaukos, the small Cretan prince, back to life in his tomb pharmaceutically; it is like the fruit of the Tree of Life in Genesis, or the fruit of the tree-fairy in the Egyptian underworld, or the life-plant which the snake stole from Gilgamesh to his despair, or the food and water of life which the gods offered Adapa and which he rejected because he thought they were deadly, or the bag of the water of life in the descent of Ishtar to the underworld, or the food and water of life sprinkled on the corpse of the goddess Inanna as she hung on a stake in the darkness. Somewhere in our world there exists a magic food or

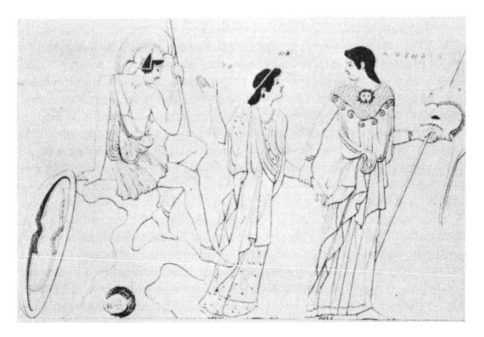

FIG. 5　Athena leads Immortality away from the hero Tydeus:
the Rosi krater, Attic red-figure, fifth century.

liquid to make us immortal and unaging. In most mythologies we mistake it, reject it, or lose it, because of our magnetic dance with death.[29]

In one Greek tale, rarely illustrated, the drug is called, simply, "immortality." Sir John Beazley discussed it in connection with the curious lost Rosi krater; Bacchylides' words on the subject are lost too.[30] The hero Tydeus, Diomedes' father, was fatally wounded in the war before the gates of Thebes. The Rosi krater displays him on a rock, half-dead, ἡμίθνητος. Athena, who loved him, asked Zeus for the drug against the disease of death, to make him immortal, δι' οὗ μὶν ποιεῖν ἀθάνατον. In her absence, Tydeus' companion Amphiaraos (who was himself to become near-immortal as a prophetic sleeper in an earth chasm and should have known better) cut off the head of Tydeus' enemy Melanippos and gave it to the dying hero as the kind of snack or pacifier heroes so longed for at Troy, an enemy liver to eat or a head to play with. Tydeus was busy drawing the brain out and sucking it like a chimpanzee when Athena returned; she was nauseated at the sight, μυσαχθεῖσα, and grudged him the gift she brought. Grudge, phthonos; it always gets in the way; and we merit it.

Evidently what Athena brought to the dying man was an old soul-food, a drug, the pharmakon immortality, athanasia. In the usual fifth-century manner it was personified as a girl, the Athenians often confusing their organs of pleasure. On the vase immortality is being led away, and the head discarded, all pleasures lost. That such a drug was once popularly thought to exist is suggested by the number of Greek poets who insist that it does not. Archilochos claims "the gods gave us strong courage to be our pharmakon," the hard real way (7.6), and Ibykos agrees, "there is no pharmakon of life for wasting people still to find" (313 P.). Creatures of myth are more optimistic; so, for Pindar, the sons of the North Wind join the voyage of the Argo to show their skill and find a pharmakon for death in renown (Pythian IV.186f.). In one story, attractive to pessimists, the pharmakon is death itself. The moon's lover Endymion keeps it in a flask, like a philtre or hemlock, to be steward of his own life whenever he should weary of sleeping with a brilliant heavenly lover and should wish to put a quiet end to her contaminations of immortality.[31] As the Egyptian poet said,

> Death [stands] before me today
> As a man longs to see his house
> After he has spent many years held in captivity.[32]

Men who sleep with the moon, or the dawn, perhaps even those who simply land on the island of the sun, have already moved outside the usual boundaries of mortal experience to strange places where death and life interpenetrate in subtle ways. I am not sure how the Greeks really thought of their cosmos; it is probable they seldom imagined it as we diagram it for them now. Certainly the Greek world had an outside to it as well as an inside, regions near or beyond the boundaries and springs of ocean where almost anything could

happen. Ocean formed a flat deep ring around the earth and seas, the river Ocean flowing ever back on itself. Half of this ring, if it were imagined standing vertically over the known world, would represent the arc of the sun's journey from east to west, through our air which is contained in a bowl whose skin is fiery aither. After setting, the sun either traveled back in a gold bowl around one half of the Ocean ring by night, from the Hesperids to the Aithiopians; or his arc was a full circle under the world, through the gates mentioned in the second *Odyssey* Nekyia; or through Tartaros or some narrow cave-space where he might damage his rays.

The sun's setting and rising pulled the other sky travelers around the arc too. For fifth-century painters the sky was full of such cosmic charioteers and horsemen.[33] The moon followed the sun with her chariot or a single horse; as the sun climbed, the night dipped into the sea with her chariot; dawn drove ahead, and the little stars went plunging into the ocean where they would be refreshed and washed for the next night's shining (fig. 6). These circling divinities, far from Olympos, alternately waking and working, or sleeping and growing strong, offered a cyclic boundary outside of which mortal knowledge could not normally penetrate. The alternate tension and relaxation of the cosmic figures in their cycle, the sun shining and resting, the moon released from work trying to play with Endymion, suggested to many ancient people, and to Herakleitos and most Greeks, that life and death were on a similar cycle, that one led naturally to the other and back again.

There were exceptions to the cycle and to the rules of the inner world. Occasionally the Greeks thought of five places where life was untouched by the metaphor of the sun. The first four were east of the sun and west of the moon, in fairy language: east among the brilliant Aithiopians and west of the Island of the Hesperids; south, too, among the Aithiopians who lived longer than

FIG. 6A Helios rises, the stars dive into the ocean,
Selene chases Endymion, Night rides away:
Attic red-figured bell-krater, later fifth century.

FIG. 6B Helios rises between the departing night and the dawn:
Attic black-figured lekythos, early fifth century.

other mortals and set the table for the sun each night; and north, at the back of
the north wind. Here were the Hyperboreans who never grew old; "no disease
or spoiling old age is mixed in their sacred breeding; they live without labor or
fighting" (Pindar, *Pythian* X.41). Somewhere near are the curious *Abioi* on
whom Zeus turns his shining eyes at the opening of *Iliad* XIII, neighbors of the
nomad Mare-milkers, the Hippemolgoi. They are lifeless or exempt from life,
the most just of men.[34] Their historical descendants are, for Herodotos, the tribe
with shining horses, the Argippaioi who are still somehow exempt, and, in spite
of their bald heads and snub noses, somehow divine. "No mortal man offers
injustice to these people, for they are said to be sacred, and no weapon of war is
stretched against them. These are the men who make judgments in the disputes
of those who live around them, and whoever runs away to them as a refugee is
harmed by no man" (IV.23). (The paradise inhabited by noble savages is still
a necessity for our imaginative lives, and most of us have still not abandoned
the old hope that, around the edges of the world we know, live peoples exempt
not merely from vice but from death. The international excitement at finding, in
the last few years, the pure-minded Tasaday aborigines of the Philippine rain
forest far off to the west, or far to the south the long-lived smokers and drinkers
of Villacambambo, reflects persistent ambition to discover the secrets or elixirs
of peace and life.)

The fifth direction for escaping from the cycle of life and death is, of course,
straight up. Some optimistic documents of the Christian funerary tradition

FIG. 7 The gates of heaven open.

show that the door of heaven will be kept open for us if we die from a decent life into the house of God. In archaic times, at least, the Greeks were not at all hopeful about this possibility; their myths had the gates of heaven or the great sky closed against mortals, and guarded by the Horai, the Seasons, against whom mortal ambition flew or climbed in vain.

When the heavens are closed the four boundaries of the earth are the more magnetic. To reach those distant peoples who manage life better than we do is to share in the cosmological mysteries of day and night, to cross or penetrate the trackless sea as Herakles or Perseus or Odysseus did. "Never on foot or ship could you find the marvellous road" (Pindar, *Pythian* X.29); the supernatural must intervene when a man pushes the boundaries of nature, and help Perseus with his winged sandals or cap of invisibility, or allow Odysseus to learn the uncharted ways. Herakles must wrestle the prophetic sea-god to win a verbal chart, and threaten the sun before he can come safely home in the sun's gold bowl. The western seas where the Greeks usually went when they were curious about immortality, because they neighbored the land of death, could spurt selected travelers out from normality into regions bordering Ocean, filled with islands and coastal meadows.

Here lived a series of lovely and dangerous creatures who regularly commented upon man's mortality or underlined its power in their own deaths. There were the Hesperids, daughters of the evening star, singing in clear tones around their

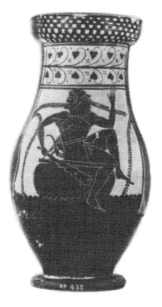

FIG. 8 Herakles crosses Ocean
in the bowl of the sun:
Attic black-figured olpe, late sixth century.

tree of golden apples with its guardian snake;[35] there were the islands of the immortal and unaging nymphs Kirke and Kalypso; there was the dancing place of the dawn-goddess Eos by the streams of Ocean; there were the Sirens on their flowery island Anthemoessa, the Gorgon sisters on their rocky island Sarpedon;[36] the faultless island Thrinakie where Helios the sun pastured his cattle;[37] the island called Red, Erytheia, where the triple-bodied lord Geryon pastured his cattle, and where Hades the lord of the dead also pastured his cattle.[38] One needed to be a master mariner to avoid going aground, but of course the point of going there was to land and meet the mysterious islanders.

Almost all the island-dwellers are known in Greek myth for their wonderful voices. Kirke and Kalypso sing in lovely voice as they weave (v.62, x.222) and Kirke is the "terrible goddess with voice" (x.136). The Hesperids have shrill clear voices, second only to Night (Hesiod, *Theogony* 275) and their tame dragon with one hundred heads is "master of many voices," ἐχρῆτο δὲ φωναῖς παντοίαις καὶ ποικίλαις (Apollodoros II.v.11). The Sirens naturally "enchant with shrill clear song" (xii.44) and even charm the winds so (Hesiod frag. 28); the Gorgons with their gargling roar[39] provide the music for the funeral wail, which Athena wove when she heard Medusa dripping song from her unapproachable snake heads as she sank weary into the grief of death (Pindar,

Pythian XII.9). Even the guardian goddesses of Libya with their supernatural siren knowledge are "chthonic voiced goddesses," χθόνιαι θεαὶ αὐδήεσσαι, ἡρῷσσαι (Apollonios Rhodios IV.1322), and Geryon is evidently named for his ability to emit γῆρυς, sung poetry which teaches, "terme noble et religieux." [40]

Some of these singing creatures of the western seas were, like other hybrids, in the difficult position of being supernatural but not necessarily immortal. Anyone who is born as a chimaira or a sphinx, or even just plainly winged, must be aware that he is special; but there is the same danger as the gods experience, of being born outside the natural cycle, and being unsure whether the cycle will complete itself in death or whether one is exempt. The shapes of many monsters of Greek myth are borrowed, from Mesopotamia more than Egypt; yet so far as one can guess it was principally the Greeks who animated them with characters and life stories of their own, beyond the usual destiny of the monster to be killed by the hero or to serve the god. Greek artists delighted in monsters for their curious shapes; Greek mythmakers, for the power of their bodies, and the ingenious, innocent quality of their minds. In Greek as in Mesopotamian tales they were destined often to be outwitted or killed, but they had character while they lived, and served as mirrors for men: natural antagonists with mortal characteristics but freer ways.

Many Greek monsters, apart from centaurs and certain giants, were solitaries. They might be isolated entirely, or express themselves as twins or triplets, living on lonely islands, confined to hills or caves or desert places. They were amiable if undisturbed, but the stories they were in were designed to disturb them, and when in such stories a human being came along to abuse their hospitality or suggest a different way of doing things, they got irritable like a parent with a persistent and disruptive child. This parental character springs from the monsters' role as "elder creatures," relics of some past time which have been slow to adapt to our ways, like dinosaurs and dragons. Arguments between men and monsters usually end in the monster's annihilation, and in renown for both parties.

Of the monsters on the western islands, some are considered in a scholarly way to have been death-spirits. This was true in some sense for figures like the Gorgons or the Sirens, less obvious for the Hesperids or Geryon, though doubtless a streak in their make-up. Yet it is not a complete imagining for any of them. They are not abstractions meant to stand for an aspect of death, like *ker* or *thanatos*. More vivid than simple darkness, they never come into the normal world to take any individual away to death. The man must look for them, and offer battle, physical or spiritual. They have a richer life in fiction than even a popular figure like Eros; when myth endowed them with peculiar shapes and powers it endowed them with character, however faintly drawn. In a sense, the power of these creatures does not even begin until they are defeated or dead themselves, an odd fortune for a death-spirit.

The Gorgon Queen Medusa illustrates this fortune dramatically.[41] The origin and function of the Gorgon and her head or mask have been debated for many years; she is borrowed from the East, and quickly absorbed into Greek fantasy in various forms, as a snake-tailed dragon, or a horse-queen, or a lovely dangerous woman. The great gargling voice, the snake hair, and the power to petrify, belong to an old world of magic and fear tamed by an otherwise ineffective princeling of the Argolid. Greek narrative, though not Greek art, drained out most of the interest of the tale by converting it into a Cinderella story, three sisters with the interesting one marked out for love by the sea-king Poseidon who lay with her in a soft meadow among spring flowers (Hesiod, *Theogony* 279). While Medusa lived she was not remarkable, although doubtless very attractive. It was only when she died that she became both fertile and powerful in the world of men. When Perseus arrived on the island Sarpedon to kill Medusa, or to be intimate with her (for cutting off a head is an intimate act), the death was at once a sexual release, freeing the Gorgon's children Pegasos and Chrysaor from her severed neck to carry her mixed immortal and mortal heritage, and a guarantee of Medusa's own immortality in myth.

Until Medusa dies she has no powers. She does not pursue men or kill them or turn anyone to stone. It is only when, through a cleft between the supernatural and natural worlds, her head is brought back into the mortal sphere that her power becomes obvious. Because she was the only Gorgon sister marked out for dying, she became the only famous one in poetry and art. The

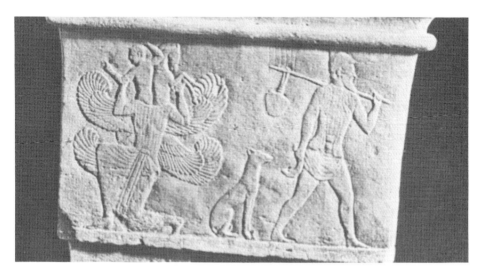

FIG. 9 Pegasos and Chrysaor are born from the Gorgon's severed neck:
Cypriote sarcophagus, fifth century.

FIG. 10 Triple-bodied Geryon and his two-headed dog Orthos ambushed by Herakles:
Attic black-figured amphora, mid sixth century.

Gorgons who are still alive scarcely disturb men; with difficulty we recall their names; renown without death is rare. The myth seems to want to say, among other things, that when a hero prides himself on "killing" a major figure of death, he releases both death and immortality from the debris.

The mortal Gorgon mated to an immortal sea-god produced children who evidently carry some degree of mortality, which is unpredictable in revealing itself. Pegasos is immortal and sterile, carrying thunderbolts for Zeus; he is without marriage or descendants.[42] Chrysaor, whose name should mean "possessor of the gold double axe,"[43] is not immortal, apparently, and has a son to whom he bequeaths the mortal strain, Geryon, Pegasos' nephew. Geryon's herd-dog, Orthros or Orthos (his own half-great-uncle in the family tree of Hesiod's *Theogony* [280f., 327]), is to be killed by Herakles; but Orthos' daughter the Sphinx seems invulnerable except to mockery and the buffets of passion. In fact these monsters are vulnerable to nothing but the wishes of the myth-maker. In myth there is no stable order of behavior between monsters and men—only murder and sex, as between gods and men, or enemies at Troy; a confrontation might go either way, like the drops of Gorgon's blood which can kill or cure, although the myth-maker is naturally partial to the human protagonist.[44]

Geryon is among the most interesting of the chancy immortals of the western islands, and in Stesichoros' long important poem *Geryoneïs* the problems of death and immortality are central.[45] From the surviving fragments, the poet seems to have seen the myth from the inside, with particular sympathy for the triple-bodied monster. Geryon's distant island Erytheia may have been physically reddish or dark, close to sunset;[46] it was large enough for Geryon's whole kingdom, and for some cattle of Hades who are pastured there in the care of Menoites; it is a cattle refuge characteristic of coastal ranching enterprises, safe from wolves and lions. The juxtaposition of Geryon and Hades on the same island has naturally suggested to scholars that they are versions of the same figure, or that Geryon was a daimonic servant of Hades', but it seems more likely that two separate tales were attracted. Geryon's winged triple body and capacity for personal death give him independent standing.[47] There is a stress on landscape in this myth, as there often is in stories of giants: the misty stable of Geryon's cows; the river Anthemoïs which waters the island; Geryon's idiosyncratic tree, part pine and part fir;[48] the size of the ranch across which Menoites must come with the news of Herakles' arrival; the death of the dog Orthos and of the herdsman Eurytion; an atmosphere of space and danger. The picture of red cattle on a red island beyond the pillars of Herakles, where the sun sets, the world ends, and the ranch-king makes a powerful or religious noise out of his three heroic chests, is one of Greek myth's best.[49]

Stesichoros' poem is full of pictures and conversation. The birth of the herder Eurytion by a Hesperid nymph is shown "in a hollow of rock by the

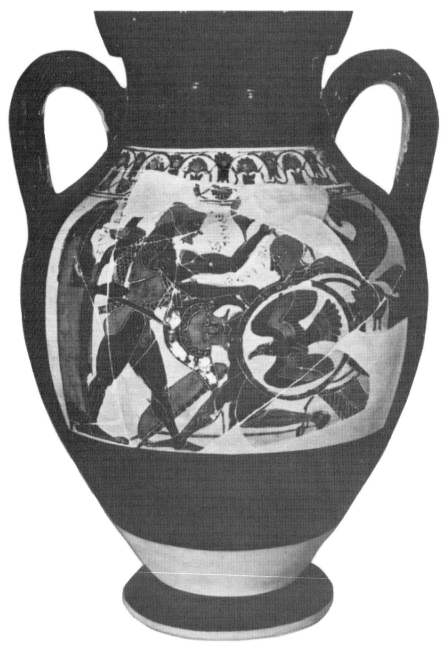

FIG. 11 Two Geryons dying in Herakles' attack:
Chalkidian amphora, mid sixth century.

boundless silver-rooted springs of Tartessos river"; the young mother returns to the gold houses of the Hesperids on their lovely island; Menoites appeals to Geryon, as a friend, not to sadden his parents' lives by fighting Herakles; the nymph Kallirrhoe begs her son, "Listen, be persuaded, child . . . if you ever suckled my breast," and there is scent on her robes; there is a quarrel in heaven about the coming fight, and some ancient promise of Geryon's death which his grandfather Poseidon resists. It is a duel in the larger setting of epic. The center of the poem appears to be Geryon's gallant debate in the style of the Sarpedon of *Iliad* XII on testing his own capacity for death:

> Do not try to frighten me with death . . . if I am [immortal in family] and unaging [so as to share the life] on Olympos, it were better . . . but if, my friend, I must come to old [age] and live among [creatures of the day] far from the blessed gods . . . now it would be far [nobler to experience] what is destined . . . may this not be what the blessed gods want [for me] . . . for my cattle . . . [50]

The "monster" does not know which race he rightfully belongs to, immortal or mortal, since he mingles both bloods in his odd body; had he been undisturbed by a mortal cattle-raider in a lion's skin, he would have lived peacefully and enduringly outside the borders of the mortal world.

The outcome was already known from the pictorial tradition. Herakles played the game secretly, from ambush, with poisoned arrows, using gall "from the pains of the man-ruining shimmering-necked hydra," and in a baroque climax Stesichoros shows the arrow in silence, like a thief, piercing Geryon's forehead; it split right through the flesh and the bones with god's will, stuck at the top of the skull, and darkened with red blood the cuirass and bloody legs below. One of the three Geryons leaned crooked from the neck as when a poppy, spoiling its delicate shape, sheds its petals quickly [to earth]. There is little doubt where the western poet's sympathies lay. Geryon does not know what could happen to him, for his destiny was immortality in poetry and art like his grandmother before him.

Sarpedon and Geryon have a passing glimpse of what it might mean to be immortal and unaging, ἀθάνατος καὶ ἀγήρως, but it is a daydream the heroes of Greek poetic fiction consistently reject. Immortal men like Ganymede or Tithonos are not heroes in cult or literature; they are interesting attractive figures, instructive for some antique beliefs, but they cannot exert the same power over the mind as men who die. Stesichoros' poem uses a paradox not unlike that of the Herakleitos fragment. The mortal Herakles will join the gods through his work in killing monsters who should have been immortal, dying their life and living their death. Like the fruit-*pharmaka* hanging with the crucified skeleton on the Tree of Life and Death in Eden, the superficially incompatible states of existence in Greek myth are linked by many mechanisms

"It's awfully kind of you, but I'm trying to give up smoking."

FIG. 12 Drawing by R. Taylor;
© 1948, 1976 *The New Yorker* Magazine, Inc.

of sin, redemption, and alteration. Christian doctrine was simpler; the good soul was bound to be blessed and immortal. For Geryon and other Greeks the moment of the test of death had to be faced, and the decision could go either way until the last. Like the reformed smoker in front of the firing squad, who does not really believe in death in spite of the compelling evidence marshalled against him (fig. 12), the Greeks persisted in the arrogant feeling that the world of immortals was totally absorbed in man, that they were jealous of his beauty and his wit, envious of his happiness, and deprived of something which only man could supply to complement the life of the god.

V

ON THE WINGS OF THE MORNING: THE PORNOGRAPHY OF DEATH

> O magic sleep! O comfortable bird,
> That broodest o'er the troubled sea of the mind
> Till it is hush'd and smooth!
> KEATS, *Endymion* 453

THE seventh-century poet Alkman, in his "other" *partheneion*, the choral song for girls which is so pitiably torn, makes a phrase which seems at first deliberately odd in the conventions of Greek poetry. Apparently addressing himself to one of the girls, he says,

> λυσιμελεῖ τε πόσῳ, τακερώτερα
> δ'ὕπνω καὶ σανάτω ποτιδέρκεται

"in limb-relaxing longing, she looks more meltingly than sleep and death."[1] Pothos, Hypnos and Thanatos are linked, and love is in the air.

The "more meltingly than sleep and death" comes after a long gap in the papyrus, as one of a series of memorable images—a girl like a gold twig, or a soft feather. The seventh century must have been one of the great epochs of erotic poetry, though constrained by myth and the traditional decencies and puns of language. A poet so rich in inventiveness and sensuality as Alkman knew exactly what he meant by the melting glance of sleep and death. If these twin sons of Night express for him the dangers and delights of the opposite sex, we accept it with pleasure. The epic tradition was on Alkman's side, too, although we are not trained to think of Death, at least, as enticing, since we have in some ways discarded a theme of more romantic eras.[2] Yet in Homer Death was neither ugly nor malicious. He was a darkness who did not kill but accepted the dead. His more threatening epithets, like δυσηχής, with ugly echo, or τανηλεγής, who lays a man flat, were confined to men's fantasies as they feared his coming; he did not act badly. In practice the τέλος θανάτοιο came gently and Thanatos could be helpful, as when he cared for the body of Sarpedon in that one grand abnormal figured scene; he came often as a dark cloud or a mist shed around the head and covering the eyes; he loosened a man's legs and veiled his sight. Love has done as much for many.

Death's twin or little brother Sleep naturally shared the family traits of the children of Night, with attractive and dangerous sides. Twins are often considered dangerous, and dangers are easily personified as twins. Hypnos was

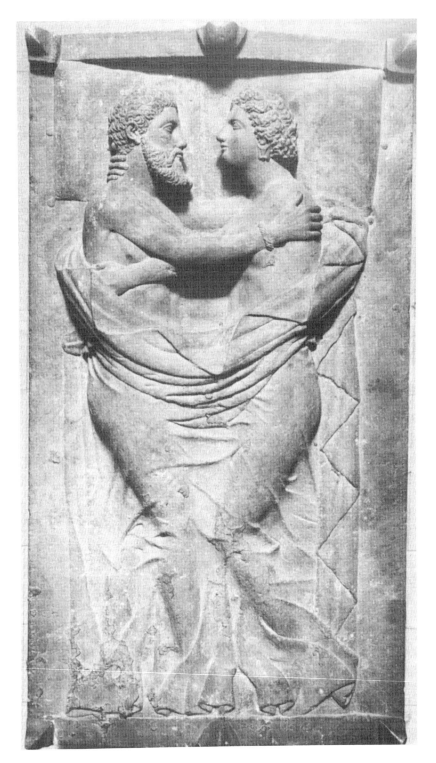

FIG. 1 Married couple united in death: Etruscan sarcophagus, fourth century.

more completely personified in Homer than Thanatos, brought to a more visible shape out of general and inchoate ideas. He had a richer history and more ambitions. His two major scenes are with death and sex: the journey to Lycia with the battered body of Sarpedon, and Hera's seduction of Zeus when Sleep turned off his shining eyes, through which the intelligent plans which governed the world expressed themselves, a temporary death (XIV.236). The seduction scene made vivid the dominion of Sleep over both mortals and immortals, in a state where their cycles intersect, while Death has only one of these constituencies for his own.

Sleep is small, winged and shimmering, as he hides in the form of a *chalkis-kymindis* bird, perhaps a blue roller, in the branches of the tallest pine on Mount Ida. The tree's branches stick through the skin of air into heaven, joining the worlds. Like other immortals, Sleep is unsatisfied and vulnerable. He has desires—he wants a wife, a chair, a footstool—and he fears that once again Zeus may try to drown him or exile him, as he tried before to throw him "unseen out of the aither into the sea," ἄιστον πόντῳ (XIV.258). To drown Sleep which even the gods need might seem short-sighted, though rage can have stupid effects. It was Night who saved her son, swift ambrosial Night who masters both men and gods, and has the power to pain the immortal thumos, doing ἀποθύμια (XIV.261). Epic phrases for the rhythms of time make it clear that the gods do not control their own lives or their own light, but must wait like everyone else, as in the lovely formula "Dawn rose from her bed beside noble Tithonos to bring light to immortals and mortals" (XI.1, v.1). Just as the Sun could threaten to shine among the dead (xii.383), so Dawn might fail to come, and the empire of Sleep be extended. Since the gods are held in the same turnings of day and night as men, they may get a small image of what death is like, and their sex lives can also the more easily interact for good or bad with those of mortals.

Alkman may have had several motives for calling Sleep and Death melting or enticing in their looks, none of them because he was suicidal. It was not really before the sixth century that death became—for poets in certain moods—a blessing to be summoned in moments of uncertainty, a pleasant image like Elysion, as when Sappho momentarily yearns for the lotos banks of Acheron.[3] But, from the beginnings of Greek poetry, Sleep was a release, λύων μελεδήματα θυμοῦ, λυσιμελής (xx.56). He is sweet, pleasure-giving, honey-hearted, soft, ambrosial like Night, warm, ἡδύς, νήδυμος, γλυκύς, μελίφρων, μαλακός, ἀμβρόσιος, λιαρός. The sweet enervating aspects of Sleep did not always suit the army's charge of alertness; a soldier μαλακῷ δεδμήμενος ὕπνῳ even with his weapons piled beside him might lose his life. Only children needed to sleep right through the night; a man could get bored with sleep and love-making; too much sleep without talk wasted time (XIII.636, XV.394). This blinding and softening side of Sleep accentuates his brotherhood with Death, as he is shed on a man like a

liquid, a mist, or the cloud of death; he can run a man down, snatch him and catch him, hold him, master him in softness, and undo his legs. He can transport a man to a different and necessary state, to bed or beyond. Like darkness he is the lord of all, ἄναξ παντῶν τε θεῶν παντῶν τ' ἀνθρώπων (XIV.233), as a master who holds and will not release, like Odysseus' famous sleep on his way home to Ithaka,

κat τῷ νήδυμος ὕπνος ἐπὶ βλεφάροισιν ἔπιπτε,
νήγρετος ἥδιστος, θανάτῳ ἄγχιστα ἐοικώς

"and sweet sleep fell on his eyelids, too deep for waking, sweetest, likest to death" (xiii.79); or the bronze sleep that held Iphidamas at Troy.[4]

The epic tradition of misty, limb-relaxing and transporting Sleep, both beneficent and dangerous, must lie behind Alkman's phrase. There may have been visual stimuli in early Sparta also. There were sets of statues on the acropolis, wooden images in the temple of Aphrodite Warrior, "as old as any in Greece," and images of Sleep and Death next to Aphrodite Who Postpones Old Age, Ambologera.[5] These were probably made too late for Alkman's chorus, although small-scale images of the divine twins in bronze, wood or ivory may well have circulated in Sparta in the seventh century, when boys were rendered remarkably attractively. Sleep and Death are never ugly in Greek art.

The Chest of Kypselos dedicated by the Corinthian tyrants at Olympia about 570 B.C. showed Sleep and Death as infants in the arms of their mother Night.[6] It is clear from Pausanias' description that they were inlaid in contrasting colors of ivory and cedar wood, the pale child sleeping, the dark child "like one who sleeps," with their feet turned in opposite directions. There is a Hesiodic character to this scene of infant daimons, although Hesiod himself excludes Death from his group of Night and Sleep, down in front of Tartaros, the gods' prison:

> The frightening house of dark Night stood there wrapped in dark-blue clouds . . . where Night and Day come close to each other and speak as they cross the great bronze threshold. One will go down inside, the other comes to the door . . . One holds light with his sharp sight for men on earth, but dreadful Night holds Sleep in her arms, the brother of Death, and she is wrapped in a misty cloud,
>
> [Theogony 744f.]

the little darkness where the light in your head never really goes off. The infant Sleep in this context is like the sun, new every day, but quickly growing adult with his own house independent of Night, roaming the world "gentle and kindly to men" (763).

In the late sixth and early fifth centuries the iconography of Sleep and Death became more fixed, although it still fluctuated slightly. They appear in a series

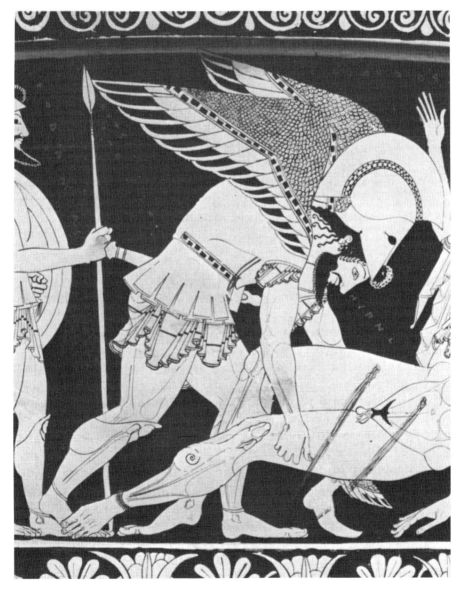

FIG. 2 Sleep with the body of Sarpedon:
Attic red-figured calyx krater, late sixth century.

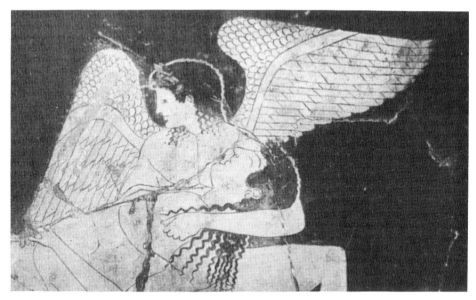

FIG. 3 Sleep cradling the dead Sarpedon:
Attic red-figured calyx krater, late sixth century.

of scenes to carry away the dead body of Sarpedon prince of Lycia (fig. 2), or dead Memnon son of the Dawn—only mythical foreigners at first, in the tradition of the *Iliad* and the *Aithiopis*, a theme perhaps carried on in Simonides' dithyramb *Memnon* written for the Delians.[7] At this work of carrying away the dead, Sleep and Death are sometimes beardless civilian boys, sometimes grown but youthful warriors, not because they are aggressive in themselves but because of their duties on the battlefield. Their wings make them easy to confuse with the major winds, Boreas and Zephyros, who were occasionally called Memnon's brothers and who helped at his funeral, as they did at Patroklos'.[8] When Sleep and Death are young, the body often seems too heavy for them to lift (fig. 3); when they are bearded and mature, the body itself may seem childish and they assume a parental role. During the course of the fifth century, as funeral painting increases its repertoire, they begin to carry off ordinary Greeks, and toward the end of the century they even take women, who had been nearly excluded from the serious world of Thanatos before;[9] the development is contemporary with Euripides' *Alkestis* (fig. 4). Sometimes the brothers may be contrasted in painting, as they had been on the Chest of Kypselos and in Hesiod, as an elder and perhaps more implacable Death ("the heart in his breast is bronze and pitiless," *Theogony* 764), with a younger more amiable Sleep, although this is not a strict rule and reflects the painter's need to vary his rhythms and colors as much as myth. Sometimes Sleep may take the head, where he sits in life, and Death the feet, for the journey, but this is

FIG. 4 Sleep and Death carry off a dead woman with Hermes watching.
Attic white-ground lekythos, later fifth century.

not consistent either, since the Greeks were seldom constrained by such obvious symbolism.

Given the ambiguities of the epic treatment of Sleep and Death, and the difficulties in art of distinguishing among slight male winged figures, it was perhaps inevitable that the roles of Sleep and Death should fuse with those of other daimonic powers. There are several sets of brothers or twins in the archaic world who shared similar or contrasting powers. Kastor and Polydeukes are an obvious analogy, the *Dios kouroi* who work together but have different destinies: Polydeukes invulnerable even when smashed on the chest with a polished grave-stone; ἄγαλμ' Ἀΐδα, Kastor tied in eye and voice by darkness because of his mortal heritage, σπέρμα θνατόν (Pindar, *Nemean* X.67, 82).[10] Other children cradled in their mother's arms are not always Sleep and Death, but pairs who share their qualities as closely. Sometimes they are Leda's twins, the divine killers Apollo and Artemis. Sometimes they are Ariadne's boys, the sons of Dionysos whose role in drunkenness touches on the spheres of sleep and love. Sometimes it is Aphrodite with her sons Himeros and Eros, Desire and Love, related as Sleep is to Death, minuscule to majuscule.[11]

Sleep is the tie between Death and Love. He comes unasked, and takes possession of the eyes; Menelaos trembles because Sleep was not sitting on his eyelids (X.26); Hera will shed warm painless sleep on Zeus' eyelids and stiff

FIG. 5 Aphrodite with her twin sons Himeros and Eros (?):
Attic black-figured pinax, sixth century.

ideas (XIV.165). Once Sleep has settled on the eyelids anything may happen, travel, new experiences, dreams and visions, coma or love; it is transition, and though we know it has a normal cycle and should lift again (the little, not the big sleep) it may change events. The heroine Kyrene so liked to wrestle lions she had little time for Sleep: "she did not use much of the sleep that slept with her upon her eyelids, tilting her toward dawn," ῥέποντα πρὸς ἀῶ, to a new lover and life (Pindar, *Pythian* IX.24). The scales of Death are more familiar than the scales of Sleep; the Dawn stands by both of them.

The poetic figure of Sleep upon the eyelids was translated into art as a little winged *eidolon* who perches on a man's head or heart, and binds him (fig. 6). The painters, of course, cannot set him on the eyelids; if they draw him big enough he will obscure the face; they set him at head, shoulder or belly where he will display well. The sleep that binds may lead to death, like the bronze sleep of Iphidamas; this is most common in pictures of the Giant Alkyoneus asleep in the woods, stalked by Herakles in ambush; he will not wake up once Hypnos makes him quiescent and vulnerable to murder.[12] There are less dangerous sleeps which do not bind forever, but alter life, like Ariadne's on

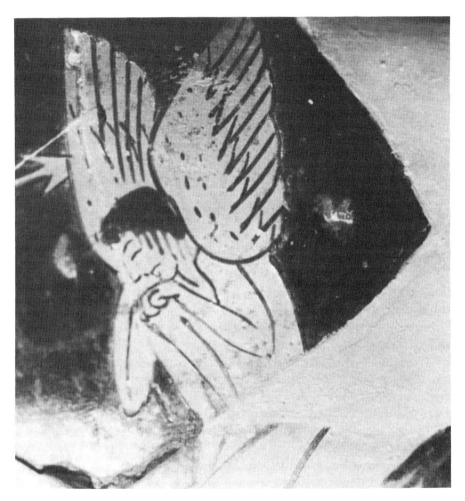

FIG. 6 Sleep perched on the chest of the giant Alkyoneus as he dies:
Attic red-figured cup, early fifth century.

Naxos, where sleep is the natural aftermath of love, and also delusive; dawn
brings an emptier scene.[13]

In some sleep scenes the *eidolon* is not shown, but Sleep's powers to veil
consciousness are suggested, as on Makron's cup (fig. 7) where two satyrs
surprise a sleeping mainad and prepare to take advantage. On the other side,
she wakes in surprise; one of the satyrs wants to close her eyelids again and
reduce her to a more passive, less enlightened condition. In other scenes where
sleep and sex are fused the roles may be reversed—although this is more Roman
than Greek—as when a lovely winged image, a "lady," a succuba, descends
upon a sleeping traveler in the country, to surprise and bind him (fig. 8). This

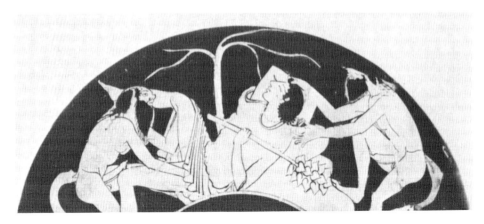

FIG. 7 Sleep and sex with silens and a mainad:
Attic red-figured cup, fifth century.

is a theme of nightmare, the vampire who drains a man's blood or strength in
the dark and ultimately kills him.

In these contiguous spheres of sleep, erotic change, and death, Alkman's
"limb-relaxing *pothos*" seems exactly right joined to the enticing look of Hypnos
and Thanatos. Pothos is the third brother to the twins Aphrodite holds in her
arms, Eros and Himeros, and may join them in flying overseas (chapter 6,
fig. 25) or receive dedications jointly with Aphrodite.[14] *Pothos* is generally a
feeling of longing in the nighttime for someone who is not there, a lover gone
overseas, or the absent dead. It is strong enough to kill—it killed Odysseus'
mother (xi.202)—or to ruin the images of love, as "in the blankness of statues'
eyes all love is vanished" (Aischylos, *Agamemnon* 416f.), but it can also be
magical and necromantic, like the *pothos* which Protesilaos' wife felt as she slept
with a statue of her dead husband, until she raised him briefly from the dead.

Alkman's πόθος λυσιμελής is a predictable variant on epic Thanatos who
λῦσε δὲ γυῖα; Sleep also undoes the limbs of the weary, in contexts of deep
yearning (xx.57). In Hesiod it is Eros λυσιμελής flowing down from the
glancing eyelids of the Graces (*Theogony* 911); in Archilochos as in Alkman it
is *pothos*, ἀλλά μ' ὁ λυσιμελής, ὦ 'ταῖρε, δάμναται πόθος, "*pothos* undoes my legs
and masters me" (118), and also removes the *psyche* (104). *Pothos* may block
Sleep because it centers the thoughts upon the dead: "but Achilles was crying
as he remembered his dear companion, and mastering Sleep [πανδαμάτωρ] did
not catch him, but he was twisting this way and that, longing [ποθέων] for the
manliness of Patroklos and his kind strength" (XXIV.3). The gods warn that
Diomedes' wife may wake with the funeral cry on her lips, in *pothos* for her dead
husband, ἐξ ὕπνου γοόωσα ... ποθεοῦσα πόσιν (V.413), for *pothos* is a serious
element in the lament for the dead, like the yearning to weep, γόου ἵμερος,

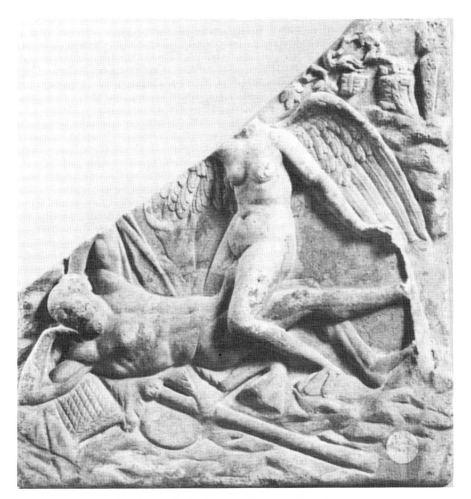

Fig. 8 A traveler's dream, the noonday nightmare:
Roman marble relief, first century.

which rises in a man's chest with the sound of funeral music.[15] *Pothos* is often used in the *Iliad* to describe the feelings a horse may have for his absent master; this association may help to convert the theme from horses to girls in archaic love poetry, Anakreon's Thracian filly, or Sappho's meadow where the horses graze.[16] The horse, the widow, and the yearning lover share a need for a master, a πανδαμάτωρ, who can undo anxiety as well as limbs, as Sleep λύει μελεδήματα (xxiii.62).

Eros is the most magical and flexible of the three, with a clearer role in cosmogony and fertility, a greater capacity for helping men pass the time, day

and night; a promoter of unions and partings, more welcome at symposia than Sleep or Death, and generally with a more enthusiastic audience in both poetry and art.[17] Eros had not grown a body yet in Homeric epic, but the common noun *eros* already shared the powers and epithets of Sleep and Death; *eros* sheds a mist or cloud around the head, veils the wits, ἔρως φρένας ἀμφεκάλυψεν (III.442), loosens the legs, λύτο γούνατ' (xviii.212), relaxes them, masters men as though they were horses or women, δαμάζει, becomes their lord, δυναστής, and is hard to fight.

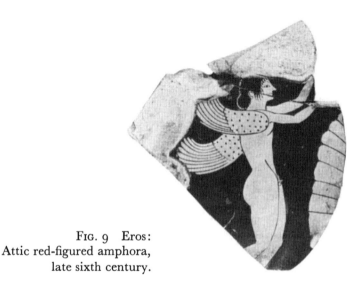

FIG. 9 Eros:
Attic red-figured amphora,
late sixth century.

Eros was the partner and enemy of Sleep. When Sleep brings *pothos* or *eros* it may involve apparitions of the loved one or unsettling dreams of danger and parting; the intelligence may wander very far, the identity be shaken, the soul move beyond limits of waking experience. It is natural for Eros to carry the magic wand, to follow the paths of Sleep, and, like Hermes, to enchant, θέλγει, the eyes of men whom he wants to, and also wake the sleepers (XXIV.343, xxiv.5). Just as enchantment, *thelxis*, is often a strong element in magic and singing, so Eros is often the singer or musician, the Eros with the lyre, a scene which may appear upon vases in the shape of the knucklebones used for gaming, which are fit for the games of love as well as underworld games. One remembers Anakreon's phrase, that "the knucklebones of Eros are madness and battle-noise," μανίαι τε καὶ κυδοιμοί (398 P.); Herakleitos felt that life was a child playing *pessoi* with gaming pieces (B 52 D-K); he may have been right.

Eros was also the predator, capturing deer and hare, running in the company of lions, as his mother mastered animals and as Sleep lulled a lion in a statue at Sikyon. He was classically the hunter with the bow, hard to fight, invincible,

FIG. 10 Eros the poet:
Attic red-figured knucklebone, fifth century.

ἀμήχανος, ἀνίκατος μάχαν, stressing the old association between *toxa* the weapon and the toxic poison dart.[18] For early Greeks, Eros the hunter who drives his victim into the net (Ibykos 287 P.), or the soldier who smashes you with a bronze axe for the coup de grâce (Anakreon 413 P.) was scarcely just another pretty boy. That youthful innocent Eros whose looks conceal his powers was not much in vogue before the period of the Parthenon, when so much that now seems canonical to us was in fact original and provocative. The archaic and early classical Eros is adolescent, well-muscled, and powerfully winged, a dangerous compulsion toward sex. He is one of the company of winged rapists who transported you forcibly to another place, like Boreas the north wind, or Sleep and Death, the Harpy and the Sphinx; he is the Eros of Ibykos, the black bold love who comes flashing in madness like the north wind flaming under lightning, who shakes the intelligence from the bottom up like a wave of the sea (286 P.).

Homer has a habit, at mocking moments, of treating enemies as lovers, fusing the effects of Eros and Thanatos. The *oaristus* of war, the manipulated bodies, the lily-white fallen enemy stripped on the field with the spear lusting to taste him, the marriage with death, those "jeux meurtriers" which have struck some as a curious prelude to Alexandrian bad taste, seem rather very archaic, and inevitable in war slang of all cultures.[19] The epic tradition said, in effect, that the losing warrior had round heels, and when his legs were undone he could take the consequences. This old battle style must have been further crystallized and sexualized in the lost epic *Aithiopis* with its two famous anti-Greek stars, the Amazon queen Penthesileia and the Aithiopian prince Memnon. The *Aithiopis* was a particularly influential epic for Greek art, and helped make the Amazon and the Aithiopian more popular than ordinary Trojans like Hektor or Paris, for their foreign distinction, sex and color, and the pathos of their deaths.

The first scenes of Amazons in battle were painted early in the seventh century, contemporary with Alkman and the *Aithiopis*. Their war with Herakles, the episode of Penthesileia at Troy, and generalized battle against Greeks were illustrated with undimmed enthusiasm through Roman imperial times. The moment when Achilles felt a shock of love for the Amazon queen just as he plunged his spear between her breast and throat had an early popularity; while

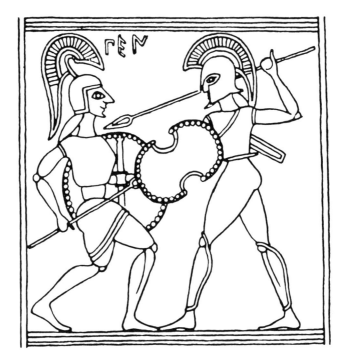

FIG. 11 Achilles and Penthesileia: section of an archaic bronze shield-strap from Olympia.

the scene might be overwrought for the austerity of Homer, similar ideas were latent in the language of the *Iliad*, love and death as two sides of the same instant. The only extensive literary description comes from Quintus Smyrnaeus in the fourth century A.D.:

> Her strength was like the strength of Death . . . she was drenched in hot blood . . . the son of Peleus rushed on her in rage and pierced the body of the girl and her windswift horse . . . though she fell in the blood and the dust her face shone out . . . beautiful even in death . . . Achilles could not control the grief in his heart, because he had killed her, and had not taken her as his glorious wife [I.610f.].[20]

Neither epic fragments nor archaic pictures hint what Achilles' intentions were when he carried her off the field, but her burial must have aroused intense feelings of *pothos* and the desire of mourning, *himeros gooio*.

Such death-flirtations, between Herakles or Achilles and his Amazon, were sometimes designed in cup tondos on the same principles as the more familiar sexual encounter between satyr and mainad. In both cases there is pleasure in the attraction of opposites, black and white, male and female, willing and unwilling, and the underlying message from Greek painters and poets alike that, whether killed or raped, the female should be grateful for any attention the male cares to pay her. Hence the pleased expressions on many Amazon faces, as they are carried forcibly into new countries and experiences, like the happy dead in a Harpy's arms.

Eros with the wand of Hermes, Eros the killer, Eros and Thanatos: it was a formal principle of Greek myth and literature that love and death were two aspects of the same power, as in the myth of Persephone or Helen of Troy. We have seen the daimonic pair of Erotes playing at a gaming board (fig. 12), more like death-spirits in the context of the association of the gaming board and the underworld, as though it were a supernatural version of the game of

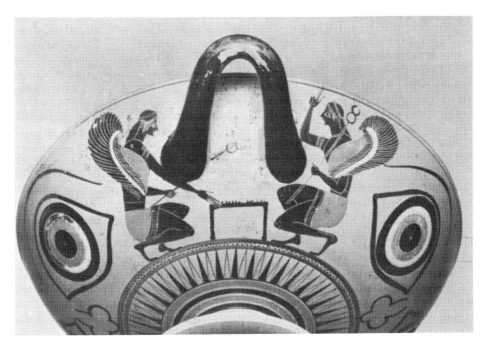

Fig. 12 Winged daimons with magic wands at a board-game:
Attic black-figured cup, sixth century.

Achilles and Aias. This takes place under the handle of an eye-cup, in the position where there is often a battle over a corpse, to save it for burial. It does not seem an idle game, for one daimon has acknowledged with a clear two-finger gesture that he has lost, the gesture of *apagoreuein*.[21] If they are gambling for a man's soul it is a different image for the same theme as the *psychostasia* or *kerostasia*, the testing of the last moment of a man's destiny.

In the *Iliad* the image of the scales of destiny, with *keres* in the scale pans, signaled a major duel—Achilles and Hektor—or a general shift in the fortunes of battle (VIII.69, XVI.658, XXII. 209). In late archaic and classical art the weighing of destiny, *psychostasia*, was in practice limited to the duel of Achilles and Memnon described in the *Aithiopis*.[22] It marked the moment when Achilles' physical superiority was already visible. The *psychostasia* is a supernatural confirmation of the inevitable, just as in Egypt it had been the external sign of the judgment already made by the habits of a man's life. If Zeus watches, or Hermes holds the balance, it is not because they need the sign, but because an

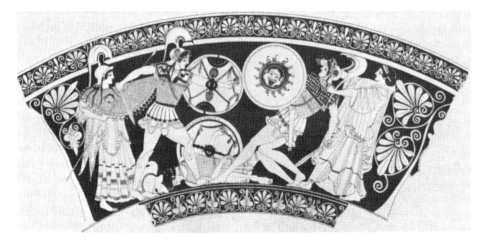

FIG. 13 Achilles, the goddess Athena behind him, is attacking
Memnon, whose mother the dawn-goddess Eos supports his falling body:
Attic red-figured calyx-krater, early fifth century.

immortal presence is proper at important deaths. The two half-mortals who are sons of the dawn-goddess and the sea-goddess are testing their own human training and talent, and not the quality of their mothers' powers inherited in them. Both mothers act because of their mythical mésalliances with men through one-sided love, and because the dawn confirms a man's death and the sea is one way of getting there, and provides in the Nereids the oldest mourning chorus. In the standard Memnon scene painters usually show little *eidola* of soldiers flourishing at each other like the bodies they represent; the watching

mothers make traditional gestures of sorrow, alarm, and begging; the scale pan closer to the ground is the sign of death and descent into the earth (fig. 14).

The enigmatic version of this scene known as the Boston Throne uses for the central figure holding the scales, in place of Zeus or chthonic Hermes, a young boy who seems to be a clear fusion of Eros and Thanatos (fig. 15).[23] This end of an altar, made in South Italy in the early fifth century B.C., has never been satisfactorily interpreted, although several converging ideas suggest its cult connections.[24] The short sides bear figures of youth and old age, the beginning and ending of intelligent life. The front has Eros-Thanatos holding the scales, and seated women watching the outcome. In the scale-pans, in the place of the usual fighting warriors, there are bound captives, naked with their hands roped over their heads. The usual meaning of the *psychostasia* has been inverted, because the woman or goddess on whose side the scale pan sinks does not find this grievous, but watches it with tenderness and pride, while the rising pan which should mean life evokes a gesture of resigned sorrow. The relief has often been connected to the Persephone cults which flourished in the western Greek

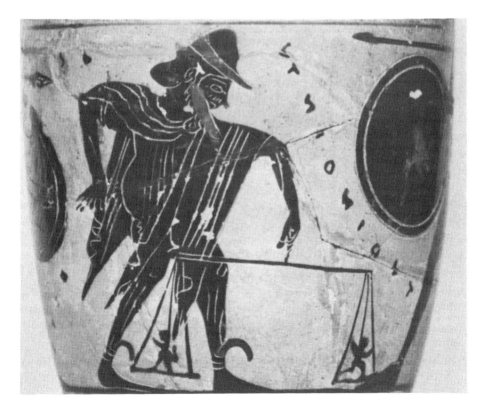

FIG. 14 Hermes weighs the winged *eidola* on the scale-balance:
Attic black-figured lekythos, early fifth century.

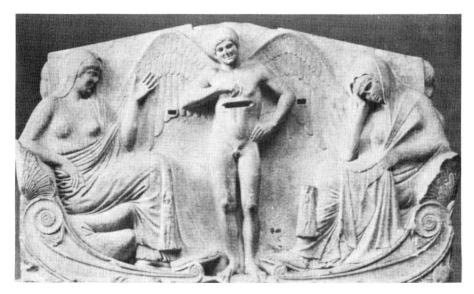

Fig. 15　The Boston Throne;
Eros-Thanatos weighs the captive *eidola* on the scale-balance:
South Italian, early fifth century.

world, and perhaps it was indeed intended to convey a "mystic" doctrine, still fairly new in the fifth century: one should be proud of the soul that sinks because it has released itself at last from bondage to the long cycles which educate the soul after death; one must sorrow for the rising pan because its *psyche* is still a prisoner destined to rise once more into the upper world, the Greek purgatory, for further training in goodness. The precise interpretation is less important here than the figure who presides over the judgment of death and release. He is Alkman's enticing Sleep or Death, a young Eros, a final Thanatos, an iconographic fusion of two superficially incompatible aspects of divinity which in the fifth century came to seem inseparable, like mirror images of two big human experiences.[25]

The change of experience which is mythologically marked by Sleep, Death and Eros seems to be more than a euphemism for the Greeks. It is figured in many ways: by immortal passions for mortals; sudden disappearances underground, into the mountains, overseas, up into the winds and clouds; a succession of rapes by Zeus, Poseidon, Hermes, Apollo, Boreas, Zephyros; and on the female side most conspicuously by Eos (Aphrodite tends rather to love them and leave them).[26] Eos the Dawn is the end of normal sleep, and in many myths she signals not just a new day but the beginning of a new life with the gods. The idea is perhaps parallel to the phrases in the Hittite death ceremony which tell how the king goes to join the gods and the ordinary man returns "to

the day of his mother"; [27] in Greece the idea is invoked for the passage of hero or king after the long ceremonial process of dying and funeral. When Eos the early-born, herald of light and of the sun, rises fresh from the streams of Ocean and the bed of her mortal husband proud Tithonos, scattering her yellow robe over the whole land, followed by the sacred day, she is more than an eastern compass-point and a change of time; she marks also the limit to which mortal reputation can reach: σὸν δ᾽ ἦ τοι κλέος ἔσται ὅσον τ᾽ ἐπικίδναται ἠώς (VII.451, 458). Beyond Eos and Ocean is a vanishing point, but those who stay with Eos are not lost.

In practical terms Eos marks the end of a funeral. In epic this was certainly true; when Eos rose over the blackened pyre of Patroklos at Troy the winds who lit the blaze in the night went home again over the sea, and Achilles was released from mourning into sweet sleep (XXIII.216, 232). At Hektor's funeral the dawn marked the end of the fire and the mourning (XXIV.788). In classical Athens the funeral was conducted at night, partly from a reluctance to pollute the day and the living, partly to confirm the release of the soul at dawn. It was natural to express the reason for the practice in mythological terms, that Eos the Dawn goddess carried off the dead "on the wings of the morning," and to motivate the event by simple sexual attraction or love.

In one of the Homeric Allegories, Herakleitos gave an early example of the ritual theory of myth. "There was an ancient custom that the bodies of the dead [diseased?], once they had stopped living, should not be taken for their burial at night, nor when the noontide heat spreads over the earth, but in deep dawn when the rays of the rising sun were still fireless. When a young man well-born and beautiful should die, they euphemistically describe the dawn funeral procession as the snatching [ἁρπαγή] by Day ['Ημέρα] not of a dead man, but through erotic desire for the one who was snatched. Following Homer they say this." The theory tries to protect Homer from charges of mentioning the improper loves of gods for men, a feeling scarcely decent even among men. [28] The passage of the dead is accomplished in chastity and love rather than sexual desire, as in Donne's "Nor ever chaste, except You ravish me."

There is a pleasant Greek arrogance as well as euphemism in the idea of a man's death as an erotic fulfillment for the gods. The conceit that gods needed men for their beauty as well as their worship, that heaven was incomplete without mortals, is surely more marked in Greek myths than in those of other cultures. Greek myth offers a vision of disturbingly heavy traffic on the double ladders up and down between immortality and mortality, the deprived desirous gods driven by sexual compulsion, Zeus plunging down in generative power on ranks of unwilling girls, to drop immortal seeds on earth; Eos flying up with a succession of lovely and very young boys in her arms to try them out as incomplete lovers. To take Greek myth at face value—aside from the obvious need for divine ancestry of heroes and foundation myths—is to learn that the

gods have only two easy ways of communicating with men: by killing them or raping them.

The rape motif is not only Greek, of course, and the famous rapes centered in the old royal family of Troy—weaving beautiful boys, wind-swift horses, wind-storms, harpies, and the gods into a splendid shifting pattern of interchange—where there may be elements of Anatolian ritual as well as Greek taste. It was not uncommon for the Greeks to displace perfectly Hellenic erotic scenes onto "foreigners," as in the cases of Aphrodite, Adonis, Andromeda, Dionysos, Medea and Phaidra. The Trojan princes Ganymede and Tithonos were welcome in the Greek pantheon, whatever the genesis of their myths. Zeus took Ganymede, Eos took Tithonos, both "for the sake of his beauty," κάλλεος εἵνεκα οἷο (XX.235); they were exempt from death, and therefore could never acquire the strength of personality in myth which dead Greeks have. The immortality which depends on external accidents like beauty was less admired than the mortality which one worked for.

Both Trojan rapes are popular in fifth-century art, as in earlier poetry (for painting and verse were never quite in phase). Ganymede the innocent hoop-player pursued by a knowledgeable bearded Zeus was a scene naturally in demand by those who commissioned symposium vases; Tithonos pursued by a young and lovely Eos is a tribute to a boy's own beauty (fig. 16). Sometimes he wears an expression of startled apprehension, like one acquiring a new perspective on the world; the nearness of the god may be suggested by setting the rape during a sacrifice when divinity might anyway hover close to earth. Whatever Tithonos apprehends, he is unaware that his poetic immortality will come through a sexual joke; he is remembered not as the ancient august figure of Homer, lying in his bed beside Dawn at the lip of Ocean, but as a memento to the witless Dawn (νηπίη, οὐδ' ἐνόησε) of the *Homeric Hymn to Aphrodite*, who remembered to ask for immortality for her lover that he should live "all the days," but forgot to ask the power to peel off deadly old age. As he grew perpetually older and the white hairs poured down his lovely head, the goddess had to dandle him in her lap like an infant; when he could not even lift his limbs or *anaeirai*, "get it up" any more, she had to put him down in the bedroom and shut the shining doors (224f.). The story has an undercurrent of Anatolian fear and pride at being unmanned in the erotic service of a goddess, but was shaped in seventh-century Ionia in an age of increasing male concern about longevity and fading personal attractions, a peacetime preoccupation. It is the classic tale of delusion, of desire which cannot be fulfilled because mortality must decay and is stronger than immortality; they are in some sense fatal to each other, intelligence faltering on one side and sexual power on the other.

The extreme youth of Eos' lovers may well be the older center of the myth, the helpless infant dead being mothered by a kindly *ker*, like the little corpses seen in their cradles on the ends of Mycenaean sarcophagi, or the bodies which

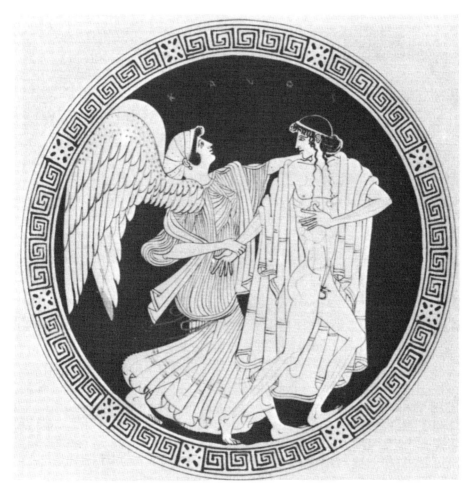

FIG. 16 Eos the dawn-goddess rapes Tithonos from Troy:
Attic red-figured cup, early fifth century.

seem so young and light for Sleep and Death to carry. Dawn is one of the transporters out of the darkness toward the rising sun and the Ocean, and the dead cling to her in the air since they have no other mother to turn to (fig. 17). Naturally these childish pictures have an advantage for the artist too, since it is more persuasive that the light-winged Dawn could carry such burdens; when she cannot, when she lifts her dead son Memnon in her arms, he is rendered on a heroic scale and we know he is too heavy. Sleep and Death must intervene. But a more subtle impression is conveyed by the small boys, that the Dawn has taken on the role of the chief female singer of the funeral lament, and that her emotion is *pothos*, which would later in manipulative hands be converted to full *eros*.

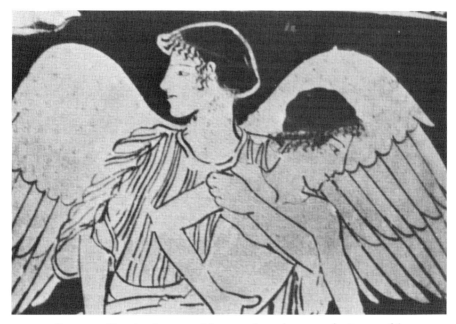

FIG. 17 Eos the dawn-goddess carries a boy to a better world:
Attic red-figured rhyton, fifth century.

Ganymede is also hesitant to go, although he will fill the distinguished role of being Zeus' cup-bearer, a post which is often filled from a royal or noble house in the East.[29] If there is other work involved, Ganymede may seem too young for it; and yet his name implies his capacity for work. Zeus is the supreme muscular power among the gods, and the supreme intelligence; his wit and his genitals are the same, *medea*, the intellectual powers and the generative powers.[30] The Zeus who μήδεα εἰδώς is also the Zeus who dizzies the observer of Greek myth with his capacity for union with phalanxes of mortal women who are, in spite of the honor, still careful to transmit their own mortality nearly intact to their sons. If, when Zeus withdraws to Olympos between earthly expeditions, Ganymede is able to put a new high sheen or polish, γάνος, γάνυμαι, upon the *medea* of Zeus, we recognize a myth which shines with intellectual fervor.

In Attic pictures, where the myth served as an impeccable model for pederasty, Zeus as a gentleman about town offers Ganymede the usual love gifts, a cock or a hoop (fig. 18).[31] But he also gave him wings, which many gods do not possess, to account for the sudden disappearance beyond death, and might assume wings himself or send his winged messenger the raptor eagle. We still have the same idea, when a child dies; "an angel took him to heaven because he was so good"; "he went to heaven because God wanted him"; and, to the

"*George! George! Drop the keys!*"

FIG. 18 (*above*) Zeus rapes Ganymede from Troy: Attic red-figured kantharos, early fifth century.

FIG. 19 (*left*) Rape by the heavenly eagle makes domestic difficulties: drawing by Chas. Addams; © 1948, 1976 *The New Yorker* Magazine, Inc.

literal-minded questioner, asking how did he get there? "God gave him wings, dear." Ganymede assumes his new wings to mark his passage, and to play his new immortal role as Zeus' private Eros. Angels of love and death are still winged for us.

After the fifth century it grew more popular to conceive of the rape of Ganymede with the big bird coming out of the skies to get him. Erotic mismatching of bodies was a classical taste; such sexual fusions as Leda and the swan—"Zeus brilliant through the upper air snowfleshed on swan's wing" (Euripides, *Helen* 215)—would replace the archaic vision of the Harpy or Siren with her dead warrior. The birds of the *Iliad* also played a role somewhere between death and rape, as the vultures wived the corpses. Sappho's Aphrodite crossed the gulf between gods and men behind lecherous sparrows whirling on crowded wings, and the soul exalted in love is lifted, on alien wings or on its own. What Paris gave Helen was more than a long sea-voyage, it was wings for flight: ἀναπτερώσας αὐτὴν οἴχεται ἔχων, "fluttering her up you went off with her" (Herodotos II.115.4).[32] Imperial Romans or Americans specially favored by god rise up with their winged guides in a spasm of violent travel soothed with tender personal concern. This is still the natural mechanism of apotheosis on tombstones.

Greek women are generally not allowed to reach heaven this way; their heaven was thought to exist in sex, in a night's quick union with an Olympian, or perpetual mating in a dark cave with a master of storm, or a trip into a wave

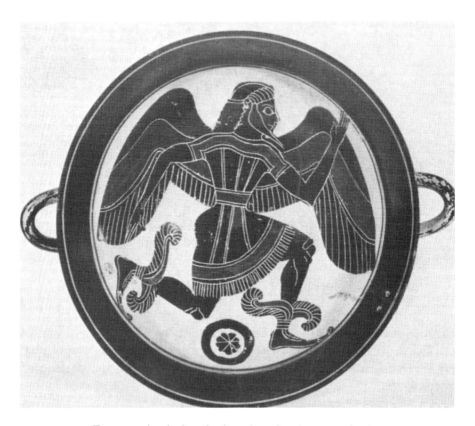

FIG. 20 A wind-god winged at shoulder and heel:
Laconian black-figured cup, sixth century.

of Ocean for peaceful oblivion. For women it is the North Wind Boreas or his
sons who descend "for the sake of their beauty," winged at shoulder and ankle;
they descend like Ibykos' Eros the storm-wind, or Sappho's Eros who rattles
her wits the way a wind falls on mountain oaks (286 P.; 47 D.). Like Eros and
Thanatos, like Eos, the wind-gods play a double role in the game of disappearing
mortals, lighting their funeral pyres or carrying them off for love, as Boreas
took Oreithyia from the grassy riverbank in Athens. That scene was not
painted before the historical moment when Boreas helped Athens against the
Persian fleet off Euboia in 480, but when it does appear in early classical art it
codifies a much older theme. The wind-god comes in agitated power with
bristling hair and ruffled clothes, he who was the father of storm-footed horses,
who mated with the Harpy, ἁρπυῖα, the storm-gust who is also *thuella* the
snatching hurricane.

Greek women had for centuries wished to die in such an embrace, especially when they felt stupid or uncertain, as men might wish the earth to swallow them in similar moods. So Penelope's dramatic desire, "I wish a storm-gust would snatch me up and carry me along the misty paths and drop me where surging Ocean pours his streams" (xx.61f.), as she begins the affecting tale of the daughters of Pandareus who were snatched off by *thuellai* or *harpuiai*—the terms are interchangeable. So Helen wants the *thuella* to have taken her: "how I wish a wicked whirl of wind had carried me into the hill or the wave of the noisy sea, where the wave would have washed me away before these things could happen" (VI.345). These were similar destinations, the cavern or the cavern of the deep. It is a safe feminine wish, unlikely to be fulfilled, and it is usually made in poetic contexts where Eros threatens or delays.[33]

The terrific power of storm-winds living in mountains and blasting out through caves along the light-legged paths of the winds, λαιψηρα κέλευθα, made them natural carriers to unexpected invisible places. Alkaios had the idea that Eros was himself the child of the west wind Zephyros with gold hair, and the rainbow Iris (327.3 L-P.). This may be a spontaneous idea, or a pedigree of respectable antiquity in the Aegean, considering Mycenaean references to the priestess of the Winds at Knossos, and to Zephyros at Pylos, or the epic formula for the dead going ὑπὸ ζόφον ἠερόεντα, under the windy dark, Zephyros' home in the west.[34] Zephyros is as competent an impregnator as Boreas; and fathered the famous Trojan horses on the Harpy, the payment for Ganymede caught up by the storm wind for Zeus. He is most often seen taking young boys, but his sexual powers were clearly not restricted.[35]

The Harpy-winds are most beguiling on the Harpy Tomb of Xanthos in Lycia.[36] They are the mother-birds at the corners, carrying the little bodies of the dead who retain enough life and emotion to reach up their arms about the Harpies' necks with love. Here is a happy guidance and caring, a voyage not necessarily to Hades at all, but to some kind of fruitful paradise which the Harpy's aesthetic descent from Egypt might promise. Of course the scene is more Lycian than Ionian, the Lycia of Sarpedon who may be linguistically related to the Harpy; so Sophokles wrote that the winds lived in caves by the rock of Sarpedon, ἐν ἄντροις, ἔνθα Σαρπηδὼν πέτρα (*Tympanistai*, fr. 575), a Sarpedon cliff distinct from the Atlantic island so called by Stesichoros and the island of the Gorgons named by Hesiod.[37] It is not too surprising that Homer makes Sarpedon the subject of the only big snatch in the *Iliad*, though he transformed the carriers from lady birds to Sleep and Death, to match more familiar configurations of epic mortality.

Harpies are often difficult to distinguish from Sirens until the latter's feet grow webbed; they are equally charming as they wait, so often, under the handles of vases with battle scenes, until the dead warrior is ready to go—often simply ornamental figures, but with an inherited content in the language of

FIG. 21 A Harpy cradles a dead man on the way to a better world:
Lycian marble relief from a pillar-tomb at Xanthos, early fifth century.

war art. Like other wind-gods and rapists the Harpies seem deeply attached to those they remove. However, the transformation they effect may be too private in its happy obscurity; so they are thought to have snatched away Odysseus without *kleos*, though probably careful of his other needs (i.241).

Of all the winged lovers and death-*keres*, Sphinx is the most muscular and erotic. We have seen her as a death-angel on Mycenaean coffins, and as a guardian of the house and the tomb.[38] Her glide into the classical world of war and funerals was assured by the beginning of the seventh century, where she would join a procession of soldiers, accompany the ekphora, and mingle with the dogs and birds of battle, whose features she combines. Like the funeral horse and the mourning woman, she is embroidered upon the robes of Athenian ladies performing the lament, or painted on dice for the underworld game.[39] She waits beside the younger Harpies on the field of battle; like the Siren, she marks the tomb; her most general function throughout classical antiquity is to act as watchdog on a grave stele or pillar, to punish those who disturb the dead. The dead are at once her victims and her lovers.

The Sphinx is exceptionally attractive and intelligent, a singer, the poetic hound, ῥαψῳδὸς κύων (Sophokles, *Oidipous* 391) who makes her victims sing or sung about, "carrying her tuneful hunting in her talons," ἀοίδιμον ἄγραν (Euripides, *Elektra* 472). She is sometimes treated as the Hound of Hades, the equivalent of Kerberos on the female side (in myth she is his niece, fathered by Geryon's dog but harder to kill than her father); like Kerberos, a wingless version of her can occasionally be seen following on a leash behind Herakles, acquiescent because she is interested in men.[40] Greek artists often emphasize her femininity, giving her human breasts or swelling teats, like a lion's, full as though she had just given birth and were ready to suckle, or were ready for an episode of passion. The difference is that a lioness in this mood can usually find a lion, but the Greek male sphinx is notoriously rare and shy; in any case, the female sphinx really prefers young men.

Sphinx spends much of her artistic life talking with young boys, with Oidipous or other youths of Thebes, posing them riddles of what life and manhood may be when they are still too inexperienced to understand, like a demon lover offering new knowledge and sexual success. She combines the clawed body of a man-eater with the wings of a raptor and a face made for love, and clumsy man who prides himself on his intelligence is likely to end up eaten in her cave, a bordello full of bones, and a cavernous passage to other places. A series of late archaic pictures show Sphinx inflamed with erotic desire, pursuing young men (fig. 23); him she catches she cradles in her paws close to her swollen belly—like a mother with her young? A lady with her lover? A hungry predator?

> ὑπὸ λεοντόπουν βάσιν
> ἀποφέρουσ' ὠκύπτερον

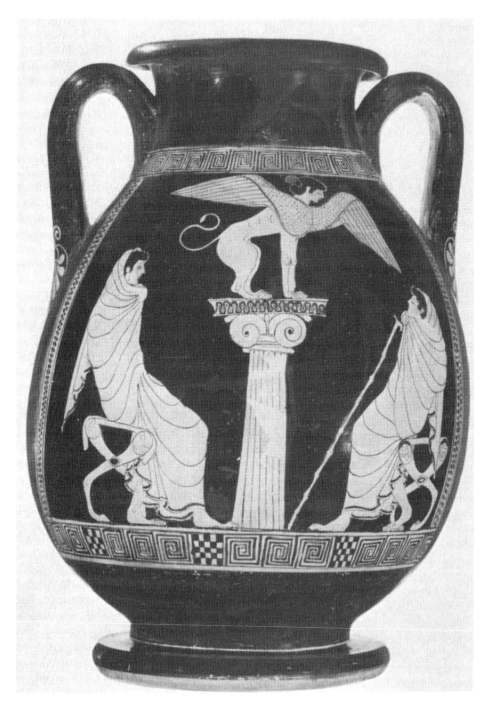

FIG. 22 The Sphinx on her pillar instructs the youths of Thebes:
Attic red-figured pelike, fifth century.

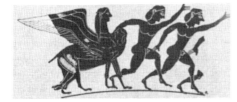

FIG. 23 The Sphinx pursues attractive boys and gets one: Attic black-figured cup, late sixth century.

"snatching away in quick winged lionfooted motion."[41] The songs of the Sphinx that accompanied her quest for young men must have had different tunes we can barely imagine. Sometimes the boy is an ephebe, armed and alarmed, who fights back (though he may smile); sometimes he is quiet and contented, and seems to learn more from his mentor than the infant dead whom the Harpies carry. From small archaic gems to the great marble composition

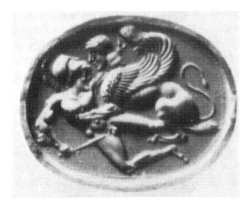

FIG. 24 Sphinx gets her man: chalcedony gem by the Semon Master, early fifth century.

which once ornamented the throne of the Pheidian Zeus at Olympia and was reproduced at Ephesos, the theme of the raping sphinx was a popular and important one for Greeks reflecting on mortality. The act of death could be an act of love. It could be painful or pleasant, but for Greeks it was usually instructive. The winged agent of death might protect the body, or mother it, straddle it like a battle companion, or mate it; it always knew what to do next, and could guide a mortal to a state of which he had no experience before.[42]

In this context, it is not surprising to find on one odd gem a figure of Eros masquerading as a sphinx (fig. 25).[43] Eros is a changeable power with daimonic transformations; as hunter, as raptor, as a winged companion of lions and a song-maker, as a form of Thanatos, he fuses well with Sphinx. But most of all, winged Eros is master of the cock, the favorite Athenian love gift; and of the cock-end of that typically Greek invention the phallos-bird, a playful and witty animal—the pecker, τὸ πουλάκι, *le oiseau que les femmes adorent, das Vögelschen*—it too can be the agent of travel in strange realms and may substitute for

Fig. 25 Eros as a sphinx:
bronze ring, fourth century.

more normal angels. It is surely in this sense that the phallos is sometimes
marked on the tomb, defiant of death, and that the phallos-bird who shares
with the dead a consuming need for fresh water may haunt the bird-bath or
mark the grave (fig. 26).[44] In other pictures the phallos-bird may have clawed
talons like a Harpy, and carry a flower-tendril like Eros who comes with the

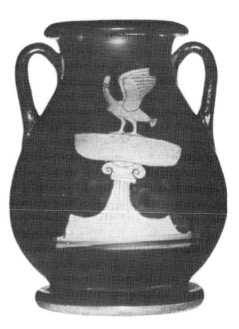

Fig. 26 A phallos-bird perches
on a bird-bath (over a grave?):
Attic red-figured pelike, fifth century.

FIG. 27 A phallos-bird as a
soul-bird in poetic reverie:
East Greek kalpis, sixth century.

spring flowers, a soul-bird singing a siren song, unmistakeably headed in the right direction.[45]

The whole range of games which Greek poets and painters play around the theme of the winged angel of death springs from a very natural feeling that *le coq, c'est moi;* and that both their generative and their intellectual powers are welcome to the gods, and may, with god's grace, survive death. This must be the message of one of the most peculiar of all Greek grave-reliefs—it seems to be a grave-relief and not a public monument—from the island of Kos, made about 530 B.C. It presents death as a continuing wild party, a symposium where the music sounds and the bodies refuse to yield to the chill of mortality, but enjoy life even beyond its natural end until collapsed in exhaustion on the floor.[46] Even the Etruscans produced no more joyful and hopeful monument.

The same hope is expressed in one of Anakreon's pleasanter poems, which ends, unfortunately, in a pun I cannot translate:[47]

> There is gray upon my temples
> and my hair is turning white now;
> my delightful youth is passing
> and my teeth are rather aged;
> of the sweetness of a lifespan
> not so many days are left me—
>
> so my sobs rise close together
> because Tartaros has scared me;
> for the inner room of Hades
> is a frightful place, and savage
> is the path down and a man might
> never get it up again there.

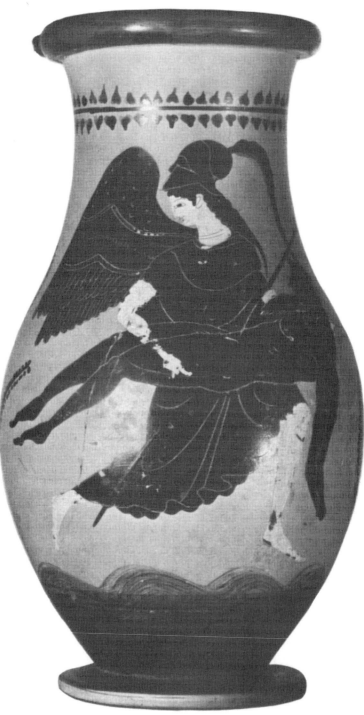

FIG. 28 Athena carries a dead soldier over the waves:
Attic black-figured olpe, late sixth century.

καταβάντι μὴ ἀναβῆναι: possibly "deflated," "amputated," "not mated," but the rendering is difficult. So, for some poets, there is doubt that the way down and the way up is one and the same, but humor allays the common fear.

What is perhaps wrongly called here the pornography of death is only one part of a far more general and serious theme, interconnected spheres of fictions through which the Greeks insisted upon their real goodness and desireability— qualities which were noticed by the gods, and to which they responded by coming down swiftly from heaven with all *medea* flying. Greek fantasies of being lovers of the gods were linked to their certainty of being children of the gods. The gods loved them as partners, and cared for them as parents, the creators and progenitors who would, in some hopes, take care of them when they died. Death on the wings of the morning had two sides. Eos the Dawn goddess' disappointment in a mortal love was less enduring than her feeling for her half-mortal son Memnon, killed by Achilles, weighed and found not wanting, but with a surprising potency of mortality in him which overcame the divine strain. The love expressed as his mother carried his dead body across the seas is the same love virgin Athena shows toward the dead warrior she lifts in her arms over the waves, beyond both sex and motherhood, a lasting *pothos* and mourning (fig. 28).

Death grieves the gods, and more especially the goddesses, but they can displace some of the grief with *pothos* and *himeros*, with sung lament, with the comforts of Sleep and Death, and with a love which has some power to revive the darkened mind. On a ruined lekythos whose spoiled surface still repays attention, the gift of the living to the dead awakens a response, which is Eros itself, replacing the winged *psyche* of more ordinary imagination.[48] It is not the phallos-bird, or the rape, but the complex of loves between men and gods which have ultimate power to withstand death. In the familiar words of the psalm,

> Such knowledge is too wonderful for me: it is high, I cannot
> attain unto it . . .
> If I ascend up into heaven thou art there: if I make my bed in
> hell, behold thou art there.
> If I take the wings of the morning and dwell in the uttermost
> parts of the sea
> Even there shall thy hand lead me and thy right hand shall
> hold me . . .
> . . . the darkness and the light are both alike to thee,
> For thou hast possessed my reins: thou hast covered me in my
> mother's womb.
> . . . I am fearfully and wonderfully made.

The Greeks shared those feelings of mystery, but, being Greeks (and this may be the reason many of us are Hellenists) they lightened the potential bathos of the theme with frequent, necessary, and refreshing sparks of irreverence and self-mockery.

FIG. 29 Eros unites the dead and the living:
Attic white-ground lekythos, fifth century.

VI

SEA MONSTERS, MAGIC, AND POETRY

Death, like a narrow sea, divides
That heavenly land from ours.
ISAAC WATTS, "When I Survey the Wondrous Cross"

THE SEA looks harmless in most Greek pictures, because the sound is left out.
Poets better than painters control the sudden storm-winds, the waves groaning
on headlands, the black ripple on the surface under the north wind, the colors
changing from green to gray to dark purple and black. The sea is the more
dangerous because you cannot look far below the surface, however much light
plays across the top; it is as dark as the underworld below, with its own liquid
paths, deep valleys, crossings, ποροὶ ἁλός, βένθεα and hollow or silvery caves,
where the Nereids dance and sea monsters, the *ketea*, lurk behind rocks, where
Tritons pasture their underwater flocks, and the bones of the dead lie rolling
in the sand (xiv.133).

In late archaic and early classical poetry, images which were latent in
Homer crystallized into commonplaces—the sea as the realm of death, and as
the external counterpart of the human mind, changeable, darkened by sudden
storms, "muddled senses on a choppy sea" (Euripides, *Herakles* 1091); over-
whelmed by waves of fortune, life never reaching safe harbor. The old marvel
of the whirlpool Charybdis which spun open until the lower sands were visible
became the door to death through which we are all sucked (Simonides 522 P.);
one sailed to the harbor of Hades' tears (Euripides, *Herakles* 426); or resigned
oneself with not being able to call a father from the common harbor of Hades,
ἐξ Ἀϊδᾶ παγκοίνου λίμνας, with funeral songs or entreaties (Sophokles, *Elektra*
137); the wave of Hades comes alike to all, it falls on the man who does not
expect it and on him who does, κοινὸν γὰρ ἔρχεται κῦμ' Ἀϊδά (Pindar,
Nemean VII.31). A plunge into the water was always a familiar passage to
death, by lake or sea, as in the modern Greek γιοφύρι μεσ' στὸ πέλαγο, σκάλα
στὸν κάτω κόσμο. These basic images provoked later classical poets into con-
siderable marine elaboration of the sea's noise, color, and sorrow, Euripides'
call for help "over the greygreen saltswell and bluefleshed pale foam of the sea"
(*Helen* 1501), trouble coming "through the salt-thudding sea-wave of brine"
(*Hippolytos* 753) or Phaidra "longing in secret trouble to ground her ship at the
sad bourne of death" (*Hippolytos* 139). The admirable Timotheos saw the
emerald sea reddening in shippy drops as she gargled on soul-less bodies; but

179

perhaps the most embarrassingly memorable lines about the sea were not by a Hellene but a Phil-Hellene, Byron's remarkable rhyme

> There is no sea the passenger e'er pukes in
> casts up more dangerous breakers than the Euxine.[1]

Because the Greeks were interested in unseen possibilities, the horizon between what they knew and what they imagined was easily represented for them by the water surface, which provoked a kind of double vision. Painters and poets were both attracted by the two realms which were mutually invisible. The Ambrosios Painter's cup (fig. 1) shows life above and below the water line;

Fig. 1 Boy fishing:
Attic red-figured cup, early fifth century.

the boy knows what he is doing, but cannot see everything, like the octopus hiding under the rock; the octopus knows what is being done, and circumvents it. It is a decorative picture, without overtones, but suggests that communications between up and down are through experience and intelligence. The sea makes a double viewpoint easy, as in the famous simile of the dead suitors in the *Odyssey*, lying in blood and dust like fish hauled out of the gray sea poured onto the sand, longing, ποθέοντες, for the waves of the salt, but the sun draws out their *thumos* (xxii.384f.); the shape of the dead gives the fisherman's viewpoint; the feelings of being at home in the dark and vulnerable to the sun

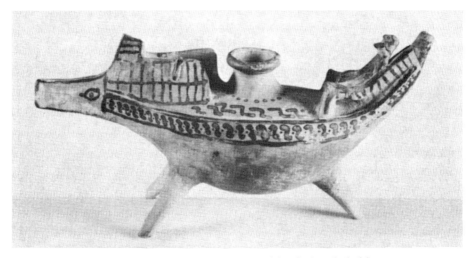

FIG. 2 Pilot or poet at ease on his pig-headed ship:
Late Geometric drinking horn, Boiotia.

belong to the fish, as though man's world and the sea's world were in mirror image, sometimes inimical, sometimes sympathetically linked, like men and gods.[2]

Most pictures cannot do this; they stay on top, and observe surface effects of the moving waves or the wind in the sails; the focus is on the ship, the sailors, the pleasure or danger of traveling, summed up in the early terracotta sometimes thought of as the poet Hesiod on his nervous journey from Aulis to Chalkis to sing in the funeral games, a distance of some six hundred yards which inspired in him remarkable advice on how evil it is for man to desire uncomfortable sea journeys, ναυτιλίης δυσπεμφέλου ἵμερος (*Works and Days* 618).

Ships and sailors and sea battles along foreign coasts were favorite themes from the eighth century on, and the pilots were especially commemorated in votive plaques for their skill (fig. 3). The early dedication at Sounion, near where Menelaos' man Phrontis fell overboard with the steering rudder in his hands, is a quiet but vivid sketch, and evocative of the many contests celebrated for famous dead pilots of the past in coastal sanctuaries. Phrontis, Ponto-noos, Alkinoos, Noemon, son of Phronios (iv. 630); often the names denote the intelligence of the masters of sea voyages, in a profession where the unexpected was a daily happening.[3] The effects of sudden storms and high waves on small wooden ships were frightening enough; at any time an unforeseen impact upon man's ambition might turn him turtle or drown him. But there were further horrors, magnified by those sailors' tales which the sea-life offers time to embroider, about the creatures below who were the worse for being unseen,

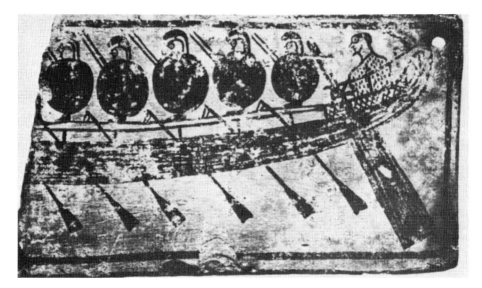

FIG. 3 Steersman guiding armed marines:
Proto-Attic votive plaque from Cape Sounion, c. 700.

and who might frighten a man slipping off the steering oar to the point of
losing all bodily control—a theme not usually associated with dangers on dry
land.

Early poets like to describe the sea as a place where invisible creatures
swarm. There are many Greek words for the sea; one of the most common is
pontos, which keeps some of its connotations as the bridge, the way home at

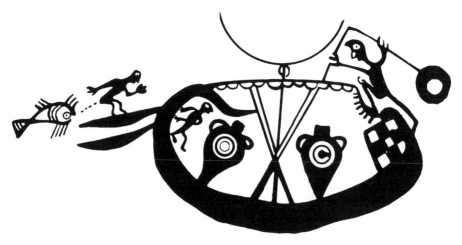

FIG. 4 A frightened sailor falls overboard:
Cypriote Bichrome IV, seventh century.

times with god's grace, but one from which you may unwittingly stray since the track is not marked; each ship cuts its own path fresh, διαπρησσοῦσα κέλευθα, and leaves no blazons; under the bridge creatures wait to bite you if you fall off; it might seem more like a tightrope over an open tiger-pit than a safe road home.[4]

The waters even close to shore were not for cheerful swimming. A hero might step into the waves to wash the worst of his sweat off, as Odysseus and Diomedes do at the end of the Doloneia, but only as far as the hip-joint and thigh. Like Theseus' man on the François Vase who swam ashore from his ship in gladness at the land, ἐπεὶ ἀσπασίως ἴδε γαῖαν (iv.523), a Greek made sure the water was not more than ankle-deep. Swimming was better done in the lovely streams of a river, like Alkaios' girls with their delicate legs in the waters of the Hebros (113 P.). At sea you might end up more like Archilochos' friend, slammed on the shore at Salmydessos, vomiting seaweed and chattering your teeth like a dog (79 D = Hipponax, West 115).

As in the sad tale of the Deacon and the Shark, an encounter the abbots of Mount Athos remember well, though it happened in the ninth century—A.D. or B.C.?—certain places were always hunted by *theria*, the wild animals of the sea. Herodotos knew that the waters off Mount Athos were packed with sea-monsters, long before the deacon took his plunge—θηριωδεστάτης ἐούσης τῆς θαλάσσης (VI.44.3); numbers of Persians were "ruined" there by the animals. These sounded more dangerous for not having specific names, just nameless "*ketea* or dolphins or dogs whom Amphitrite breeds in their thousands" (xi.96), and who perhaps grew less threatening as marine biology developed, dissecting and classifying them. The *Odyssey*, not yet distinguishing much, displays fish at their most dangerous, sea scavengers like the birds and dogs of the *Iliad*: "already the dogs and quick birds have pulled the skin off his bones,

FIG. 5 Sea serpent: Yarmouth, 1897.

or the fish have eaten him in the sea" (xiv.133); "either the fish have eaten him in the sea or he is dessert for the animals and birds on dry land" (xxiv.291); or, like Eumaios' nurse, "they threw her out to be a plaything for the seals and fish" (xv.480). So today, if a corpse is found in Greek island waters, the better-natured local cooks take lobster off the menu for a day, aware what it has been eating.[5]

"Food for fishes" is worse than for birds and dogs, because it is harder to find the body again, and bury it properly. Poetic fish are silent stealthy hunters, voiceless, ἄναυδοι; Aischylos says "as voiceless as a tuna" (fr. 167), registering surprise that such great creatures could be netted without the power to protest. Partly it is because they so look as if they were trying to speak, with *pothos* for a voice. Fish also eat their food raw, ὠμησταί and ὠμοφάγοι, like lions, wolves and Achilles. This inability of animals to cook only disturbs a poet when a human body is in question; we are their meat and they are "uncivilized." Hesiod thinks it is because "justice" has not been invented among them, so Zeus allows the wild animals and winged birds to eat each other (*Works and Days* 277), but when they eat us we are frightened and offended.

In the well-known Late Geometric shipwreck scene from Pithekoussai in the Bay of Naples,[6] two men are still alive under the capsized ship, among twenty-one fish who range from man-eaters to little spectators. Two sailors have lost or are losing their heads, and one his arms; two have lost their genitals, perhaps bitten off by the fish, or perhaps as a sign of low vitality and *medea*. These creatures are the swarming inhabitants of the fish-way, πόντος ἰχθυόεις; heedless, ἀκήδεες like those Achilles imagines eating the boy Lykaon; "your mother will not lay you on your [funeral] bed or raise the *goos*, but Skamander

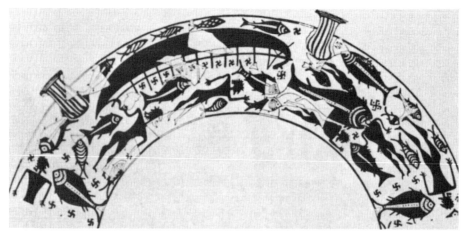

FIG. 6 Capsized ship and sailors swallowed by fish:
Late Geometric krater from Pithekoussai.

will whirl you to the broad breast of the salt where a fish will flash up through the black ripple on the wave to eat your shining fat" (XXI.121). The cruelty of the taunt lies partly in the loneliness of these dead, never joining the rest of the community through proper burial. As Skamander threatened Achilles, "I swear his strength will not help him, or his beauty, or his lovely weapons deep under the mud, but the Greeks will not know where to look for his bones to collect them; I'll build him a *sema*, of sand, he will not need a funeral mound" (XXI.316f.). Personal fame and immortality would be blotted out, without the tumulus Achilles won at the mythical end of his story, "shining far out at sea," τηλεφανὴς ἐκ πόντοιο (xxiv.83).

The eaters under the sea, and the sea's own power to swallow and conceal a man completely, made it natural for the poetic and mythological phrase "gullet of the salt [sea]," μέγα λαῖτμα ἁλός, λαῖτμα θαλάσσης, to develop as an analogy to the yawning earth, γαῖα χάνοι. The sea which welcomed and returned land gods like Dionysos and Hephaistos (who both had ancient sea connections) could also take in tabu objects safely, at the close of particular

FIG. 7 Iphigeneia being sacrificed at Aulis (?), with waiting sea-monsters:
Proto-Attic krater, seventh century.

sacrifices. In the *Iliad*, during Agamemnon's apology to Achilles, the sacrificial boar was thrown to the fish because it should not be eaten by man. "Talthybios whirled it and threw it into the great gullet of the gray salt, food for fish" (XIX.267). The carcass carried the burden of Agamemnon's oath to Earth, Sun, and the Furies under the earth, and the sea was the path of its dedicated travel to the powers below. Another sacrifice that ought not to have been eaten was Iphigeneia, killed as a wind-charm at Aulis. In the upper frieze of the first Greek picture of her, in the seventh century, she is carried toward the sacrificial altar by men; in the lower frieze, as the sea grows calm, tiers of lion-headed fish or sea-dragons are waiting and grinning.[7] For the army to share the sacrifice would be deep pollution, but the cathartic power of the sea is legendary, and, if that is what the painter intended, the guilt of human sacrifice might be washed cleaner with help from the sea monsters.

The sea-dragon cooperates with the swallowing waters in the necessary work

FIG. 8 A Scylla or sea-pantheress chewing a polyp:
Hellenistic chalcedony gem.

of death. Dragons with multiple heads, as on the Proto-Attic krater, are not so common in Greek art as they would become in medieval fantasy, for the few sea-monsters of Greek myth are meant to be killed by a single hero, in the eastern style; and such combat was dangerous enough without a complication of mouths. Scylla was always the many-headed favorite, thrusting out of her cave six necks each with a terrible head, each mouth with three rows of teeth, "full of black death" (XII.90f.). On this the *Odyssey* scholiast remarks, "more likely a dragon than a dog, for only dragons have three rows of teeth," revealing the classical scholar's passion for verifying the facts.[8] The six-headed version was hard to draw; more often Scylla is a single-headed pregnant dog eating polyps.[9]

The gullet of the salt is less kind than the hollows of the earth to the dead, who are more lost in it. More Greek cenotaphs replace the bodies of drowned men than of soldiers lost on the battlefield, and early epigrams stress the substitution of the stone, the *sema*, for the man. "This is the *sema* of Arniadas; grinning Ares ruined him as he fought by the ships . . . "; "this is the *sema* of Deinias whom the shameless *pontos* lost"; Neos of Sikinos got a *mnema*, but "the sea veiled me, myself."[10] Tombstones carved with wrecked ships begin later, in late classical to Roman times, but stress the same loneliness as the epigrams do:

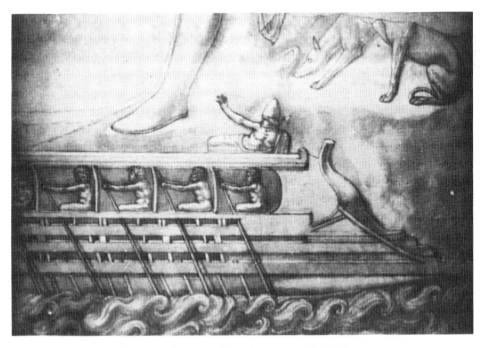

FIG. 9 Grave relief of a man and his dog,
evidently lost at sea and mourning: early fourth century.

the dead man by his ship on an empty shore, or the ship going on alone. A man lost at sea might be less likely to join his family in the underworld, unless the incomplete burial could be strengthened by ceremony and a stone image, a partly magical function. The Egyptians also made a point of reassuring drowned men, sunk under the ripples, that they, too, could "come to the other side." As the Gloucester poetess said,

> God bless them all who die at sea.
> If they must sleep in restless waves,
> God make them dream they are ashore,
> with grass above their graves.
> [Sara Orne Jewett, *The Gloucester Mother*]

The sea was full of domestic flocks as well as predators, just as on land, since there were wild and tame countrysides in it. The flocks are the seals of Proteus,

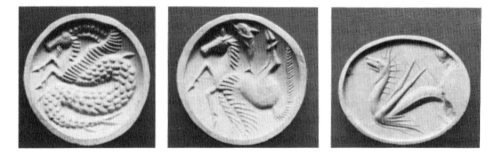

FIG. 10 (a) A sea-goat and (b) a sea-horse: green steatite gem from the Greek islands, seventh century.

FIG. 11 A sea-serpent: chalcedony gem from the Greek islands, seventh century.

or the *ketea* schooling around Poseidon's chariot wheels, or the winged goat-fish of early island gems, or the sea-horses.[11] Their shepherds are creatures like Glaukos of Anthedon, the fisherman who became immortal by eating grass, and who even drove land cattle into the water to add to his sea cows; or Triton with his obscure watery name. Triton most attracts the painters of the two edges of his domain, eastern Greece and Etruria; he may be painted with human legs and a long fish-tailed bustle, chasing sea-horses in the water, or he may be fish from the armpits down, playing with fish, possibly catching them for dinner.

These sea-herders were simple rustics; probably there is no significance to the vines the Tritons sometimes hold, but it was the fruit of the vine that caught the saddest Triton of them all, the one Pausanias saw stuffed at Tanagra.[12] He was the reverse of Glaukos, an immortal tricked into death. Perhaps obstreperous, and like many immortals hard to control or filled with sudden passions, he used to steal cows and boats and attack women in the water. One night they

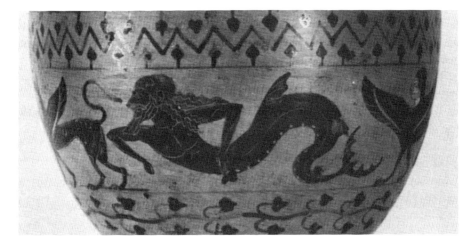

FIG. 12 A Triton swimming:
Etruscan black-figured amphora, sixth century.

set a bowl of wine out for him which smelled so sweet he came on shore, got
drunk, and had his head chopped off. The body was exhibited as a local
curiosity, "monstrously fat and bloated," a predecessor of Mr. Barnum's
hideously attractive Feejee Mermaid, whose "mouth was wide open, revealing
bestial teeth, and the whole expression of the face gave the vivid impression
that the animal had died in extreme agony." The Tanagra Triton of course
had no head, but a smaller one exhibited in Rome had also a "broad mouth
and bestial teeth"; the siren-mermaid sighted off the Sandwich Islands in
March, 1869, was seen, when the sailors threw her oranges, "to have a magni-
ficent range of yellowed teeth"; and the sea-monster or mermaid caught
recently off Tanzania was also reported by the Ministry of Information to have
had good teeth as well as "one ear, a horn, a hump, a glowing eye, and a
beard."[13] The Greeks were not alone in their vision of the biters of the sea, the
Scyllas and the *ketea*, "and if Amphitrite breeds anything worse."

Grass made Glaukos immortal (it was his *pharmakon*) but wine was poison to
Triton, as it was to most innocent half-wild creatures—the centaurs, the giant
Polyphemos—as were the "ephemeral fruits," the grapes which weakened him,
to the monster Typhoeus when he was on the run from Zeus.[14] Wine was too
civilized for monsters who usually drank clean water or milk; Polyphemos
thought it must "come from where nectar and ambrosia flow in abundance"
(ix.359), as fatal to him as nectar to men. For men, conversely, wine often
created an interior sea on which they floated, or dreamed they made fabulous
voyages as the cups circled round, cups often painted with ships and dolphins,
with sea-god or wine-jar at the center—love and hope flashed through the

drinkers' wits, dreams of monarchy and "grain ships bringing the greatest wealth from Egypt across the shining sea-bridge" (Bacchylides 20B.14); "the tiring anxieties of men float out of the breast, and we all swim in a sea of golden wealth toward a cliff of delusion" (Pindar 124S.5). *Ephemeroi*, used to ephemeral fruits, need these delusions and visions, false prophecies of the future and voyages to happiness filled with sea-music which the best kind of dreams are made of, although drink may provoke eccentricities of behavior in the body that is left behind while the soul is dreaming.[15] For the Greeks the sea of wine was a *pharmakon* for the anxieties of life, and focused their imaginations on the prophetic powers and songs of the sea-daimons.

Almost all sea-creatures have the gift of prophecy. It may be minor and limited, but some who were born with the beginning of the world, older than the Olympian gods (Hesiod, *Theogony* 131, 233), had vast aboriginal experience combined with knowledge of the intense constant changes of the sea under wind and sun, and their prophetic power had an authority which land oracles and newer gods could not rival. It was a knowledge of multiple possibilities, of transformations, mutations, and grandeur because it was not limited to the simple affairs of men on land. Sometimes their personal vision is short: Triton or Proteus are unable to foretell that the mortal who pesters them will hold them in the end and force their knowledge out of them. Yet each mythological figure under the waves has a touch of the gift, from the boys riding on their

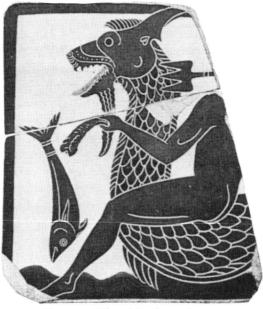

FIG. 13 The rider from the sea:
Corinthian votive plaque, sixth century.

ketos-monsters to the Old Man of the Sea, ἀψευδὴς καὶ ἀληθής, Nereus who does not lie, who is true, who knows just and gentle thoughts (Hesiod, *Theogony* 233).[16]

Sea-daimons control the paths of knowledge as they go along the liquid ways, the ὑγρὰ κέλευθα, the fish ways, ἰχθυόεντα κέλευθα (iii.177), which correspond to the misty ways inside the earth, ἠερόεντα κέλευθα, or the light-legged paths of the shrill winds above, λιγέων ἀνέμων λαιψήρα κέλευθα (XIV.17, XV.620). The tracks of the cosmos are only visible on earth, though you need a guide with knowledge to go down along them; the other tracks of wind and water vanish as they happen, like the paths of Night and Day or the paths of thought. The ship cuts her track on top of the waves, the fish make theirs under the surface; and below that there are hollow and polished caves, or the silvery caves the Nereids dance in, and the known paths and crossings of the salt, πόροι ἁλός, at many levels. The figure of the rider in the sea is widespread in European mythology; he and the other prophets like Ino the white goddess, who was once a "speaking mortal," or Glaukos, who spoke "to those who wished it," could be guides along the paths of the sea; and the paths usually ran in two directions, one toward home, and one toward a kind of paradise with vines and fruits.

This was the place the Greeks sometimes called the Garden of God, which was not easy to find, and which contained either mysterious fruits of immortality, like the gold apples of the Hesperids or the gold fruit of the Egyptian tree-fairy, or was sometimes a magic vineyard with Dionysiac goats where maidens tended the grapes.[17] As the daughters of Hesperus were associated with

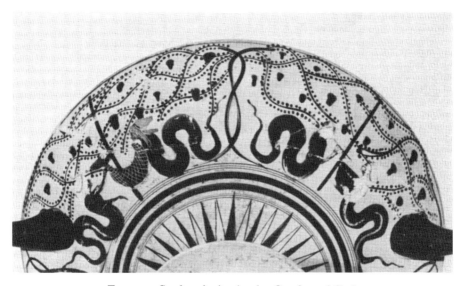

FIG. 14 Snake-virgins in the Garden of God:
Attic black-figured cup, later sixth century.

the snake or dragon who guarded their garden, so these virgins, *parthenoi*, are themselves part snake, μειξοπάρθενός τις ἔχιδνα (Herodotos IV.9.1) and we should imagine them singing to themselves at work, like the clear-voiced Hesperids or the earth-born goddesses who guard Libya, χθόνιαι θεαὶ αὐδήεσσαι (Apollonios Rhodios IV.1322). We have already noted the impressive or beautiful voices of most of the enchanters in the west. The gardens, islands of flowers, orchards of potent and possibly life-saving fruits, and wordless songs are not places where men can find an alternative to death, exactly; not a fixed row of Elysia, but places any man who wanted to learn more of the world would want to reach, without knowing how.

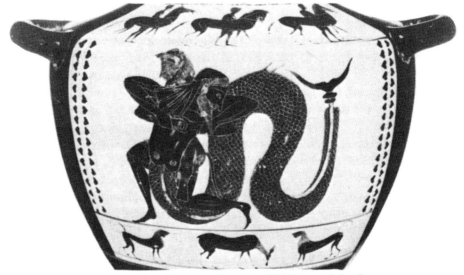

FIG. 15 Herakles wrestling the Old Man of the Sea:
Attic black-figured hydria, sixth century.

The speakers in the sea were sometimes reluctant to give the desired information, or show you how to get where mortals are not supposed to go—so, the popular scene of Herakles wrestling with mutable Triton or the Old Man of the Sea, the Halios Geron, to find the way to Geryon's island. Herakles must sometimes use considerable force; one early sherd at least seems to show the Old Man in distress from a bang on the nose, and black marks on his face like bruises.[18] By the fifth century it is more often accurate, kindly Nereus in human shape, νημερτής τε καὶ ἤπιος (Hesiod, *Theogony* 235), but he is still unwilling to tell all the secrets of the sea. When any sea-god speaks at last he is unerring in language, with an *epos nemertes*, and his language is less directed to the ways of the journey or to the future than it is to uncovering secrets of the past, toward which human curiosity is so strongly drawn.

The solitary prophet in the sea may avoid men or try metamorphosis to delude them. The sea-monster, who cannot change his shape, is also solitary by nature, but at moments in his life he may be passionately attracted to men or starved for their company, which makes him a nuisance. Prophets and monsters personify two aspects of the sea, which for the Greeks was ever double-faced and changeable, sometimes the way to paradise and sometimes the jaws of death, but never predictable. Most sea-dragons of ancient times were male, or seemed so to sailors, and their masculine drive made them more dangerous when they fell in love—which was generally with the daughter of a king, since they have excellent taste and a sense of self-respect.[19]

The myth of the sea-dragon and the princess came to the Greeks from the East, in the parallel versions of Herakles and Hesione, Perseus and Andromeda. Greek story-tellers usually suppressed the genuine love-feelings of the monster and stressed his devouring powers, perhaps because in their own mythology the dangerous lovers of the sea are female, like Nereids and Sirens.[20] Perhaps it is also Greek that the dragon attacks the hero, not the girl. "The dark-haired god [Poseidon] led the way to the heaped wall of holy Herakles, the high wall which the Trojans and Pallas Athena built so he might run up there and avoid the *ketos* whenever it should rush him from the shore to the plain" (XX.144f.).

Part of the original attraction of the story must have been the wedding of incompatible bodies, the element of erotic shuddering which is often associated with European tales of the dragon's bride—the virgin raped beneath the waves, and drowned in the act of love. In classical art the usual Perseus scene shows Andromeda as the dragon's bride, bound to a rock and surrounded by Aithiopian servants bringing her bridal dowry to the shore, the wedding to be consummated by tooth; or, in illustrations of tragedy, she is tied to a wooden pillar in the proskenion of the theater at Athens. We do not know how the dragon was managed—offstage with roarings, perhaps, or with papier-mâché. In the tale of Hesione whom Herakles rescues from the amorous monster different aspects are emphasized—the hero is swallowed by the dragon and emerges again to life, or the hero and heroine combine to frighten the dragon off with arrows against which he cannot retaliate, or rocks which pound his head and tongue (fig. 16). When the dragon has been reduced to quiescence, Herakles draws his sword to cut the tongue off (fig. 17). The Greeks may have regarded the dragon's tongue as a simple trophy, so the hero can prove to the king what he has done, since the whole creature would be too big to bring. Considering the magical properties of dragons' tongues in other lands, or drops of dragon blood, and their power to help you understand new languages, like the language of birds (Greek land-dragons taught it by licking men's ears), one wonders if the motif of the dragon's tongue was not once more meaningful to the Greeks than it is in the late folktale versions we have.[21]

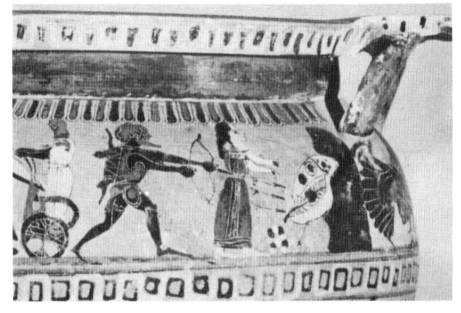

FIG. 16　Herakles and Hesione battle the sea-monster at his rock:
Late Corinthian column-krater from Italy, sixth century.

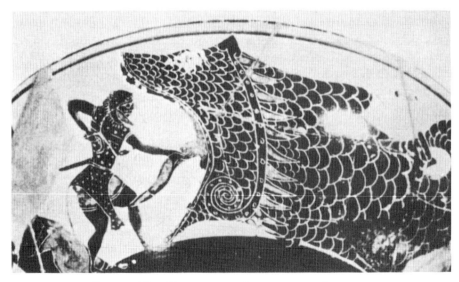

FIG. 17　Herakles cuts out the sea-monster's tongue:
Attic black-figured cup, sixth century.

FIG. 18 The armed hero emerges from the sea-monster's belly:
sard gem, early fifth century.

FIG. 19 Winged Gorgon as a lion-sea-monster:
bronze shield blazon from Olympia, sixth century.

When female dragons were considered they were even more deadly, like Scylla, or loving, like Lamia. The chief of the sea-queens, or sea-dragonesses, was the Gorgon, who is often represented with a split snake-tail, or a great fish-tail. Her tongue is always conspicuous. The only mortal Gorgon of the three sisters, she was also the only one to become immortal in poetry; drops of her magic blood could kill or cure. In a recess of Greek thought which is somehow just beyond analysis, she was not simply herself a source of death, but also the source of the music of the funeral song, the sound Athena wove from the Gorgon's snake-hair as she sank weary into the grief of death; and the music of the funeral *goos* is, we know, the only effective way to speak to the dead and perhaps to raise them. This double aspect of destroying and healing has come, by curious but understandable by-ways, to be represented in Greece by the figure of the Gorgon Virgin Mary, the Panaghia Gorgona, in a summation of ancient fantasy: the queen saving the ships at sea, the birds flying, the *ketos* swallowing the sailor who fell off the *pontos*-bridge, and the mermaid singing while she holds a human head (or is it her own reflection in a mirror?).

Fig. 20　The Virgin Mary as the All-Holy Gorgon,
riding a swallowing sea-monster:
nineteenth-century Greek icon.

The motif of the severed head, the speaking, oracular or poetic head, is, like the Gorgon's head or the dragon's tongue, an old fantasy, as though language and knowledge could survive death if anything could. There are several Greek heads of this kind; usually it is the head of Orpheus, which floated down the river Hebros over the waves to Lesbos, where it had an effect on Lesbian poetry, answered questions and knew the past.[22] The head of the murdered poet is

FIG. 21 Consulting the severed, oracular head of Orpheus:
Attic red-figured hydria, mid-fifth century.

linked with the dichotomies in the sea, the mute and the musical, the voiceless fish who long for music and, when Orpheus played, "jumped upright out of the dark-blue water with the lovely song" (Simonides 567 P.), set against the singing voices in and around the sea, which contributed an old mythic element to Greek poetry.

Alkman made a curious phrase, "voices with teeth like sharks" καρχάραισι φωναῖς (138 *PMG*). This may reflect a widespread belief that poetry and music can be dangerous, because they exert the same kind of double influence over the soul that magic does.[23] In English, images for the tongue and words are perhaps more drawn from storms and light and winds; for the Greeks the tongue was generally a dangerous instrument, a weapon. Sometimes it launched arrows of language, Homer's winged words, or the gold or rippling shafts of poetry; more often it had a cutting edge: to slice my word, διακέρσαι ἐμὸν ἔπος (VIII.8), the

metallic tongue which could, like Pindar's, be sharpened on the shrill whetstone, hammered on the anvil of truth, launched like a bronze javelin (*Olympian* VI.82, *Pythian* I.86, *Nemean* VII.72), shivered or splintered like Sappho's, or capable of chasing and engraving a whole song, τόρευε πᾶσαν ᾠδήν (Aristophanes, *Thesmophoriazousai* 986). The tongue was a sharp sword to wound, as in Sophokles' *Aias*, γλῶσσά σου τεθηγμένη (584); the mouth may be iron, hardened or softened in the tempering, the voice may be bronze, χαλκεόφωνος, like Stentor's, or Kerberos', or the voices of the women on the Shield of Herakles who stand on the city tower and shout their sharp bronze cry.[24] We are used to sharp tongues, but the Greek conceit seems to go beyond our own, in words that are harsh whetted swords, τραχεῖς τε καὶ τεθηγμένους λόγους (Aischylos, *Prometheus* 314).

Poets equipped with such special weapons often think their work is real, and therefore important, with power to influence the listening world for good or bad. This is a natural, and historically true if partly childish, assumption of a talent to control minds, related to but separate from the tribal roles of the poet-magician or the shaman, enchanter, or wizard. The poet uses some of the same technical devices as the magician, who frequently needs marked and simple rhymes and rhythms. The only Greek witch I ever met wrote to foxes in rhyming couplets on white papers she tied on trees with string. The power is in the word, or formula, or rhyme, which may lose its efficacy if changed. We do not know what Odysseus' family in the boar-hunt on Mount Parnassos sang over his thigh to stop the blood spurting (XIX.457); they used *epaoidé*, a sung chant, perhaps nothing more elaborate than Cato the Elder's song for a broken limb, *huat hanat huat, ista pista sista* (*De Re Rustica* 161).[25] Only a few examples of Greek poetic magic before 400 B.C. survive, yet obviously there must have been words to go with the whirling of the Geometric clay-wheel with *iunx*-birds bound on the rim for a love-charm. There are clear wizard phrases in Aischylos, particularly in the impressive raisings of the dead, Darius in *The Persians* or Agamemnon in the *Choephoroi*, or the binding hymn of the Eumenides, ὕμνος δέσμιος or καταδέσμιος; and there may be diluted magic in children's rhymes, or in the fixed formulas of curse tablets, or some utterances of Empedokles, or even of Gorgias.

The poets share a large vocabulary with the magicians, and feel, like magicians, that the results can be for good or bad, like the drops of the Gorgon's blood or the sword-tongue, depending on who is using it for what purposes. The shared language mostly centers on *aoidé* or *epaoidé*, on *thelxis*, θέλγειν, on enchantment which may apparently be silent, as Poseidon silently enchanted the eyes of Alkathoos at Troy and bound his limbs in chains, θέλξας ὄσσε φαεινά, πέδησε δὲ φαίδιμα γυῖα (XIII.435); the *pharmakon* is used by both, and γοητεία, general magic or specific necromancy. Words often have a power for evil, in seduction or deception, as Aigisthos seduced Klytaimestra enchanting her with words (iii.264); Kalypso tried with Odysseus, in soft deceptive words

FIG. 22 A magic wheel with *iunx*-birds tied on, for love charms?:
Geometric, eighth century.

on an island charged with the scent of magic drugs and song (i.56, v.173);
Achilles thought his mother had enchanted him with lies, ψευδέσσιν ἔθελγεν
(XXI.276), but being a sea-creature she told the truth. The singer also en-
chants, the ἀοιδὸς ἀνήρ, as Eumaios says, laying a spell on the heart, θέλγοιτό
κέ τοι φίλον ἦτορ (xvii.514), so that poets declare they have magic powers to
ensnare the soul and manipulate it, subjecting the listener's mind to the poet's
will or way of seeing things, in the state of one momentarily captive or bound,
ῥιπαῖσι κατασχόμενος (Pindar, *Pythian* I.10).

It is in this sphere that the Greeks felt the poet had a special responsibility he
could not always be trusted to discharge properly. When poetry-magic of a
personal kind needed to be done, there were drawbacks to putting yourself in
the hands of a professional, who might not use "the true voice," a matter of
particular concern for the *goos*, the *goes*, and the funeral song.

There are basic techniques for communicating with the dead, with rules
reflecting their own slightly stupid and sleepy condition and the dangers of
calling up the wrong one; you must remind him of his name, his titles, his
exploits, and that he is loved, as Aischylos does in *The Persians*,

ἦ φίλος ἀνήρ, ἦ φίλος ὄχθος

βαλήν, ἀρχαῖος βαλήν, ἴθι ἱκοῦ

βάσκε, πάτερ ἄκακε Δαριάν, οἴ.

(647, 657, 663)

invocations set in a sea of hard simple funeral rhythms and rhymes.²⁶ It worked
all right, on stage; but of course between Homer and classical poetry there was
a gradual, perhaps necessary, tendency to put such matters in professional
hands, not unskilled relatives like the Homeric women of the house who
reassured the dead with love in the *goos*, or untrained but intense Elektra's
rhythmical songs and steps at Agamemnon's tomb, ὦ ἔμβα ἔμβα κατακλαίουσα
(Euripides, *Elektra* 113f.).

In the oldest Greek texts, the mourning soul relieved itself through grief in
poetry. The song was personal, brief and intimate. The *goos* was later elaborated
into more ceremonial and antithetic forms; the responses were still sung by the
women most grieved, but a professional *exarches*, leader of song and sacrifice, a
poet, was called in and paid to "remember" the dead for the family. By late
archaic times, the poem had, on occasion, been dissociated from the body,
shifting to the third person or to the soul, as in our own funeral services, or as
in Simonides' song for the dead at Thermopylai: "their tomb is an altar, theirs
memory in place of *gooi*, praise instead of pity"; handsome intellectual rhetoric,
with direct communication gone. Simonides could contrast *goos* and memory,
mnastis, but once they had been the same. As others came to sing your songs for
you, so others began to raise your dead for you and speak to them on your
behalf, speech filtered through an uncaring and talented third party. This
growing professionalism of *psychagogeia* corresponded with the anxiety of fifth-
century intellectual lost souls to retrieve them at reputable institutions, like the
Soul-Finders College run by Sokrates at the lake of the Shadow-Feet (Aristo-
phanes, *Birds* 1554).

By the fourth century, when Plato had the roughest things to say about
magicians, enchanters, druggists, and poets, the new professionalism had rebuilt
and modernized, on the chthonic edges of Greece, the class of establishment
later so mocked by Lucian, the Nekyomanteion where people with *pothos* for the
dead could travel to consult their souls on a commercial basis. The one in
Epeiros exploited all the traditional imagery—the voyage, past the White Rock,
the south cliff of Leukas, Leukara, up the river Acheron in a punt, through a
lake with reeds to the fortresslike enclosure of Hades, where your mind was
prepared for visions with cleansing and hymns and a poisonous diet of narcotic
beans, lathyrism. After passing through underground passages (so much less
impressive with the roofs off) with prayer and song in the dark, you came to a
lower room where, by an ingenious lifting device on cogs like theater machinery,
with flashes of light and burning sulphur, the apparitions of the dead, *phasmata*
or *eidola*, were lifted up and wheeled across for your admiration, all at a high
price. The excavator recreates the scene: "In total darkness, with the scent and
dark reflection of burning sulphur, the *eidola* were made to appear and converse
with the consultor of the oracle, whose senses and intellect were already subtly
disordered by the diet and psychological impressions which had been

arranged."[27] This kind of deceptive magic, *thelxis* and γοητεία, still flourishes, of course to a milder degree, at some American cemeteries.

The Nekyomanteion shared, however cheaply, in the powers of sea-divinities to reveal the past; the future was not its province, and the present was filled with grief: the kingdom of the dead embodied the happier days gone by. This is also the burden of the most famous music or magic to come out of or across the sea, the Sirens' song, full of *thelxis* and certainly not harmless, but quite professional. The Sirens are incarnate attractions for the poet, beguiling and dangerous. While most prophets and inhabitants of the sea can be relied on, the Sirens cannot, unless you understand what they are doing to you. One of

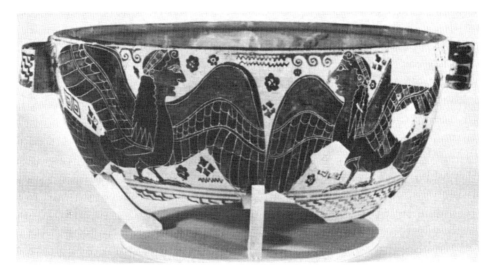

FIG. 23 A pair of Sirens: Proto-Attic bowl, seventh century.

the tribe of western island dwellers with extraordinary voices, they are not strictly of the sea, but on it, on their flowery island Anthemoessa. Who the Sirens really are has always been a difficulty for the scientifically minded. It has, I think, been proved with some conclusiveness that they are not mermaids and never were, neither bees, nor wasps, nor owls or ostriches, as in the passage of Isaiah, "and owls [or ostriches, σειρῆνες] shall dwell there and satyrs shall dance there and the wild beasts of the islands shall cry in their desolate houses, and dragons in their pleasant palaces" (13.21–22). It has also been shown, with finality, that the Sirens were not oysters, for the oyster has a living heart, which you see pounding the more rapidly and pathetically as you move him toward your lips; Sirens were rumored to be heartless.

Most early Greeks thought of Sirens as bird-ladies and associated them with birds like those who perch on the rigging of Geometric ships. They are often

very difficult to distinguish from Harpies, although the Harpy is more likely to operate alone, and Sirens in pairs; the Harpy is less musical, and likes dead boys more than live ones. When the Siren later grows webbed feet and the Harpy keeps her talons they split off more markedly from their shared Egyptian model, the *ba*. When men are not passing their island, Sirens may be pictured as plump and self-delighting, chucking each other under the chin; the Siren is sometimes introvert, trying on a necklace or looking at herself in a mirror (fig. 24), part of her attraction for poets.[28]

In an early picture which we hope is an illustration of Odysseus' adventure with the Sirens, since the hero is strapped to the mast (fig. 25), there is a confluence of elements, perhaps Kirke's palace with phalloi mounted at the corner, perhaps Kirke herself behind the Sirens. The Sirens stand peacefully and

FIG. 24 A Siren examines her face in a mirror and holds her necklace:
carnelian gem, sixth century.

FIG. 25 Odysseus and his men sail past the Sirens' rock, assaulted by birds:
Late Corinthian aryballos, sixth century.

attractively as the ship comes closer; they do nothing overtly dangerous, but simply watch their attendant birds, of whom one at least looks like a battlefield vulture at sea, who express the physical dangers accompanying the Sirens' song. We know Sirens are dangerous because Homer tells us so; in the flowers on their island lies "a big pile of bones of rotting men with the skin drawing smaller around them" (xii.45), not eaten, apparently, but starved castaways. The "rotting men" derive from the same Greek pun as the rotting dragon Python at Delphi; these are bones of ἀνδρῶν πυθομένων, "men who came to ask questions" (xii.46; *Hymn to Apollo* 363, 369).

The kind of question to which they are tempted to hear the answer concerns knowledge of how wonderful they are, and this the Sirens promise. "Come along here, much-praised Odysseus, great glory of the Achaians . . . no one has ever gone past till he sailed on delighting and knowing more" (xii.184f.). It is the perfect mixture of flattery and temptation, like the best court-poetry, or a victory ode; the temptation is to know your ultimate reputation before you are dead, conjuring up the quality of Odysseus' performance at Troy as an *eidolon*, an image of himself to please his greedy soul, and in this sense the Sirens too are necromancers. But the consultor of this island Nekyomanteion is transgressing a basic law: death first, renown afterwards. To sail on *pleiona eidos*, knowing more than you did, is a delicate euphemism for death.

The famous Siren vase in London, so characteristically fifth century in its addition of an extra Siren who commits suicide in a nose-dive because the first mortal has resisted her temptation,[29] has on the reverse the three figures often called Erotes flying over seas; but only one is labeled, the boy Himeros. He

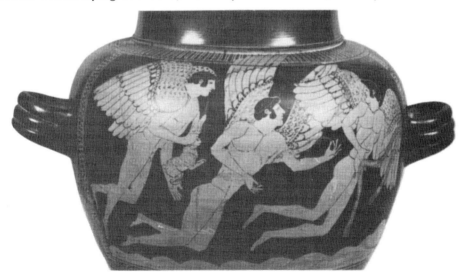

FIG. 26 Erotes fly over the waves with love-gifts:
Attic red-figured stamnos, fifth century.

suggests the *himeros* of the poet, with his song of desire, ἱμερόεσσαν ἀοιδήν (i.421, xviii.304), who knows how to sing songs that stir desire in mortals, ἀείδῃ δεδαὼς ἔπε' ἱμερόεντα βροτοῖσιν (xvii.519); or the seeker after vision and knowledge, ἵμερος ἔχει με ... τὰν χθόνιον ἑστίαν ἰδεῖν, "I have *himeros* to see the chthonic hearth" (Sophokles, *Oidipous at Kolonos* 1725); or ἵμερος ἐπείρεσθαί μοι ἐπῆλθε, "a *himeros* to ask questions came into me" (Herodotos I.30). These boys are not just the Erotes ὑπερπόντιοι, love coming across the waves, although that conceit is behind the picture too, but smug young winged Athenians—amateur poets, no doubt—bringing love-gifts to the Sirens to hear more, and better, about themselves.

A kind of paradise and immortality lies in the image or reputation held in the archives of the past by the singers overseas. The gods who escort the dead are shown also passing over the waves—Hermes traveling "over the wet and over the endless earth with a breath of wind," or Eros *hyperpontios*. Some heroes get there on their own wings, some depend on poets for launching, like Theognis' love, σοὶ μὲν ἐγὼ πτέρ' ἔδωκα, σὺν οἶσ' ἐπ' ἀπείρονα πόντον πωτήσῃ (237). Some only travel there dead in the arms of a mothering goddess or *ker* (chapter 5 fig. 28). One is aware, in the period of change between the epic and the fifth century, of an increasing anxiety to transfer as many famous figures out of Hades as possible, and to install them on happy islands from which they may appear to passing sailors. The old *Iliad* picture of one gathering place for all dead men where all were treated alike seems a better expression of the archaic

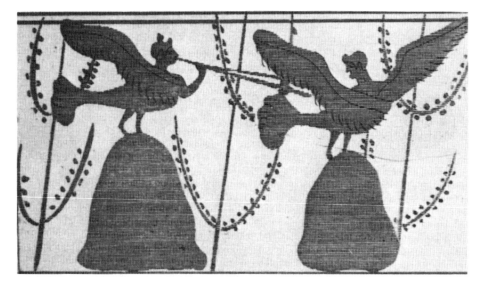

FIG. 27 Musical Sirens on a pair of earth-heaped tombs in a grove: Attic black-figured lekythos, fifth century.

honor of Greece, but even in the *Odyssey* it was stressed that the dead heroes were anxious to know what people thought about them, and that travelers from overseas were the only ones who could reassure them about their reputations. Odysseus functioned for dead Achilles and Agamemnon as the Sirens offered to function for him, to bring intelligence like the *ba*-soul, and unlock the secret of one's position in the eyes of the living.

The poetry, music, and renown which the Sirens offered on dangerous conditions to those who were still alive were combined in Greek imagery with their function of mourning for the dead. In late classical times they almost supplanted the traditional sphinx and Harpy and lion figures, because they had the power of music, piping and fluting in a sorrowful way over children and adults, as they gradually turned into the "Muses of the Underworld."[30] They

FIG. 28 Thetis and the mourning Nereids bring armor to Achilles:
white-ground band on an Attic red-figured lekythos, later fifth century.

became the virgin, childless, professional singers of the funeral lament, with more controlled attitudes than the sorrowing Nereids who were the first mythical creatures to sing it at Troy, riding their dolphins as Thetis "made rise up in them the desire for the funeral song," Θέτις γόου ἵμερον ὦρσε (XXIII. 14). The sands were wet and the armor of the men was wet with tears, such the *pothos* they felt. When Achilles died the Nereids came again with a huge supernatural cry over the sea, βοὴ δ' ἐπὶ πόντον ὀρώρει θεσπεσίη (xxiv.48), and the Muses sang the *threnos* in a voice so clear, you would not have seen a Greek who was not crying.

As time passed, the Sirens in art and the poets in real life took over the management of such personal feelings, in songs which may have lost the sense of direct bereavement but which were constructed with the brilliant professional skill one expects of Greeks. Both, in their music, reassured the listener of his own

renown and raised images of the past for the present generation, so that it could marvel at and feel *pothos* for the dead. The poet was trained in necromancy and in myth, and, like a sea prophet, could respond to human curiosity about the past, releasing the dead to new actions and new conversations, or creating a new past life for those whose names and actions were forgotten.

The countryside of Greece was filled with nameless and forgotten dead who, especially in the eighth and seventh centuries, achieved the rank of local hero. A hero was both a guardian of his land and a threat to living people who forgot to pay him respect. His worship was often strange and local, and a testimony to a general Greek capacity to make myth out of bones. The hero of Corinth who

FIG. 29 A nameless hero of Corinth, forty-five years old, with arthritis: ninth century.

rejoices in the modern name of Hero 72–4 is a grand example of the impulse to honor the dead and the grave of the unknown soldier. A man of about forty-five years, tall and broad-shouldered, with bad teeth, marked degenerative osteo-arthritis, a narrow flat-sided brain case and a fractured right hand, he died in the Protogeometric period when few records were kept. His existence was rediscovered in the Early Corinthian period, at the end of the seventh century, when his funeral gifts were removed from under his feet. Attitudes changed in Middle Corinthian, when an open-air temenos was built around his and other graves; from Late Corinthian it became fashionable to bring him presents from time to time—such things as a krater with a picture of Achilles in battle—and this habit of respect and gifts lasted until the sack of Corinth in 146 B.C.[31] His body was probably found by accident, and perhaps people concluded from his antiquity, his size, and his broken sword-hand that he was one of the heroes of old with whom they wanted to continue in communication.

Pausanias the traveler takes us to hundreds of Greek villages and towns with similar little precincts of local heroes, and Greek history is filled with accounts of towns which discovered, stole, bought, and displayed reverend bones of the past, bones that conferred peculiar virtues on their burial places. Some remained nameless, simply The Hero; others acquired names from the mythical past, particularly the figures of the Trojan War. Thebes, for example, could be proud not only of the grave of Semele mother of Dionysos, but also Kaänthos son of Ocean, Phokos grandson of Sisyphos, Amphion and Zethos the magical musician and architect, Tydeus who nearly did not die, the children of Niobe, the children of Herakles, the children of Oidipous, the daughters of Antipoinos, the prophet Teiresias, and Hektor son of Priam who was brought specially from Troy for Thebes' protection. Such shrines all through the country were visible reminders to the Greeks that the past was longer than their knowledge of it, and that the bones of older generations literally supported all their under-takings. It was the work of poets, story-tellers and artists to release these people from the isolated kingdom of the dead into the light again for the use and pleasure of the living.

The poet and the artist who raise the dead cannot be quite trusted, perhaps; they have filled the past with invention and inserted the ardent fictions of their intellect into the ranks of the dead; but we are often drawn even more strongly to these than to any real bony ancestor. The best part of dying, Sokrates thought, would be "to get down there and question the man who led the great army to Troy, or Odysseus, or Sisyphos, or ten thousand others one could name, men and women" (*Apology* 41); true and false, they are waiting for us. The dead are our biggest resource, kept alive by our curiosity and *pothos*, filling our books and paintings and universities and minds. They know what we want to know and cannot discover without them; they made us what we are today and

FIG. 30 The empty chair; gone but not forgotten:
nineteenth-century tombstone.

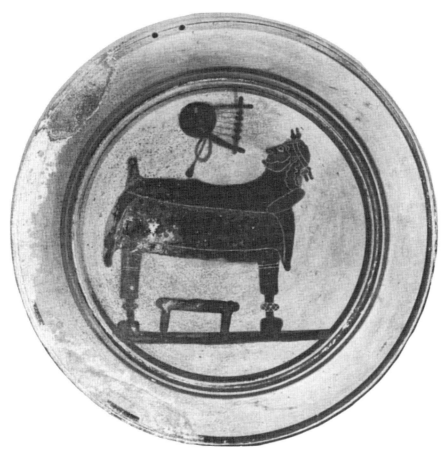

Fig. 31 The poet musing on the past, in bed or dead:
Middle Corinthian plate, sixth century.

we hope to learn if they are satisfied. In the meantime we keep a place for them, a chair and a book, as a memorial in sun and rain to evoke the past and make solemn the longing of the living for the one we cannot see now. So the Greek poet lies waiting—on his deathbed? or musing until he is ready to take down his instrument and play again?—to raise the classical dead and install them once more at the heart of life.

NOTES

The *Iliad* is referred to in roman upper case (I.1), the *Odyssey* in lower case (i.1).

CHAPTER I
CREATURES OF THE DAY:
THE STUPID DEAD

1. *Odyssey* xii.22, "you have come living out from under Hades' house twice-dead when other men die once"; Alkaios 110 P., 73 D. (restored); Theognis 702f. The usual list of underworld adventurers includes Sisyphos, Odysseus, Herakles; later Orpheus, Dionysos, Theseus, Peirithoos; see Ganschinietz, "Katabasis," *RE* X.2359; Rohde, *RhM* I (1895) 600f., *Psyche* 32f.; Bibliography p. 261. The lost "visits to the dead" in the epic poems *Minyas* and *Nostoi* probably contained standard panoramas of beautiful or bloody ghosts, as reflected in Polygnotos' underworld painting at Delphi, Pausanias X.28–30.

A version of this lecture was given to the Department of Classics at Smith College in 1973.

2. E.g. Herakleitos B 88 D-K; Plato, *Phaido* 71d; Lucian, "Menippus and Tantalus," *Dialogues of the Dead* 7; and the relation of life-in-death to fertility and hunting cult, in Burkert, *HN* 45f.

3. The extensive bibliography on Greek modes of burial is selectively listed on p. 262; see K-B 51f.; Andronikos, *Totenkult* 37f.

4. The function of the tomb as a continuing representative of the deceased is clear from an item in *The Boston Globe* February 1974: "In an attempt to liven up the local graveyard, Floridian X.X. is trying to market a novel kind of tombstone. The deluxe model will include a tape recording of the deceased's voice, a movie projector and screen showing typical scenes from his life, and a twenty-foot scroll containing his writings . . . at a price he terms 'costly'." For American funeral customs, beyond the two classics, Evelyn Waugh, *The Loved One* (1948), and Jessica Mitford, *The American Way of Death* (1963), I am indebted to the trustees of the Mount Auburn Cemetery of Cambridge, Massachusetts (see B. Rotundo, "Mount Auburn Cemetery: A Proper Boston Institution," *Harvard Library Bulletin* 22 (1974) 268), and to Mr. Leo Burns of Boston. Mr. Burns taught me of the faith of the Boston Irish in the future life, which has prompted requests for a bottle of whisky in the coffin, or the inclusion of a pet cat or canary; it is common to have the American flag pasted inside the lid facing the dead, or a photograph of the spouse; money may be carried for the journey, and even fixative for false teeth in heaven.

5. Epigram XIII.3–4, R. Pfeiffer, *Callimachus* (1949).

6. It seems curious that the description of Pyriphlegethon and Kokytos flowing into Acheron at a special rock, in the *Odyssey* (x. 513–15) has so little effect on Greek fantasy of the underworld, at least before Aischylos; is it possible that these lines have been retrojected into the *Odyssey* text, in the late sixth or early fifth century? The two *Odyssey* Nekyiai do not name these rivers, and Hesiod knows only Styx (*Th.* 383, 776, as Homer also does, II.775, x.514, +), and omits the others from his catalogue of rivers (*Th.* 337f.). Sappho and Alkaios both allude to Acheron in the realm of the dead (Sappho 97.12 D., 95 P.; Alkaios 73 D.2, 8, 38A P.) and the next to make the allusion is Aischylos, νῦν δ'ἀμφὶ Κωκυτόν τε κ'Ἀχερουσίους/ὄχθους ἔοικα θεσπιωιδήσειν τάχα, *Agamemnon* 1160–1. In most ancient imaginings of death there is water to cross, but our impression of the great named rivers bounding Greek Hades is based on less substantial early, pre-fifth-century evidence than I thought as a child. See *RE* I.218; VI.2791; Rohde, *Psyche* 214. Pindar, too, knows or names only Acheron (*Pythian* XI.21, *Nemean* IV.85, fr. 131.3) and Styx (*Paian* 10.14), like his predecessors, apart from the nameless darkness of fr. 114.c.2, and even the Kokytos in Euripides, *Alkestis* 458 has been doubted. The one river in Polygnotos' underworld scene is not labeled; Pausanias thinks it must be Acheron (X.28.1); the others do not affect the scene. Ἀχερωίς, white poplar, is also Homeric (XVI.482), probably old like most tree names, and Acheron should be the original single river in a grove which the dead must cross; but see Chantraine, *Dictionnaire*, s.v.

7. For Charon, O. Waser, *Charon, Charun,*

Charos (1898), with emphasis on the water barrier between the living and the dead in comparative mythology, ships of the dead and the island of the dead; also G. Krüger, "Charon und Thanatos," *ArchZeit* 25 (1867); A. Furtwängler, "Charon," *ArchfRel* 8 (1905) 191; Roscher 884 (Roscher); R. Lullies, "Charon," *AA* 1944–45 (1949) 25; G. van Hoorn, "Charon, Charu, Kerberos," *Nederlands Kunsthistorisch Jaarboek* 5 (1951) 141f.; F. Brommer, *Madrider Mitteilungen* 10 (1969) 155f., Anh. 3; L. Radermacher, *Jenseits* 90f., *Meer* 315f.; J. C. Lawson, *Modern Greek Folklore and Ancient Greek Religion* (1910) 98f. For possible connections with Egypt, see chapter 2 note 57.

It has not yet been shown that Charon played any significant role in Greek death imagery until after the Persian Wars. Charon's appearance in the epic *Minyas*, from which Pausanias quotes when looking at Polygnotos' painting of the Underworld at Delphi (X.28. 2.):

ἔνθ' ἤτοι νέα μὲν νεκυάμβατον, ἣν ὁ γεραιὸς
πορθμεὺς ἦγε Χάρων, οὐκ ἔλλαβον ἔνδοθεν ὅρμου

is probably a fifth-century conception, to judge from the poem's emphasis on Theseus and Peirithoos, a classical not an archaic interest. See G. Kinkel, *Epicorum Graecorum Fragmenta* (1877) 215, G. Huxley, *Greek Epic Poetry* (1969) 119, A. Ward (ed.), *Quest for Theseus* (1970) 155. The first authoritative literary reference seems to be in Aischylos, *Seven*, 852f., which mentions the boat but does not give the ferryman's name,

πίτυλον, ὃς αἰὲν δι' Ἀχέροντ' ἀμείβεται
τὰν ἄστολον μελάγκροκον θεωρίδα . . .

"Charon the carpenter" in Archilochos 19 (West) may yet prove to derive from too great condensation of text in Aristotle, *Rhetoric* III p. 1418ᵇ23, considering that Charon's boat in Polygnotos' painting carries Archilochos' grandfather Tellis; see M. Robertson, *A History of Greek Art* (1975) 266f. After the Polygnotan painting Charon appears more or less familiarly in tragedy, comedy, and on white-ground funeral lekythoi, whose relations to Polygnotos are discussed in E. Pottier, *Les lécythes blancs attiques* (1883) 111, 119 and Fairbanks, *AWL* II, 218f. Charon is shown as a traveler and worker, in a rustic, often hairy *pilos*, the brimless hat natural for sailors, and

a rude *exomis* or short cloak; he may sometimes carry a sword, as though to compel the reluctant dead or bar reverse passage to others, a continuation of the old *Odyssey* joke (xi.82, 231). What shape his passengers were in when he took them, is not a metaphysical but a painter's problem; they are life-sized and lively-looking, not the winged *psychai*, who would not need him. Lucian, among others, jests that the boat leaks from the weight of the dead, weight caused by sins and worldly cares which the soul must still discard (*Charon and Hermes, Dialogues of the Dead* 14 [342], 20 [363f.]). "Charon's obol" first appears as a conceit during the Peloponnesian Wars (Aristophanes, *Frogs* 140, 270, see also *Birds* 503), in relation to the *diobelia* of the Dekeleian War, Waser, *Charon* 30f.; the obol appears in the mouths of the dead occasionally in the fourth century, more frequently in Hellenistic times when the whole fairly recent tradition had begun to acquire a patina of age; K-B 163, 166, 211.

8. C. Robert, *Die Nekyia des Polygnot* (1893); M. Robertson, *A History of Greek Art* (1975) 266f.

9. Aelian, *On Animals* V.49; only men bury but most animals mourn; see Burkert, *HN* 29, 60f.

10. Aischylos, *Prometheus Bound* 248–50, foreknowledge of death a disease requiring a *pharmakon*; see E. R. Dodds, *Plato, Gorgias* (1959) on 523 a 1f.

11. Dieterich, *Nekyia*² (1913) 71f.

12. *Psyche* is not really a technical term in early Greek, but a conventional expression, from a wind-breath root (ψύχω, ψυχρός); Chantraine, *Dictionnaire* s.v. Loss of *psyche* can signify fainting (V.696, XXII.466, XXIV. 348) as well as death; *psyche* stands for "life" in phrases for hazarding life, IX.322: ψυχὴν παραβαλλόμενος; iii.74: ψυχὰς παρθέμενοι; xxii.245: περί τε ψυχέων ἐμάχοντο. This is extended to "life-with-honor" among the dead, Aischylos, *Eum.* 114. The tradition and conventionality of its formulaic uses is suggested by the frequent coupling of *psyche* with *menos* (especially for charioteers, λύθη ψυχή τε μένος τε V.296, VIII.123, 315); with *aion* (Sarpedon, XVI.453, cf. V.685; Polyphemos, ix.523); with *thumos* (XI.334; xxi.153, 170).

In ordinary practice the *psyche* is the visible part of the dead, small enough to escape from limbs (XVI.856, XII.361), or a wound (XIV.

518); stick on the spear (XVI.505; see chapter 3 p. 98); settle in the neck (XXII.325); flow out on the breath (ψυχὰν ἀποπνεῖν) Simonides 52 D., 553 P.; it is weightless like smoke (e.g., XIII.100); floats in the arms of the sea (Archilochos 23 D.). In circumstances agreeable to the poet it can weep (XVI.857, XXII.363) and feel self-pity. In the *Odyssey* Nekyia, where any internal "contradictions" seem principally motivated by the poet's stagecraft (below p. 29) it can move itself to drink blood, or display anger (by gesture and facial expression? xi.544), or recognition (xi.390). The visitor to the underworld sees the *psyche*, but it is the person who speaks. This differs from the crowd scenes with ἔθνε(α) μυρία νεκρῶν who make frightening noises (xi.632), though *psychai* in groups can also be noisy (xi.42). The shift from *psyche* to *eidolon* to *nekros* is a matter of convenience, like the vision of bodies on the souls of the dead, or warriors with wounds and bloody armor (xi.39f.). When a *psyche* needs to be big it may be, like Patroklos'; when it needs to be small it will be (XXIII.65f.). In short, the *psyche* may be real enough to be noticed when it is no longer there (Dodds, *Irrational* 15f., n. 95), but it must be handled as a poetic convenience, flexible in size, behavior and significance.

On the subject in general see Rohde, *Psyche* 28f.; Roscher 3201 (Waser); *RE* VI A.1813, XXIII.1434; Bruck, *Totenteil und Seelgerät*; Bickel, *Homerische Seelenglaube*; Wilamowitz, *Glaube* I, 370; Dodds, *Irrational* 135f.; T. Zielinski, *La Guerre à l'Outretombe* (*Mélanges Bidez* II, 1934) 1021f.; R. Onians, *The Origins of European Thought* (1951) 99, 254; D. Furley, *BICS* 3 (1956) 1; H. Sichtermann, "Die Flügel der Psyche," *Opuscula* 5 (Stockholm Studies in Classical Antiquity [1968]) 49f.; J. Warden, *Phoenix* 25 (1971) 95f.; J. Redfield, *Nature and Culture in the Iliad* (1975) 174f.; H. Ingenkap, *RhM* 118 (1975) 148; and the Bibliography p. 265.

13. The metaphor "shade" or "shadow" in the underworld, or of ghosts, implies a source of light which is in some sense the colored substantial body. Egyptians drew shade-figures of the dead (e.g. in the Am-Duat Book on the walls of the tomb of Tuthmosis III, Thebes 34, W. Forman and H. Kischkewitz, *Egyptian Drawings* [1972] pl. 12) as an initial sketch not yet "colored alive"; shadow-drawing is the negative attached to

the living person, traveling without willpower on the ground. *Skia* has less substance than *eidolon*. The *eidolon* may be a winged image, like the *psyche*, and is so drawn regularly in late archaic times, in the tomb pictures of the Leagros group (chapter 3 fig. 27) but may lose its wings in the fifth century (chapter 1 figs. 24, 25); it can leap, gesticulate, express pleasure. Sappho's disliked poetess travels winged among the dark dead (58 D.) in an unclear form; the distinctions begin to blur early, and are well confounded by the late fifth century in works like Euripides' *Hekabe*, where Achilles appears unwinged over his tomb (37, 110), but dream, *phasma* or *opsis* have black wings (71, 704–5); Sophokles fr. 12, ἀνθρωπός ἐστι πνεῦμα καὶ σκιὰ μόνον, εἴδωλον ἄλλως. The principal passages are *Od.* x.495, xi.207, 222; Pindar *Pythian* 8, 95; Sophokles *Aias* 125, *Antigone* 1170, *Philoktetes* 946, frs. 331, 659.6, 945; Aischylos *Prometheus Bound* 448; fr. Trag. adesp. N² 95. It may be that for Homer the dead lack intelligence because they lack color (blood), III.278, XXIII.72, xi,476, xxiv.14. In general, Rohde, *Psyche* 7; L. Malten, "Das Pferd im Totenglauben," *JdI* 29 (1914) 179f.; M. P. Nilsson, "Immortality of the Soul in Greek Religion," *OpSel* III, 40; Dodds, *Irrational* 102f.; J. Hundt, *Der Traumglaube bei Homer* (1935); G. Björck, *Eranos* 44 (1946) 309; E. Vermeule, *JHS* 85 (1965) 146, and *BMFA* 63 (1965) 34f.; K. Stähler, *Grab und Psyche des Patroklos* (1967); H. Schaefer, "Das Eidolon des Leonidas," *Charites* (Festschrift E. Langlotz [1957]) 223; A. Lesky, *Gnomon* 22 (1950) 99, and 27 (1955) 483; P. Arias, "Morte di un Eroe," *ArchClass* 21 (1969) 190f.

14. Dr. Nils-Olof Jacobson, *Life After Death* (*Boston Globe*, 19 December 1972).

15. *Catalogue of the Norbert Schimmel Collection* (ed. O. W. Muscarella) (1974) no. 63; for similar gestures on several vases, W. Reizler, *Weissgrundige Attische Lekythen* (1914), pl. 44, Athens 1926; Fairbanks, *AWL* I pl. XIVa, II 44, 62, 165; but the mimicry of the boy by his own soul is unusual.

16. The iconography of Geometric funeral scenes has been studied long and from many angles; bibliographies in K-B 346–51 (to 1970), and Andronikos, *Totenkult* 43f. (to 1967). Among others see W. Zschietzmann, "Die Darstellungen der Prothesis in der griechischen Kunst," *AM* 53 (1928) 17f.; G.

Ahlberg, *Prothesis and Ekphora* (1973) and *OpAth* 7 (1967) 177f., and *Fighting on Land and Sea;* J. Benson, *Horse, Bird, Man* (1970); J. Boardman, "Attic Geometric Vase Scenes, Old and New," *JHS* 86 (1966) 1, and "Painted Funerary Plaques and Some Remarks on Prothesis," *BSA* 50 (1955) 51, and *Gnomon* 92 (1970) 493; N. Coldstream, *Greek Geometric Pottery* (1968) 37f.; J. M. Cook, "A Geometric Graveside Scene," *BCH* 70 (1946) 97; H. Marwitz, "Das Bahrtuch," *Antike und Abendland* 10 (1961) 7; D. Ohly, *Griechische Goldbleche* (1953) 70; F. Poulsen, *Die Dipylongräber und die Dipylonvasen* (1905); B. Schweitzer, *Greek Geometric Art* (1971) 37f.; R. Tölle, *AA* (1963) 210; R. Young, *Late Geometric Graves, Hesperia Supplement* II (1939); and Bibliography p. 262.

17. The values and styles of mourning are excellently discussed in both Reiner, *Totenklage*, and Alexiou, *Lament*; for continuity of tradition, see also B. Schmidt, "Totengebräuche und Gräberkultus im heutigen Griechenland," *ArchfRel* 24 (1926) 281f.

18. See the Bibliography p. 262, with Rohde, *Psyche* 162f., *Kerameikos* V.1. 19f.; Zschietzmann, *AM* 53 (1928) 17f.; G. Ahlberg, *Prothesis and Ekphora* (1973).

19. On cenotaph, *sema*, and kolos(s)os, see A. W. Persson, *AA* (1936) 188 and *Royal Tombs at Dendra* (1931) 80f.; P. Jacoby, "Patrios Nomos," *JHS* 64 (1944) 37f.; C. Picard, *Rev Phil* (1933) 343; T. Zielinski, *Eos* 30 (1927) 37f.; the instructions at Kyrene for replacing a dead stranger with a kolos(s)os, F. Sokolowski, *Les lois sacrées des cités grecques, Supplément* (1962), No. 115, 189, line 29f.; H. Jeanmaire, *REG* 54 (1945) 66f.; J. Servais, *BCH* 84 (1960) 112f.; and W. R. Halliday, "Cenotaphs and Sacred Localities," *BSA* 17 (1910–11) 182; E. Fraenkel, *Aeschylus, Agamemnon* (1962) on verse 416; J.-P. Vernant, "Figuration de l'invisible et catégorie psychologique du double: le colossos," *Mythe et Pensée²* (1969) 251f.; E. Benveniste, "Le sens du mot κολοσσός et les noms grecs de la statue," *BIFAO* (1930) 447; Rohde, *Psyche* 46 n. 25; K-B 257f.; on the cenotaph of Nikokreon at Enkomi, Cyprus, with clay heads of the dead substituted for them, on poles, V. Karageorghis, *Salamis* (1969) ch. 4; cf. Demosthenes XXI. 512.

20. Wilamowitz, *Sappho und Simonides* (1913) 272 and *Glaube* III, 79. I am indebted to E. Lowry for a study of the subject. θνῃσκόντες

πίπτωσι is the beginning of the process, I.243. The dead Achaians of VII.328 are still in process, but their blood is in the river and their souls in Hades, descriptive drama not metaphysics. See also VI.71, X.343, XXII.52, 164. The image of Achilles' team standing like a grave-stele (XVII.435) specifies the *tumbos* of a man or woman τεθνηότος, stabilized, like the completed dead in the underworld, νεκύων κατατεθνηώτων (x.530, xi.37).

21. The formula (x.526, xi.34) is rare and seems to have no special significance, but spreads from κλυτὰ τεύχεα (V.435), εἵματα (vi.58), κλυτὰ φῦλ' ἀνθρώπων (XIV.361). ἔθνεα often applies to winged creatures (II.459, birds, 469, flies), though pigs may crowd so (xiv.73), and the dead may be assumed to throng and flutter without being winged.

22. In myth such connections often center around boiled children and resurrections or failed attempts at immortality, as Tantalos son of Thyestes was buried in a bronze bowl at Corinth, Pausanias II.22.2. On bronze cauldrons as burial urns at Eretria, K. Schefold, *AntK* 9 (1966) 120f., with parallels; these are of the same form as victors' tripods at (funeral) games; see also *Kerameikos* V. 1. 205f.

23.

> πυλῶν πάροιθε δ'οὐχ ὁρῶ
> πηγαῖον ὡς νομίζεται
> χέρνιβ' ἐπὶ φθιτῶν πύλαις
> [Euripides, *Alkestis* 98f.]

cf. Aristophanes, *Ekklesiazousai* 1030f. In general, Stengel, *Kultusaltertümer* 144; Eitrem, *Opferritus* 76, 105; M. Ninck, *Die Bedeutung des Wassers im Kult und Leben der Alten* (*Philologus* Sup. 14 [1921]); L. Mouliner, *Le Pur et l'Impur dans la Pensée des Grecs* (1952) 76f.; R. Ginouvès, *Balaneutiké: Récherches sur le Bain dans l'antiquité Grecque* (1967) 239f. *Chernips* is evidently a Bronze Age word, recorded in Linear B texts at Knossos, Ws 8497 *ke-ni-qa*, with *a-sa-mi-to* the tub, and at Mycenae, Wt 503 *ke-ni-qe-te-we;* cf. XXIV.304, i.306. It is not restricted to sacrifice and purification. There does not seem to be any fear of pollution after funerals in Hesiod's advice to abstain from sexual relations then, only the feeling that a child begotten upon such an occasion would be unluckier than one conceived after a feast of the gods, *WD* 735. Fear

of infection or miasma from normal death is rare in Greek literature; miasma comes rather from sin (Hesiod *WD* 238f.) and murder (Aischylos *Ag.* 1028, 1645, Sophokles *OT* 97, 241); see Rohde, *Psyche* 175 n. 176.

24. For chin straps see P. Wolters, "Ein griechischer Bestattungsbrauch," *AM* 21 (1896) 367; Andronikos, *Totenkult* 41; D. Ohly, *Griechische Goldbleche* (1953) 70f.

25. P. Jacobsthal, "The Nekyia Krater in New York," *Metropolitan Museum Studies* 5 (1934–36) 117f.; P. Friedländer, *AA* (1935) 20.

26. For similar gestures in Egypt, the Levant and the Mycenaean world, chapter 2 notes 42, 56.

27. J. Kakridis, *Homeric Researches* (1949) 65f. See also Reiner, *Totenklage*, 20f.; Alexiou, *Lament* 14; G. Petersmann, "Die monologische Totenklage der Ilias," *RhM* 116 (1973) 3f.

28. Alexiou, *Lament*, passim; J. Mavrogordato, "Modern Greek Folk-Songs of the Dead," *JHS* 75 (1955) 42. Reiner, *Totenklage* 20 n. 55, well describes this as "Selbstbeklagung ... der primitive Egoismus der Totenklage...." The black-figured phormiskos of Myrrhine from the Kerameikos (Inv. 691) gives the simple words οιμοιο θυγα, seen by A. Rumpf as οἴμοι ὦ θύγα[τερ]; K. Kübler, *AA* (1935) 299 fig. 24; R. Lullies, *JdI* 61/62 (1946–47), pl. 13.44.

29. Alexiou, *Lament* 127; N. G. Polites, Ἐκλογαὶ ἀπὸ τὰ Τραγούδια τοῦ Ἑλληνικοῦ λαοῦ (1925) 198.

For another light on the scene, among many that could be cast, A. L. Strong, *The Road to the Grey Pamir* (1930), on the laments of the Moslem Kirghiz of the Altai valley:

From within the yurt rose loud wailing, shrill and continuous, and yet with something dramatically artificial in its tone. Sounding thus in the darkness, after the howls of the dogs from this lonely yurt under a storm, it was indescribably eerie.... two women knelt facing the wall; their voices rose and fell in continuous shrieks of lament, ... the wail required by custom for the death of a near relative. A relation of the younger woman had recently died; the older woman was merely sociably accompanying the lament.... After half an hour of monotonous wailing, the women suddenly ceased, took off the lofty headdresses and more cumbersome garments, and busied themselves with housework as if nothing had happened. There were no tears in their eyes or sorrow on their faces. [229–31]

When a man died with us, they had first the funeral and after seven days they gave a dinner, and again after forty days. After a year they gave a very big feast called the *ash*, at which many sheep and even horses were killed. After the *ash* the wife could marry again. But for the first year she must sit always at the side of the yurt, wailing and weeping very often and singing songs of lament, removed from life and going out seldom. [This was changed after the Soviet revolution:] his wife can marry on the very next day.... This is right, for women among us are scarce, and why should she and some other man lose a year of life? [158–59]

30. Characteristic, in their reference to the self and the mourner's pain and privation, are extracts from apparently standard cries as in Euripides *Suppliants* 918–24:

ἰὼ τέκνον, δυστυχῆ σ' ἔτρεφον, ἔφερον ὑφ' ἥπατος
 πόνους ἐνεγκοῦσ' ἐν ὠδῖσι· καὶ
νῦν Ἀιδας τὸν ἐμὸν ἔχει μόχθον ἀθλίας,
 ἐγὼ δὲ γηροβοσκὸν οὐκ ἔχω, τεκοῦσ'
 ἁ τάλαινα παῖδα.

A fundamental function of mourning must be self-healing through self-pity. In Lucian's *On Funerals* (20) the idiot kin send for a professor of threnodies who has gathered a repertory of ancient bereavements, τινα θρήνων σοφιστὴν συνειλοχότα παλαιὰς συμφοράς, missing the point as we still do in awe of "professionals."

31. Reiner, *Totenklage* 20ff. and 27–28 for a list of incantatory expressions in tragedy; see also W. Burkert, "Γοής" *RhM* 105 (1962) 36; J. de Romilly, *Magic and Rhetoric in Ancient Greece* (1975) 13, 31. Cf. Bickel, *Seelenglaube* 22; Rohde, *Psyche* 14, 198.

32. R. Tölle, *AA* (1963) 662 fig. 20; J. Boardman, *JHS* 86 (1966) 1f.

33. The Vari (Anagyrous) cart, G. Oikonomos, P. Stavropoulos, *AA* (1937), 123; E. Vanderpool, *AJA* 61 (1957) 281, pl. 84; Hampe, *Grabfund* (1960) 73, fig. 46; cf. *Kerameikos* VI.1, 94, VI.2, 380, 393; Andronikos, *Totenkult* 51 pl. 4a; for the bird, Weicker, *Seelenvogel* passim, and, on the Boston plaque, J. Boardman, *BSA* 50 (1955) 59 no. 5.

34. Chapter 5 note 28.

35. In the collections of early grave epigrams by Peek, Lattimore, Friedländer, Jeffery, Pfohl and others (Bibliography p.263), references to the "mythology" of death are almost non-existent before the second quarter of the fifth century. Emphasis is on *sema*,

mnema, the love of parents for children, and the virtues of the dead. Occasionally an epic tag appears, without rich coloring, such as the lost inscription from Athens, L. Jeffery, *BSA* 57 (1962) 132 no. 31, Στεσιο hον Θανατο[ς δακρυ]/οες καθ[ε]χει or from Velanideza (Athens NM 6732) Jeffery *loc. cit.* 140–50 pl. 39b; V. Stais, *Deltion* (1890) 25f.; Peek *GV*, I.71, hος θα/[νατοιο] ποτμος/[κιχεν hελι] κι[αι μαλ' ahop]ος, or Damasistratos of Sounion, *IG* I² 1022; Friedländer 28; Pfohl 73, το γαρ γερας εστι θανοντω[ν] or Thera (Pfohl 179; *IG* XII 3, 768; Peek *GV* 1529) δοματ' ε[βα]ς Αιδα. Mention of Hades or Persephone is not common before the fifth century and had not much pictorial or imaginative quality earlier. There is no general use of Charon, the underground rivers, gates, dogs, or other impediments or fears of death; no punishment, sinners or spectacle. Acceptance, not complaint, is nearly universal, although war-deaths stress the youth and excellence of the destroyed, and the blunders of Ares (literary type, *AnthPal* VII.160.2, Pfohl 182 [Teos]; Bacchylides V.130). The Aristion stele from the Agora (Athens NM 10647–8) (Jeffery *loc. cit.* 120. 8, pl. 34a–c; Peek *GV* 1227; *IG* I² 972) half-quotes Achilles to Lykaon, επ[ει] κ[αι] / σε μενει θανατος (XXI.103). Perhaps it could be argued that the mythological picture of death which developed during the fifth century was a kind of escapism in delineating and populating the other world, assuring sights and sensations in it, and figures with whom to relate and exchange memories. Whatever one may think of the date of the *Odyssey* Nekyiai (below note 49), it seems clear that the literary traditions about the underworld, for fantasy and amusement, were for a long time kept separate from the domain of family grief and pride, and only began to replace those more private feelings in the fifth century.

36. D. Frame, *The Origins of Greek Nous* (diss. Harvard 1971) explores the connections among *nous*, death, *neomai*, *nostos* and Nestor in a perceptive study linking language and myth.

37. On the poetic function of *kleos aphthiton* and its Indo-European connections, G. Nagy, *Comparative Studies in Greek and Indic Meter* (1974), 229–61, Appendix A (mēdea, aphthita mēdea eidōs).

38. Simonides 48 D., 387 P.

39. H. Fraenkel, "Man's Ephemeros Nature According to Pindar and Others," *TAPA* 77 (1946) 131; Pindar's *Pythian* VIII suggests day as status, like *nostimon hēmar* (i.9), *eleutheron hēmar* (VI.455); fr. 143 B, ὦ τάλας ἐφάμερε, νήπια βάζεις makes the same intellectual connections as xxi.85, Semonides, and Archilochos 68 D. For *nepios* and fatality, chapter 3 note 36. On the Semonides verses, M. Dickie, *Illinois Classical Studies* I (1976) 7f.; D. Gerber, *TAPA* 100 (1969) 177f., opposing G. Björck, *SymbOsl* 15–16 (1936) 86, who would have read βροτοί for βοτά; R. Laurenti, "Pessimismo e non pessimismo nella poesia di Semonide l'Amorgino," *Sophia* 32 (1964) 83f.; H. Lloyd-Jones, *Females of the Species* (1975) 14. The infant mind and the reborn sun are explicitly connected by Demokritos B 158 D-K; (Plut. *de latenter vivendo* 5 p. 1129 E): (ὁ ἥλιος ἀνασχών · · · συνώρμησε τῷ φωτὶ τὰς πράξεις καὶ τὰς νοήσεις τὰς ἁπάντων, ὥς φησι Δ.) νέα ἐφ'ἡμέρῃ φρονέοντες ἄνθρωποι.

40. The connotation of *sophrosyne* is suggested in xxiii.1f., in connection with the deep sleep of Penelope, which shackled her, and her irritation with the "witless" nurse who announced Odysseus' return, waking the dead untimely; cf. H. North, *Sophrosyne* (1966) 3.

41. Herodotos VII.159; the Spartan remark is only a figure of speech, but with the sound of a cliché or proverb.

42. For states of sleep and death as productive of superior knowledge in privileged mythical personalities, L. Deubner, *De incubatione* (1900); *RE* 9, 1258 (Pley); Roscher, "Oneiros" 3.907 (Türk); E. and L. Edelstein, *Asclepius* (1945) 139f.; R. Flacelière, *Greek Oracles* (1965) 23f.

For Amphiaraos, Pausanias I.34.5 and Frazer, *Pausanias ad loc.*; for Trophonios, Pausanias IX.39.2f., Frazer *ad loc.*; N. Pharaklas, *AAA* (1969), 233; F. Sokolowski, *Les lois sacrées des cités grecques* (1969) 150; R. Clark, *TAPA* 99 (1968) 63; for Epimenides, D-K I.27f. The sleepers, the oracles, and the cave-entrances to the underworld all overlap as sources of mantic awareness; cf. Pausanias II.35.7 (Hermione), III.25.4 (Tainaron, with Strabo VIII.5.1.363); Strabo VIII.15.344, on Acheron and sacred places of Hades; Ganschinietz, *RE* X.2359 "Katabasis"; P. Faure, "Plutonia," *BCH* 82 (1958) 800f.; Roscher 1243, "Endymion" (v. Sybel); D. Clay, *TAPA* 101 (1970) 119; Pausanias V.1.5. The murderer Althaimenes who "prayed and

was hidden in a chasm" (Apollodoros, *Library* III.2.2) is a type close to Oidipous in the grove of the Eumenides at Kolonos; for the shamanistic nature of such disappearances and the learning acquired in caves, holes and chests, by trance or spirit-voyage, R. Carpenter, *Folk-Tale, Fiction and Saga in the Homeric Epics* (1956) 112f.; Dodds, *Irrational* 135f.; W. Burkert, *Lore and Science in Ancient Pythagoreanism* (1972) 141f.; Empedokles B 111.3 D-K; J. D. P. Bolton, *Aristeas of Proconnesus* (1962) 123f.; Rohde, *Psyche* 300f.

43. W. Allen, *The New Yorker*, 20 January 1973, 32–33. Another fear raised in that essay is also Greek: "The fear that there may be no afterlife—a depressing thought, particularly for those who have bothered to shave. Also, there is the fear that there is an afterlife but no one will know where it is being held." The Christian tradition, abandoning Hermes and the helpful *ker* as guides, lessened western apprehension about "the way" to some degree, when the responsibility for physical destiny after death was transferred to a judicial real estate agent allotting places of torture or bliss in a tradition which Plato elaborated out of older ideas of judgment and allocation (*Gorgias* 523f., *Phaido* 107 d 5f., *Republic* 6146f.; see E. R. Dodds, *Plato, Gorgias* (1959) 372; Rohde, *Psyche* 238; Dieterich, *Nekyia*[2] 111). The dangers of the road toward death became less severe when the dangers of what happened on arrival increased. The transference of the Last Voyage to the Last Judgment clarified imaginative panoramas to the degree that they could be painted.

44. The Old Babylonian version of the Gilgamesh epic, X.i, *ANET*[2] 89, 10f.,

> After marching and roving over the steppe,
> Must I lay my head in the heart of the earth
> That I may sleep all through the years?
> Let my eyes behold the sun that I may have my fill of the light!
> Darkness withdraws when there is enough light.
> May one who indeed is dead behold yet the radiance of the sun!

The Akhenaten identification of sun the lifegiver and sun the source of knowledge is also traditional, as it is eloquent:

> When thou settest in the western horizon,
> The land is in darkness, in the manner of death.
> They sleep in a room with heads wrapped up,
> Nor sees one eye the other.

> All their goods which are under their heads might be stolen,
> [But] they would not perceive [it].
>
> The world came into being by thy hand,
> According as thou hast made them.
> When thou hast risen they live,
> When thou settest they die.
> Thou art lifetime thine own self,
> For one lives [only] through thee.
> [*ANET*[2] 370; c. 1350 B.C.]

45. XI.109, 323; xi.109; eyes like fire, I.104, XII.466, XIII.474; sharp rays XVII. 373; the sun's sight sharpest XIV.344 (sight has a cutting edge like the tongue, cf. chapter 6 p. 197); looking as a synonym of living, I.88, XVIII.61 +. On looking as lighting the scene in varied ways, V.771, XIX.16 (flash from the eye), III.397, IV.347, XV.13, and in general M. Leumann, *Homerische Wörter* (1950) 149f.; D. Tarrant, "Greek Metaphors of Light," *CQ* 10 (1960) 181; M. Treu, "Licht und Leuchtendes in der archaischen griechischen Poesie," *Studium Generale* 18 (1965) 84f.; R. Bultmann, "Zur Geschichte der Lichtsymbolik im Altertum," *Philologus* 97 (1948) 1.

46. For the peculiar scene of souls issuing from a pithos on the Jena lekythos (Jena 338, *ARV*[2] 760.41, near the Tymbos P.; *Paralipomena* 414) see L. Deubner, *Attische Feste* (1932) 95, Nilsson, *GGR* I[2] 196, 597; the connection with the Anthesteria is not certain. In general, S. Eitrem, *Hermes und die Toten* (1909); P. Raingeard, *Hermès Psychagogue* (1935); J. Duchemin, *Hermès et Apollon* (1960); S. Karouzou, "Hermes Psychopompos," *AM* 76 (1961) 91f.; W. Fauth, *Gymnasium* 69 (1962) 12f. and in *Der Kleine Pauly*, s.v.; E. Simon, *Die Götter der Griechen* (1969) 301f. (Hermes is chthonios but not psychopompos in early Greece) and *ÖJh* 42 (1955) 11; H. Herter, "Hermes," *RhM* 119 (1976) 193f.

47. For angry heroes, see J. Fontenrose, "The Hero as Athlete," *California Studies in Classical Antiquity* 1 (1968) 73f.; the two most notorious angry heroes are Aktaion, who ravaged the land carrying a rock (Pausanias IX.38.5; Burkert, *HN* 127f.) and the hero of Temesos, who demanded a virgin a year for seven centuries (Pausanisas VI.6.7, Strabo VI.1.5.255, Kallimachos fr. 98 Pfeiffer). For wakeful prophets in caves, note 42 above.

48. J. Zandee, *Death as an Enemy* (1960), on the Coffin Texts A.4.q (p. 12), V.233.g (pp. 62, 64). See also chapter 2 note 55.

49. Some problems with the two *Odyssey* Nekyai, for scholars who are more troubled by than appreciative of them, may derive from a hope that they represent a genuine and consistent Greek theology or eschatology rather than poetic comment on the deepest themes of both epics. Rohde thought, of the Herakles passage, xi.601f., "Whoever wrote this was practising a little theology on his own account" (*Psyche* 39), a habit natural in any Greek poet. D. L. Page gives the fullest account of the internal inconsistencies, *The Homeric Odyssey* (1955) 21–51; important discussions, among many, in Dieterich, *Nekyia*² (1913); Rohde, *RhM* 1 (1895) 600f. [*Kleine Schriften* ii.255] and *Psyche* 32; L. Radermacher, *RhM* 14 (1908) 531; E. Bethe, *Odyssee* (1922) 126; W. Büchner, "Probleme der homerischen Nekyia," *Hermes* 72 (1937) 104; P. von der Muhll, "Zur Erfindung in der Nekyia der Odyssee," *Philologus* 93 (1938) 3; A. Lord, *The Singer of Tales* (1960) 164; G. Petzl, *Antike Diskussionen über die beiden Nekyai* (1969); see Frame, note 36 above.

Büchner is especially appreciative of the role of audience and poet. G. Petzl's *Antike Diskussionen über die beiden Nekyai* (1969) is illuminating for the scholiasts' total lack of information, and their facility in transforming speculation into scholarly tradition, providing solutions for such problems as how Odysseus could see from the *bothros* to the inside of Hades, how Otos and Ephialtes could be μήκιστοι when they were shorter than Tityos, how Tantalos' tree could grow in a pool, and why the dead fear Herakles' arrows. The second Nekyia raised such problems as are still difficult for perfectionists: how the suitors could reach Hades before burial, the topography of the gates of the sun and the land of dreams. In the same way as the White Rock, shades can be seen, Schol. H: οἱ γὰρ νεκροὶ ἐκλείψαντος τοῦ αἵματος λευκοειδεῖς ὁρῶνται. In fact both Nekyai, different as they are in their strange, romantic topography and curious theology, seem poetically excellent and crucial to the resolution of epic issues. For the Nereids at Achilles' funeral see chapter 6.

50. Petzl, *op. cit.*, note 49.

51. The best discussions still seem to be in Rohde, *Psyche*; and Roscher, "Psyche," 3201f. (Waser). See also Boehme, *Die Seele und das Ich in homerischen Epos* (1923). Rohde 19f. on appeasement by fire must be modified by more recent archaeological observation and he is perhaps too convinced of the restlessness of unburned souls (V.410), but the principles must be correct, and even ancestor-worship, theoretically unpopular now, flourished in myth and in the intensification, revival, or institution of cults in the fifth century. Rohde I nn. 77, 79, on *eidola*, V and n. 83f. on Genesia, Nemesis and ghosts, nn. 123f. on Tritopatores and wind-soul ghosts; see note 12 above.

52. Boston 95.47, ARV² 670.17, Manner of the P. of London E. 342, Fairbanks, *AWL* I pl. 7; see also Fairbanks I.347, II 232, and note 15 above.

53. Plato, *Phaido* 80 d 5, 81 c 9: τοιαύτη ψυχὴ βαρύνεταί τε καὶ ἕλκεται πάλιν εἰς τὸν ὁρατὸν τόπον φόβῳ τοῦ ἀιδοῦς τε καὶ Ἅιδου, ὥσπερ λέγεται, περὶ τὰ μνήματά τε καὶ τοὺς τάφους κυλινδουμένη, περὶ ἃ δὴ καὶ ὤφθη ἄττα ψυχῶν σκιοειδῆ φαντάσματα, οἷα παρέχονται τοιαῦται ψυχαὶ εἴδωλα. See Rohde, *Psyche* 170.

54. See the Bibliography, p. 263.

55. Vermeule, *BMFA* 63 (1965) 34; L. Malten, *JdI* 29 (1914) 215f.

56. *RE* V A.1246 (Lesky); Roscher 481f. (Waser); Rohde, *Psyche* 159; Robert, *Thanatos*; Heinemann, *Thanatos*; Farnell, *Cults* III, 280–88; Nilsson, *GGR* I² 452; and see the Bibliography p. 265. Hades' temple in Elis without priests, Pausanias VI.25.2; his temenos on Mount Minthe, Strabo VIII p. 344; his cult as Klymenos (?) in Hermione, Pausanias II.35.9, cf. IX.34.1; his lack of gifts, Aischylos fr. 161 N²; Plato, *Phaido* 80 d, ἀγαθὸς καὶ φρόνιμος θεός. For Hades and Persephone cults in general, *RE* Sup. III, 867 (Prehn), a list of cult and literary epithets; G. Zuntz, *Persephone* (1971); Stengel, *Opferbräuche*; K. Dilthey, "Jäger Hades und Jägerin Persephone," *ArchZeit* 31 (1874) 82, κυνηγέτης; for Hades κυανοχαίτης, N. Richardson, *The Homeric Hymn to Demeter* (1975) on 347; P. Thieme in R. Schmitt, *Indogermanische Dichtersprache* (1968) 133f.

The common Homeric adjectives are πυλάρτης, στυγερός (VIII.368), ἀμείλιχος, ἀδάμαστος (IX.158), ἄναξ ἐνέρων (XV.188, XX.61), πελώριος (V.395), κλυτόπωλος (V. 654, XI.445). The quasi-magical euphemisms of the *Hymn to Demeter* include polydektos (9), polyonymos (18), polysemantor (31, 376), which Aischylos develops as *ho polyxenotatos, Zeus ton*

kekmekoton (*Suppliants* 144; *nekrodegmon*, *Prometheus* 153). Other classical writers develop similar themes of dark hair, horsemanship and hospitality without really altering the Homeric divinity until the Attic-Eleusinian influence of Plouton softens the image on one side, as a benign giver, and hardens it on the other as a possessive and unbending, though not malignant, jailer. For Hades' horsemanship and horses on gravestones and Totenmahl reliefs, L. Malten, *JdI* 29 (1914) 179f.; D. Frame, *Nous* (note 36), passim; Persephone pictures collected in A. Peschlow-Bindokat, *JdI* 87 (1972) 60f.; Hades and Plouton, K. Schauenburg, *JdI* 68 (1953) 38f.

57. E.g. Aischylos, *Persians* 629, "Earth and Hermes and king of the dead"; 640, "Earth and other rulers of the chthonian powers"; *Choeph.* 489, "O Earth, release father to me "

58. Chapter 4 note 20.

59. Cf. Ganschinietz, "Katabasis," *RE* X.2359; and Pausanias II.35.10, 37.6, Diodorus Siculus IV.25.4; J. G. Frazer, on Apollodoros, *Library* III.5.3; and Plutarch's picture of the pool at Lerna where Dionysos plunged down to bring Semele from the dead, or at the Troizenian shore, "a mighty chasm mantled with woods and green grass and blooming flowers . . . exhaling a delicious, an intoxicating perfume, while all about it the souls of the departed circled and stooped upon the wing like flights of birds . . . , " *De sera numinis vindicta* 22, 565f.

60. In the annals of Shalmaneser III (858–824; *ANET*² 279), after the battle of Karkara there were so many corpses clogging the plain that the souls could find no free space or cavities to get down through: "The plain was too small to let all their [lit. his] souls descend, the vast field gave out to bury them."

61. P. Thieme, "Hades," *BVSAW* 98 (1952) 35f. (R. Schmitt, ed., *Indogermanische Dichtersprache* [1968] 133f.).

62. The single gate-keeper of Greek myth is Hades-plus-dog; the Argive Dionysiac rite with lamb-sacrifice in the water, Plutarch, *Isis and Osiris* 35.364f.; Farnell, *Cults* V, 305 n. 89; W. C. K. Guthrie, *The Greeks and their Gods* (1950) 162. The single gate-keeper attends all seven gates in the Akkadian Descent of Ishtar (*ANET*² 107); in Sumerian myth the chief keeper is Neti. The seven gate-keepers of Egypt have multiple titles, such as

(1) Face Downward, Sad of Voice; (2) Spy, Guard, "Watchful"; (3) Eater of the Excrement of His Posterior, Alert of Face; (4) Repulsive of Face, Garrulous, Repeller of the Crocodile; (5) He who Lives on Rotten Meat, Face a-fire; (6) Clawer of Bread, Vibrant of Voice; (7) Keenest of Them, Big of Voice, Repeller of Attackers (T. G. Allen, *The Egyptian Book of the Dead* (1960), ch. 144).

The Greek gates of Hades, V.646, IX.312, difficult to exit through XXIII.71, 76, οὐκ εὐέξοδον, Aischylos, *Persians* 688; dark, Theognis 709; the dog, VIII.368, σκοτοδασοπυκνότριχα, Aristophanes, *Acharnians* 390; Gates of Heaven, V.749, VIII.393, 411; of Tartaros, Hesiod, *Theogony* 119, 721f.; of the Sun, xxiv.12, of Dreams, iv.809, xix.562; the Pylos Gate, V.397 and Pindar, *Olympian* V.29.

63. P. Jacobsthal, "The Nekyia Krater in New York," *Metropolitan Museum Studies* 5 (1934–36) 117f.; P. Friedländer, "Zur New Yorker Nekyia," *AA* (1935) 20f.

64. Cf. the anonymous tragic fragment Nauck-Snell 909, 372. Burial in an alien land may bring parallel loneliness to the *psyche*, as for Sthenelos Aktor's son in the *Argonautika* (Apollonios II.911f.) whom "Persephone" sends up on top of his barrow to see men like himself again; poetry not theology. Hector goes to Hades formulaically, XXII.362, but does not appear there.

65. Thanatos is δυσηχής (XVI.442, XXII.180), λευγαλέος (XXI.281, v.312, xv.359), κακός (III.173, XXI.66, XXII.300), μέλας (II.834, XI.332, XVI.687), καταθύμιος (XVII.201, X.383), πορφύρεος (XVI.334, XX.477), τανηλεγής (VIII.70, XXII.210) in the *Iliad*. In the *Odyssey* he is also τανηλεγής and λευγαλέος, to which are added στυγερός (xii.341, xxiv.414), οὐκ ἀτελής (xvii.546), ὁμοίϊον (iii.236), οἴκτιστός (xi.412, xxiv.34, xii.342), μαλακός (xviii.202) and ἀβληχρός (xi.135). The adjectives are less "personal" than those for Moira, although similar; Moira πέδησε (IV.517, XXII.5), ὦρσεν (V.629), and δάμασσε (XVIII.119, δαμῆναι XVII.421).

I am not sure in what sense the two "invitations to death" are given to Patroklos (XVI.693) and Hektor (XXII.297); like a summons to a banquet? The phrase θεοὶ θανατόνδε κάλεσσαν is adapted also to invitations to assembly (XX.16), to bed (ii.348), to home (xi.410), or to conversation apart (xv.529).

66. The common formulas joining *thanatos* to another abstraction are:

θάνατος καὶ μοῖρα κιχάνει
 XVIII.478, 672, XXII.436
ἄγχι παρέστηκεν θάνατος καὶ μοῖρα κραταιή
 XVI.853, XXIV.132
ἔλλαβε πορφύρεος θάνατος καὶ μοῖρα κραταιή
 V.83, XVI.334, XX.477
ἀλλ' ἐπί τοι καὶ ἐμοὶ θάνατος καὶ μοῖρα κραταιή
 XXI.110
ἡμέων δ'ὁπποτέρῳ θάνατος καὶ μοῖρα τέτυκται
 III.101
οὐ γάρ πώ τοι μοῖρα θανεῖν καὶ πότμον ἐπισπεῖν
 VII.52
αἴ κε θάνῃς καὶ μοῖραν⎫
πότμον ⎭ἀναπλήσῃς IV.170
φύγομεν θάνατόν τε μόρον τε
 ix.61, xi.409, xvi.421, xx.241
τὸν δ'ἄγε μοῖρα κακὴ θανάτοιο τέλοσδε XIII.602
μοῖρ' ὀλοὴ καθέλῃσι τανηλεγέος θανάτοιο
 ii.100, iii.238, xix.145, xxiv.135
ἀλλ' ὅτε κέν δὴ μοῖρα παρεστήκῃ θανάτοιο
 Hymn to Aphrodite 269
θάνατον καὶ πότμον ἐπίσπῃ
 II.354, XV.495, XX.337,
iv.196, xi.389, 412, xiv.274, xxiv.22
κῆρες θανάτοιο II.302, 834, XI.332, XIV.207
κῆρα κακὴν μέλανος θανάτοιο XVI.687
θάνατόν τε κακὸν καὶ κῆρα μέλαιναν
 XXI.66, ii.283, iii.242, xiii.157,
xv.275, xxii.14, xxiv.127
θάνατον καὶ κῆρα φύγωμεν XVII.714
θάνατόν τε κακὸν καὶ κῆρα λιτέσθαι XVI.47
θάνατον καὶ κῆρας ἀλύξαι XXI.565
κῆρες ἐφεστᾶσι θανάτοιο XII.326
δύο κῆρε τανηλεγέος θανάτοιο VIII.170, XXII.210
διχθαδίας κῆρας φέρεμεν θανάτοιο τέλοσδε IX.411
θάνατος καὶ κήδεα IV.270
θάνατόν τε φυγεῖν καὶ μῶλον Ἄρηος II.401
θάνατον καὶ φύζαν ἑταίρων XVII.381

67. Black: earth III.699, XV.715, XVII.416, XX.494, with blood; night XIV.439, VIII.486, X.297, 394, 468, VIII.502, IX.65, XXIV.366, 653; μελαίνης νυκτὸς ἀμολγῷ XV.324, *Od.* and *Hymns*; blood IV.149, VII.262, X.298, 469, XI.813 αἷμα μέλαν κελάρυζε· νόος γε μὲν ἔμπεδος ἦεν, XIII.655, XXI.119, XVI.529, XXIV.587, XX.470, XXIII.806, iii.455, *Hermes* 122; cloud, of death XVI.350, iv.180, of grief xxiv.315; sea and waves XXI.126, XXIII.693, iv.402, v.353; pain IV.117, 191; springs IX.14, XVI.3, 160, XXI.257, xx.158; XXI.202, iv.359, vi.91, xii.104; ashes XVIII.25, v.488; dust *Hermes* 140, 345. Cf. φρένες ἀμφιμέλαιναι, I.103, Aischylos, *Persians* 116 μελαγχίτων φρὴν ἀμύσσεται φόβῳ.

Porphyry: cloud XVII.551, *Hermes* 217; rainbow XVII.547; blood XVII.361; sea I.482, XVI.391; heart XXI.551, iv.427, 572, x.309, XIV.16 ὡς δ'ὅτε πορφύρῃ πέλαγος μέγα κύματι κωφῷ (cf. 391, I.182); or Skamander

 μορμύρων ἀφρῷ τε καὶ αἵματι καὶ νεκύεσσι.
 πορφύρεον δ' ἄρα κῦμα διιπετέος ποταμοῖο
 ἵστατ' ἀειρόμενον . . .

 [XXI.325]

Cloths: III.126, XXII.441, grave-cloth XXIV.796. πορφύρεος θάνατος V.83, XVI.334, XX.477; θανάτου μέλαν νέφος ἀμφεκάλυψεν V.68, XVI.350, 502, cf. II.834, XI.332, XVI.687; and τέλος θανάτοιο κάλυψε(ν) XVI.502, 855, XXII.361, cf. V.68.

68. The etymology of *ker, keres* is still unknown, suggesting it may be a loan word; but a relation to Semitic *cherub, kerab* is unsubstantiated. See Chantraine, *Dictionnaire*; Frisk, *Wörterbuch* 842f.; D. J. N. Lee, *Glotta* 39 (1961) 191f.; W. Pötscher, *Wiener Studien* 73 (1960) 5f., esp. 14–22; older views in *RE* Supp. IV.883 (Malten), *RE* V.2806 (Körk), *RE* Supp. III.267 'Daimon'; Roscher III.3215; F. Hauser in F-R III, 2; P. Hartwig, *JHS* 11 (1891) 340; A. Evans, *The Palace of Minos* I (1921) 710 (*gryps* and *kerub*); Harrison, *Prolegomena* 163–256. For images, Hampe, *Grabfund* 66f. κήρ in the *Iliad* is, like μοῖρα, ὀλοή (XIII.665, XVIII.535), κακή (XII.113, XVI.687, XXII.202); like death, μελαίνα (II.859, III.360, VII.254, XI.360, XIV.462, V.22, 652, XI.443, XVII.714, XXI.66). She (they) are mistress of θάνατος (in the genitive) or paired with φόνος (V.652, XI.443, XVII.714, XXI.66). The most interesting passage, apart from the Shield (XVIII.535), is the expression κηρεσσιφορήτους κύνας (VIII.527), with the same associations as for Hekate, Hades, and the gods who clean the corpses on the battlefield (below chapter 3 p. 103). The Hesiodic *Shield* insists on white fangs, claws, and bloodthirst, 248f. Post-Homeric authors tend to invest κῆρες with a greater sense of moral duty and cosmic function than is discernible in epic —νηλεοποῖνοι (Hesiod, *Th.* 217) may not be later, but is "ethical" where the Homeric intent is not; cf. ἀναπλάκητοι Sophokles, *OT* 472; the "conversion" to Sphinx (ἁρπαξάνδρα κήρ', Aischylos, *Seven* 777) is or may be the pre-Homeric idea harmonizing with Patroklos' remark and the cherub (chapter 2 p. 69).

For κήρυνος, a throw of dice, see below, chapter 2 note 73.

69. Chantraine, *Dictionnaire* s.v.

CHAPTER II
DEATH IN THE BRONZE AGE:
A HOUSE IS NOT A HOME

1. Aspects of early burial practice in Anatolia, J. Mellaart, *Earliest Civilizations in the Near East* (1965) 86f., and *Çatal Hüyük* (1967) 204f.; in Greece, G. Hourmouziades in D. Theochares, *et al.*, *Neolithic Greece* (1973) 201f.; see also K. Bittel, *WVDOG* 71 (1958), C. Hawkes, *The Prehistoric Foundations of Europe* (1973) 335f., V. G. Childe, *Man Makes Himself* (1936) 54f., and *Man* 4 (1945) 13f., P. Ucko, *World Archaeology* 1 (1969) 262f., and see below, notes 12, 27. The Jericho skulls in J. Garstang, *The Story of Jericho* (1940) 57f., and Mellink-Filip, *FSK* pl. 113; the Dhahariye mask *ibid.* pl. XIX.

2. W. S. Smith, *Egyptian Sculpture and Painting in the Old Kingdom* (1949) 23f.; C. W. Blegen, "Early Greek Portraits," *AJA* 66 (1962) 245f.; M. Pallottino, *The Etruscans*[2] (1975) 147f.; G. Von Vaccano, *The Etruscans in the Ancient World* (1960) 55f.; E. Panofsky, *Tomb Sculpture* (1964) 49f.; M. Nagler at Berkeley suggested the appropriateness of James Dickey's poem *Helmets* to the themes of military cemeteries.

3. E.g. the Mesolithic burial in the Franchthi Cave, T. Jacobsen, *Hesperia* 38 (1969) 374 pl. 100 b,c; here Fig. 3.

4. Chapter 1 note 19; F. Eichler, "Σῆμα und Μνῆμα", *AM* 39 (1914) 138; W. Schiering, "Stele und Bild," *AA* (1974), 651; Nilsson, *GGR* I[2] 191; B. Schweitzer, *SBLeipzig* 91 (1939) 4, 8f.

5. J. Mellaart, *Çatal Hüyük* (1967) 204; a "ball of fine cloth" was substituted for the brain in one skull; there was excarnation of an unborn child in shrine VI.14 (by immersion?); see also *Earliest Civilizations in the Near East* (1965) 86. Is this why vultures are "always female," as Aelian reports, *On Animals* II.46? They are impregnated by the south or east winds, and give live birth, without eggs. The horror the ancients felt for the hyena may originate in burial practices in Africa; cf. P. Ucko, *World Archaeology* 1 (1969) 270; T. H. White, *The Bestiary* (1954) 30f.:

"The Yena . . . is accustomed to live in the sepulchres of the dead and to devour their bodies. Its nature is that at one moment it is masculine and at another moment feminine, and hence it is a dirty brute . . . in order that it may prey upon men . . . it copies the sound of human vomiting . . . it gobbles up with hypocritical sobs." Aelian passes on Aristotle's report of the hyena's power to send any living creature to sleep with a touch of his left paw, VI.14, and powers of sorcery in moonlight, making silence by its shadow, like a special dog of Hekate.

6. Meuli, *Opferbraüche* 224f. and Burkert, *HN* 24f. on the ritual behavior of hunters with the bones of those they have killed; it is always the bones which must be collected, buried and venerated. The most disturbing vision in the *Odyssey* is of the white bones rotting in the rain (i.161), rolling in the sea or lying unheeded on the sand (xiv.135). Archilochus' πεπαρμένος δι' ὀστέων (104) sets passion and grief in the bone or marrow, the idea of the soul being contained in the bones rather than the flesh is a natural one, perhaps reinforced by early impressions of the importance of bone marrow, and is understood in fairy tales like The Singing Bone. The father weeps when he burns his son's bones, not his flesh (XXIII.222), the ὀστέα μυελόεντα (ix. 293).

7. See chapter 3 note 24 on birds and dogs; for the problem of αὐτός as the real self, in αὐτοὺς δὲ ἑλώρια τεῦχε κύνεσσιν and the peculiar usages of σῶμα in Homer, H. Herter, "Soma bei Homer," *Charites* (*Festschrift E. Langlotz*, 1957) 206–17; A. Lesky, *Gnomon* 22 (1950) 99, and 27 (1955) 483. αὐτός at least denotes the edible part of the human complex.

8. J. Mellaart, *Çatal Hüyük* (1967) 167f.

9. "Vultures even follow armies on the march abroad, knowing by some prophetic skill that they are going to war and that every battle produces corpses, and they have come to understand this" (Aelian, *On Animals* II.46). Battlefield-Lion palette, Abydos, c. 3400–3200, London/Oxford/Lucerne; Mellink-Filip, *FSK* pl. 212a, H. Müller, *ZAeS* 84 (1959) 68f., J. Harris, *JEA* 46 (1960) 104f., W. S. Smith, *BMFA* 65 (1967) 77f. Vulture Stele, A. Moortgat, *Art of Ancient Mesopotamia* (1969) pll. 118–121; Louvre AO 2346–2348; E. Strommenger, *Art of Mesopotamia* (1964)

pll. 66–69; L. Heuzey, *Catalogue des Antiquités Chaldéens . . . du Louvre* (1902) 101f.; E. de Sarzec and L. Heuzey, *Découvertes en Chaldée* (1884–1906) pll. 3–4, 48, 48 bis.

10. J. Perrot, in Mellink-Filip, *FSK* pl. 127; "Une Tombe à ossuaires du IVᵉ millénaire à Azor," *'Atiquot* 3 (1961) 1f.; E. Panofsky, *Tomb Sculpture* (1964) 10 n. 2 (P. Kahane); *Illustrated London News* 237 (1960) 998; cf. F. Behn, *Hausurnen* (1924). Some ossuaries have beaks, like vultures', and like Gorgias' γῦπες: ἔμψυχοι τάφοι (D-K B.5a25); cf. Mellink-Filip, *FSK* 128a–129b.

11. F. Matz, *Die Antike* 4 (1928) 266; A. W. Lawrence, *Greek Architecture* (1957) 211f.; K. F. Kinch, *Le tombeau de Niausta* (1920); P. Petsas, *O Taphos ton Leukadion* (1966); K-B 273, 377.

12. S. Iakovides, *Perati* B (1970) 43f. with bibliography, and note 27 below, end.

13. This oversimplified contrast between individual Middle Helladic cist graves and Mycenaean chamber-tombs should include the group tumulus graves with individual cells, at such sites as Samikon, Koukirikos, Papoulia, Makrysia and Pylos on the west coast, Marathon, Aphidna, Argos and Asine on the east; N. G. L. Hammond, *BSA* 62 (1967) 77 and *Migrations and Invasions in Greece and Adjacent Areas* (1976) 113f.; W. Taylour in C. Blegen, M. Rawson, W. Taylour, W. Donovan, *Pylos* III (1973) 151; S. Marinatos, in R. Crossland, A. Birchall, eds., *Bronze Age Migrations* (1974) 111.

14. Aischylos, *Agamemnon* 1553f. and E. Fraenkel (1962) on 1157; Pindar, *Pythian* XI.19; the widespread belief in the dead as messengers to the dead documented among the Getae (Herodotos IV.94); Euripides makes Odysseus imagine that the dead whisper, as they stand by Persephone, of Greek ingratitude to Greek, aware of current events at Troy, *Hekabe* 136; cf. Alexiou, *Lament* 41:

> A wise housewife, an orderly woman,
> has made up her mind and decided to go down
> to Hades.
> If you have messages to send, give them to her
> to take,
> and if you have a son unarmed, send him
> weapons too.

15. See J. M. Cook, "The Cult of Agamemnon at Mycenae," *BSA* 48 (1953) 31, and *Geras Keramopoullos* (1953).

16. See chapter 3 note 30. See also Nilsson,

GGR I² 92, 99; R. C. Jebb, *Sophocles, The Electra* (1907) on 445. The *moria* of the dead men which get bound round the neck very probably include genitals in practice, although literary sources are shy of mentioning it; in our own times this has been reported in Algeria and Vietnam. See chapter 3 notes 18, 30.

17. E. Waugh, *The Loved One* (1948) 45: "I presume the Loved One was Caucasian?" "No, why did you think that? He was purely English." "English are purely Caucasian, Mr. Barlow. This is a restricted park. The Dreamer has made that rule for the sake of the Waiting Ones. In their time of trial they prefer to be with their own people." "I think I understand. Well, let me assure you Sir Francis was quite white."

"There's no restriction any more against Negroes being buried here. There are none here, though," he hastened to assure me. "I guess they feel more comfortable among their own people." J. Mitford, *The American Way of Death* (1963) 128.

18. I am not sure when these words were first applied by modern archaeologists to Mycenaean tholos tombs; *dromos*, at least, is used by H. Schliemann *Mycenae and Tiryns* (1878) 43; probably all three were the natural vernacular description, adopted by archaeologists from local practice, and familiar from Tsountas' time on (Ch. Tsountas, J. Manatt, *The Mycenaean Age* [1897] 115f.). *Thalamos* was applied to the grave, in an equally natural way, by Aischylos (*Persians* 624, libations to the underground chambers), then by Sophokles (e.g. *Antigone* 804, 947), and Euripides (*Herakles* 807, *Suppliant Women* 1022); *stomion* by Aischylos (*Choephoroi* 807) and Sophokles (*Antigone* 1217), mixed with the entrance to the underworld as in Plato, *Republic* 615 d,e. Artemidoros, *On Dreams*, epigrammatizes, Στόμα ἔοικε τάφῳ, ὅσα γὰρ ἂν λάβοι τὸ στόμα διαφθείρει καὶ φυλάττει. The traditional Homeric use of *thalamos* both for women's inner chambers, bedrooms (III.423, XI.227) and for storerooms with valuables (XXIV. 191, xxi.8) made it easy to convert tholoi into treasuries (see Dodwell, quoted by Schliemann, *op. cit.* 47) and into the bedrooms of heroines, the bedroom-vault of Danae in the Treasury of Atreus, or the bedrooms of the daughters of Proitos between Tiryns and the sea (Pausanias II.25.9) or the *sema* and *theke* of

the Hyperborean maidens on Delos. θαλάμη may be used for sea-caverns and octopus lairs (v.432; Arist. *Historia Animalium* 535a, 549b, 32), dragons' dens (Euripides, *Phoinissai*, 931), prophetic caverns (Trophonios, Euripides, *Ion* 394), or the grave (Euripides, *Suppliant Women* 980); these matters are all connected. There might be a relation between the Dromos in Athens to "the race-track of life" and the state graves along it, τὸν περὶ ψυχῆς δρόμον δραμεῖν Aristophanes, *Wasps* 375, περὶ ψυχῆς ὁ δρόμος Plato, *Theaitetos* 173a, though it seems far-fetched; cf. F. Jacoby, "Patrios Nomos: State Burials in Athens," *JHS* 64 (1944) 37f.; K. Gebauer, *AA* (1938) 612, 1940, 345; R. C. Jebb, *Sophocles, Antigone* on 848, 1216.

19. D. L. Page suggested the idea in Athens, 1965; cf. G. Papathanasopoulos, *AAA* 4 (1971) 12, 149, 289; N. Lambert, *AAA* 5 (1972) 199.

20. Chapter 1 note 6.

21. Cf. E. Vermeule, *Festschrift F. Brommer* (1977); and for Lamia in general, Roscher II (1818) (Drexler); *RE* V, 2540 (Waser, Empusa); Rohde, *Psyche* 410; J. C. Lawson, *Modern Greek Folklore and Ancient Greek Religion* (1910) 173; M. Mayer, "Kanne auf Kameiros," *ArchZeit* 43 (1885) and *AM* 16 (1891) 300; W. W. Hyde, *Greek Religion and its Survivals* (1923) 175f.; Haspels, *ABL* 143; J. Fontenrose, *Python* (1959) 94f. The derivation from *lamos, laimos*, gullet, establishes a parallel to the Egyptian hippopotamos-headed or -bodied Devourer; at home in the sea at least from Stesichoros, 43 D, D. L. Page, *PMG* 220, a daughter of Scylla, or possibly a by-name of Scylla's mother Krataïs, xii.124; displaced like other feminine threats to barbarian lands, Libya, by Euripides' time, *Busiris* (?; cf. Wilamowitz, *Glaube* I, 267); note 22 below.

22. *Wasps* 1035 = *Peace* 755; *Wasps* 1177; for testicles, their connection with dancing and fertility, C. Watkins, *BullSocLinguistique de Paris* 70 (1975) 11.

23. See J. D. P. Bolton, *Aristeas of Proconnesus* (1962) 40, 54, 93; J. H. Croon, *The Herdsman of the Dead* (1952); H. J. Rose, *Numen* I (1954) 213; *Homeric Hymn to Apollo* 412, and Frazer, *Pausanias* on II.35.10; chapter 4 note 45.

24. The interesting subject of what the classical Greeks really knew about the Mycenaean Greeks has not yet been explored in

any depth; of the robbed tholos tombs, which number in hundreds, Menidi-Acharnai is best known for the cult it apparently engendered; H. Lolling *et al.*, *Das Kuppelgrab bei Menidi* (1880), P. Wolters, "Vasen aus Menidi," *JdI* 14 (1899) 103; C. W. Blegen, "Post-Mycenaean Deposits in Chamber Tombs," *EphArch* (1937) 377; for Orchomenos, C. Belger, "Grab des Hesiod in Orchomenos," *AA* (1891) 186. See also R. K. Hack, "Homer and the Cult of Heroes," *TAPA* 60 (1929) 57; T. Hadzisteliou-Price, "Hero-cult and Homer," *Historia* 22 (1973) 129; J. N. Coldstream, "Hero-cults in the Age of Homer," *JHS* 96 (1976) 8f.; R. Hägg, "Mykenische Kultstätten," *OpAth* 8 (1968) 39f.; Nilsson, *MMR*² 603.

Characteristic fifth-century graves in Athens and Attica (K-B 96–100, 354) include oblong pits and shafts, sometimes with coffins, clay tubs, or cover slabs; earth mounds with multiple single graves, tile graves, cremations in bronze cauldrons or hydriai often set in stone boxes, and a few built tombs, of mud-brick as in archaic times, or occasionally with a stone facade; cf. C. Boulter, "Graves in Lenormant Street, Athens," *Hesperia* 32 (1963) 113–37; S. Charitonides, "Excavations of Classical Burials near Syntagma Square," *EphArch* (1958) 1–152; B. Schlorb-Vierneisel, *AM* 81 (1966) 4–111.

The living death in a rocky vaulted cavern-tomb is threatened again in Sophokles' *Elektra*, 380f., a sign of the picturesque interest in caverns and crags in fifth-century scenery; see W. Jobst, *Die Höhle im griechischen Theater des 5. und 4. Jahrhunderts v. Chr.* (1970), and T. B. L. Webster, *JHS* 91 (1971) 209. Most caverns naturally appear only verbally, in messenger speeches.

25. The belief that the loutrophoros-vase is a sign of burial of an unwedded person who has become wedded in death is based mainly on Demosthenes, *Against Leochares*, 18 and 30 (λουτροφόρος ἐφέστηκεν ἐπὶ τῷ τοῦ Ἀρχιάδου τάφῳ), although in antiquity this was usually taken to mean a person bringing *loutra* and not a vase; P. Wolters, "Rotfigurige Lutrophoren," *AM* 16 (1891) 371f., and a justly skeptical discussion in K-B, 149f. Archaeological and literary evidence is collected in R. Ginouvès, *Balaneutiké*, "Le bain et les rites funéraires," 245f.; cf. H. Kenner, "Das Luterion im Kult," *ÖJh* 29 (1935) 150. There is no doubt that water was a key element in

funeral rites (Eitrem, *Opferritus* 76f., Stengel, *Kultusaltertümer* 155f.), but there is some doubt that the "bride of death" theme was as popular as we think (K-B 127, 151); even the *Antigone* is restrained on this topic (1204 λιθόστρωτον ... νυμφεῖον Ἄιδου κοῖλον), yet the idea is so firmly held that Euripides, *Hekabe* 611,

ὡς παῖδα λουτροῖς τοῖς πανυστάτοις ἐμήν
νύμφην τ' ἄνυμφον παρθένον τ' ἀπάρθενον
λούσω προθῶμαι θ'—

could be translated: "I must give my daughter's body its last bath / before her burial, this wedding which is death. For she marries Hades, and I must bathe the bride / and lay her out as she deserves" (W. Arrowsmith in *Complete Greek Tragedies*, Euripides 3, 34). The reference is to the unconsummated wedding with the dead Achilles. The first reference to (virginal) bridal in Hades may be the well-known epigram for Attic Phrasikleia, c. 540,

Σῆμα Φρασικλείας, | κόρε κεκλέσομαι | αἰεί,
ἀντὶ γάμο | παρὰ θεοῦ τοῦτο | λαχôσ' ὄνομα

(G. Kaibel, *Epigrammata Graeca* 6; *IG* I² 1014; Peek, *GV* 68, *GG* 30; Jeffery, *BSA* 57 (1962) 138, pl. 39a, fig. 14f.; Pfohl, *Greek Poems on Stones* no. 61; Lattimore, *Themes* 192f.; N. Kontoleon, *EphArch* (1974) 1f). The reverse conceit, bridegroom of Persephone, is far rarer except in mythical form, like the quest of Peirithoos. The bridal of Polyxena with dead Achilles, L. Malten, *JdI* 29 (1914) 260f.; H. J. Rose, "The Bride of Hades," *CP* 20 (1925) 238; F. Schwenn, *Die Menschenopfer bei den Griechen und Römer* (1915) 154, 166; Burkert, *HN* 79f. (Polyxena as "whore of the army").

26. S. Iakovides, *Perati* B (1970) 76; the body evidently still seemed capable of feeling.

27. C. W. Blegen, *Prosymna* (1937) 108, 213, 255, for the priest and the carpenter; smiths and soldiers are easily identified; such gifts are no proof of the feelings of the dead about their belongings since the style of burial is determined by the survivors who must often have kept what they wanted. The needs of some ancestral Minoan dead are attested by the terracotta model with offerings of food and drink to the seated dead by smaller living attendants, from the tholos tomb at Kamilari near Phaistos in Crete, but there seems to be nothing comparable so far from mainland Greece (D. Levi, "La Tomba a Tholos di Kamilari presso a Festòs," *Annuario* n.s. 23–24 (1961–62) 123f.). The feelings and placation of the dead are very differently estimated by authors of different temperaments; some like the livid, longing dead in their graves (e.g. A. Schnaufer, *Frühgriechischer Totenglaube* [1970], cf. C. Sourvinou-Inwood, *JHS* 92 [1972] 220), as opposed to the cheerful pragmatic spirit displayed throughout in K-B. In some moods there is an over-estimation of Greek fear of ghosts and *deisidaimonia* in general, for which we are partly indebted to the persuasive eloquence and learning of Jane Harrison; there is no good early testimony for "killing" a man's weapons by bending or breaking them (cf. chapter 1 fig. 1, K-B 52); "seconds" are freely used in burials without fear of reprisals (cf. *Hesperia* 35 [1966] 67); there is no ghost-fear in Homer apart from the natural nervousness attendant on visiting the underworld, and little in Hesiod apart from the kind spirits who roam the earth (*WD* 123); although murder must always make the murderer uneasy (see chapter 3 note 30 on *maschalismos*). Most ghost tales are late, rooted in folktale, some kinds of romance, and the deliberate revival of antiquarian terrors in which some Athenians delighted after the Persian Wars, partly in the feeling that the older and more wicked they could paint their ancestral past, the more remarkable they themselves became both for their antique origins and their improved behavior. See Nilsson, *GGR* I² 182; L. Collison Morley, *Greek and Roman Ghost Stories* (1912); E. Dingwall, *Ghosts and Spirits in the Ancient World* (1930); J. Fontenrose, "The Hero as Athlete," *California Studies in Classical Antiquity* 1 (1968) 79; for the Tritopatreion in Athens (winds and ancestral ghosts) L. Deubner, *Attische Feste* (1932) 44, n. 7; Rohde, *Psyche* 246; S. Eitrem, *Eranos* 20 (1921–22) 98; B. Hemberg, *Eranos* 52 (1954) 172; D. Ohly, *AA* (1965) 327; K. Kübler, *AA* (1973) 189; J. Travlos, *Pictorial Dictionary of Ancient Athens* (1971) 302; S. Benton, *Studi in onore di Luisa Banti* (1965) 49.

Mycenaean ceremony is lost to us, although tomb-contents are so well known; it is the reverse of the Hittite situation, with the monumental text of Hittite Boğazköy prescribing the funeral of royalty, and the poor actual contents of Hittite burials. Because

Mycenaean funeral prescriptions were oral, and probably showed local differences in spite of a general mainland homogeneity of tomb-types, there is no hope of reconstructing them through any combination of Homeric cremation-passages and recalcitrant Pylos texts, although some minor manifestations like flights of arrows and smashed drinking cups are recognizable enough. The Hittite death-wagon, pavilion, images of fruits, wise women with scales and antiphonal songs, music, gold cups, grapevine cut with a silver hatchet, oxen with silvered horns, offerings of bread and beer, would leave little trace, though the stone house of the dead, the bed, chair, stool and lamp might well do. Probably there was a good deal of music, singing, prayer, animal slaughter, and rites by women skilled in funerals, for all Mycenaean burials and particularly for royal ones, and although we cannot tell if a similar distinction was made as among the Hittites, between a king who became a god on death and ordinary men who returned "to the day of the mother," it may not be unlikely for the διοτρεφέες βασιλῆες. This is a matter separable from hero-cult or cult of the dead. The magnificence of Mycenaean royal burials, so far as they survived looting, compared to the relative poverty of Hittite cremation burials, may suggest that Mycenaean conceptions and rites were no less splendid. See H. Otten, *Hethitische Totenrituale, AbhBerl/ InstOrientforschung* 37 (1958); "Ein Totenritual hethitischer Könige," *MDOG* 78 (1940) 3f., on KUB XXX and XII; K. Bittel, "Die hethitischen Grabfunde von Osmankayasi," *MDOG* 71 (1933), "Hethitische Bestattungsbräuche," *MDOG* 78 (1940) 12. The possible correspondence between the Hittite use of the grapevine in funerals and the frequent use of vine-shoots in Attic burials (K-B 52, 64, 66, 73), whether as fuel or with Dionysiac implications, might deserve investigation.

Greek tomb-robbers were no more deterred by ghosts than their counterparts in Egypt and the East, as in the *Ludlul bel nemeqi*, "The grave was still open when they rifled my treasures, while I was not yet dead already they stopped mourning," H. Frankfort *et al.*, *Before Philosophy* (1949) 228.

28. See M. Ventris, J. Chadwick, *Documents in Mycenaean Greek*² (1973) 479; E. Bennett, *The Olive Oil Tablets of Pylos, Minos Supplement* 2 (1958) on Fr 1220, Fr 1231; cf.

Fr. 1218, Fr 1240. The Dipsioi as the dead, W. C. K. Guthrie *BICS* 6 (1959) 45; as the little genii who water plants and bring libations, S. Marinatos, *Cambridge Colloquium on Mycenaean Studies* (1966) 265; on Dipsia as, possibly, Earth or a cult title of earth, F. Adrados, *Minos* 9 (1968) 187, generating the Thessalian month-name Dipsios. G. Zuntz, *Persephone* (1971) 370f., stresses the Egyptian analogies for the thirst expressed on Greek gold-leaf tablets (see note 33 below), e.g. "may Osiris give you fresh cold water" (*IG* XIV.1488), and quotes The Book of the Dead, ch. 59 "O sycamore of Nut, give me your water," ch. 62 "Let me attain the water! let me drink the water!"; see also W. Déonna, "La soif des morts," *Revue de l'Histoire des Religions* 109 (1939) 53f., who reports (72) that the thirst of the dead has roots in the factual thirst of the dying, not in climate, for Eskimos also ask "Bring us ice, for we are suffering from thirst for cold water." Eitrem, *Opferritus* 105f., collects analogies to Egypt, Mesopotamia and India; cf. Stengel, *Kultusaltertümer* 144, 162.

29. See note 69 below for the *ba*-soul and the fresh waters of death; the drinking of the *ba* and of the dead person often shown in Egyptian funeral art, e.g. N. Davies, *Ancient Egyptian Painting* (1936) II pl. 87 (T. of Userhet, Thebes No. 51); A. Piankoff, B. Rambova, *Egyptian Religious Texts and Representations* III (1957) *Mythological Papyri* I, 71 (The Book of the Dead of the Lady Cheritwebeshet); H. Kischkewitz, W. Forman, *Egyptian Drawings* (1972) pl. 56.

30. C. Long, *The Ayia Triadha Sarcophagus* (1974) with bibliography; cf. Nilsson, *GGR* I² 177, 326f.; Andronikos, *Totenkult* 93f.; J. P. Nauert, *AntK* 8 (1965) 91; R. Paribeni, *MonAnt* 19 (1908) 5–86; Eitrem, *Opferritus* 76f., 416.

31. K-B 57–58.

32. Collected recently, N. Thönges-Stringaris, "Das griechische Totenmahl," *AM* 80 (1965) 1f.; cf. H. von Fritz, *AM* 21 (1896) 347, 473; J. Dentzer, *RevArch* (1971) 215f.

33. N. Verdelis, *EphArch* (1950–51) 80, 98. The idea persists in modern Greek, as in A. Thumb, *Handbook of the Modern Greek Vernacular* (1912) 215.7 (Passow 409),

Χάρε μου, κόνεψ' εἰς χωριό, κόνεψ' εἰς κρύα βρύσι,
Νὰ πιοῦν οἱ γέροντες νερὸ κ' οἱ νιοὶ νὰ λιθαρίσουν,

or in the euphemism "the thirsty," οἱ διψασ-
μένοι, for the dead. See note 28 above.

34. *ABV* 316.7, Munich 1493. See Roscher,
"Danaiden," 950 (Bernhard); F. Studniczka,
Kyrene (1890) 25; Harrison, *Prolegomena* 617,
Themis 529; C. Robert, *Die Nekyia des Polygnot*
(1892) 62; A. Furtwängler, *Münchner Studien*
(1909) 276, *AA* (1890) 24, *Kleine Schriften*
(1912–13) II.126; for the Palermo lekythos,
Palermo 996, see Haspels, *ABL* pl. 19.5. The
vases are an early manifestation of some con-
fusion between sinners ("Danaids") and the
uninitiated who suffer torments of thirst in
the underworld, and who are so labeled in
Polygnotos' Underworld painting; see I. M.
Linforth, "Soul and Sieve in Plato's *Gorgias*,"
*University of California Publications in Classical
Philology* 12 no. 17 (1944) 295f.; M. Robertson,
A History of Greek Art (1975) 266f. Plato carries
on the tradition in comments on the promises
of Orpheus and Mousaios to believers, and
how the unjust are buried in mud, carrying
water in sieves, *Republic* 363 d, e; these are
the unjust of both sexes, and the Danaids are
not among them before pseudo-Plato, *Axiochos*
371 e; see S. Reinach, *Cultes, Mythes, et
Religions* (1905–22) II, 193, E. R. Dodds,
Plato, Gorgias (1959) 372f.; males are con-
demned to bale the leaky pithos in Xenophon,
Oikonomikos VII.40. The old Homeric refer-
ences to the punishment of the dead are vague
and concern breakers of oaths (III.279,
XIX.259); considering the usual Homeric
fears (chapter 3 p. 110) social alienation would
seem a worse punishment than repetitive
drudgery. The archaic picture in Munich
may have more to do with thirst than punish-
ment. (I have not seen E. Keuls, *The Water
Carriers in Hades* [1974].)

35. A. Furumark, *The Mycenaean Pottery*
(1950) 32, 67.

36. For animals in tombs in general,
Wiesner, *Grab und Jenseits* 135f., 153f.; the
bat at Dendra, B. Schweitzer, *Gnomon* 9 (1933)
180; for wild goats and stags, below note 52;
birds at Aigina, A. Keramopoullos, *EphArch*
(1910) 207; burials at Perati included sheep,
birds, and a dog, S. Iakovides, *Perati* B (1970)
32, 33, 46, 52, 59, 86, 480; a whole ox at
Pylos, Kephalovrysi Tomb 2, *Ergon* (1964)
79, 81; general discussions in J. L. Benson,
Horse, Bird, Man (1970) 20f., G. Mylonas,
Mycenae and the Mycenaean Age (1965) 116f.,
Andronikos, *Totenkult* 84f. Most are concerned

with horse burial, or horse sacrifice, a practice
more common on Cyprus than in Greece; a
recent survey, H. Kassimatis, *RDAC* (1973).
The bull-sacrifice in the *tholos* at Arkhanes,
I. Sakellarakis, *Proceedings of the Second Creto-
logical Congress* (1968) 244; dogs at Arkhanes,
Praktika 1966 (1968), 178; cf. *Archaeology* 20
(1967) 278. The major Mycenaean horse
burials are at *Marathon* (see note 42): *Ergon*
(1958) 23f.; Vermeule, *GBA* pl. 47; *Nauplion–
Pronoia*: V. Stais, *EphArch* (1895) 206; Chr.
Tsountas and J. Manatt, *The Mycenaean World*
(1897) 152; *Mycenae*: Wace, *Chamber Tombs at
Mycenae* (1932) 14; *Argos*: *BCH* 80 (1956) 365;
Eleusis: (?) A. Skias, *EphArch* (1898) 89. Cf.
also R. Forrer, "Les chars cultuelles pré-
historiques," *Préhistoire* I (1932) 18; H.
Metzger, "Ekphora, Convoi Funèbre," *Rev-
Arch* (1975) 20; and see note 42.

It is sometimes thought that terracotta
animals in tombs were substitutes for real
animals killed along with the dead, but they
are far more numerous and of a wider range
than any real remains had ever been, a cheap
way of making "traditional" gifts which the
tradition had never made. Animal types
include cattle, horse, goat, sheep, stag, dog,
boar and pig, bear and bird, and were joined
by beds, chairs and boats; E. French, *BSA* 66
(1971) 154f.

37. *Iliad* XXIII.243, *Odyssey* xxiv.77 with
Antilochos separate in the same tumulus;
this poetic union of friends in death is not
continued in myth or art; Achilles' tumulus
on the Hellespont does not contain Patroklos
when he appears alone to sailors or marries
Polyxena; Patroklos' tomb, so familiar in art,
is normally the first, "temporary" mound
built while Achilles still lived, cf. K. Friis
Johansen, *The Iliad in Greek Art* (1967) 139–52,
and chapter 1 note 55.

38. The subject was elaborated in J. Kak-
ridis, *Homeric Researches* (1949) 73f.; cf.
chapter 5 notes 8, 35.

39. *The Boston Globe*, 25 February 1974.

40. For the themes and functions of picto-
rial kraters see among others Vermeule, *JHS*
85 (1965) 140, A. Furumark, *The Mycenaean
Pottery* (1950) 453, H. Lorimer, *Homer and the
Monuments* (1950) 48, and (forthcoming) V.
Karageorghis and E. Vermeule, *Mycenaean
Pictorial Vases*. The kraters have only a few
standard themes, such as chariots, bulls,
stags, goats, and birds; they are not all

funerary, or in funeral contexts, even in Cyprus, and on the mainland more than half are not from tombs, where the context is known.

41. The pig with a soul at *Odyssey* xiv.426 is notorious: usually a slain animal has only its *thumos* to lose. The problem of Orion's herding before him in the underworld the dead animals he has killed in the hills, xi.572, or Herakles' hunting stance, xi.607, which exercised the scholiasts, is of course quite separate from the problem of Greek belief; these pictures are literary impressions, like Pindar's horses (fr. 114) or the lives of the swan, the nightingale, or the lion, eagle, and monkey lying around in Plato's *Myth of Er* for men to choose (*Republic* X.620). Most Greeks, then and now, would not even have considered an animal's chances of afterlife, although they provided a useful formal element in theories of metempsychosis.

42. The three-legged horse burial at Marathon, S. Marinatos, *Praktika* (1970) 11, pl. 15, and in R. Crossland and A. Birchall, *Bronze Age Migrations* (1974) 111, pll. 13, 14. It is not clear from the reports whether the horse was missing one leg, whether it had been sacrificed in some way before burial, or whether the leg was lost in some more recent accident. While the Marathon horse had raised hopes for extending the German tradition of the three-legged death horse, with its uneven menacing gait, backward into prehistory (cf. L. Malten, "Das Pferd im Totenglaube," *JdI* 29 [1914] 210–11), the eight-year-old Przewalski does not illuminate sacrifice very much. Most horses buried with aristocrats are intact, companions or chariot-drawers, not eaten; and even in the fantasies of Mary Renault, the King Horse's legs are not removed with his life (*The King Must Die*, 11). The team buried in the *dromos* of the Marathon *tholos* tomb (the chariot was not found), *Ergon* (1958) 23; *Praktika* (1958) 15, pl. 17; Vermeule, *GBA* pl. 47 B, 349 note 8. Horse and chariot burials at Salamis and Old Paphos in Cyprus, P. Dikaios, "A 'Royal' Tomb at Salamis," *AA* (1963) 126; V. Karageorghis, *Salamis: Necropolis* I (1967) 117f.; *Salamis* (1969) 50f.; *Cyprus* (1969) 151f.; "Une Tombe de Guerrier à Palaepaphos," *BCH* 87 (1963) 294; *BCH* 91 (1961) 337. At Gordion in Anatolia there are slightly earlier horse burials outside the chamber of Tumulus

Ky, near roof level, providing a link with Scythian horse burials and the Kimmerians (R. S. Young, *AJA* 60 [1956] 266). On horse sacrifices to rivers (*Iliad* XXI.132, Herodotus IV.61, VII.113, and, surely, I.189) E. Delebecque, *Le Cheval dans l'Iliade* (1951) 239f., and J. G. Frazer, *Pausanias* VIII.7.2; P. Stengel, *Philologus* 39 (1880) 182; and on "going home" with horses, D. Frame, *Nous* (1970). The Indo-European rite discussed recently in J. Puhvel, "Aspects of Equine Functionality," *Myth and Law Among the Indo-Europeans* (1970) 159. Cf. also M. Detienne in J. P. Vernant, *Problèmes de la Guerre en Grèce ancienne* (1968) 313; D. Dunham, *El Kurru* (1950) 110f.

43. K. Meuli, *Der griechische Agon* (1968), "Der Ursprung der olympischer Spiele," *Antike* 17 (1941) 189f.; L. Malten, "Leichenspiel und Totenkult," *RhM* 38/39 (1923/4) 300f. Boxers on Mycenaean (funeral) vases: BM C333, 334, 335 (*CVA* Gt. Britain pl. 23.15, 18), Pierides 35 (*CVA* Cyprus pl. 42), Kition 14/2418 (*BCH* 95 [1971] 385 fig. 94); non-funerary, Mycenae-Athens NM 1272 (Furtwängler-Loeschke, *Mykenische Vasen* [1886] pl. XLI.426); 60–223 (W. Taylour, in E. L. Bennett, *The Mycenae Tablets* III, *TAPS* 52.7 [1963] 44 fig. 91).

44. Probably completed when flesh and ligaments are absolutely corrupted and dissolved, a condition which may take three to seven years depending on soil conditions. In Orthodox practice the skull may be removed to a chapel after three years.

45. For Mycenaean mourning women on bowls, S. Iakovides, *AJA* 70 (1966); of the detached archaic specimens, the Thera examples are most elegant, H. v. Gaertringen, H. Dragendorff, *Thera* II (1903) 24 fig. 57, N. Kontoleon, *AthMitt* 73 (1958) 119, 157; in Athens, on a loutrophoros hydria, *Deltion* 19 (1964) b, pl. 37, K-B pl. 13; on a trefoil jug with snakes and flowers, *Kerameikos* VI.2, 456f., K-B pl. 14; on a bowl, *Kerameikos* VI.2, 500f., K-B pl. 15. For gaming-boards with mourners, note 75 below.

46. E.g. T. Spyropoulos, *Praktika* (1969) pll. 1–14; (1970) 29–36 fig. 48a; (1971) pll. 5–21; *Ergon* (1970) fig. 17; *Connaissance des Arts* (April 1971) 72–77; *Archaeology* 25 (1972) 206f. The Boston loutrophoros-hydria (24.151) most recently in *CVA* Boston 2, pl. 67.

47. E.g. the Mycenaean krater from

Cyprus on which the dead man steers the griffin of his chariot by the tail, BM C 397, Enkomi T. 48, BM *CatVases* i, 80, *CVA* pl. 7.1, S. Immerwahr, *Archaeology* 13 (1960) 12 fig. 15, R. Higgins, *Minoan and Mycenaean Art* (1967) fig. 134.

For griffin and wild-goat teams on the Haghia Triada sarcophagus and related images, note 30 above. The upper panel on one end of the sarcophagus is seldom discussed—an escort on foot? An analogous scene in the upper register of the funerary Painted Stele from Mycenae may have a seated female receiving the walkers, like a "Persephone" with visitors.

48. Mycenaean boots, Voula (Alyke), J. Papademetriou, *Ergon* (1955) 24–25; S. Marinatos, *Crete and Mycenae* (1960) 236. For Hittite model boots, K. Bittel, "Vorläufiger Bericht . . . Boğazköy," *MDOG* 73 (1935) 24 figs. 14–15, 77 (1939) 30f.; and the instruction to the messenger god Imbaluris, "Take staff in hand and put swift shoes on thy [feet]" *ANET*² 122. See N. Gialouris, "Πτερόεντα πέδιλα," *BCH* 77 (1953) 293. The potent shoes of a messenger or traveler are a natural idea, and for long journeys one would prefer boots to sandals. The Homeric picture, of Hermes who ἐδήσατο the footgear, may mean lacing up the front as well as binding around the sole. The Greek examples are Geometric or archaic; Eleusis, *EphArch* 1898, pl. 4, 4; Athens, R. Young, *Hesperia* 18 (1949) 287–88, 296 fig. 12, pl. 67, 22–23, pl. 70; cf. *Hesperia* 2 (1933) 553, fig. 11, 6 figs. 20, 12; K-B pl. 8; *Kerameikos* V. 1. 281f. pl. 29, *JdI* 77 (1962) 102; *Deltion* (1964) B. 54f, pl. 49 c, d; Corinthia, H. Payne, *Perachora* I (1940) 186 pl. 85; S. Marinatos, *ArchHom* A (1967) pl. VI, *Crete and Mycenae* (1960) 236; for the meaning, Wiesner, *Grab und Jenseits* 210. The South Italian sarcophagus, K-B 212, fig. 42, Hellenistic from Rhegion, *NSc* (1957) 388 fig. 22.

49. The Mycenaean "psyche," Vermeule, *JHS* 85 (1965) 146, *Catalogue of the Ludwig Collection* (1968) 9; the modeled soul-birds (before), T. Spyropoulos, *AAA* III (1970) 190 fig. 8; after, *Connaissance des Arts* (April 1971) 76.

50. The interesting coffins from Armenoi (Rethymno), now in the Chania Museum, were discussed briefly by I. Tzedakis, *AAA* IV (1971) 216f., with color plates. The ensemble includes bulls walking among religious symbols

or being speared, deer, birds, marine animals, and a goddess with lifted arms (T.24 no. 2). See note 51.

51. The studies of Minoan ideas of the afterlife were generally undertaken before the coffins appeared or were studied, and are based on some misapprehensions, as in A. Evans, *The Palace of Minos* III (1930) 145f., on the forged "Ring of Nestor" and the tree of Paradise. The notion of a Cretan paradise overseas, like Elysion (note 58), has much to commend it imaginatively, but it is a mainly literary notion, documented by a few gold rings with ships, ships on a few coffins, the "Minoan" name of Rhadamanthys, an instinctive link between Crete and Phaeacia, some garden imagery common to LM I A frescoes and poetic ideas of Elysion, and the real possibility that some important Minoans were buried at sea (to account for the lack of royal burials), and Theseus' plunge into a gracious sea-palace in a Cretan context (Bacchylides XVII, 83f.). Cf. L. Malten, "Elysion und Rhadamanthys," *JdI* 28 (1913) 35f.; L. Radermacher, *Das Jenseits im Mythos der Hellenen* (1903); M. P. Nilsson, *MMR*² 621f.; S. Marinatos, *BCH* 57 (1933) 227, and *The Mycenaeans in the Eastern Mediterranean* (1973) 3f.; A. W. Persson, *Prehistoric Religion* 80f.; for "pre-Greek" Rhadamanthys, V. Giorgiev in R. Crossland and A. Birchall, *Bronze Age Migrations* 243, rebuttal by J. Chadwick, 254. The best ship larnax, S. Alexiou, *EphArch* (1972) pl. 34 (from Gazi); dolphin coffin-lid, C. Mavriyannaki, *Recherches sur les Larnakes* (1972) pl. 12; the common fish, dolphins, octopods, waves, birds and plants on Cretan coffins witness to an extensive and commonly shared imagery.

52. Tanagra goats, *AAA* III (1970) 196–97; Pylos (Kephalovrysi), an ox, *Ergon* (1964) 79–81, (Koukounara) half a stag, *Ergon* (1963) 81.

53. M. Delcourt, *Legendes et cultes de héros en Grèce* (1942) 58; G. Germain, *Genèse de l'Odyssée* (1954) 383; see below chapter 5 note 41 on sphinxes.

54. Alexiou, *Lament* 121 (from Olympia); *Laographia* (1912–13) 183.

55. The Egyptian evidence is so large, and, because of its own consistency and authority, only peripherally relevant to the Greek theme, only a selection of useful texts can be mentioned. For relations between Greece and

Egypt in the Bronze Age see V. Hankey, P. Warren, *BICS* 21 (1974) 142, with bibliography; after the Dark Ages, J. Boardman, *The Greeks Overseas* (1964) 134.

General books on Egyptian funerary practice, belief, illustrations and texts: M. M. Abdul-Quadar, *The Development of Funerary Beliefs and Practices* (1966); T. G. Allen, *The Egyptian Book of the Dead—Documents in the Oriental Institute Museum at the University of Chicago*, OIP LXXXII (1960–Chicago); P. Barguet, *Le Livre des Morts des Anciens Égyptiens* (1967); J. Breasted, *Development of Religion and Thought in Ancient Egypt* (1912); A. de Buck, *The Egyptian Coffin Texts* (1935–54); A. Erman, *Die Religion der Ägypter*[2] (1934); E. Hornung, *Aegyptische Unterweltsbücher* (1972); A. H. Gardiner, "The Attitude of ancient Egyptians to death and the dead," *Frazer Lecture* (1935); G. Jéquier, *Considérations sur les Religions Égyptiennes* (1946); H. Kees, *Totenglauben und Jenseitsvorstellungen der Älter Ägypter*[2] (1956); L. Lesko, *The Egyptian Book of Two Ways* (1972); S. Morenz, *Egyptian Religion* (1973); A. Piankoff, B. Rambova, *Egyptian Religious Texts and Representations* II (1957); J. Vandier, *La religion égyptienne* (1949), *Manuel d'archéologie* II (1959); R. Weill, *Le champ des roseaux et le champ des offrandes* (1936); J. Zandee, *Death as an Enemy* (1960). For Egypt and Mycenae, E. Vermeule, *Art of the Shaft Graves of Mycenae* (1975) 18f.; for Egypt and the Odyssey, W. Burkert, *Gräzer Beiträge* 1 (1973) 69f., "Das hunderttorige Theben," *Wiener Studien* n.s. 10 (1976) 5f.; J. Boardman, *The Greeks Overseas* (1964), thought Egyptian influence on Greek religion relatively slight, most intense 660–525 B.C. (pl. 9a, the archaic Greek prothesis scene in the Mortuary Temple of Sahure at Abusir; fig. 47a, Greek obeisance before a mummy); but strong connections in iconography as well as ideas are explored by J. L. Benson, *Horse, Bird, Man* (1970) 90f.; strong Egyptian links were always argued by M. P. Nilsson, e.g. *MMR*[2] 428, 438, 625f.; see C. Froidefond, *Le mirage égyptien dans la littérature grecque* (1971) and note 58 below.

56. P. Montet, *Byblos et L'Égypte* (1928–29) 215f., pll. 127–41; E. Porada, "Notes on the Sarcophagus of Ahiram," *Journal of the Ancient Near Eastern Society of Columbia University* 5 (1973) 355f.

57. For Charon's late appearance in Greece see chapter 1 note 7. The ferryman of the dead

is familiar in Egyptian tradition, as in the Book of the Dead ch. 99:

O thou who bringest the ferry boat from deep over yon bad shoal,
Bring me the ferry boat, attach for me the tow rope, in peace, in peace.
O Lord of red linen, who controllest hearts, O lord of storm.

T. G. Allen, *The Book of the Dead* (1960)

The lord is Seth; if Charon is a figure borrowed from Egypt (and a Greek etymology, a derivation from χάροψ, is increasingly doubted) his name may come from the boat, not the boatman; yet the derivation from *qaro*, "boat," boat of the sun of the dead (adopted by G. Germain, *Genèse de l'Odyssée* [1954] 359 n. 1 from A. Moret, *Rois et dieux d'Égypte* [1925]) is philologically unpromising. Late Egyptian *kr*, a small boat, fisherboat, is not promising either, according to E. Brovarski, Museum of Fine Arts, Boston, and D. Larkin, University of California, Berkeley; cf. A. Brugsch, *Hieroglyphisch-demotisches Wörterbuch* (1867–82) 1466; A. Erman, H. Grapow, *Wörterbuch der Ägyptische Sprache* V, 134, 14–15. It may, however, have been a word used in archaic Naukratis. For the moment, the connection, for Greek or Etruscan Charu(n), has not been made. The transference of other Egyptian figures to the Etruscan world is freshly documented by the Anubis in a Troilos scene in the Astarita Collection at the Vatican, M. Schmidt, "Ein ägyptischer Dämon in Etrurien," *ZÄeS* 97 (1971) 118f.; cf. K. Schauenburg, *JdI* 85 (1970) 68f. (The ferryman of Egypt, like the one of the Near East and Hades in Greece, "turns his face backward," cf. *ANET*[3] 328, "with his nose behind him and his face reversed"; so that he cannot eye the vulnerable living, as Orpheus should not have looked at the dead.)

58. It has often seemed curious that after the use of the word Elysion in *Od.* iv.536 it does not recur in literature until Apollonios of Rhodes (*Argonautica* 4.811). The normal archaic and classical expression for paradise is Isles of the Blest. The Isles may be quite separate, in the minds of those few who thought about them, from the Elysian Field, 'Ηλύσιον πέδιον, which is a meadow (λειμών) in Lucian, or a χῶρος, but not necessarily an island. However, the relation to Ialu Field(s), like Champ(s)-Elysées is more curious, when the expression occurs in two poems where

interest in Egypt is marked. J. Puhvel would prefer as a source a Hittite meadow-word, neuter *wellu* (Ú·SAL, Akk. *usullu*), used funerarily when the sun-god makes a meadow for the dead king, "'Meadows of the Otherworld' in Indo-European Tradition," *Zeitschrift für Vergleichende Sprachforschung* 83 (1969) 64–69; I owe this reference to John Dillon. However, there are philological obstacles there as well; Hittite influence in the *Odyssey* seems negligible compared to the author's fascination with Egypt; the Hittite does not bring with it the other aspects of the Ialu Fields which mark the Greek Isles of the Blest, from breeze to wheat. On this topic see among others, Rohde, *Psyche* 68f., 369f.; Dieterich, *Nekyia*² 22f.; *RE* V, 2470 (Waser); L. Malten, "Elysion und Rhadamanthys," *JdI* 28 (1913) 35f.; Nilsson, *MMR*² 625f.; P. Capelle, "Elysion und Inseln der Seliger," *ArchfRel* 25 (1927) 245–64, 26 (1928) 17–40; A. D. Nock, *AJA* 50 (1946) 153; *HThR* 25 (1932) 32; W. Burkert, *Glotta* 39 (1960) 208f., (ἐνηλύσια—struck by lightning, Aisch. *Ag.* 17; ἐπηλυσίη bewitching) and *Lore and Science in Ancient Pythagoreanism* (1972) ch. V; H. Bonner, *Reallexikon der Ägypt. Religionsgeschichte*, s.v. *Earu Gefilde* (*Book of the Dead* ch. 110, 144–49); W. J. Knight, *Elysion* (1970); P. Thieme, *Studien zur indogermanische Wortkunde und Religionsgeschichte* (Berlin *BVSAW* 98.5 [1952]) 47f.

59. R. Lattimore, *Themes in Greek and Latin Epitaphs* (1942), 97f.

60. L. Lesko, *op. cit.* note 55, extract from Coffin Text 464; J. Zandee, *Death as an Enemy* (1960) 225.

61. Cf. L. Lesko, "The Field of Ḥetep in Egyptian Coffin Texts," *JARCE* 9 (1971–72) 89–101; ch. 110 of *The Book of the Dead* parallel to spells 464–68 of the Coffin Texts (this is CT 464). Cf. J. Zandee, *Death as an Enemy* (1960) 225.

62. I learned this connection from the late William Stevenson Smith of the Museum of Fine Arts, Boston; cf. B. Hemmerdinger, "Noms communs grecs d'origine égyptienne," *Glotta* 46 (1968) 238f.; but the equation is dismissed with contempt by R. Pierce, "Egyptian Loan-Words in Ancient Greek," *SymbOsl* 46 (1971) 105. Cf. Vermeule, *Arch Hom* V (1974) 126; A. Krappe, *RevPhil* 66 (1940) 245; Frisk, *Wörterbuch* II, 162f.

63. Cf. Aristophanes fr. 488, 10; Plato,

Laws 947e; some confusion in *IG* I² 1085, ἐς Ἀΐδα κατέβα πᾶσιν μακαριστὸς ἰδέσθαι.

64. E. Boisacq, *Dictionnaire étymologique* (1938) s.v. (though he connected it to μέγας and grandeur).

65. T. G. Allen, *The Egyptian Book of the Dead* (1960) 184, Ch. 110. E. Brovarski of the Museum of Fine Arts, Boston, tells me that the uncertain islands may be the "Lady of Two Lands" (from the Coffin Texts) and the "King of the Sea"; they lie beyond the Lake of the Hippopotamus which is one thousand leagues long and of untold breadth, containing no fish, snakes or plants, that is, no life.

66. Good typical pictures in the Tomb of Sennedjem at Thebes, J. Capart, M. Werbrouck, *Thebes* (1926) 329, 334; E. W. Budge, *The Papyrus of Ani* (1894) pll. 7, 10; K. Seele, *The Tomb of Tjanefer at Thebes* (1959) pl. 15. P. A. A. Boeser, *Ägyptische Sammlung des ... Niederlandische Reichsmuseums der Altertümer in Leiden*, IV (1911) pl. XII (Grave of Pa-atenem-heb, second register); *Medinet Habu* VI (Oriental Institute Publications 84 [1963]) pl. 469.

67. The White Island (near Sigeion? in the Euxine?) in Tzetzes *Schol. Lyc.* 174 (from Ibykos? Simonides?); cf. Apollonios Rhodios IV.810, Quintus Smyrnaeus, *Posthomerica* III. 527, 766–87, Pausanias III.19.11–13; Philostratos, *Heroica* XX.32–40, Apollodoros, *Epitome* V.5—with Helen? or Medea? or in other moods, Antilochos?

68. Apollodoros, *Epitome* II.1 cf. Frazer *ad loc.*; Archilochos 55 D.; Schol. Pindar *Olympian* I.55, 60, *Isthmian* VIII.10; Euripides, *Orestes* 4–10; Plato, *Kratylos* 395 d–e; Lucian, *Dialogues of the Dead* 17; Pausanias X.31.10. Sophokles' lost *Tantalos* only hides him dead under the earth (N² 518). Both mythical versions contribute to the pun on Tantalos / Tantala, Talanta, the swaying scales. For the importance to the Egyptians of water and fruit in the underworld, cf. K. Seele, *The Tomb of Tjanefer at Thebes* (Oriental Institute Publications 86 [1959]); J. Capart, M. Werbrouck, *Thebes* (1925) (Userhet) 341 fig. 247; from Abusir, c. 1310 B.C. (Kestner Museum, Hanover), the priest Niajj and his wife getting food and drink from the tree-goddess; I. Woldering, *Gods, Men and Pharaohs* (1967) pl. 90.

69. L. V. Žabkar, *A Study of the Ba Concept in Ancient Egyptian Texts* (1968); for the *ba*

flying down the tomb-shaft, pl. 5 and T. Deveria, P. Pierret, *Le Papyrus de Neb-qed* (1872) pl. 3, H. Bonnet, *Reallexikon der äg. Religionsgeschichte* s.v. *ba*, J. Vandier, *La religion égyptienne* (1949) 131; *Book of the Dead* 144–47; and see C. Weickert, *Seelenvogel*, *passim*, and chapter 5 p. 169. R. Barnett's ingenious suggestion that the myth of the harpies at the feast of Phineus may come ultimately from Urartu and king Uspina, Išpuiniš, along with the importation into the Greek world of Urartu bronze cauldrons with "siren" attachments (in S. Weinberg, ed., *The Aegean and the Near East, Studies Presented to Hetty Goldman* [1956] 231) is attractive; yet the Egyptian claim seems stronger when viewed in connection with all the other funerary elements. The female-headed bird was already known in the Aegean world (e.g. the Zakro "eagle-women," D. Hogarth, *JHS* 22 [1902] pll. VI, VII).

70. Cf. E. Wüst, "Die Seelenwagung in Aegypten," *ArchfRelig.* 36 (1939); M. Nilsson, *MMR*[2] 34 with bibliography, *BLund* (1933) 29f.; see also chapter 5 note 22.

71. H. Otten, *Hethitische Totenrituale* (n. 27), 13 (day 11 and other days of the funeral rite). Why scales were relatively common in rich burials of the early Mycenaean age, and rare later, is puzzling. Often only the scale-pans survive, hard to distinguish from bronze disc mirrors. Those known to me include *Argos* (Deiras T.24, *JHS Archaeological Reports* 1955.9); *Dendra* (A. Persson, *New Tombs at Dendra* [1942] 72 G.86, T.10); *Knossos* (*BSA* XXVIII [1926–27] 253, Mavro Spelio; A. Evans, *The Palace of Minos* II.556, III. 151); *Mycenae* (*Shaft Graves*, 3 pairs, Karo, *Schachtgräber* pl. 34; A. J. B. Wace, *Chamber Tombs at Mycenae* (1932) 190, n. 5, pl. 29: 20, T. 515); *Myrsinochorion-Rutsi* (*Praktika* [1956] 205); *Prosymna* (C. W. Blegen, *Prosymna* [1937] 351f. Ts.2, 25, 26, 43, 44); *Pylos* (C. W. Blegen *et al.*, *Pylos* III [1973] 158, 168, figs. 227:10, 230:7) and *Vapheio* (five pairs) Chr. Tsountas, *EphArch* (1889) pl. 8:4; *The Mycenaean Age* (1897) 144.

72. For classical *psychostasiai* see chapter 5 note 24.

73. For ancient games see especially R. Austin, "Greek Board-Games," *Antiquity* 14 (1940) 263; H. J. R. Murray, *A History of Board Games Other than Chess* (1952), in both of which the ancient sources are cited (e.g.

Pollux, *Onomasticon* IX.97.8), and useful articles in *RE* (Lamer, "Lusoria Tabula" [1972]) and Daremberg-Saglio (Latrunculi and Lusoria Tabula).

Murray disputes that the Knossos board is even a game, but R. Brumbaugh (*AJA* 79 [1975]) takes it as a variant on the Ur board (L. Woolley, *Ur Excavations* I [1934] 276–78, II pls. 95–98), although duller, without a river. See also *BSA* VII (1900–1) 77–82, A. Evans, *The Palace of Minos* I (1921) 472f.; the Shaft Grave draught-board is so incomplete nothing can be said of it (Karo, *Schachtgräber* 115, nos. 555, 556, 558). The Enkomi box (J. Ridgeway, *JHS* 16 [1896] 288) seems a variant on the Egyptian *Snt*. C. J. Gadd, "Babylonian Chess," *Iraq* 8 (1944) 66, W. K. Pritchett, "Five Lines and *IG* I² 324," *California Classical Studies* I (1968) 187 with bibliography; J. D. Beazley, C-B III, no. 114 (Boston 01.8037), *Development* 65, 113; F. Hauser in F-R III 65–72; A. Henrichs, *ZPE* 8 (1971) 1f., who refers to M. N. Kokolakes, *Morphologia tés Kubeutikés Metaphoras* (1965); B. Schweitzer, *JdI* 44 (1929) 116; K. Schefold, *JdI* 52 (1937) 30, 68; Kunze, *Schildbänder* 142; A. Gow, *Theokritos* (1950) ii. 122; O. Broneer, *AJA* 37 (1933) 564, *Hesperia* 16 (1947) 241; I. Nikolaou, *BCH* 94 (1970) 549 (cf. 89 [1965] 122) and, on dice, note 75 below.

It may be that when Oineus of Kalydon killed his son Toxeus, "whom he slew with his own hand because he leaped over the ditch," Apollodoros, *Library* I.8.1, it was not a Romulus and Remus situation as Frazer thought but a sudden quarrel at the gaming board.

74. I am much indebted to Timothy Kendall of the Museum of Fine Arts, Boston, for instruction on this topic and the opportunity to read his paper "The Thirty-Square Draught Game: A discussion of the Material, Pictorial and Textual Evidence," delivered to the American Research Center in Egypt, 1974; also W. Needler, "A Thirty-Square Draught Board in the Royal Ontario Museum," *JEA* 39 (1953) 60. The king of Egypt plays dice with Demeter (Isis) in Hades, "winning and losing," Herodotos II.122.

75. The Anagyrous Middle Proto-Attic gaming table with mourners at the corners and six compartments, B. Kallipolitis, *Deltion* 18A (1963) 123f., pll. 53, 55, *BCH* 87 (1963) 715 fig. 28; the Kerameikos example, *Kerameikos*

VI.1.87, VI.2.394, 512, *Kat.* 129, Inv. 45, pl. 102; *AA* (1933) 279; both publications with good bibliography. A number of seventh- and sixth-century graves have yielded dice, which are most recently reflected upon by S. Karouzou, "Der Erfinder des Würfels, Das älteste Griechische Mythische Porträt," *AM* 88 (1973) 55f., pll. 53–56, with bibliography. The die (showing Palamedes?) by the Ram Jug Painter is one of a group of votives on the Athenian Acropolis, obviously not funerary, but connected in perhaps a similar way with the ups and downs of fortune, and the unpredictable favor of the gods; G-L I.259; nrs. 2695 (sirens, one with lyre, man and owl, lion, Chimaira, women), 2696 (bird), 2697 (horseman), 2698 (boy running), 2699 (horseman), 2700 (Silen and mainad); 2703 is gaming pieces made of discarded sherds.

See also, in Heidelberg, H. Gropengiesser, *CVA* 4, 16, pl. 141, 11; F. Hülsen, *RömMitt* 19 (1904) 145; Copenhagen, N. Breitenstein, *Cat. Terracottas* (1941) 19, pl. 19.171; Kerameikos, *Kerameikos* VI.1, 80, VI.2, 514, pl. 102 (horse); Brauron, *Ergon* (1953) 20 fig. 22; Leukandi, M. Popham and L. H. Sackett, *Excavations at Leukandi* (1968) 35 fig. 81; Perachora, T. J. Dunbabin *et al.*, *Perachora* II (1962) pl. 132–33; P. Wolters, *Münchner Jahrbuch für bildenden Kunst* 8 (1913) 91; C. Blinkenberg, *AM* 23 (1898) 1; RE XIII, 1996f.; W. Déonna, *Le mobilier délien, Délos* XVIII (1938) 337, fig. 424; C. Rolley, *Collection H. Stathatos* III (1963) 119 fig. 52; on the Aias and Achilles scene, C-B III, no. 114. The themes of birds, horses, riders and sirens are all those of funerals, and the "inventor," the murdered Palamedes, is suitable; Pausanias reported a die the hero dedicated in the sanctuary of Tyche at Argos, II.20.3, which must, he thinks, make the shrine "very old." The connected Mycenaean practice may be seen in the Shaft Graves (Karo, *Schachtgräber* 243f., 319, 353), and, in a different sphere, the groups of flattened lead-weighted shells for some youthful game like jacks in the tombs of Perati (S. Iakovides, *Perati* B (1970) 364f., who collects the tombs from twelve other sites where shells are connected with child burials). Adults take pleasure in bags full of knucklebones for gaming. "King Midas" of Gordion had 144.

76. See R. C. Jebb, *The Ajax* (1896); J. C. Kamerbeek, *The Ajax* (1953); W. B. Stanford,

Sophocles. *Ajax* (1963) *ad loc.* The Rubaiyat conceit was connected by Jebb.

CHAPTER III
THE HAPPY HERO

1. Discussions of Homeric warfare are often more focused on equipment and tactics than on the pleasure it gave the participants. Details of formulaic battle scenes best in W.-H. Friedrich, *Verwundung und Tod, AbhGöttingen* 38 (1956), and B. Fenik, *Typical Battle Scenes in the Iliad, Hermes Einzelschriften* 21 (1968); see also the Bibliography p. 266. The military delight of the hero is presented vividly in C. M. Bowra's "The Greek Heroic Age," in G. Kirk (ed.), *Language and Background of Homer* (1964); A. Severyns, *Homère* III (1948) 100f.; G. Kirk, *The Songs of Homer* (1962) 342 ("It was not just one singer, Homer, who thought up all these different deaths; though it could be that he first used them in such profusion and variety and as a deliberate stylistic element"); cf. "War and the Warrior," in J. P. Vernant, *Problèmes de la Guerre en Grèce ancienne* (1968). G. Murray, *The Rise of the Greek Epic* (1934) 52f. offers a reconstruction: "The dead men are lying all about us. We will fling them into the sea tomorrow. The women are suitably tied up and guarded. The old one who kept shrieking curses has been spiked with a lance and tossed over the cliff. The wailing and sobbing of the rest will stop in a day or two . . . "; cf. F. J. Tritsch, "The 'Sackers of Cities'," in R. A. Crossland, A. Birchall, *Bronze Age Migrations in the Aegean* (1974) 233–39, P. Ducrey, *Le traitement des prisonniers de guerre dans la Grèce antique* (*École Française d'Athènes, Travaux et Mémoires* 17 [1968]).

2. Odysseus kills Astyanax in *Iliou Persis* (fr.1), Neoptolemos in the *Little Iliad*, fr. 19 Allen, cf. *Iliad* XXIV.735, Pausanias X.25.9; artists prefer Neoptolemos: M. Wiencke, "An Epic Theme in Greek Art," *AJA* 58 (1954) 285–306; M. Ervin, "A Relief Pithos from Mykonos," *Deltion* 18 (1964) 63f.; *AJA* 80 (1976) 39; K. Friis Johansen, *The Iliad in Early Greek Art* (1967) 28f.; E. Brann, *AntK* 2 (1959) 35; K. Fittschen, *Sagendarstellungen* (1969) 23 fig. 11; Beazley, C-B iii, 61f.; C. Robert, *Die griechische Heldensage* 4 (1920–26) 1263; G. Huxley, *Greek Epic Poetry* (1969) 156. Motivation swings between Stasinos' νήπιος

ὃς πατέρα κτείνας παῖδας καταλείπει (*Kypria* fr. 22, Loeb, Kinkel, 25 Allen), and Murray's "You might wish to take your little boy. But would the rest of us, think you, choose to be encumbered with another consumer of bread, who could never help in a fight, who might delay us in charging or flying, might cry from the pain of hunger or fatigue and betray us all? No, leave him on the beach" (*loc. cit.* note 1). See note 44 below.

3. ix.65; Vergil, *Aeneid* VI, 506; Rohde, *Psyche* 42.

4. E. Vermeule, *The Art of the Shaft Graves at Mycenae* (1975) 25, 51; for classical art, F. Hölscher, *Die Bedeutung Archaischer Tierkampfbilder, Beiträge zur Archäologie* 5 (1972) to which I am much indebted; M. L. and H. Erlenmeyer, "Über griechische und altorientalische Tierkampfgruppen," *AntK* 1 (1958) 53f.; E. Buschor, "Burglöwen," *AM* 47 (1922) 92f.; and see notes 5, 6 below.

5. Individual but generally unsentimental coloring is applied to figures like the very hungry lions of XI.547 or XII.299, the wounded stag eaten by scavengers XI.474, the anguished lion who has lost cubs XVIII.318, the bewildered fawns IV.243, the dogs ripping a wounded fawn XV.579, the hungry mother bird IX.323, the ospreys or vultures who have lost their children xvi.216, and a variety of animals exhibited in moments of physical or emotional distress. On the subject in general see H. Fränkel, *Die homerischen Gleichnisse* (1921); O. Körner, *Die homerische Tierwelt* (1930); R. Hampe, *Die Gleichnisse Homers* (1952); D. Ohly, *Griechische Goldbleche* (1953) 76f.; W. Schadewalt, "Die homerische Gleichniswelt," *Von Homers Werk und Welt*[3] (1959) 87f.; H. Rahn, "Das Tier in der homerischen Dichtung," *Studium Generale* 20 (1967) 90f.; W. Scott, *The Oral Nature of the Homeric Simile*, *Mnemosyne* Sup. 28 (1974); and note 7 below.

6. Gilgamesh, *ANET*[2] 88, N. K. Sandars, *The Epic of Gilgamesh* (1960) 97; Amenhotep II, *ANET*[2] 245; see also W. Wreszinski, *Das Löwenjagd im alten Ägypten* (1932); C. de Wit, *Le rôle et le sens de lion dans l'Égypte ancienne* (1951); E. Hornung, "Die Bedeutung des Tieres im alten Ägypten," *Studium Generale* 20 (1967) 69f. I am indebted to Alan Forbes for a preview of his "Lions, Warriors and War: the Identity of Euphronios' Sarpedon" (Cambridge 1974) which collects parallels from the

BaThongas of South Africa to Sekhmet the lion-goddess of war in Egypt.

7. Antipater, *AnthPal* VII. 426 (D. L. Page, *Epigrammata Graeca* [1975] XXXI); F. Hölscher, *Tierkampfbilder* (note 4) 63ff. with J. M. Cook's review *JHS* 94 (1974) 247; M. Mühl, "Relikte der Tier- und Sachstrafe bei Homer," *REG* 84 (1971); see also C. C. Vermeule, "Greek Funerary Animals, 450–300 B.C.," *AJA* 76 (1972) 49–59, H. Gabelmann, *Studien zum frühgriechischen Löwenbild* (1965); for Leon of Sinope, S. Karouzou, *The National Archaeological Museum Collection of Sculpture* (1968) 107 and (Simonides) *AnthPal* VII.344a θηρῶν μὲν κάρτιστος ἐγώ, θνατῶν δ'ὃν ἐγὼ νῦν / φρουρῶ, τῷδε τάφῳ λαΐνῳ ἐμβεβαώς; Kallimachos *AnthPal* VII.344b. A lion on a classical tomb checks on the funeral offerings and may eat or refuse them, on a white-ground lekythos, Riezler, *WGL* pl. 57 (Athens NM 1938). For dogs, M. Collignon, *RA* 4 (1904) 48; L. Malten, *JdI* 29 (1914) 236f. The whole connection of lions, dogs and birds in funerary art, Hampe, *Grabfund* 66f. See note 24.

8. Philostratos, *Life of Apollonios of Tyana* IV.10, on the artful old mendicant at Ephesos in whom Apollonios detected a plague-causing animal-demon, suggests an interesting superstitious reverse of the usual principle—"they found that he had disappeared and instead of him there was a hound who resembled in form and look a Molossian dog, but was in size the equal of the largest lion; there he lay before their eyes, pounded to a pulp by their stones and vomiting foam as mad dogs do." The good lion-man, Herakles Apotropaios, is set over the evil man-lion, the slain "ghost" (*phasma*). (F. C. Conybeare, Loeb edition [1969]). Cf. Burkert on werewolves, *HN* 98f.

9. F. Yeats-Brown, *The Lives of a Bengal Lancer* (1930) 54f.; R. S. S. Baden-Powell, *Pig-Sticking or Hog-Hunting* (1889). Xenophon is certain the boars' tusks are hot enough (from strength and rage) to singe the hounds' coats even when it does not gore them, *On Hunting* X.17. Cf. F. Hölscher, *op. cit.* note 4; R. Blatter, *AntK* 5 (1962) 45; G. Daltrop, *Die Kalydonische Jagd* (1966); F. Kleiner, *AntK* 15 (1972) 7.

10. Chantraine, *Dictionnaire*, more properly distinguishes the etymologies, βροτός related to arm. (and O. *Persian*) *mard*, Skrt. mr̥tá; βρότος related to Skrt. mūrtá—βιβρώσκω from

the root* g^wer ($\beta\rho\omega\tau\delta\varsigma$, $\beta o\rho\acute{a}$); cf. P. Thieme, "Ambrosia," in R. Schmitt (ed.), *Indogermanische Dichtersprache* (1968) 113.

11. See W. Friedrich, *Verwundung und Tod* (note 1), for the "niederer Realismus," 52f., and "biotischer Realismus" (groans and so forth); G. Murray (and J. A. K. Thomson) think there were older and worse $\mathring{a}\epsilon\iota\kappa\acute{\epsilon}a$ $\mathring{\epsilon}\rho\gamma a$ being cleaned up in our *Iliad*, *Rise of the Greek Epic* 145f., but their evidence should go the other way; it is the fifth century which delights in $\mathring{a}\epsilon\iota\kappa\acute{\epsilon}a$ $\mathring{\epsilon}\rho\gamma a$, like the dragging of living Hector, Soph. *Aias* 1031, Euripides *Andromache* 399; S. E. Bassett, *The Poetry of Homer* (1938) 229, "The public that has tasted the $a\mathring{\iota}\sigma\chi\rho\acute{o}\nu$, like the man in Plato's *Republic* who has once eaten human flesh, becomes, if not wolfish, at least more animal in his aesthetic likings." See also C. Segal, *The Theme of the Mutilation of the Corpse, Mnemosyne* Sup. 17 (1971); Agamemnon is "wantonly cruel"; Homer does not like "grisly details of mutilation" for its own sake but to stress the agony of the relatives, or, 47, "Homer uses the outrage of Hektor's corpse to explore the widening circles of savagery released by the war. Ultimately the outrage of the corpse comes to forbode the outrage of Troy itself and of the civilization guarded behind Troy's gates." Perhaps Homer would be surprised at the delicate stomachs of his later readers, for it is certainly not uncommon in any culture to continue the battle-anger from the living enemy to the dead enemy. See the sensible remarks of S. E. Bassett, "Achilles' Treatment of Hektor's Body," *TAPA* 64 (1933) 41f., on modern sympathy for the weaker (not a generally Greek trait), and the "hardness that repels affection" in the ancient man of decision or hero. Bassett was probably right that $\mathring{a}\epsilon\iota\kappa\acute{\epsilon}a$ $\mathring{\epsilon}\rho\gamma a$ did not, in Homer, express any sense of horror or moral outrage, but was descriptive of "harm to the object of the action, and not the injustice of the actor" (45). Cf. W. Leaf on *Iliad* XXIII.176.

12. W. Burkert's eloquent argument that paleolithic behavior, hunting ritual, and submerged emotions lasted in Greece into classical times, in *Homo Necans* (1972), has the advantage of advancing attractive theoretical impulses for rites no longer fully understandable, though some disadvantage in reducing all kinds of evidence of different periods to equal value, as though paleolithic man lived

on in Greece unchanged and manifested himself equally through the tongue of Euripides, Plutarch, or the Second Vatican Mythographer. On the Bouphonia, Burkert, *HN* 154f.; Harrison, *Prolegomena* 111, L. Deubner, *Attische Feste* (1932) 158f.

13. A useful list of all Homeric vocabulary for the outer and inner parts of man is given in O. Körner's *Die Ärtzlichen Kentnisse in Ilias und Odyssee* (1929); diseases, psychic possibilities, and sources of knowledge (sacrifice, hunt, battle wounds, deduction). Size, external shape and coloring are easy; as well as peculiarities like crippled limbs, round shoulders (xix.146) or pointed heads (II.219) or special skills like being ambidextrous (Asteropaios, XXI.163). The skeletal system is well articulated, from the skull case to the neck and spinal vertebrae (XIV.465, XX.482) of men and animals (x.161), shoulder blades, collarbones, ribs, sections of arms and legs, elbow, hand, wrist, palm, knee, shin, thigh, flat of foot, ankle and heel, containing jugular veins, food pipes and wind pipes, lungs, livers, guts, the fat around the kidneys, tendons, nerves and marrow. Is there another epic tradition so well informed about the human anatomy, or so eager to break it apart for our amusement and edification?

14. XIII.282, 442; XXII.452.

15. S. E. Bassett, *The Poetry of Homer* (1938) 256 n. 37: 318 heroes are killed, 243 of them are named.

16. See chapter 2 note 7.

17. V.66

$\beta\epsilon\beta\lambda\acute{\eta}\kappa\epsilon\iota$ $\gamma\lambda o\nu\tau\grave{o}\nu$ $\kappa a\tau\grave{a}$ $\delta\acute{\epsilon}\xi\iota o\nu\cdot$ $\mathring{\eta}$ $\delta\grave{\epsilon}$ $\delta\iota a\pi\rho\grave{o}$
$\mathring{a}\nu\tau\iota\kappa\rho\grave{\upsilon}$ $\kappa a\tau\grave{a}$ $\kappa\acute{\upsilon}\sigma\tau\iota\nu$ $\mathring{\upsilon}\pi'$ $\mathring{o}\sigma\tau\acute{\epsilon}o\nu$ $\mathring{\eta}\lambda\upsilon\theta'$ $\mathring{a}\kappa\omega\kappa\acute{\eta}\cdot$
$\gamma\nu\grave{\upsilon}\xi$ δ' $\mathring{\epsilon}\rho\iota\pi'$ $o\mathring{\iota}\mu\acute{\omega}\xi a\varsigma$—

with an arrow at XIII.65of. The peculiar wound occurs only at these places; Meriones is exceptionally versatile with his weapons.

18. The closest seems to be XIII.568f., where Meriones again strikes, this time

$a\mathring{\iota}\delta o\acute{\iota}\omega\nu$ $\tau\epsilon$ $\mu\epsilon\sigma\eta\gamma\grave{\upsilon}$ $\kappa a\grave{\iota}$ $\mathring{o}\mu\phi a\lambda o\widehat{\upsilon}$, $\mathring{\epsilon}\nu\theta a$ $\mu\acute{a}\lambda\iota\sigma\tau a$
$\gamma\acute{\iota}\gamma\nu\epsilon\tau'$ $\H{A}\rho\eta\varsigma$ $\mathring{a}\lambda\epsilon\gamma\epsilon\iota\nu\grave{o}\varsigma$ $o\mathring{\iota}\zeta\upsilon\rho o\widehat{\iota}\sigma\iota$ $\beta\rho o\tau o\widehat{\iota}\sigma\iota\nu$.

To my limited knowledge, placing a man's severed genitals in his mouth, as practiced in the Algerian and Vietnam Wars, is not a Greek method of humiliation, unless it enters into the treatment of the body in *maschalismos* (see note 30).

19. On military training see note 1, and P.

Courbin, "La Guerre en Grèce à Haute Époque," in Vernant, *Guerre* (note 1) 69f.

20. Characteristic taunts liken the soldier to a weak victim animal (Agamemnon to the Argives, "why are you standing there like deer?" IV.242), to a coward or thief (to Odysseus, "why do you stand here skulking?" IV.340); they cast doubt on his ancestry (Tlepolemos to Sarpedon, "They are liars who call you a son of Zeus, since you fall far short of those really born from Zeus among former heroes," V.635f.); they remark on his poor skills ("You did not hit me, you missed," V.287), his female qualities ("you are no better than a woman, down with you, κακὴ γλήνη" VIII.163), and often concentrate on good looks betrayed by poor action, the εἶδος ἄριστε type (III.39, V. 787, XI.385, XVII.162).

21. E. Fränkel, *Aeschylus, Agamemnon* (1962) *ad loc.*, quotes Headlam on προτέλεια, "ceremonies previous to the consummation of marriage," and considers the phrase to have a ritual sacrificial element not yet faded; the Hesychius definition, ἡ πρὸ τῶν γάμων θυσία· καὶ ἑορτή is useful both for the *Agamemnon* and for the *Iliad*; the γόνατος ἐρειδομένου παλαίσματα signifies not marriage, but sex with an unconsenting partner. The Greek peasant still uses γαμῶ in a similar way.

22. Of animals, for example, the mule is most difficult, XXIII.655, ἡμίονον ... ἀδμήτην, ἥ τ' ἀλγίστη δαμάσασθαι, and so for δαμάλης (Eros, Anakreon 2.1) or the heifer δάμαλις; of girls frequently, δαμάσσεμεν XVIII.432, cf. III.301, iii.269; of enemies often, πυκνὰ καρήαθ' ὑφ' Ἕκτορι δάμνατο, Τρώεσσιν δαμνάσθαι XI.309, VIII.244. Moira does it, Μοῖρα δαμάσσει XVIII.119; Eros does it, ἔρος ... θυμὸν ἐνὶ στήθεσσιν ... ἐδάμασσεν XIV.316, and Hesiod *Th.* 122, Ἔρος ... λυσιμελὴς δάμναται ἐν στήθεσσι νόον (see chapter 5). Sexual intercourse does it, XIV.353, sleep does it, X.2. The wife is the δάμαρ; the raped girl is δεδαμναμένα (Gortyna Law 2.13), and the δμαθέντες are the dead in Euripides, *Alkestis* 127. See E. Benveniste, *Le vocabulaire des institutions indo-européennes* (1969) I.307.

23. For "make war not love" themes and the Amazons, see B. Schweitzer, *Herakles* (1922); F. Brommer, *Herakles* (1953); E. Bielefeld, *Amazonomachie* (1951); D. von Bothmer, *Amazons in Greek Art* (1957); B.

Ashmole, *Architect and Sculptor in Classical Greece* (1972) 164; M. Robertson, *A History of Greek Art* (1975) 125; K. Fittschen, *Sagendarstellungen* (1969) 150.

24. The basic love-talk is XVII.228, ἢ ἀπολέσθω / ἠὲ σαωθήτω· ἡ γὰρ πολέμου ὀαριστύς. XIII.291, opposing breast or belly to the enemy threat, must be similar, ἀλλά κεν ἢ στέρνων ἢ νηδύος ἀντιάσειε / πρόσσω ἱεμένοιο μετὰ προμάχων ὀαριστύν. The μέλπηθρον of the dogs means something they can dance and sing over, XIII.233, XVII.255, XVIII.179, a pleasure restricted to dogs in the *Iliad*. The corpse- ἕλωρ is their loot, the κύρμα their pride and glory as for a man. Cf. E. Benveniste, *Année sociologique* (1951) 6–20; Chantraine, *Dictionnaire*, s.v. ἕλωρ; M. Faust, "Die kunstlerische Verwendung von Κύων 'Hund' in den homerischen Epen," *Glotta* 48 (1970) 10–21; J. A. Scott, "Dogs in Homer," *CW* 41 (1947–48) 226. The dog-dance would occur as they dragged the victim in front of the city walls (XV.351) with white feet (XI.817); the song would be growls and howls, but these are suppressed in epic. For the dance and ὄρχις, testicle, see C. Watkins, *op. cit.*, chapter 2 note 17. Hampe, "Schlachtfeld, Hunde und Geier," *Grabfund* 66f.

25. The fragments from Tenos (Xoburgo, Athens NM 2495) and Eretria in N. Kontoleon, "Die frühgriechische Reliefkunst," *EphArch* (1969) 226, pl. 47a; J. Schäfer, *Studien zu den gr. Reliefpithoi* (1957) pl. x; E. Kunze, *Kretische Bronzereliefs* (1931) pl. 54B; M. Ervin, *AJA* 80 (1976) pl. 2 fig. 10; see note 39. J. M. Boraston, "The Birds of Homer," *JHS* 31 (1911) 216f., describes *gyps monachus*, *gyps fulvus*, the Lammergeier, and the Egyptian *vultur percnoptus*; and, 239f., "Often in the East I have stood to watch a group of such vultures at their ghoulish task, closely packed, their spread wings overlapping to form an encircling fence, all necks down and heads hidden within like men in a football scrimmage; and just as these move in a mass, following the shifting of the ball hidden among their feet, so those sway all together, now in one direction, now in another, as the carcass is dragged about the ground."

26. Chapter 2 note 40.

27. As in old crows, old biddies, old hens, fowl, old chickabiddies, old vultures, harpies? to be distinguished from bird, canary, chick, ducky, ladybird, pigeon, quail and turkey.

28. Chapter 5 p. 171.

29. Segal, *Mutilation* 47; M. Nagler, *Spontaneity and Tradition* (1974) 45.

30. Cf. Pandaros, V.214, "let some stranger take the head from my shoulders ... "; XIV.497 Peneleos to Ilioneus' head; X.455 Dolon's head; XX.481 Deukalion's head; many instances in the *Iliad* seem more than the inflicting of a fatal wound, more an instance of trophy-hunting. Myth preserves other head-hunting episodes, the heads of Hippodameia's unsuccessful suitors tacked on Oinomaos' palace at Olympia (Apollodoros, *Epitome* II.5; Pausanias thinks he buried the suitors "with no especial care," VI.21.7); Pentheus' head (like a lion's) on the palace at Thebes, Euripides, *Bacchae* 1212f.; E. R. Dodds, *Euripides, Bacchae* (1944) *ad loc.* cites Posidonius Gr. 116 Jac. (F. Gr. H.ii A 304), Celts do it to their enemies as Greek hunters their trophies; strangers sacrificed among the Taurians (Euripides, *Iphigeneia among the Taurians* 36, 621), Kyknos' temple built of heads for Ares (Hesiod, *Shield* 57f.), Apollodoros II.7.7; F. Vian, *RevEtAnc* 47 (1945) 27; S. Karouzou, *BCH* 79 (1955) 177; Antaios who roofed Poseidon's temple with skulls (Pindar, *Isthmian* IV.59f.); Diomedes, Euenos and others. The habit of nailing up such *agalmata* to the gods is often the only matter later known about these giant figures. The trophy-head and the preserved ancestor head differ more in mode of acquisition, perhaps, than in the soothing effect they have on the warrior's soul; Herodotos IV.26, 65; J. D. P. Bolton, *Aristeas of Proconnesus* (1962) 76f.

The Beldam P's lekythos with severed heads (fig. 24; Haspels *ABL* 170, 266) seems to allude to a common element in the traditional repertory of torture and taunting, also illustrated by his name-piece with the tormented female, and his "torture of prisoners by pirates," *ibid.* 170, 173. Plato records the common tortures as scourging, racking, burning out the eyes and impalement (*Republic* II.361), not necessarily "barbarian" behavior in Aischylos, *Eumenides* 186f.

The related topic of *maschalismos* is more disputed by those who regard the Greeks as incapable of brutality than by those who view them as characteristic inhabitants of the Mediterranean. See Rohde, *Psyche*, Appendix II, 582f., a straightforward and excellent treatment, except that the genitals might be included with the other severed extremities,

moria, hung round the victim's neck on the rope fastened then beneath his armpits, μασχάλαι; they would be natural ἀκρωτηριάσματα τοῦ νεκροῦ (Hesychius), corresponding to the mutilated breasts of female victims as in the tale of Masistes' wife (Herodotos IX.112; cf. E. Wolff, "Das Weib des Masistes," *Hermes* 92 [1964] 51). It of course happens to Melanthios, xxii.475, to the victims of Echetos the ogre in the *Odyssey*, and may be hinted at in Tyrtaios' αἱματόεντ' αἰδοῖα φίλαις ἐν χερσὶν ἔχοντα, 7.25 D. See also R. C. Jebb, *Sophokles, The Electra* (1907) on 445; *RE* XIV 2060 (W. Kroll, F. Boehm); G. Kittredge, "Arm-Pitting among the Greeks," *AJA* 6 (1885) 151; Nilsson, *GGR* I² 92, 99. The apotropaic function is naturally important for murderers, yet the more ordinary desire to humiliate the hated victim cannot be totally absent; religious logic and carnivorous behavior happily coincide. M. Klimburg, discussing woodcarving from Kafiristan, Afghanistan, notes the great wooden poles each with a groin-hole, which is filled with a phallos-stick for every new enemy killed (Lecture, Cambridge, Mass., Dec. 1, 1975).

Egypt and the Near East had already shaped similar aspects of the warrior code: Seti I of Egypt, "his heart is satisfied with the sight of blood. He cuts off the heads of the perverse of heart. He loves an instant of trampling more than a day of jubilation. His majesty kills them all at one time and leaves no heirs among them," *ANET*² 254; Ashurnasirpal II of Assyria piles pillars of skulls in front of the towns of Lutibu and Bur-mar'ana, *ANET*² 277; Esarhaddon caught Abdimilkutte king of Kundi and Sizu like a bird in the mountains and cut off his head: "(Then) I hung the heads of Sanduarri and of Abdimilkutte around the necks of their nobles / chief-officials to demonstrate to the population the power of Ashur, my lord, and paraded (thus) through the wide main street of Nineveh with singers (playing on) *sammû*-harps," *ANET*² 291.

31. S. Karouzou, *JHS* 92 (1972) 64–73; she cites Kimon's dream of death (Plutarch, *Life of Kimon* 18.3), ὄναρ εἶδεν ὁ Κίμων· ἐδόκει κύνα θυμουμένην ὑλακτεῖν πρὸς αὐτόν, ἐκ δὲ ὑλακῆς μεμειγμένον ἀφεῖσαν ἀνθρώπου φθόγγον εἰπεῖν

στεῖχε, φίλος γὰρ ἔσῃ καὶ ἐμοὶ καὶ ἐμοῖς σκυλάκεσσιν.

A mantic man explains the dream as death.

On the lekythos the goddess is clearly physically attached to the dogs who eat the dead; they are animal expressions of the function that resides in her.

32. Cf. IV.182, VI.282, VIII.150, XVII. 417.

33. So fire is ὀλοόν (XV.605, XIII.629); ἀκάματον (XXI.13, XXIII.52); μαλερόν (XX.316, XXI.375, IX.242), θεσπιδαές (XII.177, XV.597, XXIII.216), partly personified, partly divine, capable of both eating and causing to disappear; whereas, in English, fire is more likely to die than kill. In Greek, strength, anger and fire are the elements to quench (XXIII.250, XXIV.791, IX.674, XVI.621).

Egyptians also expressed the power of consuming fire as an animal, Herodotos III.16.3, Αἰγυπτίοισι δὲ νενόμισται ⟨τὸ⟩ πῦρ θηρίον εἶναι ἔμψυχον, πάντα δὲ αὐτὸ κατεσθίειν τό περ ἂν λάβῃ, πλησθὲν δὲ [αὐτὸ] τῆς βορῆς συναποθνῄσκειν τῷ κατεσθιομένῳ. Herodotos seems to report this as a novelty though it was built into his own language.

For fire and chimaira as ἀμαιμάκετος (VI. 179, XVI.329) cf. P. Amandry, RevArch (1949) (Mélanges Picard I, 1); T. J. Dunbabin, DMR II (1953) 1164. Ἀμαιμάκετος is used of her fire in Hesiod, Th. 319; of fire in Sophokles (OT 177), of the sea (Pindar, Pythian I.14; cf. "Hesiod," Shield 207), of quarrels, Bacchylides X.64, and of furies (Sophokles, OK 127). Μαλερός is interestingly attached to lions (Aischylos, Ag. 141), Ares (Sophokles, OT 190) pothos (Aischylos, Pers. 62) and songs (Pindar O.IX.22); cf. chapter 5 p. 154.

34. Chapter 2 note 17.

35. The Silver Siege rhyton from the Shaft Graves of Mycenae, Karo, Schachtgräber no. 481; women watching the fleet from the town walls, Thera fresco, S. Marinatos, Thera VI, pll. 7ff.; in the Egyptian wars against the Hyksos, both the Karnak stele of Kamose ("I saw his women on the roof of his house while looking out their windows" . . . , M. Hammad, Chronique d'Égypte [1954–55] 198; L. Habachi, Annales de la Service [1956] 195) and the Carnarvon Tablet (ANET² 233) use the theme: "When the time of breakfast had come, I attacked him. I broke down his walls, I killed his people, and I made his wife come down to the riverbank." Normally the defendants are on the walls, in Egyptian siege scenes (W. S. Smith, Interconnections in the Ancient Near East [1965] 168f.) while crouching wailing

women are more often shown as captives. Ashurnasirpal's sculptors put a wailing woman tearing her hair on a tower (R. D. Barnett, W. Forman, Assyrian Palace Reliefs [n.d.] pl. 11, Nimrud, NW Palace Throne Room). The motif of the woman at the window, adapted from the Near East, is used on the Tanagra larnakes, where the man is already dead inside the "house."

36. νήπιος with its epic variants νηπίαχος, νηπύτιος, νηπίεος has an arguable etymology. It was formerly thought of as a negative variant on πινυτή, understanding, prudence, wisdom, and πινυτός, discreet, intelligent (E. Boisacq, Dictionnaire etymologique [1950] s.v.; Brugmann-Delbrück, Grundriss der vergleichenden Grammatik II¹ [1892] 1012). It has been considered a negative connection of ἔπος / ϝέπος, referred by Frisk, Wörterbuch, Nachträge, III, 157) to Mycenaean na-pu-ti-jo, ne and epyo, apyo, to call aloud, cf. Lat. infans; see A. Heubeck, Studi Micenei 11 (1970) 70f. I am indebted to T. G. Rosenmeyer for discussion of the point. A broad case for nepios as negative ἤπιος (following M. Lacroix, "ΗΠΙΟΣ-ΝΗΠΙΟΣ," Mélanges offerts à A. M. Desrousseaux [1937] 261f.) is made by S. Edmunds, Homeric Νήπιος (diss. Harvard 1976): "The word νήπιος, like the English words gentle and kind, began as an expression of some fact of kinship; only later did it become an adjective of manner . . . nepios may sometimes describe initiatory death"; she discusses the mental and social disconnection of the nepios.

37. M. Ervin, "A Relief Pithos from Mykonos," Deltion 18 (1963) 37f., and "Notes on Relief Pithoi of the Tenian-Boiotian Group," AJA 80 (1976) 19f.; J. Christiansen, Meddelelser fra Ny Carlsberg Glyptotek 31 (1974) 7f. (the fragment was later returned); K. Schefold, Myth and Legend in Early Greek Art (1964) pll. 34–5.

For Astyanax, Ervin, Relief Pithos 62f.; AJA 80 (1976) 32, cf. E. Brann, AntK 2 (1959) 37 vs. Fittschen, Sagendarstellungen 23 fig. 11.

38. Jane Van Lawick Goodall, In the Shadow of Man (1971) 205, 212.

39. Quoted in an interview with E. Scribner, Boston Globe Magazine, 7 July 1974, 12.

40. As in Isaiah 13.16, "Their children also shall be dashed to pieces before their eyes; their houses shall be spoiled, and their wives ravished"; 18: "Their bows also shall

dash the young men to pieces, and they shall have no pity on the fruit of the womb; their eye shall not spare children."

It was reported in May 1975 that Cambodian officers would be executed down to the rank of second lieutenant along with their wives and sons, who share the responsibility for war-guilt.

41. Troy lies face down, πρηνές, in toppled towers; her heads are undone (IX.24), caught by the steep head (XV.558, cf. XIII.772), where the wives of children cluster on the walls (XVII.514). Nagler prefers the connection with κρήδεμνα and the rape of the bride, the ripping of her private veil, *Spontaneity and Tradition* (1974) 10, 45f. But in the old language of oath, "let brains be spilled on the earth as this wine is spilled" (III.300).

42. W. Burkert, "Das Opfer als Tötungsakt," *HN* 8f. and bibliography; F. Schwenn, *Gebet und Opfer* (1927); cf. P. Vidal-Naquet, in Vernant and Vidal-Naquet, *Mythe et Tragédie en Grèce Ancienne* (1972) ch. VI.

CHAPTER IV
IMMORTALS ARE MORTAL, MORTALS IMMORTAL

1. As in *Dialogues of the Dead* 11 (402): Diogenes and Herakles; H. "Don't you think everyone is a compound of two things, soul and body? so what prevents the soul (*psyche*), which came from Zeus, from being in heaven, and my mortal me from being among the dead? D: You would have put that very well, noble son of Amphitryon, if you were a body (*soma*), but now you are a bodiless image (*asomaton eidolon*); so you may create a triple Herakles. H: What do you mean, triple? D: This, if there is one of him in heaven, and another here among us dead which is you the image, but the body on Mount Oita is already dust, he is already these three. Start thinking what third father you will design for your body." Lucian's "images" in Hades also have bones in them when he wishes.

2. The idea of a teleprompter for the dead is not entirely facetious, since in the maintenance of memory and identity there is a double action between the viewer and the sleeper; as the Egyptians believed a man must remember his own name to stay alive in the Underworld.

3. The same themes are vividly illustrated on tombstones in the Mount Auburn and Cambridge City, Massachusetts, cemeteries, used here; see also E. V. Gillon, *Victorian Cemetery Art* (1972).

4. There seems no easy way to match the fragments of death themes in lyric and elegiac verse with the themes of archaic tombstones (chapter 1 note 63). The poets' standard comments include "it does no good to weep for the dead," "it is not good to criticize the dead," "a man who dies fighting for his country gets more honor," "life is short, miserable old age and death lie before us," "remember me," "no one will remember you," and similar proverbs and puffs of the poet's ability to confer immortality on his friends. The tomb-epigrams tend rather to introduce themselves, give information about the dead man, his family, his profession, his mode of death, with occasional phrases of advice or warnings not to disturb; gnomai are rare and theological speculation extremely rare until after the Persian Wars. Lattimore, *Themes*, and L. A. Stella, "L'ideale della morte eroica nella Grecia del V secolo," *Atene e Roma* 2 (1934) 313; G. Lange, *Den Tod betreffende Topoi in der griechische und römische Poesie* (diss. Leipzig 1956).

5. I am indebted to M. Nussbaum for discussion and for her article "Ψυχή in Herakleitos," *Phronesis* 17 (1972) 1f., 153f.; her translation of frag. B 62 is essentially "Immortals are mortal, mortals immortal, since they (mortals) are living with respect to the death of the immortals (i.e. the fact that immortals are dead to *kleos aenaon*, which constitutes mortal immortality) but are dead with respect to their (immortals') (statically eternal) life" (163). See also chapter 1 note 21. Greeks might find this interpretation difficult, since gods received enormous tributes of *kleos*, celebratory praise and memory of deeds, in theogonies, hymns, prayers and myth. See Bassett, below note 15; the incompleteness of immortals is a Greek commonplace. See also J. Mansfeld, "Heraclitus on the Psychology and Physiology of Sleep and on Rivers," *Mnemosyne* 20 (1967) 1f. Herakleitos is viewed by many as a "radical critic" of older thought, but he is also a deep conservative for whom myth had persistent power.

6. The gods can risk exile, mockery, and

loss of mortal respect, degradations not dissimilar to death. See also G. S. Kirk, "Heraclitus on Death in Battle," *AJP* 70 (1949) 384f.

7. Gilgamesh IX.ii, *ANET*² 88; Shamash rising, H. Frankfort, *Cylinder Seals* (1939) 67, 130, 160; the new-born Egyptian sun is a common New Kingdom funerary motif; A. Piankoff, B. Rambova, *Egyptian Religious Texts and Representations* III (1957): *Mythological Papyri* I/II, 1.71, II.1, Cairo Inv. 133.

8. J. Piaget, *The Child's Conception of the World* (1929) 256f.; cf. p. 208, William James' deaf-mute D'Estrella, "At first he thought there were lots of suns, one for each day"; 270, Gava: The sun is alive because "it keeps coming back"; 273, Font: it comes "from the mountain"; 226, Rat, to the question, could the sun come back in the middle of the night if it wanted to? "It wouldn't want to. It's night-time, time to go to bed."

9. "(The) souls smell in Hades" (B 98) seems similarly part mockery, part deliberate mystification, perhaps part relic of animal imagery, the *psyche* as a keen-nosed hound getting home to Hades without a guide, part recognition of retained psychic powers needed by diviners, shamans and poets, part comment on the anomalies of the Nekyia such as Sisyphos' sweat.

10. Mansfeld, *op. cit.* note 5.

11. Chapter 3 note 10; cf. M. Nagler, *Spontaneity and Tradition* (1974) 44, in connection with δῆμος people and δημός fat.

12. Chapter 2 p. 73.

13. The simple-minded biographical approach to the unknowable is characteristically Greek; it flourished among scholiasts and still does in the teaching of Greek myth, as in P. Slater's *The Glory of Hera* (1968) which explores the gods' early relationships to their mothers and consequent development of oral-narcissistic and other complications; cf. M. Lefkowitz, "Pindar's Lives," *Classica et Iberica* (Studies in Honor of the Rev. J. M.-F. Marique, [1975]) 71, and below note 15.

14. Dodds, *Irrational*, 16; Roscher 3201; Rohde, *Psyche* 364; chapter 1 note 16.

15. S. E. Bassett, *The Poetry of Homer* (1938) 222.

16. G. M. Calhoun, "Homer's Gods— Myth and Märchen," *AJP* 60 (1939) 1f.

17. *Phthonos* seems less a theological term than a practical expression of the certainty that life will go wrong if it can. It does not refer to the immortals' point of view, but to the observed fact among the Greeks that anyone who became "godlike," antitheos, in strength, happiness, wealth, marriage or prestige was soon spoiled, ἀερθέντες ἔπεσαν. Since destiny and the gods controlled matters out of sight and reach, they were naturally held responsible for the ups and downs of fortune, and it is testimony to the Greek's certainty of his own superiority, that he could genuinely believe that gods created by his own ancestral tradition could be personally jealous of his particular achievements. See H. Lloyd-Jones, *The Justice of Zeus* (1972) 55f., "Pollution and Purification."

18. Often in the *Iliad* mermera occurs in a context of debating whether to do something wicked or harmful, as Zeus may be doing here; Hera "worries" about how she may deceive Zeus (XIV.159), Diomedes how to do the most "dog-like" thing (X.503); when heroes διάνδιχα μερμήριξεν (Achilles, I.189; Diomedes, VIII.167; Odysseus, V.671) one alternative is violent or murderous, as though μέρμηρα had clothed itself in some quality from its analogue μέρμερος, mischievous, wicked. The archaic descendant of μέρμηρα, μέριμνα seems to have shed that aspect of a dilemma more natural to a warrior society, and to become vaguer, as a kind of preoccupying but undelineated anxiety, with the restlessness suggested in its first appearance, in the *Hymn to Hermes* 44:

ὡς δ' ὁπότ' ὠκὺ νόημα διὰ στέρνοιο περήσῃ
ἀνέρος, ὅν τε θαμειαὶ ἐπιστρωφῶσι μέριμναι,
αἱ δέ τε δινηθῶσιν ἀπ' ὀφθαλμῶν ἀμαρυγαί

Such anxiety was normally connected by Greeks to the intelligence rather than to "nerves" or emotional distress, as though it were provoked by consciousness of failure to understand the present or future context of the self.

19. As weather-god and king, Zeus is naturally most changeable in these sketches, therefore perhaps most insulted by Homer in the eyes of later idealists. Zeus can get very burdened with anger (I.517, 534, IV.30, VII.451), satiated with grief (XIX.95), terribly angry (VIII.397), "broken" (sexually assaulted?) by Hera's sharp language (V.893); Hera is frightened and angry (I.568, V.892), Hera and Athena school their hearts in

submission (VIII.437); all the gods may be sorrowed (I.570, XV.101), or insult each other freely (XXIV.33), feel self-pity individually (V.871) or collectively (XII.179); the scenes of divine feasting are seldom peaceful or unperturbed, in this old tradition of folk-tale impressions of families with powerful members. Homer's own skill at making the gods memorable caused him to be hanged from a tree in the "Pythagorean *katabasis*" (Hieronymos of Rhodes, in Diogenes Laertius VIII.21): "Pythagoras in Hades saw the soul of Hesiod bound to a bronze column, and the soul of Homer hanging from a tree and with snakes about it, in payment for what they said about the gods" The tradition of reproaching old poets for failing to achieve "modern" understanding of the gods, exemplified by Herakleitos, Xenophanes, Plato and other visionaries of a higher moral order, seems directly connected to Christian apocalyptic creations of the punishment of blasphemers and foul-mouthed sinners; Dieterich, *Nekyia*[2] 129; but Pythagoras himself would have missed, without Homer's grace, his favorite incarnation as Euphorbos, W. Burkert, *Lore and Science in Ancient Pythagoreanism* (1972) 139f.

20. For Tartaros, Roscher V.125 (Waser) *RE* IV[2], 2440 (Scherling), M. L. West, *Hesiod, Theogony* (1966) on 119, 841; P. Jacoby, *Hermes* 61 (1926) 173; the ταρταρα γαίης, connected to ταράσσω as κάρχαρος to χαράσσω; Mod. Grk. τὰ τάρταρα τῆς γῆς, ταρτάρια μαρτάρια, J. C. Lawson, *Modern Greek Folklore* (1969) 98f. The modern formulas make it chiefly cold and dark, while for the ancients it was more windy and watery (v.291, 394, Plato, *Phaido* 111 E f.), guarded by the Harpies and Thuella storm-wind (Pherekydes B. 5 Diels); it holds the νείατα πείρατα γαίης καὶ πόντοιο VIII.478 (cf. J-P. Vernant, *Hommages à Marie Delcourt* [1970] 57 n. 5), is filled with dark air (VIII.13, *Hermes* 256), is often plural and may be feminine (Pindar, *Pythian* P.1.15); there are ὑποταρτάριοι (XIV.279). Like all waters it has a genital force which allows it to father Typhoeus (Hesiod, *Th.* 822, cf. West on this "inorganic" line; but Ocean and Tethys are parents of us all) and to receive him again in defeat (868). Persephone, like Hekate, is sometimes called a child of Tartaros, in late curse and magical texts. For Apollodoros (from Pherekydes?)

Tartaros was a dark place inside Hades, a *muchos* of it (*Library* I.2), not escape-proof (cf. M. L. West, *Early Greek Philosophy* [1971] 26). Harpies and Thuella, chapter 5 p. 169.

21. See M. Robertson, "Laomedon's Corpse, Laomedon's Tomb," *GRBS* 11 (1970) 23f.

22. Chapter 3 note 10; W. Roscher, *Nektar und Ambrosia* (1883); P. Thieme, "Ambrosia," *Studien zur indogermanische Wortkunde und Religionsgeschichte* (Berlin *BVSAW* 98–5 [1952] II.15, = *Kleine Schriften* [1971] 145f.); "Nektar," *ibid.* I.5 (= R. Schmitt, *Indogermanische Dichtersprache* [1968] 102f.); H. Lommel, *Numen* 2 (1955) 196; Chantraine, *Dictionnaire*, with Boisacq, "triompher de la mort" (possibly by the drink of immortality).

23. The scholiast adds the necessary furniture to Hera's *thalamos* in Pindar's scene of rape, *Pythian* 2.34; for the sexuality of *hybris* in early Greek tragedy, R. Lattimore, *Story-Patterns in Greek Tragedy* (1964) 22; in law and poetry, D. MacDowell, "Hybris in Athens," *Greece and Rome* 23 (1976) 14; a horse who is *hybristes* can be cured by gelding, Xenophon, *Kyropaideia* VII.5.62; J. K. Anderson, *Ancient Greek Horsemanship* (1961) 38.

24. Cf. G. Petzl, *Nekyiai* (1969) 27, for the scholiast's guess that Sisyphos' family did not tell the whole truth about him; the older tale may have included a wooing of the queen of the underworld for her physical charms, as Peirithoos, honoring his father Ixion's blood, hoped to marry or rape her (Apollodoros, *Library* II.5.12).

25. For the political transparency of Herakles' apotheosis, J. Boardman, *JHS* 95 (1975) 1f., *RevArch* (1972) 57f.; H. Lloyd-Jones on Herakles at Eleusis and in the Underworld, *Maia* 19 (1967) 206f.

26. From a scholar's theoretical viewpoint, transformations and metamorphoses have different, cult-connected associations to goddesses whose animal powers were recognized from prehistory to late antiquity; J. Kondis, "Artemis Brauronia," *Deltion* 22 (1967) 156f.; L. Ghali-Kahil, "Images of Artemis" (Lecture, Boston 3 December 1974) *AntK* 20 (1977) 86f., *AntK* 8 (1965) 20f.; W. Sale, *RhM* 108 (1965) 11, 118 (1975) 265; Burkert, *HN* 39f. The grave-mound of Kallisto topped with fruitful and fruitless trees (Pausanias III.35.8) matches the suspected grave of Iphigeneia at Brauron; such "dead im-

mortals" may be animal in myth but human in cult-practice, and capable of appearing to local imaginations in both forms. In poetic fiction when the mortal has transformed to animal, the story often stops, leaving the impression that he is immortal in that guise.

27. Cf. A. Krappe, *The Science of Folk-Lore* (1930) ch. XIV, "The Folklore of Plants"; J. Murr, *Die Pflanzenwelt in der griechischen Mythologie* (1890); I am indebted to Mrs. Linda Perry for her illustrated analysis of the mythological plants; J. de Romilly, *Magic and Rhetoric in Ancient Greece* (1975) 26f.; the importance of foodstuffs for magic is clear, see R. Seaford, *CQ* 25 (1975) 201 on *magos* and *mageiros* the cook; D. L. Page, *Folktales in Homer's Odyssey* (1972) 65f.

28. There are several Glaukos figures in the Greek sea and myth, perhaps falsely distinguished from titles of tragedy as Glaukos Pontios, Potnieus, Taraxippos, or the Minoan prince; see H. J. Mette, *Gymnasium* 62 (1955) 395f.; Roscher I.1679 (Drexler); *RE* VII.1408 (Weicker) (and Ovid, *Metamorphoses* 13.290, Schol. Plato, *Republic* X.611 c); Pausanias IX.22.6 for Glaukos of Anthedon ("a fisherman who, on eating of the grass, turned into a deity and ever since has told men the future"; at III.21.9 distinguished from Nereus). Glaukos was respected particularly on Delos (joined in an oracle with the Nereids), Naxos, at Methymna, Corinth, Cape Malea, Gytheion, and Larymnos in Boiotia; it is perhaps the Boiotian connection which caused Pausanias to complain, "Pindar was not much moved to sing the tale of Glaukos." See also Nilsson, *GGR* I² 240 (Meerdämonen); E. Buschor, *Meermänner*, *SBMünchen* (1941) II.1f.; K. T. Shepard, *The Fish-Tailed Monster in Greek Art* (1940).

29. Gilgamesh's plant is for youth, called "Man Becomes Young in old Age," *ANET²* 96; Innana 56, Adapa 102, Ishtar 108; G. S. Kirk, *Myth, Its Meaning and Function* (1970) 107f.

30. J. D. Beazley, "The Rosi Krater," *JHS* 67 (1947) 1f.; L. Stella, *Mitologia Greca* (1956) 656. Beazley dated the krater to ca. 450 B.C. with a tentative attribution, since the vase had gone, to the Eupolis P., and compared New York 12.229.14 (G. M. A. Richter and L. Hall, *Red-Figured Athenian Vases in the Metropolitan Museum of Art* [1936] pll. 136, 138, 145) on which the word *athanasia* appears

for the first time in Greek (two letters on the Rosi krater; possibly already in Bacchylides?); Apollodoros III.6.8; C. Robert, *Oidipus* (1915) II, 48, 49 n. 37; Beazley puts together the Aristophanic scholia. The texts tell us that the gift of immortality could be inherited like any palpable treasure, and passes from Tydeus to Diomedes.

31. Beazley, *op. cit.* note 30, Schol. Ap. Rhod. IV. 57 ('Hesiod' fr. 11), Endymion receives τὸ δῶρον ἵν' αὐτῷ ταμίαν εἶναι θανάτου, ὅτε θέλοι ὀλέσθαι; R. Merkelbach, M. L. West, *Fragmenta Hesiodea* (1967) 245. On Endymion's sleeping with open eyes, as in death, C. Robert, *Bild und Lied* (1881) 49–50 (Likymnios of Chios).

32. J. A. Wilson, in H. and H. Frankfort, *Before Philosophy* (1949) 113; *ANET²* 405, "A Dispute over Suicide" (Berlin Papyrus 3024, A. Erman, "Gespräch eines Lebensmuden mit seiner Seele," *APAW* [1896] 2; R. Weill, *BIFAO* 45 [1946] 89).

33. E.g. F-R III pl. 126 (London E 466); Berlin F 2519, *CVA* III pl. 38.4; Berlin F 2524 (Curtius P.), *CVA* III pl. 111.4; F. Guirand, *Greek Mythology* (1963) 57; I have not found C. Smith, *Sunrise on Greek Vase Paintings;* but profited from S. Roberts, "Sun and Moon in Gamelion," AIA lecture December 1976; cf. K. Schauenburg, "Gestirnbilder in Athen und Unteritalien," *AntK* 5 (1962) 51f.; N. Coldstream, "A Theran Sunrise," *BICS* 12 (1965) 34 tries to identify an early Helios; Selene and the little fading stars are not popular until the fifth century.

34. But cf. W. Leaf on *Iliad* XIII.4, the Gabioi of Aischylos, *Prometheus Unbound*, most just and hospitable of men (fr. 196 N²), and the probability that Abioi "is really a proper name, not an epithet 'having no fixed subsistence', i.e. nomads" The Argippaioi (Herodotos IV.23) and Getai (IV.93) are linked; J. D. P. Bolton, *Aristeas of Proconnesus* (1962) 71, 102; How and Wells, *A Commentary on Herodotos* (1928) *ad loc.* identify the Argipaioi as Kalmucks; possibly seated under their *ponticum*-cherry tree, in S. Rudenko, *Frozen Tombs of Siberia* (1970) fig. 154 (J. K. Anderson).

35. Nilsson considered the Hesperides of Hesiod's *Theogony* (215, 275, 334), with their gold apples and snake, to be an offshoot of the Elysion theme from an Egyptian source, made into twins or triplets from the single Egyptian

tree-fairy with her gold fruit in the under-world, part of a general Bronze Age inter-cultural vision of the garden of the gods with a tree of life, *MMR*[2] 628. He felt that the Minoan contribution was to place the garden far overseas; but see chapter 2 note 51. The Hesperid tradition is unstable, for the number of maidens, their parentage, whether they lived on an island or a coast (of Africa), a shore covered with apples (or sheep), Roscher I.2594 (Seeliger, Drexler); *RE* VIII.1243 (Sittig); F. Studniczka, *Kyrene* (1890) 15f.; L. Radermacher, *Mythos und Sage* (1903) 224; A. Lesky, *Thalatta* (1947) 76f.; F. Brommer, *Herakles* (1953) 47f.; "Herakles und die Hesperiden auf Vasenbildern," *JdI* 57 (1942) 105f.; H. Götze, "Die Deutung des Hesperi-denreliefs," *JdI* 63 (1948–49) 91f. E. Harrison, "Hesperides and Heroes," *Hesperia* 33 (1964) 76f., points to the sepulchral theme of apple-picking (as in *BCH* 85 [1961] 604; B. Neutsch, *RömMitt* 60–61 [1953–54] 62f.), shown in the Sotades P.'s Hesperid cup (London D 6, *ARV*[2] 763), matched with the cup of Glaukos' recovery from death (London D 5). A man plucking fruits from a tree appears on a thirteenth-century Mycenaean vase of crude style and has been considered the first Herakles fetching the apples (V. Karageor-ghis, *AJA* 62 [1958] 386), although it may be a version of an oriental genius with a date palm.

The classical elaboration of the Hesperid theme consistently stresses the peaceful, remote character of the maidens, their care for their snake, and their lovely voices (λιγύφωνοι Hesiod *Th.* 275, ἀοιδοί Euripides *Hipp.* 743, ὑμνῳδοί *Her.* 394; ἐφίμερον ἀείδουσαι Apollonios Rh. IV. 1399, λίγ' ἔστενον 1407). An archaic mythographical tradition blends the Hesperides with the Harpies, Akousilaos B 5 D-K, Epimenides B 9 D-K, Philodemos *On Piety* 92. Their affinity with darkness is emphasized in the romantic belief that the apples must be picked between sunset and starshine (Schol. Apollonios Rh. IV.1396).

36. The moveable cape, or cliff, or island Sarpedon, ἀεὶ κλύδωνας ἔχων καὶ κυματιζό-μενος (Sophokles *Aichmalotides*, 43 N[2]) was the island of the Gorgons in the *Kypria* (fr. 21), the tomb heaped with sand by a sea-ringed grove for Aischylos (*Supp.* 869), a cave in Thrace (Sophokles *Tympanistai* 580 N[2]),

perhaps Cape Gremia or Paxi (How and Wells, *A Commentary on Herodotos* [1928] on VII.58), opposite Samothrace where Oreithyia was carried by Boreas (Schol. Apollonios Rh. I.211), or in the Troad, or near Miletos or Xanthos, Sarpedon's town where Harpies are at home; the etymological connection between Sarpedon and Harpy matches the mythical associations; see Roscher IV.393 (Immisch) for a list of Sarpedons, and *RE* II[2] 43 (Zwicker).

37. Chapter 1 notes 42, 62; chapter 2 note 23; the mythical alternation of caves and islands as cattle-pastures for the sun and Hades is no contradiction since both are circumscribed and concealed and are often interchangeable in fairy-tale.

38. J. H. Croon, *The Herdsman of the Dead* (1952); but a death-spirit who does not take victims is an oddity at least; even the herds-man Menoites who worked for Hades above ground (Apollodoros II.5.10) is a victim underground when Herakles breaks his ribs; called son of Keuthonymos, a fit epithet for Hades, of deep interest to Persephone (II.5.12), Menoites may in some local tradition be their only child. Neither Menoites or Geryon have willing contacts with the human race.

39. The derivation of Gorgon from the verb garg- is, like most etymologies in myth, disputed; T. P. Howe, *AJA* 58 (1954) 210f. nn. 7–10 [gargarizo, gargouille, garganta, gargatta, gargoyle, gurgle]; Chantraine, *Dictionnaire*, thinks of a simple female dragon Gorgo, like Mormo, but the weight of the evidence suggests a noise behind the face. Cf. below note 41.

40. Chantraine, *Dictionnaire*, s.v., "faire entendre sa voix, faire connaître, chanter."

For the other singers and voices of the western seas (chapter 6 p. 201), the Sirens are obvious (λιγυρῇ θέλγουσιν ἀοιδῇ, xii.44), as are Kirke (δεινὴ θεὸς αὐδήεσσα x.136), Kalypso (ἀοιδιάουσ' ὀπὶ καλῇ, v.62) and probably Cyclops in his island-cave (δεισάντων φθόγγον τε βαρὺν αὐτόν τε πέλωρον ix.257).

41. In the large bibliography on Gorgons, among others J. L. Benson, "The Central Group of the Corfu Pediment," *Gestalt und Geschichte* (Festschrift K. Schefold, *AntK* Beiheft 4 [1967] 48f.); H. Besig, *Gorgo und Gorgoneion* (1937); C. Blinkenberg, "Gorgonne et Lionne," *RevArch* 19/20 (1924) 267; E. Buschor, *AJA* 38 (1934) 128; C. Christou,

Potnia Theron (1969); K. Fittschen, *Sagendarstellungen* (1969) 127, 152; R. Hampe, *Frühe griechische Sagenbilder in Boiotien* (1936) 58, 67; T. Howe, *AJA* 58 (1954) 209; Kunze, *Schildbänder* 65f.; M. Milne, *Bulletin of the Metropolitan Museum of Art* (1946) 126; E. Niki, *RevArch* (1933) 145; F. Pötscher, *Gymnasium* 70 (1963) 537; K. Schauenburg, *Perseus in der Kunst des Altertums* (1960); J. Woodward, *Perseus* (1937); *RE* VII, 1630 (Ziegler).

42. Hesiod, *Th.* 285–86 and West *ad loc.*; Ullikummi, *ANET*² 123; A. Lesky, *Eranos* 52 (1954) 8; Pindar, *Olympian* 13, 92; Euripides fr. 312.

43. On Mycenaean *wa-o* (Ta 716) and the double axe or sword, E. Vermeule, *BMFA* 57 (1959) 14; M. Ventris, J. Chadwick, *Documents in Mycenaean Greek*² (1973) 502; A. Morpurgo, *Mycenaeae Graecitatis Lexikon* (1963) 353.

44. Apollodoros III.x.3.

45. The two important recent articles of Page and Robertson, supported by readings and interpretations of W. S. Barrett, put the poem and its archaic illustrations in new perspective: D. L. Page, "Stesichorus: *The Geryoneïs*," *JHS* 93 (1973) 138f.; M. Robertson, "*Geryoneïs:* Stesichorus and the Vase-Painters," *CQ* 19 (1969) 207f. Page collects the Homeric analogies for the debate on death and immortality; Robertson lists all the illustrations and distinguishes the winged Stesichorean and Chalcidian versions, and solves the mystery of the birth of the herdsman Eurytion to one of the Hesperids, Erytheia. The tale of Herakles' raid on Geryon's cattle and the extraordinary wanderings of their return was a curiously popular late archaic theme; Pindar fr. 169 (H. Lloyd-Jones, *HSCP* 76 [1972] 45f.), Isthmian I.13, Herodotos IV.8–10, Apollodoros II.V.10; the moveability of Geryon himself is attested by Pausanias' attractive story, I.35.7–8, of the discovery at Temenothyrai in Lydia when the mountain crest broke off in a storm and "there appeared bones the shape of which led one to suppose they were human, but from their size one would never have thought it. At once the story spread among the multitude that it was the corpse of Geryon son of Chrysaor . . . and a torrent they called the river Ocean, and they said that men ploughing met with horns of cattle, for the story is that

Geryon reared excellent cows." See note 47.

46. Or named for the Hesperid Erytheia who mothered Eurytion, Robertson, *op. cit.* note 45; Apollonios Rh. IV.1399 and Schol.; Pausanias X.17.5; C. Robert, *Hermes* 19 (1884) 482.

47. J. H. Croon, *The Herdsman of the Dead* (1952) makes a consistent case for a "death-god"; see *RE* VII.1290 (Weicker), *RE* VIII. 775 (Eitrem); *RE* XVIII.1495 (Scherling). Croon thought the herdsman was god of the underworld, cattle the souls of the dead, in the "meadow" of Hades (like the animals in Kirke's park); Pindar, *Olympian* IX.33, Hades drives the dead down the hollow road with the *rhabdos*, like cattle; Hermes in the *Homeric Hymn* as a psychopomp driving cattle into a cave (but early Hermes is *chthonios*, not psychopomp, H. Herter, *RhM* 119 [1976] 217); parallels with Euripides' *Alkestis*, for Admetos has large herds and is *adamastos* (Lesky, *SBWien* [1925]); but see H. J. Rose, "Chthonian Cattle," *Numen* 1 (1954) 213.

48. Pausanias I.35.6.

49. One of the deliberate ironies is the construction of the late archaic Geryon figure as three "Herakles" torsos with three Herakles heads, so that at the sale of the Cesnola Collection in New York it was possible to auction off two of the Herakles heads as duplicates.

50. Page and Barrett, *op. cit.* note 45, 150, see this scene in slightly different ways; Page, "If I am immortal, so much the better; he cannot kill me. If I am not, then I would rather die with honour than survive without"; Barrett cannot see the first part of this in the text. Page rightly emphasizes the likeness to Sarpedon in *Iliad* XII.332, Geryon as "a noble and sympathetic person."

CHAPTER V
ON THE WINGS OF THE MORNING:
THE PORNOGRAPHY OF DEATH

1. *Ox. Pap.* 2387, vol. xxiv, fr. 3 col. ii; D. L. Page, *CR* 9 (1959) 16, *PMG* 3, *LGS* 2; W. S. Barrett, *Gnomon* 33 (1961) 683; W. Peek, *Philologus* 104 (1960) 163; D. A. Campbell, *GLP* 213; T. B. L. Webster, *Greek Art and Literature 700–530* (1959) 37 n. 50.

2. As in Keats to Fanny Brawne, "I have two luxuries to brood over in my walks, your

loveliness and the hour of my death. O that I could have the possession of the both in the same minute" (25 July 1819). On death as marriage see note 48, and chapter 1 note 25; on gentle death, J. Fink, "Seele, Tod, Rachegeist," *ÖJh* 44 (1959) 100f.

3. Sappho 95 L-P; H. Fraenkel, *GöttGelAnz* (1928) 269; *Dichtung und Philosophie* (1962) 213; M. Treu, *Zetemata* 12 (1955); D. L. Page, *Sappho and Alcaeus* (1955) s.v.

4. C. Ramnoux, *La Nuit et les Enfants de la Nuit dans la Tradition Grecque* (1959); *Héraclite* (1959) 31f.; *RE* IX.323 (Jolles). Sleep is usually discussed in connection with death, Hypnos and Thanatos or the grave, e.g. C. Robert, *Thanatos*, 39 *BWPr* (1879); *Bild und Lied* (1881) 100; Fairbanks, *AWL* I (1907) 346; Heinemann, *Thanatos*; Roscher III. 2068, V.481 (Deubner, Waser); *RE* V.799, 1245 (Lesky); E. Pottier, *Mélanges Piot* 22 (1916) 39; H. Schall, *Griechische Vasen* (1923) 44f.; a recent complete list in F. Brommer, *Madrider Mitteilungen* 10 (1969) 164 App. 2; cf. D. von Bothmer, *BMMA* 31 (1972) no. 15. On the personification of sleep, L. Petersen, *Zur Geschichte der Personifikation in gr. Dichtung und bildender Kunst* (1939) 32; F. Hamdorf, *Griechische Kultpersonifikationen der vorhellenistischer Zeit* (1964) 41f.; M. Leumann, *Homerische Wörter* (1950) 44f. J.-C. Eger, *Le Sommeil et la Mort* (1966) is mostly pictures. On Sleep as a bird, D'Arcy Thompson, *A Glossary of Greek Birds* (1936) 108; Aristotle, *Hist. Anim.* IX.12; C. Watkins, in J. Puhvel (ed.), *Myth and Law Among the Indo-Europeans* (1970) 1.

Sacrifices to Sleep at Troizen, Pausanias II.31.3; his statue in the sanctuary of Asklepios at Sikyon, II.10.2—one just a head, one a pair with Dream, in which Sleep the Giver "lulls a lion," and Frazer's commentary. On Sleep and Dream in healing cults and oneirotherapy, E. and L. Edelstein, *Asclepius* (1945) II, 148f.; on the magical properties of sleep, F. de Waele, *The Magic Staff* (1927); G. Germain, *Genèse de l'Odyssée* (1954) 517; on the qualities of sleep, E. Risch, *MusHelv* 19 (1962) 197f.; P. Wiesman, *MusHelv* 29 (1972) 1f.

For the statues of Sleep and Death at Sparta, see note 5. The head in London and the statue in Madrid, H. Winnefeld, *Hypnos* (1886), H. Schrader, *Hypnos* (1926); A. Blancko, *Museo del Prado, Catalogo Escultura* (1957) no. 89, pll. 43–45.

The other principal epithets of Sleep in Homer are ἀπήμων and γλυκερός; σχέτλιος and νηλής when it causes trouble (x.69, xii. 372); it is a gift (VII.482, IX.713), allied with κάματος (x.98) and sex (xiv.353), as in the Tyro episode (xi.244).

For sleep as a killer in a context of stilling an animal to be sacrificed, see C. Watkins, "An Indo-European Word for 'Dream'," in E. S. Firchow, K. Grimstad, N. Hasselmo, W. O'Neil (eds.), *Studies for Einar Haugen* (1972) 559, or the fighter's slang of "putting to sleep."

For the equivalency of sleep and non-being, or as a border-state between living and not living, see Aristotle, *Generation of Animals* V.1, 778b, 20f.: "which state exists first in animals, sleep or waking? From the fact that, as we see, they become more awake the older they get, it seems reasonable to suppose that the opposite state, sleep, is the one that exists at the beginning of their formation—and also from the fact that the transition from not-being to being is effected through the intermediate state, and sleep would appear to be by its nature a state of this sort, being as it were a borderland between living and not living ... (779 a.20): Infants, it would seem, have not yet acquired the art of being awake, if we may put it so ... " (A. L. Peck, Loeb edition [1963]).

5. Pausanias III.17.5, 18.1–2. For divine twins at Sparta, Roscher I.1156 (Furtwängler), S. Wide, *Lakonische Kulte* (1893) 304f.; S. Eitrem, *Die göttlichen Zwillinge bei den Griechen* (1902); F. Chapouthier, *Les Dioscures au service d'une Déesse* (1935); and in general D. Ward, *Divine Twins*, Folklore Studies 19 (1968) and "The Separate Function of the Indo-European Divine Twins," in J. Puhvel (ed.), *Myth and Law Among the Indo-Europeans* (1970) 193. Ramnoux, *Nuit* (note 4) may have confused the two sets of statues mentioned by Pausanias; there is no evidence that Sleep and Death were wooden or particularly old.

6. Pausanias V.18.1, a much-quoted passage, πεποίηται δὲ γυνὴ παῖδα λευκὸν καθεύδοντα ἀνέχουσα τῇ δεξιᾷ χειρί, τῇ δὲ ἑτέρᾳ μέλανα ἔχει παῖδα καθεύδοντι ἐοικότα, ἀμφοτέρους διεστραμμένους τοὺς πόδας. δηλοῖ μὲν δὴ καὶ τὰ ἐπιγράμματα, συνεῖναι δὲ καὶ ἄνευ τῶν ἐπιγραμμάτων ἔστι Θάνατόν τε εἶναι σφᾶς καὶ Ὕπνον καὶ ἀμφοτέρους Νύκτα αὐτοῖς

τροφόν. Cf. Frazer, *Pausanias ad loc.*; Robert, *Thanatos*; Roscher 481 (Waser); an interesting reconstruction by H. Jones, *JHS* 4 (1894) pl. 1; cf. K. Schefold, *Myth and Legend in Early Greek Art* (1966) fig. 26, after W. von Massow, "Die Kypseloslade," *AthMitt* 41 (1916) 1f.; G. Roux, "Ou avait-on caché le petit Kypsélos," *RevEtAnc* 65 (1963) 279f. The *ker* in the Polyneikes-Eteokles panel is a rare illustration, with talons—a sphinx? (V.19.6).

7. In addition to the lists of Sleep and Death scenes above, note 4, cf. Beazley, *C-B* ii, no. 70 for Memnon; F. Brommer, *Vasenlisten*[3] (1972) 348f.; G. Lung, *Memnon* (1912); and note 24 below.

8. J. Kakridis, *Homeric Researches* (1949) 75f., E. Risch, "Zephyros," *MusHelv* 25 (1968) 205, E. Howald, *MusHelv* 8 (1951) 111; H. Steinmetz, "Windgötter," *JdI* 25 (1910) 33, and the relations with Hypnos, Thanatos and Harpies; on real winds, *RE* VIII A.2, 2211 (Böker), Boreas III.720 (Haebler); W. Agard, "Boreas at Athens," *CJ* 61 (1966) 241; T. B. L. Webster, *Potter and Patron in Classical Athens* (1972) 254.

Boreas may be related to sl. *burja* a storm, "Bergwind"; so the close relation to the ῾Ρίπαια ὄρη somewhere near the Hyperboreans as in ψυχραὶ ὑπὸ ῥιπῆς αἰθρηγενέος βορέαο (XIX.358); for the mountain out of which the north wind blows, J. D. P. Bolton, *Aristeas of Proconnesus* (1962) 44, 93; cf. Hippokrates, *Airs, Waters, Places* 19, Scythia "lies right close to the north and to the Rhipaian mountains, from which the north wind blows"; see J. Desautels, "Les monts Riphées et les Hyperboréens," *REG* (1971) 289. Boreas is closely associated with Cape Sarpedon or the Rock of Sarpedon (chapter 4 note 36), where his bride Oreithyia raised their daughter Kleopatra among storms in the cave, to run the rocks with horselike speed (R. C. Jebb on *Sophocles, Antigone* [1891] 981f. "in the wilds of Haemus"). See below note 35. Boreas' rape of Oreithyia was considered so close a mythical counterpart to Eos' rape of Kephalos, that the pairs were made sculptural pendants on the Temple of Apollo on Delos.

9. E.g. Thanatos P., Athens NM 1830; J. Boardman *et al.*, *Greek Art and Architecture* (1968) 372 fig. 162.

10. J. B. Bury, *Pindar, Nemean Odes* (1890) on *Nemean* X, for the twins alternating between the hollows in the earth of Therapne and the palaces of heaven (191): "There is a light about them, but it is light experiencing change, or double (ἀμφιλύκη) ... the outgoings of the morning and evening have passed, shimmering, into the story of the Laconian horsemen. For they usually rode on horses (like the Vedic açvins); and they were not heedful of the love of women."

11. On the child-twins in a mother's arms, sometimes regarded as Dionysos' children Oinopion and Staphylos, or the Dioskouroi, or Himeros and Eros (Acropolis 2536, G-L pl. 104; cf. pl. 29, 603a), see E. Simon, "Ein Anthesterion-Skyphos des Polygnotos," *AntK* 6 (1963) 6f., and *Die Götter der Griechen* (1969) 218, 230; L. Stella, *Mitologia Greca* (1956) 283; N. Himmelman-Wildschutz, *Zur Eigenart des klassisches Götterbild* (1959) 14 fig. 3; D. M. Robinson, *AJA* 60 (1956) 6 pl. 4 fig. 22 (probably not Himeros and Eros as thought); *ABV* 142, 143.2, 262.45.

12. B. Andreae, "Herakles und Alkyoneus," *JdI* 77 (1962) 130f. In Theognis 207, the Sleep that perches on the eyelids of men in epic and in the painters' tradition has been replaced by Death,

$$\Theta\acute{\alpha}\nu\alpha\tau\sigma\varsigma \ \gamma\grave{\alpha}\rho \ \grave{\alpha}\nu\alpha\iota\delta\grave{\eta}\varsigma$$
$$\pi\rho\acute{o}\sigma\theta\epsilon\nu \ \grave{\epsilon}\pi\grave{\iota} \ \beta\lambda\epsilon\phi\acute{\alpha}\rho o\iota\sigma' \ \ \acute{\epsilon}\zeta\epsilon\tau o \ \kappa\hat{\eta}\rho\alpha \ \phi\acute{\epsilon}\rho\omega\nu.$$

The winged demon-figure is also converted to death in art, A. Lesky, "Eine neue Talos-Vase," *AA* (1973) 1.

13. The most familiar classical illustration is the Pan P.'s lekythos with Ariadne and Sleep, Theseus, Peirithoos, and Night; see L. Curtius, "Lekythos in Tarent," *ÖJh* 38 (1950) 1f.; E. Simon, "Zur Lekythos des Panmalers in Tarent," *ÖJh* 41 (1954) 77f.; the scene was among Mikon's decorations of the Theseion, Pausanias I.17.2. Beazley thought the lekythos lacked lightness of touch and might be a copy, *ARV*[2] 560.5.

14. A. Boegehold, *GRBS* 15 (1974) 36 pl. 6 (fourth-century black glazed kantharos). The statue group of Eros, Himeros and Pothos by Skopas in Megara, "if indeed their actions are as different as their names," Pausanias I.43.6; cf. F. Hauser in F-R III, 26, pl. 124; H. Bulle, *JdI* 56 (1941) 140. *Pothos* kills, in xi.202; it pains, xiv.144; it has goads, Plato, *Phaidros* 253 e; it possesses the living when the dead were good, Herodotos III.67, and may bring them back alive? so there is hope for

Euripides when *pothos* bites at Dionysos, Aristophanes, *Frogs* 66. Cf. J. P. Vernant, *Mythe et Pensée*[2] (1969) 256f. for the power of *pothos* to raise phantoms, and to evoke the dead in sleep as in funeral rites. For Protesilaos, whose raising from the dead by love is not a common Greek story (more South Italian) but must have occupied Euripides' *Protesilaos*, see Burkert, *HN* 269f. ('Vampirgeschichte'); he notes an Apulian sherd with Protesilaos in Hades, 270 n. 4 = K. Schauenburg, *JdI* 73 (1958) 68f.; see now H. R. W. Smith, *Funerary Symbolism in Apulian Vase-Painting*, ed. J. K. Anderson (1976) 188 on BM F 272; in general E. Fränkel, *Aeschylus, Agamemnon* (1962) on 416; Catullus 68, 75; Ovid, *Heroides* 13.

15. W. J. Verdenius, *Mnemosyne* 28 (1975) 418; x.398.

16. Sappho 2.9; Anakreon 417 P, 88 D., Alkman 1.46, Ibykos 287 P; Theognis 257, 1249, 1267, for which J. Carrière (Budé edition 104) quotes Aristotle's opinion on mares, *Hist. Anim.* VI.18, 572 a: "In eagerness for sexual intercourse of all female animals the mare comes first ... Mares become horse-mad (hippomaniac), and the term derived from this one animal is applied by way of abuse to women who are inordinate in their sexual desires. Mares are also said to get impregnated by the wind at this season ... (they run north or south, to the sea if possible,) at that stage they discharge a certain substance which ... is the chief thing sought after by women who deal in philtres and drugs" (A. L. Peck, Loeb edition [1970]). On κέλης as a sexual image, either a fast horse or a yacht, J. Henderson, *The Maculate Muse* (1975) 164; phallos-headed horse, H. Licht, *Sittengeschichte* (1925–28) III, 79 (Berlin 2320).

17. F. Lasserre, *La Figure d'Éros dans la poésie Grecque* (1946); T. Rosenmeyer, "Eros-Erotes," *Phoenix* 5 (1951) 11; A. Greifenhagen, *Griechische Eroten* (1957), A. Furtwängler, *Eros in der griechischen Vasenmalerei* (1874); C. Seltman, *BSA* 26 (1923) 88; J. Harrison, *Prolegomena* 624f.; E. Simon, *Geburt der Aphrodite* (1959); G. Hafner, "Margos Eros," *MusHelv* 8 (1951) 137; O. Szemerenyi, *Studi Micenei* 3 (1962) 82; C. Boulter, *CVA* Cleveland 66.114, pll. 32–35; L. Stella, *Mitologia Greca* (1956) 260f. Greifenhagen lists the attributes p. 69f. For Eros the gambler, with

astragals, and funerary art, R. Hampe, "Die Stele aus Pharsalos im Louvre," *BWPr* 107 (1951).

18. *Hymn to Hermes* 434; Sophokles *Antigone* 781; G. Murray, *Rise of the Greek Epic*, 147f., on the poisoned arrows of Odysseus; on Eros the archer, "he makes a wound which looks slight ... but there is in it a burning poison from which the stricken man does not escape."

19. A. Severyns, *Homère* III (1948), 109.

20. See F. Combellack, *The War at Troy, What Homer Didn't Tell* (1968) 40f., although there Achilles rages until he removes her helmet and sees Penthesileia "attractive even among the dead." The archaic compositions begin shortly after the *Aithiopis*: Kunze, *Schildbänder* 148f.; D. von Bothmer, *Amazons in Greek Art* (1956), 4, 145; from the beginning the Amazon is wounded near the collarbone, and the eyes of the enemies lock; cf. K. Schefold, *AM* 77 (1962) 130.

21. A. Greifenhagen, *Griechische Eroten* (1957) on figs. 36–37; D. A. Amyx kindly called to my attention a comment upon the gesture, in certain archaic compositions: C. Sweet, *California Studies in Classical Antiquity* 2 (1969), 276 n. 14, with collected examples, to which Amyx adds a neck-amphora in San Simeon, *ABV* 381, below, 1; a panel-amphora in Boston, *ABV* 260.28.

22. On the specific scene of *psychostasia*, Beazley, C-B iii no. 147; G. E. Lung, *Memnon* (1912); *RE* Sup IV, 887 (Malten); F. Studniczka, *JdI* 26 (1911) 132; E. Wüst, "Die Seelenwagung in Griechenland und Ägypten," *ArchfRel* 36 (1939) 164, *RE* 23.2 (1959) 1439; E. Simon, *Geburt der Aphrodite* (1959) 72f., 110 n. 45; W. Pötscher, "Moira, Themis und τιμή im homerische Denken," *Wiener Studien* 73 (1960) 5f., especially 14–22; C. Robert, *Szenen der Ilias und Aithiopis* (1891); E. Löwy, "Zur Aithiopis", *Neue Jahrbücher* (1914) 81; C. Van Essen, "Psychostasia," *BABesch* 39 (1964) 126; (the scales hang from a tree); Erotes in the scale-pans, F. Studniczka, *JdI* 26 (1911) 140 fig. 58; phalloi, fig. 57; cf. H. Licht, *Sittengeschichte* (1925–28) III.143; G. Björck, *Eranos* 43 (1945) 58; chapter 2 notes 70–71. Beazley notes the compression of many of the pictures into the two generations c. 500–460 B.C., with precursors in the East Greek bf. hydria and the Vienna bf. dinos 3619 by the P. of the Vatican Mourner; although a

considerable share of the early fifth-century pictures are earlier than Aischylos' *Psychostasia* with its reported magnificent tableau of gods on the *theologeion* (*op. cit.* 44). The Attic pictures have Hermes hold the scales. Fränkel does not like the association of Ares the gold-changer holding the balance of the spear, *Aeschylus, Agamemnon* (1962) on 437f., with the *psychostasia* scenes of Aischylos or the *Aithiopis*; see lately G. P. Ouellette, *REG* (1971) 309.

23. M. Comstock, C. Vermeule, *Sculpture in Stone: The Greek, Etruscan and Roman Collections of the Museum of Fine Arts, Boston* (1976), no. 30 with bibliography; F. Studniczka, *JdI* 26 (1911) 50f.; H. Möbius, *Charites* (Festschrift E. Langlotz [1957]) 47; W. Young, B. Ashmole, *BMFA* 56 (1958) 124.

24. C. Sourvinou-Inwood, "The Boston Relief and the Religion of Locri Epizephyrii," *JHS* 94 (1974) 126f. On bound and spell-bound captives, J. D. Beazley, "The New York Phlyax Vase," *AJA* 56 (1952) 193f. See also C. Kardara, *EphArch* (1964) 75; Sourvinou-Inwood n. 47. It seems unlikely that the side-figures on the Boston Throne represent Orpheus and Moira.

25. Harrison, *Prolegomena* 632, on Eros the *ker* of life, in connection with a small figure on an Ariadne cup in Tarquinia, "Archaeologists wrangle over his name. Is he Life or Love or Sleep or Death? Who knows? It is this shifting uncertainty we must seize and hold; no doubt could be more beautiful and instructive."

26. Eos in general, Roscher 1252 (Rapp) with emphasis on the Indic connections; on the confusion among the traditions of the boys she snatched away, especially Tithonos and Kephalos, Beazley, C-B ii.37, iii.57, even to the introduction of Trojan Dardanos as a companion of Attic Kephalos; for the snatching of Kleitos, of the prophetic family of Melampos (xv.250), of Orion, and Eos or Aphrodite, G. Nagy, "Phaethon, Sappho's Phaon, and The White Rock of Leukas," *HSCP* 77 (1973) 137f., cf. J. Kakridis, *Wiener Studien* 48 (1930) 25; K. Reinhardt, *Festschrift B.Snell* (1956) 1; E. Simon, *Die Geburt der Aphrodite* (1959) 90; J. Diggle, *Phaethon* (1970); J. Frazer, on Apollodoros II App. xi; C. Robert, "Die Phaethonsage bei Hesiod," *Hermes* 18 (1883); L. Stella, *Mitologia Greca* (1956) 286; J. Bidez, *Eos ou Platon et l'Orient* (1945); T. B. L. Webster, *Potter and Patron in*

Classical Athens (1972) 44, notes the pair of love-gifts by the Pantoxena P., Eos and Tithonos, and the Death of Orpheus, and the common conversion of love myths to funeral myths.

27. Chapter 2 note 27.

28. C. L. Thompson called my attention to this passage; F. Buffière, *Héraclite, Allégories d'Homère* (1962) 72 no. 68; the problem *dead / diseased* lies in the interpretation of καμνόντων. Cf. Artemidoros, *On Dreams* I.80, "If a man dreams of intercourse with a god or goddess it is a sign of death and being ready to leave his earthly body." The funeral before dawn, chapter 1 p. 18 and fig. 17 (The Sappho Painter). On the throne of Apollo at Amyklai it was Hemera, not Eos, who raped away Kleitos, the same fusion as here, Pausanias III.18.12. In the context of the Greek tendency to displace Hellenic erotic impulses onto exotic creatures, J. K. Anderson recalled the American popular song "You're a sweetheart in a million, oh oh oh oh, Aurora / With your manner so Brazilian, oh oh oh oh, Aurora."

29. Roscher I.1595 (Drexler); *RE* VII.1. 737 (Friedländer); H. Sichtermann, *Ganymed, Mythos und Gestalt in der antiken Kunst* (1952), with M. J. Milne's important review, *AJA* 59 (1955) 68; at issue are the Greek-sounding name, at variance with the Trojan ancestry, and the role of noble cup-bearer to the king set against the passive *eromenos* role; cf. R. von Scheliha, *Patroklos* (1943) 388; L. Malten, *Hermes* 43 (1918) 165; H. Lorimer, *Homer and the Monuments* (1950) 488; Ph. Bruneau, "Ganymède et l'Aigle," *BCH* 86 (1962) 193f. with bibliography; K. Phillips, "A Ganymede Mosaic from Sicily," *Art Bulletin* 42 (1960) 244. The incarnation of the raping eagle is earlier in art than poetry, though not before the fourth century, but is a logical domestication of the early death-figures as well as a natural extension of the eagle who sits on the staff of Zeus; in Alexandrian or Latin poetry the eagle grows hooking claws like storm winds, e.g. Nonnos, *Dionysiaka* 25, 430,

ταρβαλέος δ' ἐτέτυκτο δι' αἰθέρος ἱπτάμενος Ζεὺς
ἀδρύπτοις ὀνύχεσσι τεθήπότα κοῦρον ἀείρων.

30. The etymological interpretation of γανυ-μήδεα, as producing a gleam or polish upon the mind / members of Zeus (cf. G. Nagy, *Comparative Studies in Greek and Indic Meter*

[1974] App. A, 265f.) may not reflect the terms in which the Greeks first thought of this mythological figure, but the fifth-century interest in erotica supported it freshly, as in the fragment of Sophokles' *Kolchides*, μηροῖς ὑπαίθων τὴν Διὸς τυραννίδα (fr. 320 N²).

31. On behavior patterns and gifts between *erastes* and *eromenos*, J. D. Beazley, *Some Attic Vases in the Cyprus Museum* (Proceedings of the British Academy 33) (1947) 195f., K. Schauenburg, "Erastes und Eromenos," *AA* (1965) 850; E. Vermeule, "Some Erotica in Boston," *AntK* 12 (1969) 9f.; O. Brendel, "The Scope and Temperament of Erotic Art in the Greco-Roman World," in T. Bowie, C. Christensen, *Studies in Erotic Art* (1970) 9f. The custom seems to have no relation to English cock-a-hoop, which refers to generous drunkenness.

32. Wings, fluttering, bird-images of both sex and fear, of alteration and disappearance, as typically in Euripides (*Helen* 478, 668, *Suppliants* 89, *Ion* 796), in the tradition of Anakreon 52; ἀναπτερῶσαι πᾶν τὸ σῶμα will lead to love, Aristophanes, *Lysistrata* 669; the famous choral line of Sophokles, *Aias* 693, ἔφριξ' ἔρωτι, περιχαρὴς δ'ἀνεπτάμαν was in an old tradition of Eros and Death. For Eros in funerary imagery, Fairbanks, *AWL* I (1907) 26f., and fig. 29 here. For the sexual implications of wings, H. Licht, *Sittengeschichte Griechenlands* (1925–28); G. Vorberg, *Glossarium Eroticum* (1932); J. Marcadé, *Eros Kalos* (1962); J. Henderson, *The Maculate Muse* (1975) 128 on πτέρων, πτέρυξ, slang for phallos; W. Arrowsmith, *Arion* n.s. 1 (1973) 164; C. Wolff, "On Euripides' *Helen*," *HSCP* 77 (1973) 63; H. R. W. Smith, *Funerary Symbolism in Apulian Vase-Painting*, ed. J. K. Anderson (1976) 33f.; for winged death-carriers, K. Peters, "Unbekannte attische Oinochoen," *JdI* 86 (1971) 103f. and H. Kenner, note 33; wings and prophecy, P. Wolters, "Der geflügelte Seher," *SBMünchen* 1928.1.

33. Notes 8, 32 above. This kind of death is a drop into deeper invisibility than Hades, where kinsmen might see the unhappy women. Thuella and the Harpies are daughters of Boreas who have Tartaros as their "moira," Pherekydes B.5 D-K; this windy wet roaring place (chapter 4 note 20) is not "social," and one need not be embarrassed there by the erotic impulses which caused the disappearance wish, any more than in the concealing ocean. Cf. E. Rohder, *Hermes der Windgott* (1878), 133f., 144. On the fusing of wind-gods, dawn-figures and love, see also H. Kenner, "Flugelfrau und Flugeldämon," *ÖJh* 31 (1939) 87f.

34. E. Risch, "Zephyros," *MusHelv* 25 (1968) 205; KN Fp 1.10, Fp 13.3; PY Ea 56 (?); *Iliad* XV.591, XXIII.51; *RE* X A 234 (Ziegler).

35. The youth is often called "Hyakinthos"; with a characteristic confusion whether the "west wind" carried him off for love, or whether he rode his lover (killer) Apollo's swan over the waves, to the back of the North Wind. M. Mellink, *Hyakinthos* (1943); Roscher 2759 (Roscher); *RE* IX.7 (Eitrem); Sichtermann, *JdI* 71 (1956) 97f.; Beazley, C-B iii.20, *Greek Vases in Cyprus* 223; E. Vermeule, *AntK* 12 (1969) 14; for the parody, with the girl on the phallos-bird, Berlin 2095, H. Licht, *Sittengeschichte* (1925–28) III, 76; J. Marcadé, *Eros Kalos* (1962) 103. Zephyros' worship in Athens, Pausanias I.37.2. Zephyros alternates with Boreas (the blue-maned stallion) as father of the Trojan horses, *Iliad* XXIII.223 vs. XVI.150, the harpy-bird Podarge; the wind a component in horse anatomy since the Shaft Graves; Aiolos the wind-king son of Hippotes (X.2); a case where the familiar language of slang and hyperbole also has mythological consequences.

36. P. Demargne, *Fouilles de Xanthos* I (1958), *Les Piliers Funéraires* 37f. with bibliography, 131; F. N. Pryce, *Catalogue of Sculpture in the British Museum* I.i (1928), 122, B 287 (the Harpies are more properly called Sirens); Rodenwaldt, *SBBerlin* (1933) 1028f.; F. J. Tritsch, *JHS* 62 (1942) 39; Weicker, *Seelenvogel* 32; M. Mellink, *RevArch* (1976) 21f., 34.

37. Chapter 4 note 36.

38. Chapter 2 note 46.

39. In the huge literature on the Sphinx, see especially *RE* III A, 1706 (Lesky) and Sup. IV, 890 (*Keres*); K. Kourouniotes, *JdI* 16 (1901) 20; C. Robert, *Oidipus* (1915) I.53, II.19; L. Malten, *JdI* 29 (1914) 242f.; P. Jacobsthal, *Die melischen Reliefs* (1931) 19f.; F. Eichler, "Thebanische Sphinx," *ÖJh* 30 (1937) 75f.; G. Rodenwaldt, "Metope aus Mykenae," *Corolla L. Curtius* (1937) 63f.; M. Delcourt, *Oédipe ou la légende du conquérant*

(1944) 108f.; M. Renard, "Sphinx ravis-
seuses et 'têtes coupées'," *Latomus* 9 (1950)
303f.; N. Verdelis, "L'Apparition du Sphinx
dans l'Art Grec," *BCH* 75 (1951) 1f.; A.
Dessenne, *Le Sphinx* (1957); Hampe, *Grabfund*
60f., 84; H. Walter, "Sphingen," *Antike und
Abendland* 9 (1960) 63; W. Porzig, "Das
Rätsel der Sphinx," in R. Schmitt, ed., *Indo-
germanische Dichtersprache* (1968) 172; K.
Kübler, *Kerameikos* VI.2 (1970) 241f.; J.
Boardman, "A Sam Wide Group Cup in
Oxford," *JHS* 90 (1970) 194; U. Hausmann,
"Oidipus und die Sphinx," *Jahrbuch der
staatlichen Kunstsammlungen in Baden-Würtemberg*
9 (1972) 7f.; F. Harl-Schaller, "Die archai-
schen 'Metopen' aus Mykene," *ÖJh* 50
(1972–73) 94f. figs. 2–3.

40. E. Vermeule, *Festschrift F. Brommer*
(1977); Haspels, *ABL* 137f., 247, 369.

41. J. Dingel, *MusHelv* 27 (1970) 90f.;
Euripides' *Oedipus*, *Oxyrhynchus Papyri* 27
(1962) 2455.

42. L. Malten, F. Eichler, *opp. cit.* note 39;
J. D. Beazley, *The Lewes House Gems* (1920)
no. 29; J. Boardman, *Greek Gems and Finger
Rings* (1970) 361, 362.

43. Beazley, *op. cit.* (note 42) no. 59,
Boston 23.601; cf. W. Peek, *Maia* 23 (1971) 99.

44. Phalloi in death: *RE* XIX.1673, 1681
(Herter); Nilsson, *GGR* I² 119 (Impetratio
Boni); C. Bérard, "Une nouvelle Péliké du
Peintre de Geras," *AntK* 9 (1966) 93f.
(Lausanne 3250); R. Vallois, "L'agalma des
Dionysiés de Délos," *BCH* 46 (1922) 94; W.
Déonna, *Fouilles de Délos* XVIII, *Le mobilier
délien* (1938) 347; J. Marcadé, *Eros Kalos*
(1962) 93f.; E. Buschor, "Ein choregisches
Denkmal," *AM* 53 (1928) 107, "Satyrtänze,"
SBMünchen (1943) 96; A. Ramage, *Studies in
Honor of George M. A. Hanfmann* (1971) 158
pl. 36 b; and see note 32 above.

45. Weicker, *Seelenvogel* 123, fig. 48, Vienna
amphora 318 (Masner); cf. p. 127 and A.
Furtwängler, *Die antiken Gemmen* (1900) pl.
8.25.

46. Chr. Karusos, "Ἄσπιλ' ἐν Νέοισιν,"
AM 77 (1962) 121f. pl. 35.

47. C. Giangrande, "Sympotic Literature
and Epigram," *Fondation Hardt* XIV (1968)
108f., 110. I am indebted to P. LaZebnik and
D. Stern for their translations.

48. Boston 03.801, Fairbanks, *AWL* II,
118 no. 6, pl. 18.2; cf. I.26f.

CHAPTER VI
SEA MONSTERS, MAGIC,
AND POETRY

1. Timotheos, *Persai* 31, 107; 88 is even
finer, the fish-crowned marble-winged bosom
of Amphitrite; the modern Greek poem is
"Charos" (Kephallenia), A. Thumb, *Hand-
book of the Modern Greek Vernacular* (1912) 218,
8 (B. Schmidt, *Gr. Märchen und Volklieder*
[1877] no. 18). Byron's verses are quoted in
H. M. Field, *The Greek Islands and Turkey after
the War* (1888) 152.

See throughout, A. Lesky, *Thalatta: Der
Weg der Griechen zum Meer* (1947); L. Rader-
macher, "Das Meer und die Toten," *Anz
Wien* 86 (1949) 307 and *Das Jenseits im Mythos
der Hellenen* (1903) 73f., *Mythos und Sagen* (1938)
279; L. Deubner, *ArchfRel* 12 (1909) 57; J.
Rudhart, *La thème de l'eau primordiale dans la
mythologie grecque* (1971); and see note 16.

2. The image of dead men as fish occurs
already in the annals of the Asiatic Cam-
paigns of Thut-mose III, *ANET* ² 237, "Then
their horses and their chariots of gold and
silver were captured as an easy [prey. Ranks]
of them were lying stretched out on their
backs, like fish in the bight of a net, while his
majesty's victorious army counted up their
possessions."

3. S. Eitrem, "Heroen der Seefahrer,"
SymbOsl 14 (1935) 53 and 26 (1948) 167; I
owe this reference and many others to H. A.
Thompson, who is working on the hero at
Sounion; cf. Ἐπιστημονικὴ Ἐπετηρὶς τῆς
Φιλοσοφικῆς Σχολῆς τοῦ Πανεπιστημίου
Ἀθηνῶν 14 (1963–64) 276; C. Picard, *RevArch*
16 (1940) 5; for boat-races, Frazer, *Pausanias*,
on II.35.1.

4. On the *pontos* and its Rigvedic analogies,
E. Benveniste, "Problèmes sémantiques de la
reconstruction," *Problèmes de linguistique Géné-
rale* (1966) 296; *Word* 10 (1954) 251; F.
Householder, G. Nagy, *Current Trends in
Linguistics* (1972) 48; cf. L. Holland, *Janus and
the Bridge* (1961); J. Hallet, "Over Troubled
Waters", *TAPA* 101 (1970) 219; E. Vermeule,
S. Chapman, *AJA* 75 (1971) 293.

5. F. Combellack, "Homer's Savage Fish,"
CJ 48 (1952) 257; cf. H. N. Couch, "Fishing
in Homer," *CJ* 31 (1936) 303; W. B. Stanford
on *Odyssey* xv.479; J. A. Scott, "Homeric
Heroes and Fish," *CJ* 32 (1937) 303; *AnthPal*

VII. 273–94. Fish are ὠμησταί (XXIV.82) like birds (XI.454), dogs (XXII.67) and Achilles (XXIV.207), like the scavengers (XI.479), wolves (XVI.157) and lions (XV. 592 +), and, like lions, voiceless; ἀφωνότερος τῶν ἰχθύων became a proverb. Cf. J. P. Brown, "Cosmological Myth and the Tuna of Gibraltar," *TAPA* 99 (1968) 36.

6. Most vividly, S. Brunnsåker, "The Pithecusan Shipwreck," *OpRom* 4 (1962) 165f.; G. Buchner, *RömMitt* 60/61 (1953–54) 47. Ordinary Geometric ship scenes in G. Ahlberg, *Fighting on Land and Sea in Greek Geometric Art* (1971) 25f.; E. Kunze in *Festschrift B. Schweitzer* (1954) 48, *EphArch* (1953) 162.

7. E. Vermeule, S. Chapman, *AJA* 75 (1971) 288; Nilsson, *GGR* I² 102; Burkert *HN* 77; M. Ninck, *Die Bedeutung des Wassers im Kult und Leben der Alten* (1921) 47f.; Stengel, *Kultusaltertümer* 124; R. Ginouvès, *Balaneutiké* (1962) 299, 376, 416f. In a parallel way *katapontismos* relieves criminals and scapegoats from their guilt.

8. Angelo Maio, *Scholia Antiqua in Homeri Odysseam* (1821) xii.91. See also F. Cross on Leviathan in *Canaanite Myth and Hebrew Epic* (1973). Scylla's mother Krataïs and her daughter Lamia are less well known, but Lamia was a renowned swallower; chapter 2 note 17.

9. J. D. Beazley, *The Lewes House Collection of Ancient Gems* (1920) no. 103; *RE* III A.647 (Schmidt).

10. The Arniadas stele, Friedländer-Hoffleit, *Epigrammata* 25, c. 580 (?) (see Bibliography p. 263); L. Jeffery, *The Local Scripts of Archaic Greece* 243.11, pl. 46; cf. Menekrates, no. 9, c. 625; Deinias, Corinth, c. 650, Jeffery 127, 131.6, pl. 18; for cenotaphs, Jeffery *JHS* 78 (1958) 145. Neos of Sikinos, early fifth century, W. Peek, *Griechische Vers-Inschriften* 163. The fifth-century stele from Amorgos is characteristic of the newer genre, ἀντὶ γυναικὸς ἐγὼ Πάριο λίθο ἔνθαδε κεῖμαι, L. Polites, *EphArch* (1953–54) 24. A. Michaelis collected the ship stelai in *ArchZeit* 29 (1872) 142f., cf. B. Graser, *ArchZeit* 32 (1875) 71f., A. Rumpf, *BWPr* 95 (1935) 14.

11. K. T. Shepard, *The Fish-Tailed Monster in Greek Art* (1940); E. Buschor, "Meermänner," *SBMünchen* (1941) II.1; Nilsson, *GGR* I² 240.

12. Triton, Tritonia, Tritonis, Tritogeneia; the names are still obscure, but all linked by water functions. The drunken Triton (Pausanias IX.20.4) was, one supposes, a hoax, and the head removed so that its gills or fish face would not undermine a tourist's confidence; see Frazer, *Pausanias, ad loc.*; a dugong? The smaller one at Rome had the head, with hair like a marsh-frog's in color. For the popularity of sea-monsters, Pausanias II.10.2, on the huge bone in the sanctuary of Asklepios at Sikyon. For representations of Tritons, among others, H. A. Geagan, "Mythological Themes on the Plaques from Penteskouphia," *AA* (1970) 31; P. Bruneau, C. Vatin, "Une Nouvelle Mosaïque a Délos," *BCH* 88 (1964) 252; H. Kähler, "Seethiasen," *Monumenta Artis Romanae* 6 (1966); H. Sichtermann, "Deutung und Interpretation der Meerwesen Sarkophage," *JdI* 85 (1970) 220, and *Griechische Vasen in Unteritalien* (1966); *AA* (1970) 214; A. Rumpf, "Meerwesen," in C. Robert, *Sarkophagreliefs* (1939) 5.1, n. 135; K. Schefold, "Zur Basis des Domitius Ahenobarbus," *Essays in Memory of Karl Lehmann* (1964) 279; P. Bober, "An Antique Sea-Thiasos in the Renaissance," *ibid.* 43; F. Eichler, "Thetis und Nereiden mit den Waffen Achills," *ibid.* 100; F. Brommer, "Okeanos," *AA* (1971) 29; S. Benton, *JHS* 90 (1970) 193; on modern Greek sea life, J. C. Lawson, *Modern Greek Folklore and Ancient Greek Religion* (1909) 130f.

13. M. B. Werner, *Barnum* (1923) 56f. gives the history of the Feejee Mermaid (I owe the reference like many others to J. K. Anderson); she and another are exhibited at the Peabody Museum at Harvard. For the Siren off the Sandwich Islands see Bernard Heuvelmans, *Histoires et Légendes de la Mer Mystérieuse* (1968) 135; she emitted "cris aigus." Cf. Jean Merrien (Fréminville), *La Légendaire de la Mer* (1969). The Tanzania mermaid was reported in the San Francisco papers 24 May 1975, along with Pinky in the St. Johns River, Florida, who "looked like a skeleton. He was real jagged looking" (*San Francisco Examiner* 8 June 1975).

" . . . it was puir Sandy's deid skreigh, or near at hand, for he was deid in half an hour. A't he could tell was that a sea-deil, or sea bogle, or sea spenster, or sic-like, had clum up by the bowsprit, an' gi'en him ae cauld, uncanny look. An', or the life was oot a' Sandy's body, we kent weel what the thing betokened, and why the wind gurled

in the taps o' the Cutchull'ns; for doon it cam'—
a wund do I ca' it! it was the wund o' the Lord's
anger—an' a' that nicht we foucht like men
dementit, and the niest that we kenned we were
ashore in Loch Uskevagh, an' the cocks were
crawing in Benbecula."

"It will have been a merman," Rorie said.

"A merman!" screamed my uncle with im-
measurable scorn. "Auld wives' clavers! There's
nae sic things as mermen."

"But what was the creature like?" I asked.

"What like was it? Gude forbid that we suld
ken what like it was! It had a kind of a heid upon
it—man could say nae mair."

Then Rorie, smarting under the affront, told
several tales of mermen, mermaids, and sea
horses that had come shore upon the islands and
attacked crews of boats upon the sea; and my
uncle, in spite of his incredulity, listened with
uneasy interest.

"Aweel, aweel" he said, "it may be sae; I may
be wrang; but I find nae word o' mermen in the
Scriptures."

[Robert Louis Stevenson,
The Merry Men (1913) (23–24)]

14. Apollodoros *Library* I.6.3; on wine as
inimical to nature daimons, A. Lesky,
Thalatta (1947) 131.

15. See recently, K. Schauenburg, "Zu
attisch-sf. Schalen mit Innenfriesen," 33f.,
AntK Beiheft 7 (1970); W. J. Slater, "Sympo-
sium at Sea," *HSCP* 80 (1976), 161–70. The
California State Senate Minority Leader
noticed a similar dichotomy in the distin-
guished University of California faculty since
the Berkeley Faculty Club was licensed
to sell liquor; "I've seen many things on that
campus that we used not to allow on the
public streets" (*Daily Cal*, May 1975).
Herakles sometimes crosses the sea on a float
of wine amphoras instead of the Cup of the
Sun: R. Stiglitz, *ÖJh* 31 (1939) 113.

16. On the wisdom of sea-daimons, K.
O'Nolan, "The Proteus Legend," *Hermes* 88
(1960) 129f.; J-P. Vernant, "Thétis et le
Poème Cosmogonique d'Alcman," *Hommages
à Marie Delcourt* (*Latomus* 114 [1970]) 38f.; M.
Detienne, J-P. Vernant, "La Métis du
Renard et du Poulpe," *Revue des études
grecques* 82 (1969) 291; 80 (1967) 68; M.
Detienne, "Le phoque, le crabe, et le for-
geron," *Hommages Delcourt* 219. On Proteus and
the other prophets, Vernant, "Thétis" 43 n. 1,

Si on attend de lui une réponse à une question,
il doit la donner désormais sans ambiguité ni
feinte, de façon claire et univoque. Ainsi le rusé à

trouvé plus rusé que lui; le vigilant a été surpris;
le maître des liens lié; celui qui déroulait tout un
cycle de metamorphoses se voir à son tour en-
cerclé; le polymorphe a été ramené à une forme
unique; l'énigmatique a été rendu clair.

Cf. K. Deichgräber, "Die Musen, Nereiden
und Okeaninen in Hesiods Theogonie,"
AbhMainz (1965) 203; and for duplicity, A.
Lesky, *Thalatta* (1947) 27f.

17. J. Bohlau, "Schlangenleibige Nym-
phen," *Philologos* 57 (1898), M. Heinemann,
*Landschaftliche Elemente in der griechischen Kunst
bis Polygnot* (1910) 58; Munich 2100 *ABV* 208;
J. Harrison, *Prolegomena* 259; Nilsson, *GGR* I²
244, pl. 49:4. Connected with Ibykos 286P,
ἵνα Παρθένων κῆπος ἀκήρατος (Beazley), or
with the snake-lady Delphyne, ἡμίθηρ (Apollo-
doros I.6.3), or with Herakles' snake-maiden
in Scythia, Herodotos IV.9.1.

18. J. Boardman, *BICS* 5 (1958) 6f.,
Boston 88.827, manner of the Gorgon
Painter. The bruises and tears are not visible
without desire to see them. Cf. S. B. Luce,
"Herakles and the Old Man of the Sea,"
AJA 26 (1922) 174f.

19. F. Brommer, "Die Königstochter und
das Ungeheuer," *MWPr* (1956) 3f. with
bibliography and list of vases.

20. A. Severyns, *Homère* III (1948) 90f., on
the enforced silence of Thetis on land, like
other mermaids out of their element when
raped by men; these marriages are typically
unfortunate.

21. For the dragon's tongue as proof of
victory, see J. G. Frazer on Apollodoros,
Library II.v.9, n. 2; Second Vatican Mytho-
grapher (G. H. Bode, I.138), S. Thompson,
Motif Index of Folk-Literature (1932–36) H. 105.
J. K. Anderson and W. O'Flaherty quote
from A. Lang, *The Pink Fairy Book* (1897) 209
(after L. Gonzenbach, *Sizilianische Märchen*)
"Give me your daughter, O King, for I slew
the seven-headed serpent. And as a sign that
my words are true, look on these seven
tongues which I cut from the seven heads."

22. M. Schmidt, "Ein Zeugnis zum Mythos
von Orpheus-Haupt," *AntK* 15 (1972) 128f.—
Terpander consults the head; *ARV*² 1174.1,
1401.1

23. J. de Romilly, *Magic and Rhetoric* (1975)
passim; "Gorgias et le Pouvoir de la Poésie,"
JHS 93 (1973) 155; W. Burkert, *RhM* 105
(1962) 36; J. Combarieu, *Music, Its Laws and
Evolutions* (1909) 89f.

24. V.785, XVIII.222; Hesiod, *Th.* 311; *Shield* 242; cf. Pindar *Paian* 2, 64 π[αρ]θένοι χαλ[κεᾳ] κελαδ[έον] τι γλυκὺν αὐδᾷ νόμον. Cf. *Paian* 3, 94. The hard word can be joined, by an expert, ἀρτιεπής; the mouth or speech forged like iron (Sophokles, *Aias* 651 and R. C. Jebb *ad loc.*). Cf. R. Wycherley, *CR* n.s. 9 (1959) 205 and *AnthPal* IX.545.

25. Combarieu, *op. cit.* note 23, 102, "we say 'the singer has charm', forgetting what it means."

26. J. de Romilly, *Magic and Rhetoric* (1975) 17; cf. S. Eitrem, "The Necromancy in the Persae of Aeschylus," *SymbOsl* 6 (1928) 1f., and "Mantis and σφάγια," *SymbOsl* 17 (1938) 9f.; H. D. Broadhead, *The Persae of Aeschylus* (1960) 202, App. III "Necromancy," "Very important were the tone of the utterances and the exact reproduction of words or formulae, rhythmical delivery and repetition being characteristic." Cf. also W. Headlam, *CR* 16 (1902) 52; H. J. Rose, "Ghost Ritual in Aeschylus," *HThR* 43 (1950) 257. Phrynichos was supposed to have said "The soul-raisers bring up the souls of the dead by certain magic chants" (Broadhead, *loc. cit.*, Bekker, *Anecdota* 73); in Lucian, *Dialogues of the Dead* 3.2, Menippos explains to the oracular Trophonios who gave glimpses of the underworld to customers, "You are a corpse like us, differing only in your *goeteia*." Cf. J. Caro Baroja, *Die Hexen und ihre Welt* (1961); W. Fauth, "Die Bedeutung der Nekromantie-Szene in Lucans Pharsalia," *RhM* 118 (1975) 325. *The Boston Globe* reported (24 January 1975) that police in Payson, Arizona, arrested three young women "who had been hauling the decomposed remains of a 75-year-old man around the state for three months while attempting to revive him through prayer."

27. S. Dakaris, *Praktika* (1961) 108f.; also *Deltion* (1960) Chron. 202; *Ergon* (1958) 95, (1960) 105, (1961) 118, (1964) 51; *BCH* 83 (1959) 665, 85 (1961) 737; *JHS* Archaeological Reports (1959) 11, (1961) 15; *AJA* 63 (1959) 282, 65 (1961) 302; "Das Totenorakel bei Ephyre," *AntK* Beiheft 1 (1963) 51f.; *The Acheron Necromanteion or Oracle of the Dead* (Apollo Guides, n.d.). The classic ancient passage for Ephyre is Herodotos V.92 (Periander and Melissa); for the oracle of the dead at Phigaleia, Pausanias III.17.9; Tainaron, Plutarch, *Moralia* 560 E; Heraklea Pontica, Plutarch, *Kimon* 6; these are unexcavated.

See also chapter 1 note 1; Lucian, *Menippos* or *Nekyomanteia*.

28. The bibliography on the Sirens is much improved by the delightful discussion in D. L. Page, *Folktales in Homer's Odyssey* (1972) 83f., 126 n. 20, and the oyster quotation from Dickens' *Martin Chuzzlewit* ch. 4; for further information on the oyster's heart and its rhythms I am deeply indebted to Mr. Bernard Ashmole. The major works are Weicker, *Seelenvogel*; E. Buschor, *Die Musen des Jenseits* (1944); E. Kunze "Sirenen," *AM* 57 (1932) 124f. See also *RE* III.1.291 (Zwicker); J. Harrison, *Prolegomena* 197 n. 3; Roscher 4.604f.; H. Schrader, *Die Sirenen nach ihrer Bedeutung und Kunstlerischen Darstellung* (1868); G. Germain, *Genèse de l'Odyssée* (1964) 382f.; R. D. Barnett, in S. Weinberg (ed.), *Studies Presented to Hetty Goldman* (1956) 231; H. Frankfort, *Cylinder Seals* (1939) 72f.; C. Picard, "Néréides et Sirènes," *Études d'Archéologie Grecques, Annales de l'École des Hautes-Études de Gand* 2 (1938) 144; K. Meuli, *Odyssee und Argonautika* (1921) 25; D. Levi, *AJA* 49 (1945) 280; J. Pollard "The Boston Siren Aryballos," *AJA* 53 (1949) 357, "Muses and Sirens," *CR* 66 (1952) 60, *Seers, Shrines and Sirens* (1965); G. Gresseth, "The Homeric Sirens," *TAPA* 101 (1970) 203; M. Kanowski, "The Siren's Name on a Corinthian Aryballos," *AJA* 77 (1973) 73 (but the etymology seems old and faulty). Hesiod frr. 27, 28, 33, in R. Merkelbach, M. L. West, *Fragmenta Hesiodea* (1967).

29. Weicker's illustration of the Naukratis sherd London B 103, *Seelenvogel* 45 fig. 18, shows the Siren upside down; possibly the suicide notion had already occurred, but it may be rather the swooping birds of other sea-pictures, or the tradition of the *ba*-soul flying down the tomb shaft, which the artist has in mind.

30. E. Buschor, *Die Musen des Jenseits* (1944) made an eloquent argument for this position, as it develops in Euripides' period and begins to affect funeral art, Σειρῆνες, εἴθ᾽ ἐμοῖς γόοις μόλοιτ᾽ (*Helen* 167).

31. C. K. Williams, J. E. Fisher, "Corinth 1972: The Forum Area," *Hesperia* 42 (1973) 4f., with an appendix by J. L. Angel on the bones (the hand fractured just where it would be exposed grasping a sword, but since the head and nose were not battered, perhaps he had not lived "the life of a warrior").

GLOSSARY

There are a number of Greek words in the text and captions, not always easy to translate with the proper nuances, or terms for objects like vases, parts of the body or soul. Vases are listed separately.

ba-soul one of the three individual Egyptian souls, figured as a small bird with a portrait head

daimon a god, supernatural, strange, or monstrous power, individual "genius," occasionally spirit of the dead

eidolon image, phantom, a more substantial apparition of the dead than psyche

ekphora the procession with a corpse from house to grave

goos the sung ritual lament for the dead, crying, grief

ialemos a dirge or lament

ker a death-spirit of uncertain origin and changing form, female, with talons and teeth; may be clothed like a woman (XVIII.538) or naked like a sphinx; a ravisher and swallower

Kerameikos the burial ground of ancient Athens; the potters' quarter

ketos a general word for sea monster

makar possibly borrowed from Egyptian *maakheru*, "justified by a voice before god," a term used at the examination of the dead in the underworld; when "justified" the blessed dead passes to the happy Ialu Fields; for the Greeks, applied to the gods and to the blessed dead

medea the word for both intellect, plans, and for genitals, the two aspects of power

menos strength, of body or emotion or soul

mnema memorial, either intangible or a grave monument, tomb

moira fate

Nekyia the rite of raising ghosts; the name of the eleventh book of the *Odyssey*, and of the beginning of the twenty-fourth book (Second Nekyia)

nous the organ of perception, then reason; the mind

phasma phantom

potmos destiny

prothesis the laying out of the corpse; the wake or vigil

psyche wind-breath, soul; a small winged stick-figure representing the dead

sema a sign or token; the sign by which a grave is known; a tomb

soma body, flesh

stomion mouth, jaws; the doorway to a Bronze Age tomb; the entrance to the underworld

temenos a (sacred) precinct, marked off

tholos a round building; a Bronze Age corbelled beehive tomb

thumos the source of feeling, passion, emotion; used of life, sometimes of mind, soul

FORMS OF GREEK VASES

amphora a two-handled storage vase with closed neck

aryballos in Corinth, a small round oil flask with a flat lip

dinos a round wide-mouthed mixing bowl without handles or feet

hydria a water-jar with a tall back handle, two small side handles

kotyle a tall flat-bottomed cup, like a skyphos

krater a broad mixing-bowl for wine, with two handles and a foot

larnax a chest; applied to clay coffins of chest-shape

lekythos a tall slender oil flask; a common funeral gift

loutrophoros Greeks meant a boy who brought water for the wedding (or funeral) bath; archaeologists mean a tall slender vase with high neck, often a wedding or funeral gift; a stone version becomes common as a grave-marker in the fourth century

oinochoe a small jug for pouring wine

pelike a baggy version of an amphora

phormiskos a non-functional archaic vase shaped like a clay tear-drop

skyphos a high flat-bottomed cup

See G. M. A. Richter and M. J. Milne, *Shapes and Names of Athenian Vases* (1935); R. M. Cook, *Greek Painted Pottery* (1960); B. Sparkes and L. Talcott, *Pots and Pans of Classical Athens* (1958).

REFERENCES FOR THE ILLUSTRATIONS

Frontispiece Boston 34.79, Lykaon P., cour-
tesy of the Museum of Fine
Arts, Boston.

CHAPTER I

FIG. 1 Athens, Agora P 20177; C. W.
Blegen, *Hesperia* 21 (1952) 280, fig.
2; Kurtz-Boardman, fig. 5.

FIG. 2 After O. M. Baron von Stackelberg,
Die Graeber der Hellenen (1837) pl. 8.

FIG. 3 After *Snoopy, Come Home*, courtesy of
United Feature Syndicate, Inc.

FIG. 4 Athens National Museum 1926,
Sabouroff P., *ARV²* 846; after W.
Riezler, *Weissgrundige attische Leky-
then* (1914) pl. 44 a.

FIG. 5 Norbert Schimmel Collection, New
York, Achilles P.; O. Muscarella
(ed.), *Ancient Art, Catalogue of the
Norbert Schimmel Collection* (1974) no.
63.

FIG. 6 New York 14.146.3 A, courtesy of
the Metropolitan Museum of Art.
From Olympos in Attica? G. M. A.
Richter, *Handbook of the Greek Col-
lection* (1953) 31, pl. 26 f.

FIG. 7 New York 54.11.5, courtesy of the
Metropolitan Museum of Art.

FIG. 8A New York 27.228, courtesy of the
Metropolitan Museum of Art.

FIG. 8B New York 08.258.21, calyx krater,
Nekyia P.; P. Jacobsthal, "The
Nekyia Krater in New York," *Met-
ropolitan Museum Studies* 5 (1934–36),
127 fig. 8, tracing F. Wolsky.

FIG. 9 Athens NM 1170, P. of Bologna 228,
ARV² 512.13, courtesy of the
National Museum, Athens.

FIG. 10 Athens NM 4310, after G. Ahlberg,
Prothesis and Ekphora (1973) fig. 19.

FIG. 11 Athens, Kerameikos Inv. 80; K.
Kübler, *Kerameikos* VI.2 (1970) pl.
15, Kat. 21, courtesy of the German
Archaeological Institute, Athens.

FIG. 12 Athens National Museum; courtesy
of the Greek Ministry of Educa-
tion.

FIG. 13 Boston 27.146, courtesy of the
Museum of Fine Arts, Boston.

FIG. 14 London E 477, Hephaistos P., *ARV²*
1114.5; courtesy of the Trustees
of the British Museum.

FIG. 15 Paris, Bibliothèque National, Cabi-
net des Médailles 353, *ABV* 346.7.

FIG. 16 Paris, Bibliothèque National, Cabi-
net des Médailles 355, *ABV* 346.8.

FIG. 17 Athens NM 450, Sappho P., courtesy
of the National Museum, Athens.

FIG. 18 New York 31.11.13, Eretria P.,
ARV² 1248.9, courtesy of the Metro-
politan Museum of Art. See also
Chapter 6 fig. 28.

FIG. 19 Jena 338, near the Tymbos P.,
ARV² 760.41.

FIG. 20 London D 35, Tymbos P., courtesy
of the Trustees of the British Museum.

FIG. 21 Mount Auburn Cemetery, Cam-
bridge, Mass.

FIG. 22 Boston 34.79, Lykaon P., C-B ii pl.
63, *ARV²* 1045.2; courtesy of the
Museum of Fine Arts, Boston.

FIG. 23 Boston 95.47, manner of the P. of
London E 342, *ARV²* 670.17, cour-
tesy of the Museum of Fine Arts,
Boston.

FIG. 24 Boston 10.220, Sabouroff P., *ARV²*
845.170, courtesy of the Museum of
Fine Arts, Boston.

FIG. 25 Boston 13.169, near the Tyszkiewicz
P., courtesy of the Museum of Fine
Arts, Boston.

FIG. 26 London B 245, Xenokles P., courtesy
of the Trustees of the British Museum.

FIG. 27 New York 1972.11.10, Euphronios,
courtesy of the Metropolitan Museum
of Art. Cf. chapter 5 fig. 2.

FIG. 28 New York, The Pierpont Morgan
Library M. 945, The Book of Hours
of Catherine of Cleves, c. 1435 A.D.,
Guennol Collection, G-f. 168 v.

FIG. 29 Lakonian cup, art market, ex-
Erskine and Symes Collections.

CHAPTER II

FIG. 1 After J. Mellaart, *Earliest Civiliza-
tions of the Near East* (1965) 98, fig.
82, tracing by F. Wolsky.

FIG. 2 The Rockefeller Museum, Jerusalem,
Jericho pre-ceramic B; cf. M.
Mellink, J. Filip, *Frühe Stufen der*

Kunst, Propyläen Kunstgeschichte 13 (1974) pl. 113; J. Garstang, J. B. E. Garstang, *The Story of Jericho* (1940) 57f.

FIG. 3 Franchthi Mesolithic skeleton, courtesy T. W. Jacobsen, Indiana University; *Hesperia* 28 (1969) 374, pl. 100 b.

FIG. 4 Istanbul, Archaeological Museum, courtesy N. Firatli.

FIG. 5 After J. Mellaart, *Earliest Civilizations of the Near East* (1965) 101, fig. 86.

FIG. 6 Stele of Eannatum from Lagash (Telloh), Musée du Louvre; after A. Moortgat, *The Art of Ancient Mesopotamia* (1969) pl. 120.

FIG. 7 Mount Auburn Cemetery, Cambridge, Mass.

FIG. 8 Cambridge City Cemetery, Cambridge, Mass.

FIG. 9 German Archaeological Institute, Athens, Myk. 126.

FIG. 10 Budapest, Museum of Fine Arts; after G. M. A. Richter, *The Furniture of the Greeks, Etruscans and Romans* (1966) fig. 24.

FIG. 11 Mount Auburn Cemetery, Cambridge, Mass.

FIG. 12 Cairo Inv. 133, courtesy of the Cairo Museum; cf. H. Kischkewitz, W. Forman, *Egyptian Drawings* (1972) pl. 56.

FIG. 13 Athens NM 1501, after V. Kallipolitis, *Museo Nazionale, Atene* (1971) no. 99.

FIG. 14 Munich 1493, Bucci P., *ABV* 316, courtesy of the Antikensammlungen, Munich.

FIG. 15 Boston 63.1611, courtesy of the Museum of Fine Arts, Boston.

FIG. 16 Photo Tombazis, courtesy of the late J. Papademetriou.

FIG. 17 Mount Auburn Cemetery, Cambridge, Mass.

FIG. 18 Mycenae 60.327, courtesy Lord William Taylour; cf. *The Mycenae Tablets* III, *Transactions of the American Philosophical Society* 52-7 (1962) fig. 91.

FIG. 19 Athens, Kerameikos 41; K. Kübler, *Kerameikos* VI.2 (1970) 500, 106; courtesy of the German Archaeological Institute, Athens.

FIG. 20 Thebes Museum, Tanagra Tomb 3, courtesy T. Spyropoulos.

FIG. 21 Athens NM, after S. Marinatos, *Crete and Mycenae* (1960) pl. 236.

FIG. 22 Boston, Museum of Fine Arts, anonymous loan.

FIG. 23 Collection of Dr. Ludwig, Aachen; courtesy of the Antikenabteilung, Staatliche Kunstsammlungen, Kassel.

FIG. 24 Chania Museum, Crete, courtesy I. Tzedakis.

FIG. 25 Hierapetra Museum, Crete, photo V. Karageorghis.

FIG. 26 Thebes Museum, Tanagra Tomb 51, Boiotia, courtesy T. Spyropoulos.

FIG. 27 Mount Auburn Cemetery, Cambridge, Mass.

FIG. 28 After R. Lullies, *AA* 1944-45 (1949) pl. 19.1 (caption error); E. Buschor, *Grab eines attischen Mädchens* (1939) 8 fig. 3.

FIG. 29 Munich 2777, Thanatos P., *ARV²* 1228.11, after W. Riezler, *Weissgrundige attische Lekythen* (1914) pl. 26, courtesy of the Antikensammlungen, Munich.

FIG. 30 K. C. Seele, *The Tomb of Tjanefer at Thebes* (1959) pl. 11, courtesy of the Oriental Institute, University of Chicago.

FIG. 31 Brussels E 5043, courtesy of the Musées Royaux du Cinquantenaire; cf. H. Kischkewitz, W. Forman, *Egyptian Drawings* (1972) pl. 21.

FIG. 32 Tomb of Nofretari, photo courtesy E. Brovarski, Boston; cf. G. Thausing, H. Goedicke, *The Tomb of Nofretari*, (1971) pl. 131.

FIG. 33 Athens, Kerameikos Inv. 45 (K. Kübler, *Kerameikos* VI.2 [1970] Kat. 129, pl. 102), courtesy of the German Archaeological Institute, Athens.

FIG. 34 Boston 1970.346; M. Comstock, C. Vermeule, *Sculpture in Stone, The Greek, Roman and Etruscan Collections of the Museum of Fine Arts, Boston* (1976) no. 406; ca. 225 A.D.

FIG. 35 Boston 01.8037, Lysippides P., *ABV* 254.2, courtesy of the Museum of Fine Arts, Boston.

FIG. 36 Copenhagen, Danish National Museum 13521, courtesy of the Museum, photo Lennart Larsen; cf. A.

Greifenhagen, *Griechische Eroten* (1957) fig. 36; see also chapter 5 fig. 12.

CHAPTER III

FIG. 1 Acropolis 606, Athens National Museum; after B. Graef, E. Langlotz, *Die antiken Vasen von der Akropolis zu Athen* (1925–33) pl. 32.

FIG. 2 Berlin 3345; *Antike Denkmäler* II (1908) pl. 28.

FIG. 3 Boston 95.14, courtesy of the Museum of Fine Arts, Boston.

FIG. 4 Athens NM 33, Shaft Grave III, Circle A, Mycenae, after G. Karo, *Die Schachtgräber von Mykenai* (1930–33) no. 294, pl. 24.

FIG. 5 Copenhagen, Danish National Museum 727, courtesy of the Museum.

FIG. 6 The Macmillan aryballos, London, from Thebes, courtesy of the Trustees of the British Museum.

FIG. 7 Boston 1970.64, courtesy of the Museum of Fine Arts, Boston.

FIG. 8 Boston 97.289; courtesy of the Museum of Fine Arts, Boston; M. Comstock and C. Vermeule, *Sculpture in Stone* (1976) no. 15.

FIG. 9 Florence, Museo Archeologico 4209, Kleitias and Ergotimos, the François Vase, *ABV* 76.1, after Furtwängler-Reichhold, *Griechische Vasenmalerei* I (1904), pl. 13.

FIG. 10 Berlin 3352, after *Antike Denkmäler* II (1908) pl. 25.

FIG. 11 Boston 61.1073, Neandros P., *Paralipomena* 69, courtesy of the Museum of Fine Arts, Boston.

FIG. 12 Athens, Agora, AP 1044, Exekias, courtesy of the American School of Classical Studies, Athens, Agora Excavations.

FIG. 13 Museum of Fine Arts, Richmond, Virginia 62.1.2, Swing P., *Paralipomena* 133, courtesy of the Museum.

FIG. 14 Würzburg 256, Swing P. (?), courtesy E. Simon, Martin von Wagner Museum; cf. E. Langlotz, *Griechische Vasen in Würzburg* (1932) pl. 83.

FIG. 15 Boston 25.43, courtesy of the Museum of Fine Arts, Boston.

FIG. 16 Boston 98.923, Botkin Class, *ABV* 169, courtesy of the Museum of Fine Arts, Boston.

FIG. 17 Boston 98.916, *ABV* 98, courtesy of the Museum of Fine Arts, Boston.

FIG. 18 New York 12.234.1, related to the C P., *ABV* 61, D. von Bothmer, *Amazons in Greek Art* (1957) pl. 17.2, courtesy of the Metropolitan Museum of Art.

FIG. 19 Boston 69.1052, Oakeshott P., courtesy of the Museum of Fine Arts, Boston.

FIGS. 20, 21 Athens NM 2495; Eretria, Coll. P. Themelis; cf. N. Kontoleon, "Die frühgriechische Reliefkunst," *EphArch* (1969) pll. 46–47.

FIG. 22 London, British Museum 124801, after R. D. Barnett, W. Forman, *Assyrian Palace Reliefs*, pl. 124.

FIG. 23 Mainz Inv. no. 154, after R. Hampe, *Ein frühattischer Grabfund* (1960), Krater B.

FIG. 24 London B 658, Beldam P., C. H. E. Haspels, *Attic Black-Figured Lekythoi* (1936) no. 67; after O. M. Baron von Stackelberg, *Die Graeber der Hellenen* (1837) pl. 11.

FIG. 25 Courtesy of *The New Yorker* Magazine, Inc.

FIG. 26 Athens NM 19765, after S. Karouzou, *JHS* 92 (1972) pl. 18 b.

FIG. 27 Boston 63.473, Leagros Group, *Paralipomena* 164.31 *bis*, courtesy of the Museum of Fine Arts, Boston.

FIG. 28 Paris, Bibliothèque National, Cabinet des Médailles, 179, courtesy of the Bibliothèque National.

FIGS. 29–30 The Mykonos Pithos, Mykonos Museum, Cyclades, metopes 14, 17, after M. Ervin, "A Relief Pithos from Mykonos," *Deltion* 18 (1963) pll. 26–27.

FIG. 31 Boston 1971.129; M. Comstock, C. Vermeule, *Sculpture in Stone* (1976) no. 64, Stratokles son of Prokles.

CHAPTER IV

FIG. 1 Louvre CA 4523, after P. Demargne, *RevArch* (1972) 45 fig. 9.

FIG. 2 Boston 13.206, near the Black Fury

P., courtesy of the Museum of Fine Arts, Boston.

FIG. 3 Boston 99.518, P. of the Boston Polyphemos, *ABV* 198, courtesy of the Museum of Fine Arts, Boston.

FIG. 4 Boston 99.539, Xenotimos P., *ARV²* 1142; courtesy of the Museum of Fine Arts, Boston.

FIG. 5 Lost; after J. D. Beazley, "The Rosi Krater," *JHS* 67 (1947), 1 fig. 1.

FIG. 6A London 67/5–8/1133, courtesy of the Trustees of The British Museum; after F-R III (1932) pl. 126.

FIG. 6B New York 41.162.29, Sappho P., *ABV* 507, courtesy of The Metropolitan Museum of Art.

FIG. 7 Mount Auburn Cemetery, Cambridge, Mass.

FIG. 8 Boston 03.783, Daybreak P., *ABV* 378; courtesy of the Museum of Fine Arts, Boston.

FIG. 9 New York, Cesnola Collection no. 1364, limestone sarcophagus from Golgoi, Cyprus, after *Antike Denkmäler* III, pl. 6; cf. L. P. di Cesnola, *Atlas of the Cesnola Collection of Cypriote Antiquities* I (1885) nos. 476–479, J. L. Myres, *Handbook of the Cesnola Collection of Antiquities from Cyprus* (1914) no. 1364.

FIG. 10 Paris, Bibliothèque National, Cabinet des Médailles 223, Swing P., *ABV* 308.77.

FIG. 11 London B 155, courtesy of the Trustees of the British Museum.

FIG. 12 Courtesy of *The New Yorker* Magazine, Inc.

CHAPTER V

FIG. 1 Boston 86.145, from Vulci; M. Comstock and C. Vermeule, *Sculpture in Stone* (1976) no. 383; courtesy of the Museum of Fine Arts, Boston.

FIG. 2 New York 1972.11.10, Euphronios; courtesy of the Metropolitan Museum of Art (cf. chapter 1 fig. 27).

FIG. 3 Louvre G 163, Eucharides P., *ARV²* 227,12; courtesy Musée du Louvre.

FIG. 4 Athens 12783, Quadrate P., *ARV²* 1237; courtesy of the National Museum, Athens.

FIG. 5 Athens National Museum, Acropolis 2526; G-L pl. 104.

FIG. 6 Private collection, Boston; cf. D. Buitron (ed.), *Attic Vase Painting in New England Collections* (1972) no. 49.

FIG. 7 Boston 01.8072, Makron, *ARV²* 461; courtesy of the Museum of Fine Arts, Boston.

FIG. 8 Boston Res. 08.34 c; M. Comstock and C. Vermeule, *Sculpture in Stone* (1976) no. 115; courtesy of the Museum of Fine Arts, Boston.

FIG. 9 Boston 10.219, Oltos, *ARV²* 54.6, C-B iii, 9; M. Robertson, "'Oltos' Amphora," *ÖJh* 47 (1964–5) 107f.; courtesy of the Museum of Fine Arts, Boston.

FIG. 10 New York 40.11.22, by an artist recalling the P. of London D 12, *ARV²* 965; courtesy of the Metropolitan Museum of Art.

FIG. 11 Olympia Museum; after E. Kunze, *Olympische Forschungen* II, *Archaische Schildbänder* (1950) pl. 60 no. 32 b, c. 600 B.C.

FIG. 12 Copenhagen, Danish National Museum 13521; photo Lennart Larsen, courtesy of the Museum.

FIG. 13 Boston 97.368, Tyszkiewicz P., *ARV²* 290.1, drawing F. Anderson; courtesy of the Museum of Fine Arts, Boston.

FIG. 14 London B 639, Sappho P., Haspels, *ABL* 227, App. XI no. 28, pl. 36.1; courtesy of the Trustees of the British Museum.

FIG. 15 Boston 08.205; M. Comstock and C. Vermeule, *Sculpture in Stone* (1976) no. 30; courtesy of the Museum of Fine Arts, Boston.

FIG. 16 Boston 95.28, Telephos P., *ARV²* 482, 816; courtesy of the Museum of Fine Arts, Boston.

FIG. 17 Leningrad 682, P. of London D 15, *ARV²* 391; A. Peredolskaya, *Krasnofigurnye attischeskie vazy* (1967) pl. 48.

FIG. 18 Boston 95.36, Brygos P., *ARV²* 381.182, C-B i, no. 17, pl. 6, drawing F. Anderson; courtesy of the Museum of Fine Arts, Boston.

FIG. 19 Courtesy of *The New Yorker* Magazine, Inc.

FIG. 20 Boston 64.1459, courtesy of the Museum of Fine Arts, Boston.

Fig. 21 London B 287, F. N. Pryce, *Catalogue of Sculpture in the Department of Greek and Roman Antiquities of the British Museum* (1928) 122f.; courtesy of the Trustees of the British Museum.

Fig. 22 Boston 1971.343, Syleus P., courtesy of the Museum of Fine Arts, Boston.

Fig. 23 Gela, cup fragment, after L. Malten, *JdI* 29 (1914) fig. 33; cf. *Monumenti Antichi* 19 (1908–09) 99 fig. 8.

Fig. 24 London 1933.10–15.1, chalcedony scaraboid, Semon Master, after J. Boardman, *Greek Gems and Finger Rings* (1970) pl. 362.

Fig. 25 Boston 23.601 (ex Lewes House), bronze ring, fourth century; J. D. Beazley, *The Lewes House Collection of Ancient Gems* (1920) no. 59, as a dog; courtesy of the Museum of Fine Arts, Boston; photo R. Wilkins.

Fig. 26 Lausanne 3250, Geras P., C. Bérard, *AntK* 9 (1966) 93f., pl. 22 fig. 3.

Fig. 27 Vienna 318 Masner, after G. Weicker, *Der Seelenvogel* (1902) fig. 48.

Fig. 28 Paris, Bibliothèque National, Cabinet des Médailles 260, Leagros Group; courtesy of the Bibliothèque National.

Fig. 29 Boston 03.801, courtesy of the Museum of Fine Arts, Boston.

CHAPTER VI

Fig. 1 Boston 01.8024, Ambrosios P., *ARV*² 173, courtesy of the Museum of Fine Arts, Boston.

Fig. 2 Boston 99.515, courtesy of the Museum of Fine Arts, Boston.

Fig. 3 Athens, National Museum, from Sounion; after J. Boardman, *Greek Art* (1964), fig. 39.

Fig. 4 London 1926.6–28.9; cf. V. Karageorghis, J. des Gagniers, *La céramique Chypriote de style figuré* (1974) 122, XI.1, drawing E. Markou.

Fig. 5 Old photograph.

Fig. 6 After S. Brunnsåker, *OpAth* 4 (1962) fig. 7; photo montage G. Eriksson.

Fig. 7 Boston 6.67, anonymous loan; drawing S. Chapman.

Fig. 8 Boston 21.1214; J. D. Beazley, *The Lewes House Collection of Ancient Gems* (1920) no. 103; courtesy of the Museum of Fine Arts, Boston.

Fig. 9 Aquila, Museo Civico; after Cassiano dal Pozzo drawing no. 201, C. C. Vermeule, *TAPS* (1960) fig. 79.

Fig. 10A New York 42.11.12, Blind Dolphin Master, courtesy of the Metropolitan Museum of Art.

Fig. 10B New York 42.11.12, as above.

Fig. 11 New York 41.160.437, courtesy of the Metropolitan Museum of Art.

Fig. 12 Paris, Bibliothèque National, Cabinet des Médailles Cat. 178.

Fig. 13 Berlin, Staatliche Museen, from Penteskouphi, Corinth; after *Antike Denkmäler* I (1887), pl. 7 no. 26.

Fig. 14 Munich 2100, P. of Munich 2100, *ABV* 316, courtesy of the Antikensammlungen, Munich.

Fig. 15 Boston 99.522, courtesy of the Museum of Fine Arts, Boston.

Fig. 16 Boston 63.420, courtesy of the Museum of Fine Arts, Boston.

Fig. 17 Taranto Inv. 52155, after *CVA* III pl. 24.

Fig. 18 Boston 21.1203; J. D. Beazley, *The Lewes House Collection of Ancient Gems* (1920) no. 46; courtesy of the Museum of Fine Arts, Boston.

Fig. 19 Olympia B 4990, courtesy of the German Archaeological Institute, Athens.

Fig. 20 Private collection, copy after an original in the Byzantine Museum, Athens.

Fig. 21 Basel, private collection, Circle of Polygnotus; after M. Schmidt, *AntK* 15 (1972) 128f.

Fig. 22 Boston 28.49, courtesy of the Museum of Fine Arts, Boston.

Fig. 23 Boston 49.65, anonymous loan.

Fig. 24 The Hague; courtesy J. Boardman, Oxford, cf. *Greek Gems and Finger Rings* (1970) pl. 317.

Fig. 25 Boston 01.8100, drawing S. Chapman; courtesy of the Museum of Fine Arts, Boston.

Fig. 26 London E 440, The Siren P., *ARV*² 289; courtesy of the Trustees of the British Museum.

Fig. 27 Once Athens, Collection Fauvel; Manner of the Emporion P., *ABV*

586; after O. M. Baron von Stackelberg, *Die Graeber der Hellenen* (1837) pl. 16.4.

FIG. 28 New York 31.11.13, Eretria P., *ARV*² 1248; courtesy of The Metropolitan Museum of Art.

FIG. 29 Corinth 72–4, courtesy of C. K. Williams and the American School of Classical Studies, Athens; cf. *Hesperia* 42 (1973) 2, 32.

FIG. 30 Tombstone in Lowell, Mass.; cf. E. V. Gillon, *Victorian Cemetery Art* (1972) 168 pl. 255.

FIG. 31 New York 06.1021.26, courtesy of the Metropolitan Museum of Art.

BIBLIOGRAPHIES

Important books are preceded by asterisks.

GENERAL

N. Åberg, "Antike Todesauffassung," *Mannus* 23 (1929).

M. Andronikos, *Totenkult, Archaeologia Homerica* W (1968).

——, "Ἑλληνικὰ Ἐπιτάφια Μνημεῖα," *Deltion* 17, 1 (1961–62) 152f.

E. Bickel, *Homerischer Seelenglaube* (1925).

J. Böhme, *Die Seele und das Ich im homerischen Epos* (1927).

E. Bruck, "Totenteil und Seelgerät im griechischen Recht," *Münchener Beiträge z. Papyrusforschung* IX (1926).

W. Burkert, *Homo Necans* (1972).

A. Chudzinski, *Tod und Totenkultus bei den alten Griechen* (1907).

L. Deubner, *Attische Feste* (1932) 93f., 229f.

A. Dieterich, *Nekyia*² (1913).

B. Dietrich, *Death, Fate and the Gods* (1965).

S. Eitrem, *Opferritus und Voropfer der Griechen und Römer* (1914).

E. E. Evans-Pritchard, *Theories of Primitive Religion* (1965).

Sister Mary Evaristus, *The Consolations of Death in Early Greek Literature* (1917).

L. R. Farnell, *Greek Hero Cults and Ideas of Immortality* (1921).

W. Fauth, "Bestattung," *Der Kleine Pauly* I, 873f.

J. G. Frazer, *The Fear of the Dead in Primitive Religion* (1933).

W. Furtwängler, *Die Idee des Todes in den Mythen und Kunstdenkmälern der Griechen* (1860).

J. Ganss, *Über den Unsterblichkeitsglauben bei den alten Griechen und Römern* (1903).

G. Gerould, *The Grateful Dead* (1908).

M. Guiomar, *Principes d'une Esthétique de la Mort* (1967).

H. Gundolf, *Totenkult und Jenseitsglaube* (1967).

W. Hahland, "Neue Denkmäler des attischen Heroen- und Totenkultes," *Festschrift F. Zucker* (1954) 117f.

A. Hahn, *Einstellungen zum Tod und ihre soziale Bedingtheit* (1968).

K. Heinemann, *Thanatos in Poesie und Kult der Griechen* (1913).

W. Helbig, "Zu den homerischen Bestattungsbräuchen," *SB München* (1900), 199f.

R. Hertz, *Death and the Right Hand* (1960).

C. Hönn, *Studien zur Geschichte der Himmelfahrt im Klassischen Altertum* (1910).

A. E. Jensen, "Über die Toten als Kulturgeschichtliche Erscheinung," *Paideuma* 4 (1950) 23.

R. Kassel, *Untersuchungen zur griechischen und römischen Konsolationsliteratur* (1958).

C. Kaufmann, *Die Jenseitshoffnungen der Griechen und Römer* (1897).

**D. Kurtz, J. Boardman, *Greek Burial Customs* (1971) (rev. J. Pollard, *JHS* 93 [1973] 250).

*A. Lesky, "Thanatos," *RE* V A 1257f.

J. Lessing, *De mortis apud veteres figura* (*Wie die Alten den Tod gebildet*) (1769).

H. Lorimer, "Pulvis et Umbra," *JHS* 53 (1933) 161f.

K. Meuli, "Griechische Opferbräuche," *Phyllobolia, Festschrift für Peter von der Mühll* (1946) 185f.

L. Moulinier, *Le Pur et l'Impur dans la pensée des Grecs* (1952), 76f.

M. P. Nilsson, *GGR*².

——, "Immortality of the Soul in Greek Religion," *OpSel* 3 (1960) 40.

W. Otto, *Die Manen, oder von den Urformen des Totenglaubens*² (1958).

G. Pfannmüller, *Tod, Jenseits und Unsterblichkeit in der Religion, Literatur und Philosophie der Griechen und Römer* (1953).

F. Pfister, *Der Reliquienkult im Altertum* (1909, 1912).

J. Pieper, *Tod und Unsterblichkeit* (1968).

L. Radermacher, *Das Jenseits im Mythos der Hellenen* (1903).

A. de Ridder, *L'idée de la mort en Grèce* (1897).

C. Robert, *Thanatos* (1879).

***E. Rohde, *Psyche*[8], trans. W. B. Hillis (1925/1950).

J. Rudhardt, *Notions fondamentales de la pensée religieuse et actes constitutifs du culte dans la Grèce antique* (1958) 238, 246.

A. von Salis, "Antiker Bestattungsbrauch," *MusHelv* 14 (1957) 89f.

E. Samter, *Geburt, Hochzeit, Tod* (1911).

K. Schefold, "Die Verantwortung vor den Toten als Deutung des Lebens," *Wandlungen, Studien zur antiken und neueren Kunst* (1975) 255f.

U. Schlenther, *Brandbestattung und Seelenglaube* (1960).

A. Schnaufer, *Frühgriechischer Totenglaube*, *Spudasmata* 20 (1970); rev. C. Sourvinou-Inwood, *JHS* 92 (1972) 220.

O. Schräder, *Totenhochzeit* (1904).

F. Schwenn, *Die Menschenopfer bei den Griechen und Römern* (1915).

G. Soury, "La vie de 'au-delà'," *RevEtAnc* 46 (1941) 171.

P. Stengel, *Die griechische Kultusaltertümer* (1920).

———, *Opferbräuche der Griechen* (1910).

P. Ucko, "Ethnography and Archaeological Interpretation of Funeral Remains," *World Archaeology* 1 (1969) 262f.

J. Vuillemin, *Essai sur la signification de la mort* (1948).

O. Waser, "Thanatos," *Roscher* 481f.

J. Wiesner, *Grab und Jenseits* (1938).

U. von Wilamowitz-Moellendorf, *Der Glaube der Hellenen* (1926, 1932).

T. Zielinski, "La Guerre à l'Outretombe," *Mélanges Bidez* II (1934) 1021.

CEMETERIES, BURIAL RITES, AND LAMENTATIONS

A fuller bibliography covering sites and details like tomb-forms, decoration, markers, legislation, vessels, jewelry, toys and gifts, in Kurtz-Boardman; the subject is covered by many volumes in the General list. Some details are given in the notes here. For Bronze Age burials, see bibliography p. 265.

G. Ahlberg, *Prothesis and Ekphora* (1973).

M. Alexiou, *The Ritual Lament in Greek Tradition* (1974).

C. Belger, "Das Grab des Hesiod in Orchomenos," *AA* (1891) 186.

J. Boardman, "Painted Funerary Plaques and Some Remarks on Prothesis," *BSA* 50 (1955) 51f.

———, "Attic Geometric Vase Scenes, Old and New," *JHS* 86 (1966) 1f.

A. Brückner, *Der Friedhof am Eridanos* (1909).

W. Burkert, "ΓΟΗΣ. Zum griechischen Schamanismus," *RhM* 105 (1962) 36f.

E. Buschor, *Grab eines attischen Mädchens* (1939).

J. Cook, "A Geometric Graveside Scene," *BCH* 70 (1946) 97f.

V. Desborough, *Protogeometric Pottery* (1952).

———, *The Greek Dark Ages* (1972) 266f.

F. Eckstein, "Die Attischen Grabmälergesetze," *JdI* 73 (1959) 18f.

J. Geroulanos, "Grabsitten des ausgehenden geometrischen Stils im Bereich des Gutes Trachones bei Athen," *AM* 88 (1973) 1f.

R. Ginouvès, "Le bain et les rites funeraires," *Balaneutiké* (1967) 239f.

E. Haberland, *Steindenkmäler und Totenkult* (1960).

W. Halliday, "Cenotaphs and Sacred Localities," *BSA* 17 (1910–11) 182f.

R. Hampe, *Ein frühattischer Grabfund* (1960).

G. Herrlinger, *Totenklage um Tiere in der antiken Dichtung* (1930).

E. Hinrichs, "Totenkultbilder der attischen Frühzeit," *Annales Universitatis Saraviensis* 4 (1955) 124f.

F. Jacoby, "*ΓΕΝΕΣΙΑ*: A Forgotten Festival of the Dead," *CQ* 38 (1944) 65f.

———, "Patrios Nomos: State Burials in Athens and the Public Cemetery and the Kerameikos," *JHS* 64 (1944) 37f.

F. Jevons, "Greek Burial Laws," *CR* 9 (1895) 24f.

G. Karo, *An Attic Cemetery* (1943).

H. Kenner, "Das Luterion im Kult," *ÖJh* 29 (1935) 109f.

Kerameikos: V.1, K. Kübler, *Die Nekropole des 10. bis 8. Jahrhunderts* (1954). VI.1, K. Kübler, *Die Nekropole des späten 8. bis frühen 6. Jahrhunderts* (1959); VI.2 (1970). (See also Brückner, Karo, Scheibler.)

W. Leaf, "Homeric Burial Rites," *Commentary on the Iliad*, Appendix L (1902).

D. Lucas, "Ἐπισπένδειν νεκρωι, 'Agamemnon' 1393-8," *Proceedings of the Cambridge Philological Society* 15 (1969) 60.

P. Maas, "Threnos," *RE* VI, 596.

L. Malten, "Leichenspiel und Totenkult," *RömMitt* 38–39 (1923/4) 300f.

H. Marwitz, "Das Bahrtuch," *Antike und Abendland* 10 (1961) 7f.

K. Meuli, *Der griechische Agon* (1968).

———, "Der Ursprung der olympischen Spiele," *Antike* 17 (1941) 189f.

M. P. Nilsson, "Der Ursprung der Tragödie [Totenklage]," *OpSel* I (1951) 61f.

———, "Das Ei im Totenkult," *OpSel* I (1951) 3f.

M. Ninck, *Die Bedeutung des Wassers im Kult und Leben der Alten*, *Philologus* Sup. 14 (1921/1960).

D. Ohly, *Griechische Goldbleche des 8. Jahrhunderts v. Chr.* (1953) 68f.

F. Poulsen, *Die Dipylongräber und die Dipylonvasen* (1905).

E. Reiner, *Die rituelle Totenklage der Griechen*, Tübinger Beiträge zur Altertumswissenschaft 30 (1938).

I. Scheibler, *The Archaic Cemetery*, Kerameikos Book No. 3, trans. S. Slenczka (1973).

E. Smithson, "The Dörpfeld Areopagus Graves and Simple Cremation in Geometric Athens," *AJA* 74 (1970) 203f.

———, "The Tomb of a Rich Athenian Lady, ca. 850 B.C.," *Hesperia* 37 (1968) 77f.

F. Sokolowski, *Les lois sacrées des cités grecques* (1969).

O. M. Baron von Stackelberg, *Die Graeber der Hellenen* (1837).

H. Thompson, "Συνέπειαί τινες τῆς Λατρείας τῶν Ἡρώων," Ἐπιστημονικὴ Ἐπετηρὶς τῆς Φιλοσοφικῆς Σχολῆς τοῦ Πανεπιστημίου Ἀθηνῶν (1963/4) 276f.

R. Tölle, "Figürliche bemalte Fragmente der geometrischen Zeit vom Kerameikos," *AA* (1963) 642f.

O. Touchefeu-Meynier, "Un Nouveau Phormiskos à Figures Noires," *RevArch* (1972) 93f.

P. Wolters, "Ein griechischer Bestattungsbrauch," *AM* 21 (1896) 376.

R. S. Young, *Sepulturae intra Urbem*, *Hesperia* 20 (1951) 67f., 80f.

W. Zschietzschmann, "Die Darstellungen der Prothesis in der griechischen Kunst" *AM* 53 (1928) 17f.

STELAI, GRAVE MONUMENTS, INSCRIPTIONS

For a fuller bibliography, K-B 356, 365, 367.

G. Bakalakis, *Hellenika Amphiglypha* (1946).

H. Biesantz, *Die thessalischen Grabreliefs* (1965).

F. Brommer, "Neue thessalische Bildwerke vorklassischer Zeit," *AM* 65 (1940) 103.

C. Clairmont, *Gravestone and Epigram* (1970); cf. G. Daux, *BCH* 96 (1972) 503f.

M. Collignon, *Les Statues Funéraires dans l'Art Grec* (1911).

A. Conze, *Die attischen Grabreliefs* (1890–94).

P. Couchoud, "L'interpretation des stèles funéraires attiques," *RevArch* 18 (1923) 104.

M. Couilloud, "Reliefs funéraires des Cyclades," *BCH* 98 (1974) 397f.

J. Dentzer, "Aux origines de l'iconographie du banquet couché," *RevArch* (1971) 215f.

H. Diepolder, *Die attischen Grabreliefs des V. und IV. Jahrhunderts B.C.* (1931).

F. Eichler, "Σῆμα und Μνῆμα," *AM* 39 (1914) 138.

P. Frazer, T. Rönne, *Boeotian and West Greek Tombstones* (1957).

J. Frel, *Les sculptures attiques anonymes, 430–300* (1969).

P. Friedländer, H. B. Hoffleit, *Epigrammata* (1948).

K. Friis Johansen, *Attic Grave Reliefs of the Classical Period* (1951).

H. von Fritz, "Zu den griechischen Totenmahlreliefs," *AM* 21 (1896) 347, 473.

E. Griessmair, *Das Motiv der Mors Immatura in den griechischen metrischen Grabinschriften* (1966).

N. Himmelmann-Wildschütz, *Studien zum Ilissos-Relief* (1956).

L. Jeffery, "The Inscribed Gravestones of Attica," *BSA* 57 (1962) 115f.

A. Kalogeropoulou, "Δύο Ἀττικὰ 'Επιτύμβια Ἀνάγλυφα," *Deltion* 24 (1969) 211f.

C. Karouzos, "Περικαλλὲς ἄγαλμα," *Epitumbion Chr. Tsounta* (1941) 535f.

———, "Ein attisches Grabmal im Nationalmuseum Athen," *Münchener Jahrbuch der bildenden Kunst* 20 (1969) 7f.

———, *Zur Geschichte der spätarchaisch-attischen Plastik und der Grabstatuen* (1961).

S. Karouzou (Papaspyridi), "Bemalte attische Stelen," *AM* 71 (1956) 124f.

———, "'Επιτύμβια στήλη τίτθης," *Hellenika* 15 (1960) 310.

N. Kontoleon, *Aspects de la Grèce Préclassique, Collège de France* (1970).

———, "Περὶ τὸ Σῆμα τῆς Φρασικλείας," *EphArch* (1974) 1f.

R. Lattimore, *Themes in Greek and Latin Epitaphs, Illinois Studies in Language and Literature* 28 (1942).

H. Metzger, "Ekphora, Convoi Funèbre, Cortège de dignitaires en Grèce et à la Périphérie du Monde Grec," *RevArch* (1975) 209.

H. Möbius, "Eigenartige attische Grabreliefs," *AM* 81 (1966) 136.

———, "Zu den Stelen von Daskyleion," *AA* (1971) 442f.

G. Neumann, *Gesten und Gebärden* (1965) 151f.

W. Peek, *Griechische Vers-Inschriften*, I, *Grab-Epigramme* (1955); cf. L. Jeffery, *JHS* 78 (1958) 144.

———, *Griechische Grabgedichte* (1960).

G. Pfohl, *Greek Poems on Stones. 1. Epitaphs, Seventh to Fifth Centuries B.C.* (1967). 2. *Inschriften der Griechen: Grab-, Weih-, und Ehreninschriften* (1972).

H. Prückner, *Die lokrischen Tonreliefs* (1968).

A. Raubitschek, "Die Inschrift als geschichtliches Denkmal," *Gymnasium* 72 (1965) 511.

G. Richter, *The Archaic Gravestones of Attica* (1961).

K. Schefold, "Zur Deutung der klassischen Grabreliefs," *MusHelv* 9 (1952) 107f.

W. Schiering, "Stele und Bild bei griechischen Grabmälern," *AA* (1974) 651.

B. Schmaltz, *Untersuchungen zu den attischen Marmorlekythen* (1970).

A. Skiadas, *'Επὶ τύμβῳ* (1967).

G. Stamiris, "Attische Grabinschriften," *AM* 67 (1942) 218f.

L. Stella, "L'ideale della morte eroica nella Grecia del V secolo," *Atene e Roma* 2 (1934) 313f.

J. Thimme, "Die Stele der Hegeso als Zeugnis des attischen Grabkultus," *AntK* 7 (1964) 16f.

———, "Bilder, Inschriften und Opfer an attischen Gräbern," *AA* (1967) 199f.

N. Thönges-Stringaris, "Das griechische Totenmahl," *AM* 80 (1965) 1f.

M. Tod, "Laudatory Epithets in Greek Epitaphs," *BSA* 46 (1951) 182f.

H. Wade-Gery, "Classical Epigrams and Epitaphs," *BSA* 46 (1951) 182f.

C. Weickert, "Zur griechischen Grabstele," *MusHelv* 8 (1951) 147.

P. Wolters, "Grabstein mit Lutrophoros," *AM* (1893) 66.

ATTIC WHITE LEKYTHOI AND THEMES OF DEATH IN PAINTING

P. Arias, "Morte di un Eroe," *Archeologia Classica* 21 (1969) 190.

J. D. Beazley, *Attic White Lekythoi* (Charlton Lecture, 1938).

C. Bérard, *Anodos. Essai sur l'imagerie des passages chthoniens, Bibliotheca Helvetica Romana* 13 (1974).

———, "Une Nouvelle Péliké du Peintre de Geras," *AntK* 9 (1966) 93.

R. C. Bosanquet, "On a Group of Early Attic Lekythoi," *JHS* 16 (1896) 164.

———, "Some Early Funerary Lekythoi," *JHS* 19 (1899) 169.

F. Brommer, "Eine Lekythos in Madrid," *Madrider Mitteilungen* 10 (1969) 155.

A. Brückner, "Zur Lekythos Tafel 4," *AA* (1891) 197.

E. Buschor, "Attische Lekythen der Parthenonzeit," *Münchener Jahrbuch der bildenden Kunst* n.s. 2 (1925).

———, "Haus und Grab," *ÖJh* 39 (1952) 12.

A. Fairbanks, *Athenian White Lekythoi* I (1907), II (1914).

F. Felten, *Thanatos und Kleophonmaler* (1971).

K. Friis Johansen, "Ajas und Hektor, ein vorhomerisches Heldenlied," *Historik-Filosofiske Meddelelser udgivet af det Kongelige Danske Videnskabernes Selskab* 39.4 (1961).

R. Hampe, *Ein frühattischer Grabfund* (1960).

P. Jacobsthal, "Aktaions Tod," *Marburger Jahrbuch für Kunstwissenschaft* 5 (1929) 1.

———, "The Nekyia Krater in New York," *Metropolitan Museum Studies* 5 (1934–36) 117.

S. Karouzou, *Ten White Lekythoi in the National Museum* (n.d.).

K. Kübler, *Kerameikos* VI.2 (1970).

D. Kurtz, *Athenian White Lekythoi: Patterns and Painters* (1975).

A. Lesky, "Eine neue Talos-Vase," *AA* (1973) 1.

A. S. Murray, H. H. Smith, *White Athenian Vases in the British Museum* (1896).

N. Pharaklas, "'Η αὐτοκτονία εἰς τὴν ἀρχαίαν παραστατικὴν τέχνην," *Deltion* 25 (1970) 36.

E. Pottier, *Études sur les lécythes blancs attiques à représentations funéraires* (1883).

———, "Thanatos et quelques autres représentations funéraires sur des lécythes blancs attiques," *Monuments Piot* 22 (1916) 35.

———, "Deux silènes démolissant un tertre funéraire," *Monuments Piot* 29 (1927–28) 149.

W. Riezler, *Weissgrundige attische Lekythen* (1914).

K. Schauenburg, "Die Totengötter in der unteritalische Vasenmalerei," *JdI* 73 (1959) 48.

H. Seyrig, "Scène d'offrande funèbre sur un lécythe blanc," *Mélanges Merlier* 2 (1956) 351.

H. R. W. Smith, *Funerary Symbolism in Apulian Vase-Painting*, ed. J. K. Anderson (1976).

P. Wolters, "Rotfigurige Lutrophoros," *AM* 18 (1893) 371, 377.

MYCENAEAN BURIAL PRACTICES

M. Andronikos, *Totenkult, Archaeologia Homerica* W (1968) 76f.

———, *Hellenika* 17 (1962) 40.

C. W. Blegen, *Prosymna. The Helladic Settlement Preceding the Argive Heraeum* (1937) 156f., 228f.

———, "Post-Mycenaean Deposits in Chamber Tombs," *EphArch* (1937), 377.

H.-G. Buchholz, V. Karageorghis, *Prehistoric Greece and Cyprus* (1973) 39f.

S. Iakovides, *Perati* (1970) B, 29f., 77.

S. Immerwahr, *Agora* XIII, *The Neolithic and Bronze Ages* (1971) 99, 158.

C. Long, *The Ayia Triadha Sarcophagus* (1974).

H. Lorimer, *Homer and the Monuments* (1950) 102.

F. Matz, "Die Ägäis," in W. Otto, R. Herbig, *Handbuch der Archäologie* 2 (*Handbuch der Altertumswissenschaft* VI.3) (1954) 264, 275.

G. Mylonas, "Homeric and Mycenaean Burial Customs," *AJA* 52 (1948) 56f.

———, "Burial Customs," in A. J. B. Wace, F. Stubbings (eds.), *A Companion to Homer* (1962) 478f.

———, *Mycenae and the Mycenaean Age* (1965) 89, 176.

A. Schnaufer, *Frühgriechischer Totenglaube, Spudasmata* 20 (1970).

E. Vermeule, *Greece in the Bronze Age* (1964) 297, 382.

A. J. B. Wace, *Chamber Tombs at Mycenae* (1932) 121.

J. Wiesner, *Grab und Jenseits* (1938).

EARLY WARFARE AND DEATH IN BATTLE

G. Ahlberg, *Fighting on Land and Sea in Greek Geometric Art* (1971).

C. Beye, "Homeric Battle Narratives and Catalogues," *HSCP* 68 (1964) 345f.

J. Carter, "The Beginnings of Narrative Art in the Greek Geometric Period," *BSA* 67 (1972) 25f.

T. J. Dunbabin, "Ἐχθρὴ παλαιή," *BSA* 37 (1936–37) 83f.

H. Erbse, "Beobachtungen über das 5. Buch der Ilias," *RhM* 104 (1961) 156f.

B. Fenik, *Typical Battle Scenes in the Iliad, Hermes Einzelschriften* 21 (1968).

W.-H. Friedrich, *Verwundung und Tod, Abh-AkadWiss Göttingen* (Phil.-Hist. Kl.3) 38 (1956).

Y. Garlan, *La guerre dans l'antiquité* (1972).

———, *War in the ancient world: a social history* (1975).

A. L. Greenhalgh, *Early Greek Warfare* (1973).

T. Krischer, *Formale Konventionen der homerische Epik, Zetemata* 56 (1971).

K. Latte, "Todesstrafe," *RE* Sup. VII, 1599.

H. Lorimer, *Homer and the Monuments* (1950) 132f.

W. Marg, "Kampf und Tod in der Ilias," *Die Antike* 18 (1942) 167.

P. Miniconi, *Études de thèmes "Guerriers"* (1951).

R. Nierhaus, "Eine frühgriechische Kampfform," *JdI* 53 (1938) 90f.

W. K. Pritchett, *Ancient Greek Military Practices* (1973).

H. Rahn, "Tier und Mensch in der homerischen Auffassung der Wirklichkeit," *Paideuma* 5 (1953–54) 227f., 431f.

K. Schefold, "Poésie homérique et art archaïque," *RevArch* (1972) 9.

A. Snodgrass, *Early Greek Armour and Weapons* (1964).

F. Stubbings, "Arms and Armour," in A. J. B. Wace, F. Stubbings, *A Companion to Homer* (1962).

R. Tölle-Kastenbein, "Homerische Kriegerehrung," *Antike Welt* 5 (1974) 21.

J. P. Vernant (ed.), *Problèmes de la guerre en Grèce ancienne* (1968).

J. Wiesner, H.-G. Buchholz et al., *Kriegswesen, ArchHom* E (1975).

F. Winter, *Die Kampfszenen in den Gesängen MNO der Ilias* (1956).

SELECT INDEX